HAIR BY
SAM McKNIGHT

HAIR BY
SAM MᶜKNIGHT

Sam McKnight *with contributions by*
Lisa Armstrong, Tim Blanks, Jessica Diner, Alexander
Fury, Amanda Harlech, Nick Knight, Karl Lagerfeld,
Camilla Morton, Carine Roitfeld, Jerry Stafford,
and Anna-Marie Solowij

RIZZOLI
NEW YORK

New York · Paris · London · Milan

Hair by Sam McKnight
Dedicated to Mary McKnight

First published in the United States of America in 2016 by
Rizzoli International Publications, Inc.
300 Park Avenue South
New York, NY 10010
www.rizzoliusa.com

Publication © 2016 Rizzoli International Publications, Inc.
Foreword © Karl Lagerfeld
Texts © 2016 Lisa Armstrong, Tim Blanks,
Gisele Bündchen, Naomi Campbell, Lucinda Chambers,
Jessica Diner, Edward Enninful, Alexander Fury, Mary Greenwell,
Amanda Harlech, Nick Knight, Sam McKnight, Camilla Morton,
Kate Moss, Kate Phelan, Carine Roitfeld, Jerry Stafford,
Alexandra Shulman, Anna-Marie Solowij,
Vivienne Westwood, Anna Wintour.

Producer and Project Editor: Eamonn Hughes
Creative Director: Myles Grimsdale
Design: Hingston Studio
Archivist: Tory Turk
Picture Research: Tobi-Rose Milward
Permissions: Jenny Parkinson

Jacket front: Kate Moss photographed by Nick Knight
for the December 2000 issue of British *Vogue*.
Photograph © Nick Knight. With thanks to Condé Nast UK.

This publication accompanies the exhibition *Hair by Sam
McKnight*, Somerset House, Strand, London, WC2R 1LA,
November 2, 2016–March 12, 2017

Printed and bound in Italy

ISBN-13: 978-0-8478-4878-2

Library of Congress Catalog Control Number: 2016934079

Contents

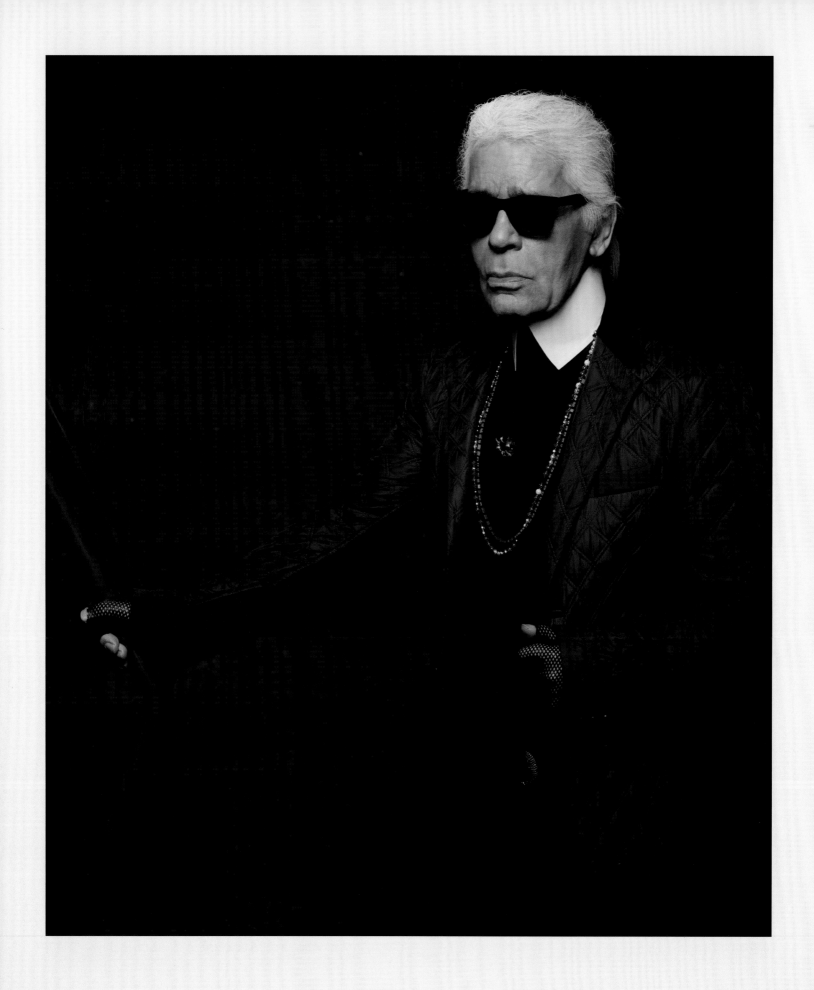

Self-portrait by Karl Lagerfeld.

HAIR IS IN THE AIR

KARL LAGERFELD

Far from occupying a completely autonomous sphere, hair constitutes today an important part of material expression in its relation to the world of fashion. Never have people paid so much attention to hair than in recent years. There are few artists ("hairdresser" is the worst word I can imagine) as gifted as Sam in the worlds of Hair and Fashion.

Sam is so open-minded (which is not the case of all the "gifted ones"). You feel safe working with him. He only admits perfection. But this hard worker is, at the same time, the funniest person one can imagine. We have a special game together, telling each other how ungifted we are, and that maybe we should make an effort when working together again—which happens often.

His work has a special sensual expression. His art is a great stimulant for all the people he works with.

As a photographer and as a designer you feel more gifted if he is around.

An important element in my account of Sam's work is the intimate connection between collections, photo shoots, designers, and models he creates. He is by instinct also motivated by the pressing issue of modernity. Nothing is ever "retro" with him. He can reinvent hairstyles and periods with a fresh and always renewed eye. His mind has the necessary aesthetic renewal so important in our world of fashion. Beauty is for him something outside of all orders of convention. This is what makes Sam unique.

Thank you, Sam, for what you are and what you give us all.

Much love, Karl

BEGINNINGS

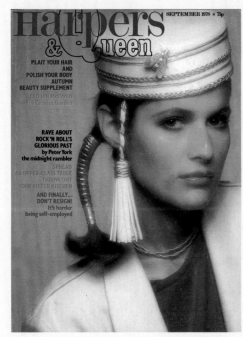

01

In this business, it's important to be part of the right team. When the team works, it's magical. I have been very fortunate to have collaborated with great teams many times in my career. Choosing the images for this book and looking back on all the people I have worked with, it seems strange that I actually fell into hair styling by accident. I should have been teaching French to ten year olds. That's what I had trained to do, but it was never a natural fit. It was the era of David Bowie, disco and glam rock, but the college was full of hippies. Two years into the course, I couldn't stand it anymore, so I left home and started helping out some friends who owned a hair salon called Josef in Prestwick. There was an American-style burger joint next door with a disco out the back. It all felt frantically glamorous for a market town in Scotland. I drove the van, did odd jobs and finally graduated to the salon floor, doing cuts for kids who wanted a Bowie look or a soul boy wedge. Scots were very cool about their music.

And something just clicked.

I was good at hair.

I was nineteen when I came to London for the first time. I had a friend named Lily Anderson from a village near mine in New Cumnock who had already made the move. She was in PR at the big Biba department store

on Kensington High Street. Witnessing this side of London firsthand was all I needed to make the move myself. It took me a year or so, but three of us eventually hitchhiked it south, with fifteen pounds between us.

I moved to London in 1974, at the height of Biba and there was a definite undercurrent of change in the air. We had old British *Vogue* magazines in our school library and I fell in love with the photographs: shoots by Norman Parkinson, models like Twiggy and, later, Jerry Hall and Marie Helvin.

02

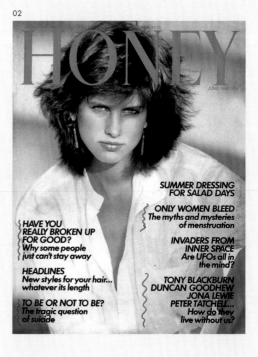

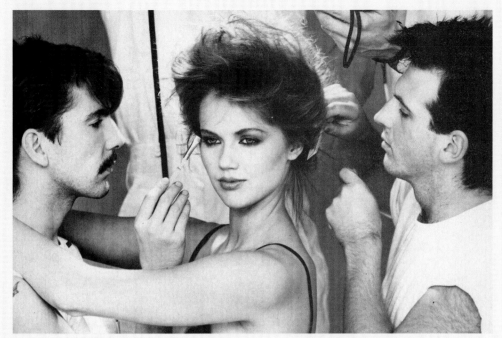

03

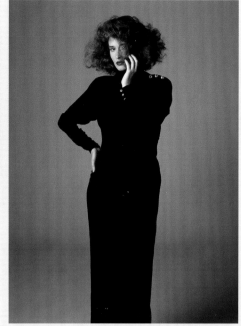

04

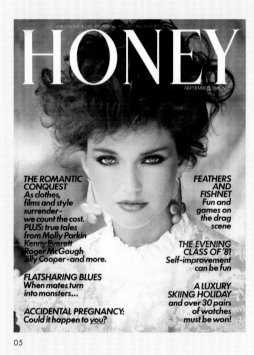

05

Doing hair was my way of connecting to that glamorous world, and when I got to London I knew I had to be part of it.

I managed to get a job at Hairworks in Miss Selfridge on Regent Street and later moved to Elizabeth Arden on Bond Street. Avidly reading the credits in *Vogue*, I became aware that it was only the people from salons who were working on fashion shoots, and the graphic cuts of Vidal Sassoon and Leonard of Mayfair were now giving way to the work of Kerry Warne from a new salon called Molton Brown. I decided then that this was where I needed to be.

Molton Brown was where I really absorbed the technical side of hairdressing. The salon was to the 1970s as Vidal Sassoon was to the 1960s, but the Molton Brown look was long and natural and less severe. The owner was Michael Collis and his wife, Caroline, was the daughter of Joan and Sidney Burstein, who had both opened Browns on South Molton Street in 1970. The salon was very much part of their budding fashion empire.

Michael had a very natural philosophy about hair and taught me not to be afraid of touching it, to use my hands more than tools, for which I will always be grateful. It's a technique I still use very much to this day.

In late 1977, when Kerry Warne wasn't available, I stepped in to work on my first editorial for British *Vogue* with photographer Eric Boman. Based on its success, I began working on further shoots with the fashion editors Anna Harvey and Liz Tilberis, as well as pieces for the *Daily Mail* with Kathy Phillips. By the end of the 1970s I began spending more time working on shoots than working in the salon, and I absolutely loved it. My first cover, in 1978, was shot by Terence Donovan for *Harper's & Queen,* and this led me to finally leave the safety of the salon and go for it full time.

First editorial for British *Vogue* in 1977. Photograph by Eric Boman.

01 First cover for *Harpers & Queen*, September 1978. Photograph by Terence Donovan.

02 *Honey* cover, June 1982. Photograph by Tony McGee.

03 Sam & Stevie Hughes on a shoot for *Honey* in 1982. Photograph by Tony McGee.

04 Rosemary McGrotha for British *Vogue*, October 1983. Photograph by Denis Piel.

05 *Honey* cover, September 1981. Photograph by Richard Dunkley.

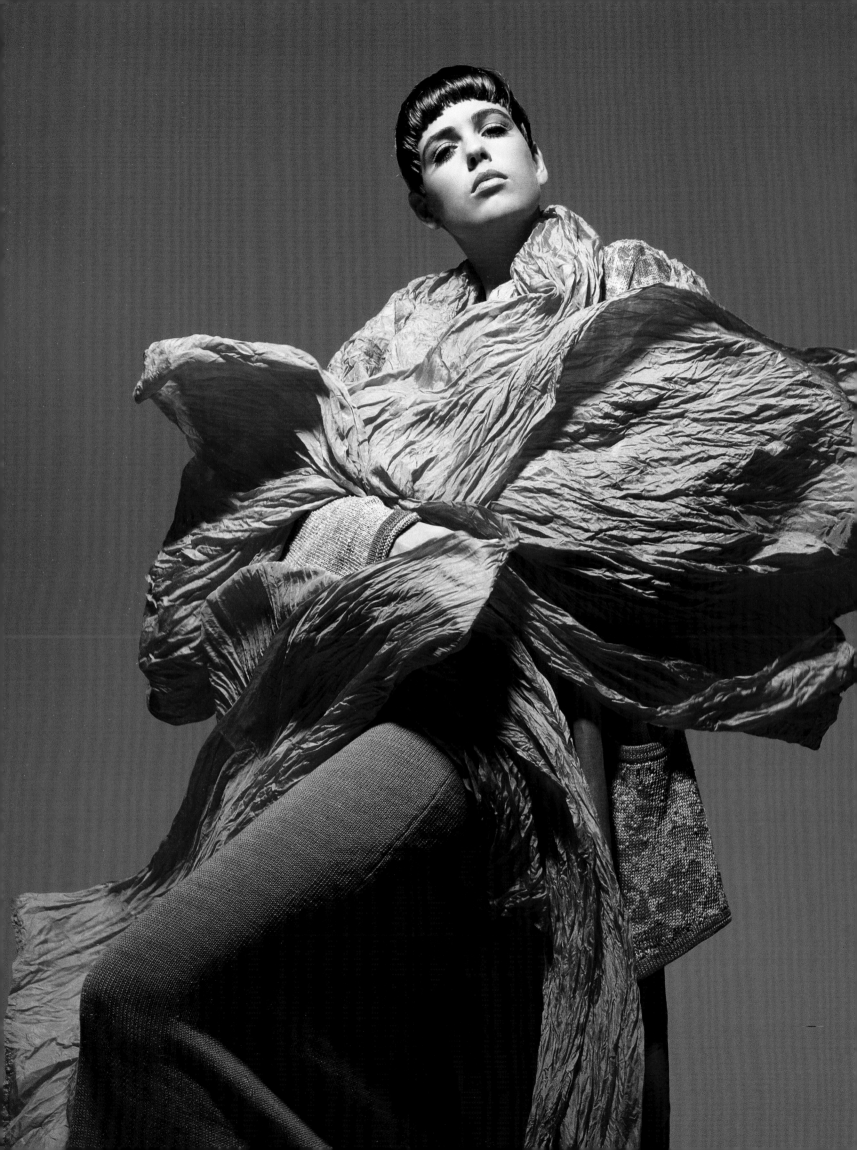

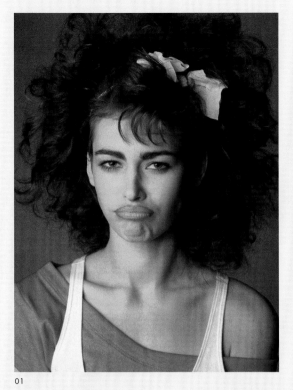

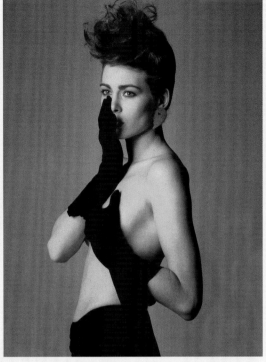

01

02

03

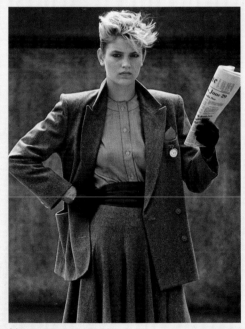

04

Opposite:

Jeny Howorth for British *Vogue*,
February 1985. Photograph
by Kim Knott.

This page:

01 Joanna Pacula for American *Vogue*,
February 1983. Photographs
by Denis Piel.

02 Joanna Pacula for American *Vogue*,
February 1983. Photographs
by Denis Piel.

03 Victoria Ewen for *Tatler*, October
1984. Photograph by Bruce Weber.

04 Jo Kelly for *Company*, September
1982. Photograph by Nick Jarvis.

05 Jeny Howorth for *The Face*, 1985.
Photograph by Martin Brading.

The industry was very different than it is today, and there weren't really any agencies booking hair and makeup people solely for editorial shoots in magazines. I set out with a small group of private clients, including Pauline and Paul Smith, and found myself busy from the start, quickly building up my portfolio with editorial shoots and covers for *Tatler, Honey* and *19 Magazine,* I was working alongside the new in-demand photographers: Tony McGee, Neil Kirk, Martin Brading, and Claus Wickrath.

Working for Honey was the first time I became part of a team and the first time I went on location trips for shoots. Pat Crouch and Linda McLean were the fashion editors, and it was an early and valuable lesson for me in the importance of building relationships in my business.

And the lesson was further reinforced by my love affair with British *Vogue.* Early on I did a job with Grace Coddington and Oliviero Toscani for *Vogue,* and more shoots with Anna Harvey and Liz Tilberis. I met Lucinda Chambers, who was then assistant to Felicity Clarke, we worked on a *Vogue* beauty story together, she modelled and I cut her hair. These were exciting times, with a distinct change in the air for the industry.

American photographer Steven Meisel came to London to shoot model Jeny Howorth for British *Vogue* in 1982, and it wouldn't be long before I bleached and cropped her hair short, transforming her into an androgynous 80s "It" girl.

05

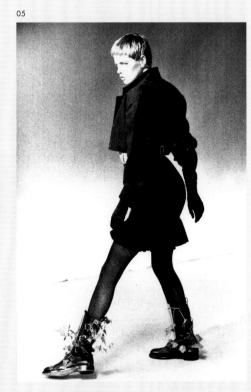

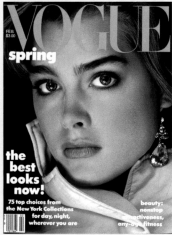

01

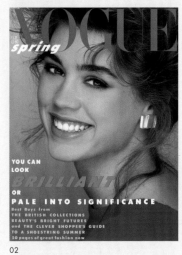

02

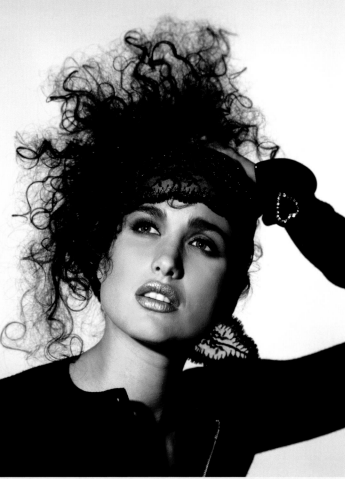

03

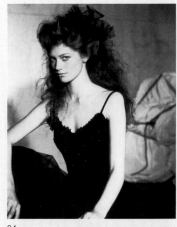

04

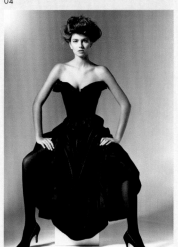

05

06

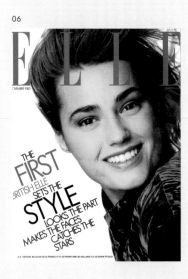

01 First cover for American *Vogue*,
February 1985, with Brooke Shields.
Photograph by Richard Avedon.
© The Richard Avedon Foundation.

02 First cover for British *Vogue* with
Lisa Hollenbeck, February 1984,
by Patrick Demarchelier.

The excitement grew further, as we felt we were a new generation all on the same learning curve. By the early 1980s, I had built a significant career in London. Makeup artist Linda Cantello and I had forged a close team and we decided that our next step was New York City. We took a trip across the pond to visit Jeny Howorth in early 1982—and never came home! We wound up sharing an apartment near Gramercy Park with our friend Isabelle Townsend, whose modelling career was also taking off.

We couldn't have timed our arrival any better. We were championed by Andrea Quinn Robinson, American *Vogue*'s beauty editor, and began working with all the models of the day: Paulina Porizkova, Kim Alexis, Nancy Donahue, Iman, Nancy DeWeir, and Andie MacDowell. Along with the new models came the new photographers, at least new for me. I began working with Richard Avedon, most notably on a Brooke Shields cover for American *Vogue*. I did several early campaigns

for Calvin Klein with Bruce Weber. I worked on an editorial with Irving Penn in 1983 championing the arrival of the new Japanese designers, namely Comme des Garçons and Issey Miyake, which was American *Vogue*'s first acknowledgement of the fashion revolution that was upending Paris. I also worked with a wonderful French photographer by the name of Patrick Demarchelier on my very first British *Vogue* cover; this was to be the beginning of a long working relationship, more than thirty years at the time of writing this book.

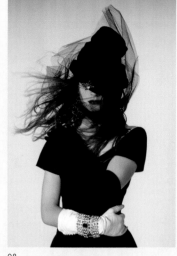

08

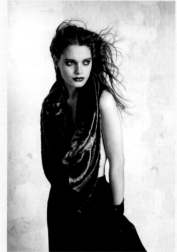

09

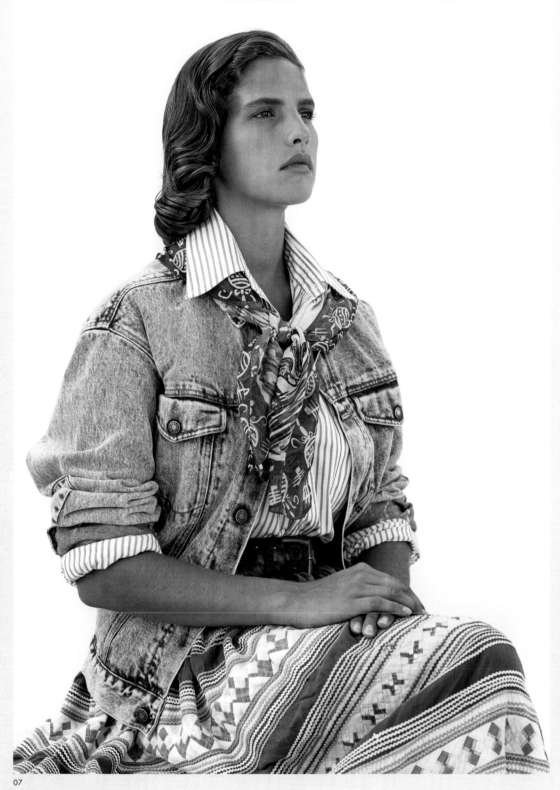

07

10

"IRVING PENN WAS AN ABSOLUTE MASTER IN HIS FIELD
AND HIS IMAGES ARE ICONIC. I AM HONOURED TO HAVE
WORKED WITH SOME OF THE PIONEERS WHO INVENTED
THE GENRE OF FASHION PHOTOGRAPHY."

— Sam McKnight

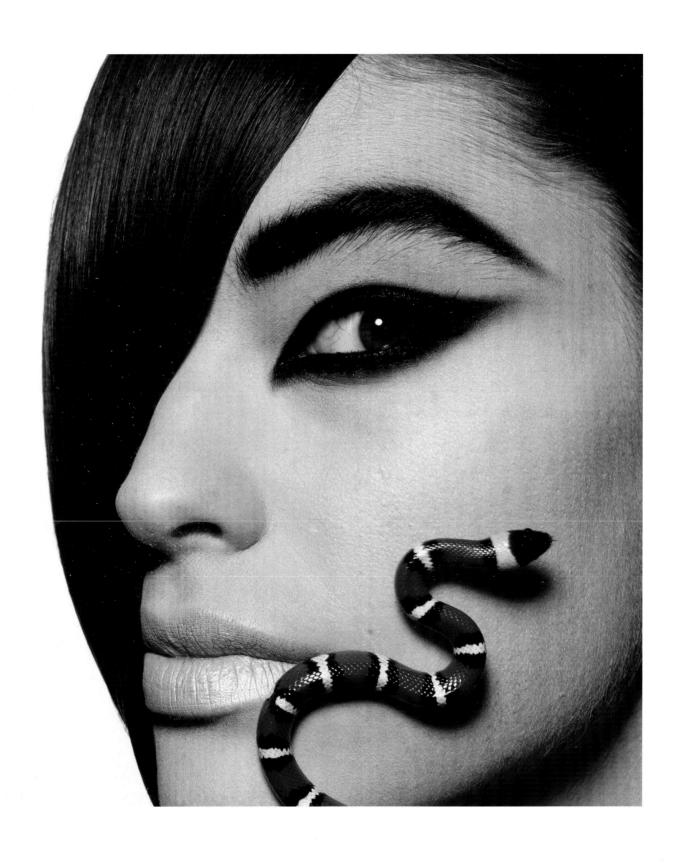

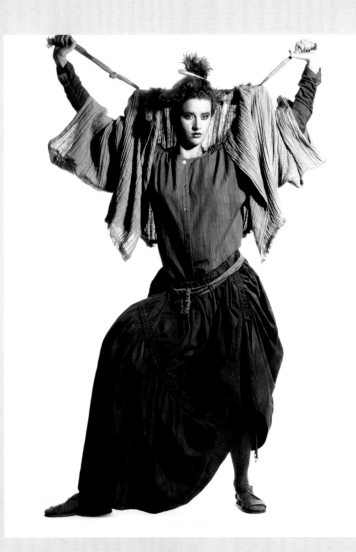
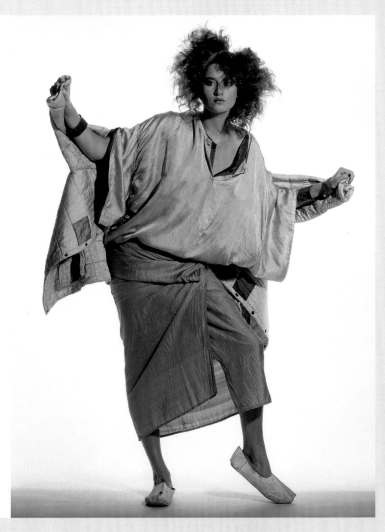
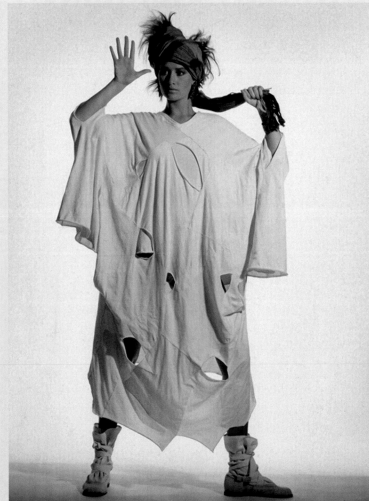
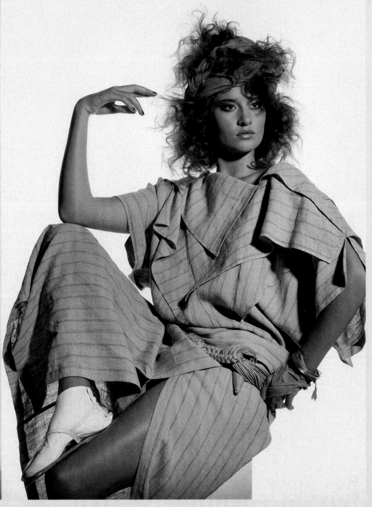

01

02

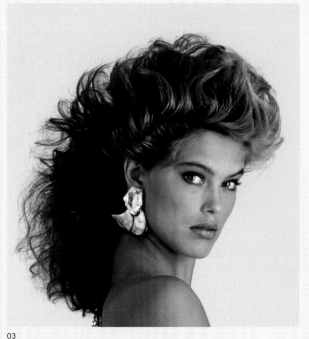

03

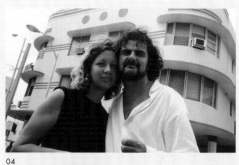

04

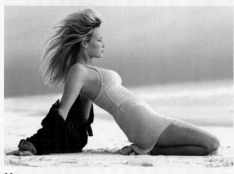

05

Opposite page:

Anette Stai in *The Next Dimension* for American *Vogue*, April 1983. Photographs by Irving Penn.

This page:

01 Christie Brinkley at the Oscars in 1984.

02 Christie Brinkley and Sam at the Oscars in 1984.

03 Renée Simonsen for American *Vogue*, November 1984. Photograph by Andrea Blanch.

04 Mary Greenwell and Patrick Demarchelier on location in 1986.

05 Estelle Lefébure for British *Vogue*, June 1987. Photograph by Patrick Demarchelier.

06 Michelle Eabry for British *Vogue*, April 1985. Photograph by Patrick Demarchelier.

By this time I had enjoyed building close relationships with creative teams, but another important kind of collaboration was developing, too, one which has become key in my career— my relationships with the people in front of the camera: the models. In the early 1980s, Christie Brinkley was at the top with her all-American looks and big hair! I had already enjoyed close collaborations with other models, but Christie was the first to take me along with everything she did, including her 1983 calendar shoot by Steven Meisel, her then boyfriend Billy Joel's video shoot for "Uptown Girl" and for her appearance at the 1984 Oscars.

By the mid-1980s, the fashion carousel was really beginning to spin. A gypsy tribe of hair and makeup teams crisscrossed the globe, traveling from shoot location to studio, from the established to up-and-coming photographers. Many times we had the luxury of spending a couple of weeks shooting an editorial piece, somewhere unexplored on the other side of the world, bonding as a creative team and nurturing young models along the way. These were fun-filled times and I am truly grateful that I arrived in the business at the start of such a creative period.

In 1984 I gate-crashed a New Year's Eve party thrown by Mary Greenwell, who was an incredible makeup artist and soon became my close friend and collaborator. I'm a great believer that either the hair *or* the makeup is important on a job. They can't be fighting each other, and when they do, it shows. Mary and I have always had perfect teamwork. Soon after we started shooting regularly with Patrick Demarchelier and it was the start of a new era.

In 1985 Anna Wintour arrived as the editor of British *Vogue*. She quickly shook things up as she set out to broaden its appeal. It included a shoot by Peter Lindbergh with Yasmin Le Bon and Jeny Howorth running through the streets of London, and I styled the hair. Grace Coddington left to work for Calvin Klein in New York, and Liz Tilberis took her place as fashion director.

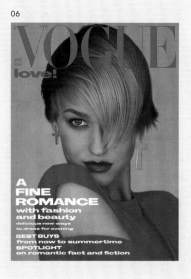

06

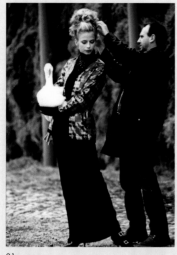

01

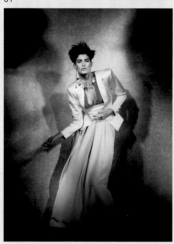

02

03

When Anna returned to New York to take up the editorship of *House & Garden* in 1987, Liz moved up to the top job at *Vogue*. Looking back now, I feel it was a watershed moment. Liz lured Lucinda Chambers back to British *Vogue* from *Elle* where she had been fashion director. When I reflect on the enduring relationships that have framed my life in hair, my relationship with Lucinda is certainly one.

Anna eventually returned to *Vogue*, but this time in charge of American *Vogue*. Her first cover was a bold step putting the nineteen-year-old model Michaela Bercu in a Christian Lacroix couture top and a faded pair of jeans on the cover. It was the first time a *Vogue* cover girl had worn jeans. It was shot once again by Peter Lindbergh, styled by Carlyne Cerf de Dudzeele, with makeup by Stephane Marais, and I was on hair duty. Asked in 2015 to pick a favourite of her *Vogue* covers Anna said it would have to be this one:

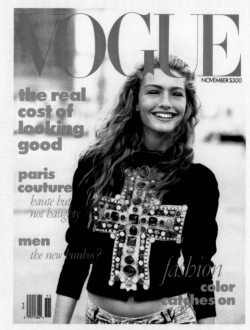

Michaela Bercu for American *Vogue*, November 1988. Photograph by Peter Lindbergh.

"THIS ONE BROKE ALL THE RULES. MICHAELA WASN'T LOOKING AT YOU, AND WORSE SHE HAD HER EYES ALMOST CLOSED. HER HAIR WAS BLOWING ACROSS HER FACE. IT LOOKED EASY, CASUAL, A MOMENT THAT HAD BEEN SNAPPED ON THE STREET, WHICH IT HAD BEEN, WHICH WAS THE WHOLE POINT. I HAD JUST LOOKED AT THAT PICTURE AND SENSED THE WINDS OF CHANGE. IT'S SOMETHING NEW, SOMETHING DIFFERENT, AND YOU CAN'T ASK FOR MORE FROM A COVER IMAGE."

— Anna Wintour, Editor-in-Chief, American *Vogue*

04

This page:

01 Sam on a British *Vogue* shoot, November 1991. Photograph by Hans Feurer.

02 Lynne Koester for British *Vogue*, March 1985. Photograph by Peter Lindbergh.

03 Lucinda Chambers for British *Vogue*, May 1981. Photograph by Sandra Lousada.

04 Kristen McMenamy for *Elle*, November 1985. Photograph by Pamela Hanson.

Opposite page:

Portrait of Sam McKnight by Simon Emmett, 2013.

In a relatively short time I had seen a huge shift in the industry. *Vogue* encouraged the evolution of a small and select mobile unit of talent, and I luckily found myself amongst them. Towards the mid-1980s, not only were the fashions starting to change, but the models were also changing. A few familiar new faces started to regularly get booked. Yasmin Le Bon, Kristen McMenamy, Christy Turlington, and Linda Evangelista were just a few of their names, but little did I know that they were to become far more than just models, and our lives were all going to change right along with them.

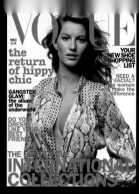

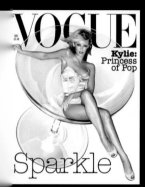
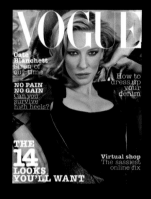
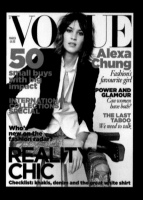
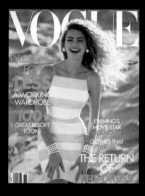
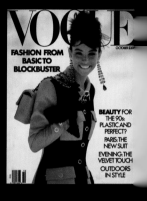
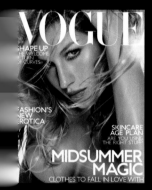
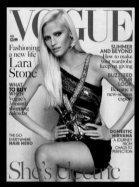
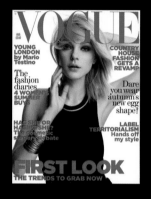
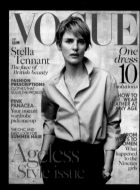
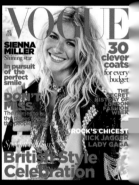

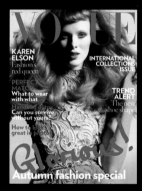
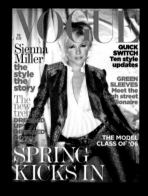

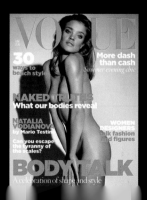
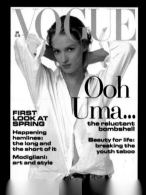
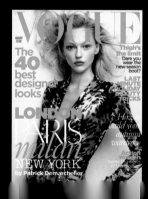
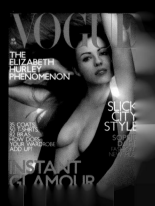

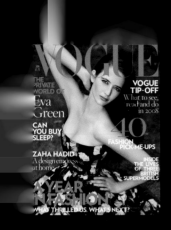 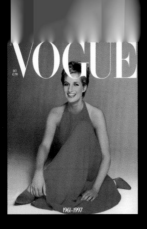 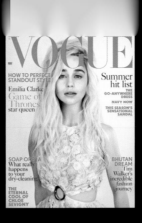 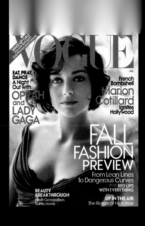 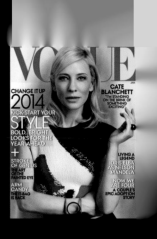

 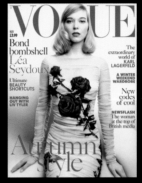 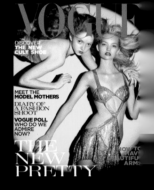

 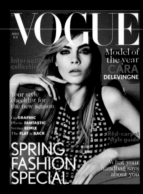 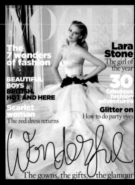 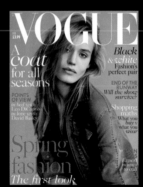 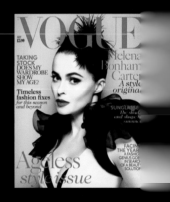

"SAM HAS BEEN A PART OF SO MANY OF BRITISH VOGUE'S
MOST IMPORTANT SHOOTS. HIS INPUT EXTENDS WELL BEYOND
DETERMINING WHAT THE HAIR WILL LOOK LIKE. WHILE HIS
MAGIC FINGERS ARE PERFORMING MIRACLES, HE ALSO ACTS AS
PSYCHOLOGICAL BALM, MAKING EVERYONE FEEL THAT EVERYTHING
WILL WORK AND THAT THEY ARE ALL IN THE BEST PLACE THEY CAN BE.
EVERYONE WANTS SAM AROUND, HELPING MAKE THE PICTURES
SING AND PRODUCING FASHION MEMORIES."

Alexandra Shulman, Editor-in-Chief of British *Vogue*

VOGUE

FASHION'S
NEW HORIZONS

hot news from the catwalk collections

SUPERS

Fashion thrives on change. The moment a trend is established, suddenly things need to change again. There have always been supermodels, girls that transcend their own moment, achieving more than what was expected of them. My generation of supermodels, however, became the ones that the world would recognize; and working with these glamazons at such close proximity, for so many years, meant that I was able to witness firsthand how incredibly professional and hard working these girls truly were, and deservedly earned every accolade that was bestowed upon them.

I first met Christy Turlington in 1985 shooting for American *Vogue* and Tatjana Patitz when she shot with Terence Donovan in 1986. That same year, Linda Evangelista showed up in London to work with Alex Chatelain. They all possessed far more than just their own beauty. Then there was Naomi Campbell, a lovely sixteen-year-old schoolgirl from Streatham. I remember her calling me from one of her first jobs in New York, in early 1987, to tell me she was working with a photographer she hadn't worked with before called Steven. I discovered it was Steven Meisel.

Patrick Demarchelier and Peter Lindbergh were all working with the same girls. Breeding a sense of solidarity in the handful of models they were working with again and again. All of us had a vested interest in making the girls look as gorgeous as possible, and the girls all trusted and knew this. And ultimately, this is why they all looked so relaxed and confident in the final images.

Working earlier with Yasmin Le Bon, who could swish her own mane perfectly from side to side in the most amazing arch of hair, I began to understand why a certain group of girls hit the zeitgeist. Our own jobs were to not only make them look more beautiful, but to encourage and assist them to become ready for the camera. They knew it was their time, and we were all on their side, helping them look and feel how they should. And my God, how hard they all worked at their craft. It was an art in itself.

Working on one of the many shoots I did with Linda, I watched her open the doors of a church in a little town in Umbria, dressed to the nines, hair and makeup perfectly in place, flying out with a dozen Dobermans running behind her. I had her mum hanging off me in mortal fear, and all Linda was concerned with, was which diamonds the photographer wanted her to highlight—the earrings or the bracelet? She completely choreographed her own leap into the frame. Of course, she not only did it flawlessly, but not a hair out of place.

Each girl was unique. The editors and designers discovered this, and their faces became instantly recognizable. We did cover after cover. Shoot after shoot. Watching their fame and power grow, along with their hair. Living their lives on the Concorde, jetting all over the world, they became the silent movie stars of their day.

Occasionally I'd get a sense of how it was all playing in the outside world, and it would always come as a shock to see just how famous the girls, who I had all met as teenagers, were becoming. Sometimes it was scarily peculiar: try walking through Miami airport with Claudia Schiffer in 1990! Other times it was sweetly peculiar. Once I had been working on a Revlon campaign with Cindy Crawford during the day, and afterwards we went to the West Village to pick up some trousers I was having adjusted. Cindy came into the store with me in full Revlon makeup. It was like a visitation. The staff crumpled. One woman fled to the back of the shop in tears—quite remarkable to witness.

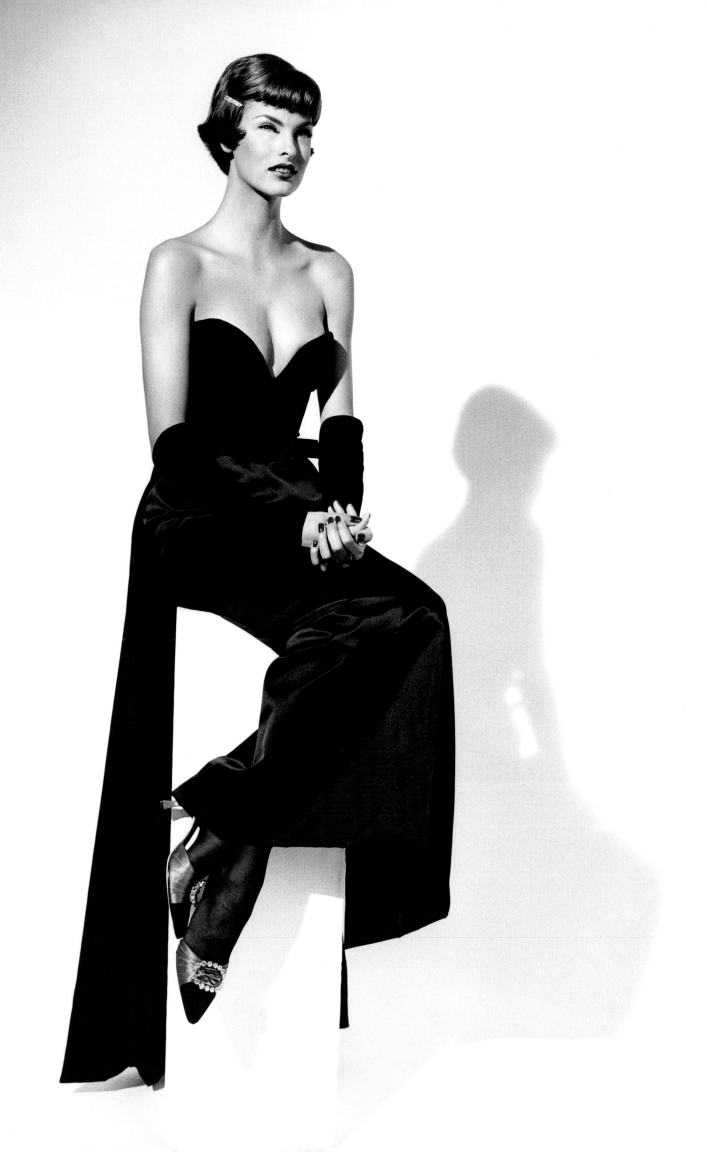

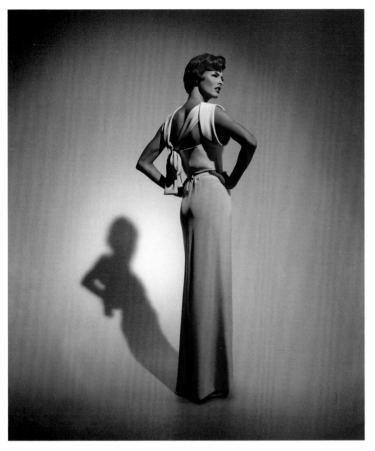

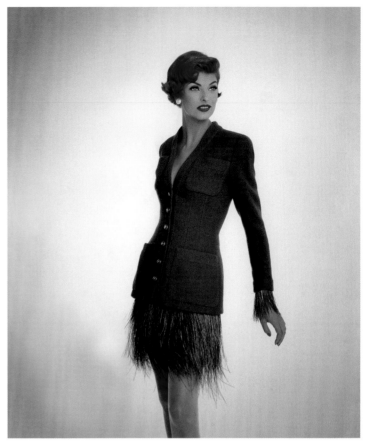

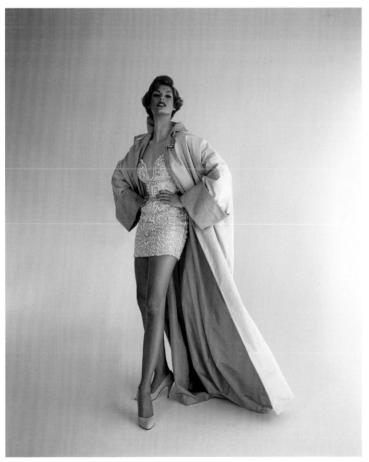

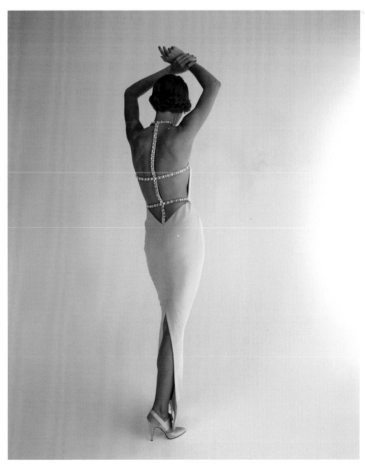

Page 21:

Linda Evangelista, British
Vogue, August 1991. Photograph
by Patrick Demarchelier.

Opposite and above:

This was one of my all-time favourite
shoots with Linda. We were shooting
couture in Paris with Patrick, Mary,
and Sarajane Hoare for British
Vogue, October 1991. All photographs
by Patrick Demarchelier.

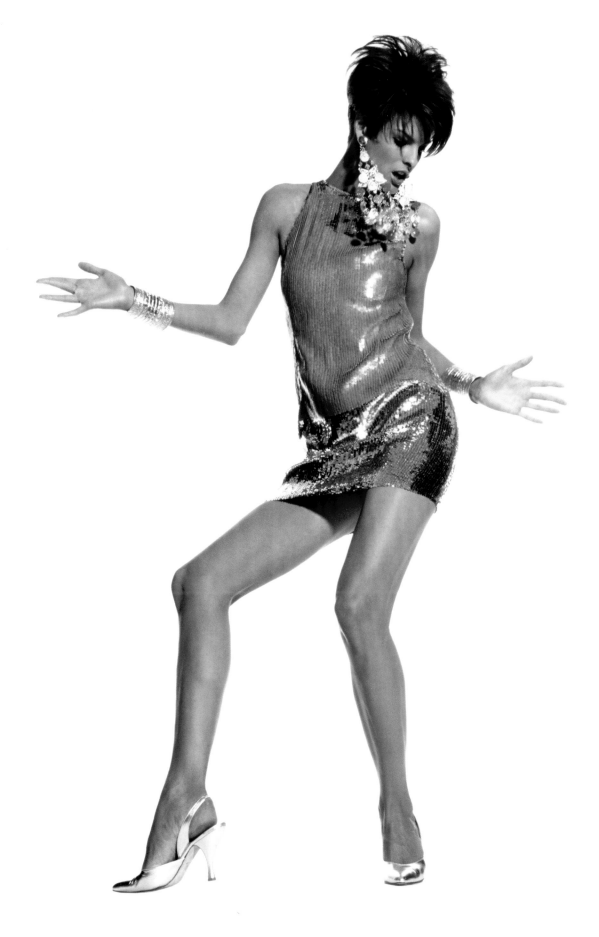

Above:

Linda dancing for Mr. Penn. Carlyne Cerf de Dudzeele and I saw Linda dancing in her Bob Mackie dress in the fitting room and invited Mr. Penn to come and look. When he saw her moving, he asked her to dance on set, then shot his first moving photographs in thirty years. He turned to me with a wink and said I had brought the devil into the studio. American *Vogue*, February 1990. Photograph by Irving Penn.

Opposite:

Linda and Christy Turlington in Mexico, British *Vogue*, May 1990. Photograph by Patrick Demarchelier.

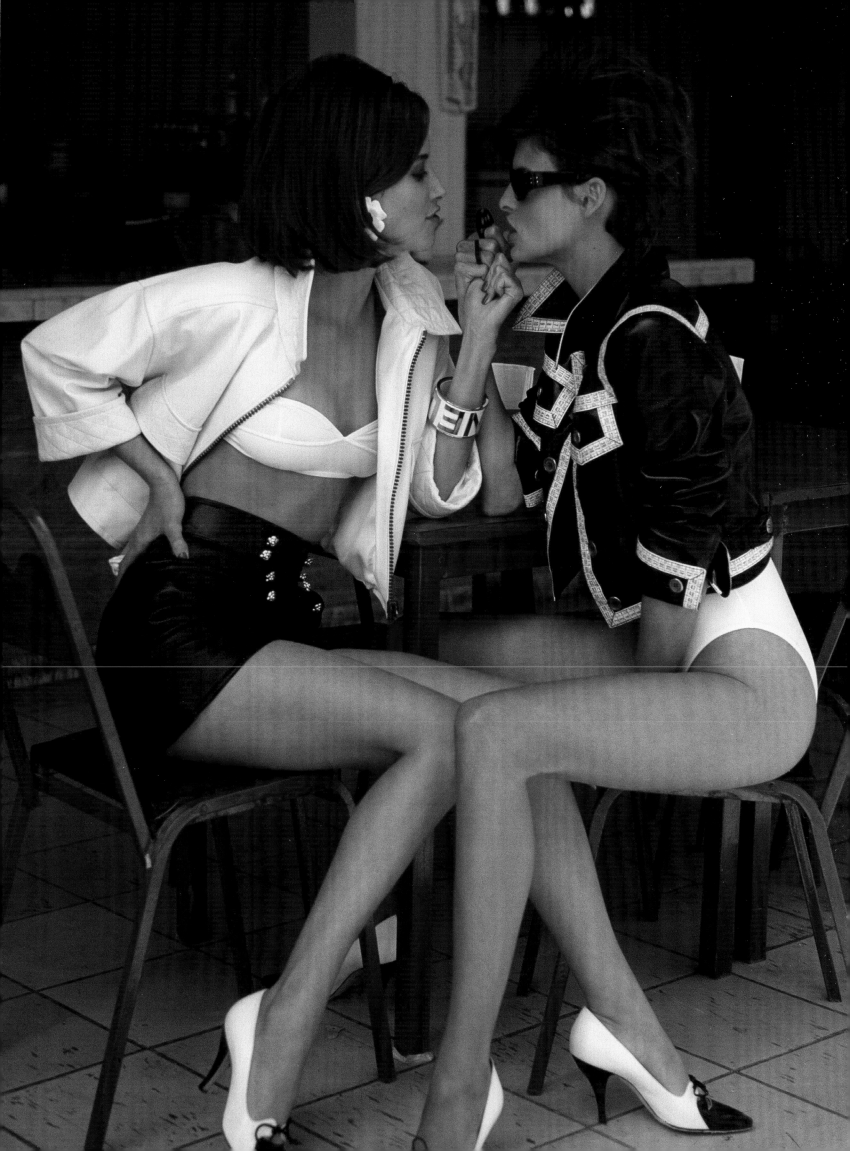

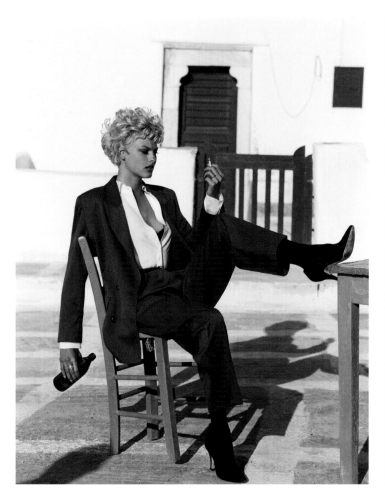

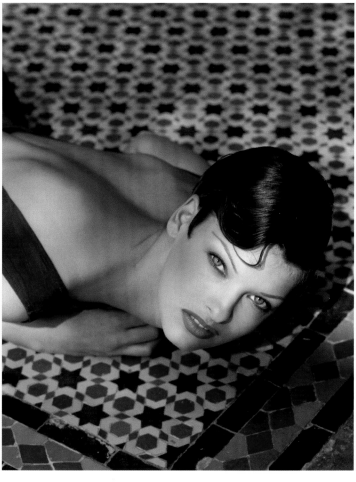

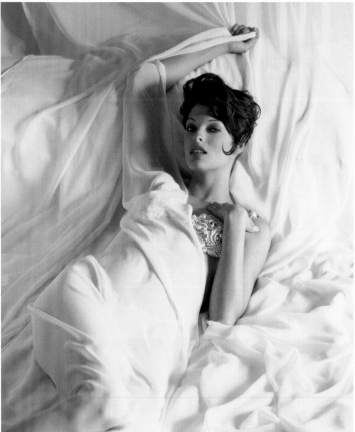

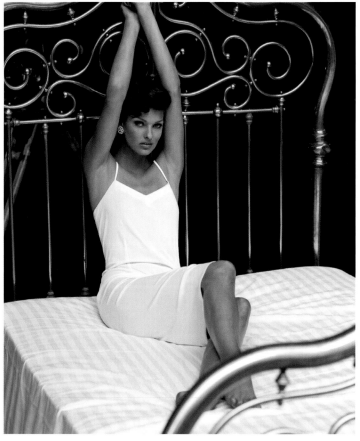

Above:

The different characters of Linda, making every picture memorable. Kenar campaigns 1992–93. All photographs by Laspata DeCaro.

Opposite:

Linda's long hair twisted into a windswept updo. American *Vogue*, August 1988. Photograph by Peter Lindbergh.

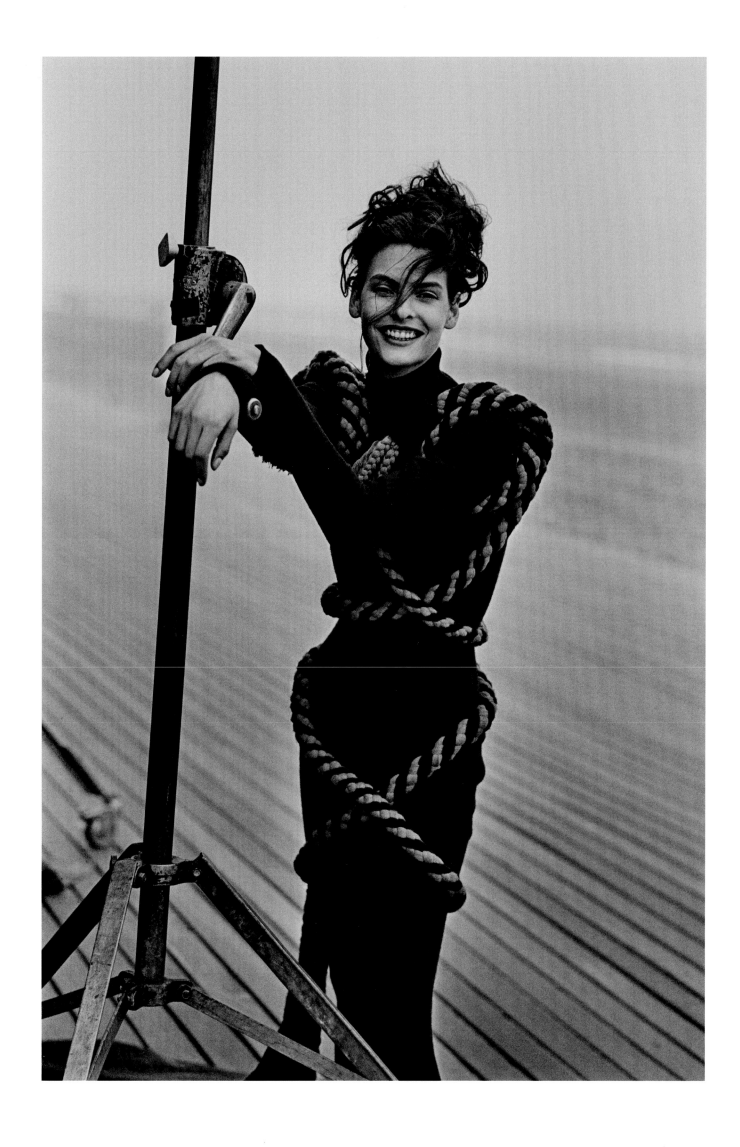

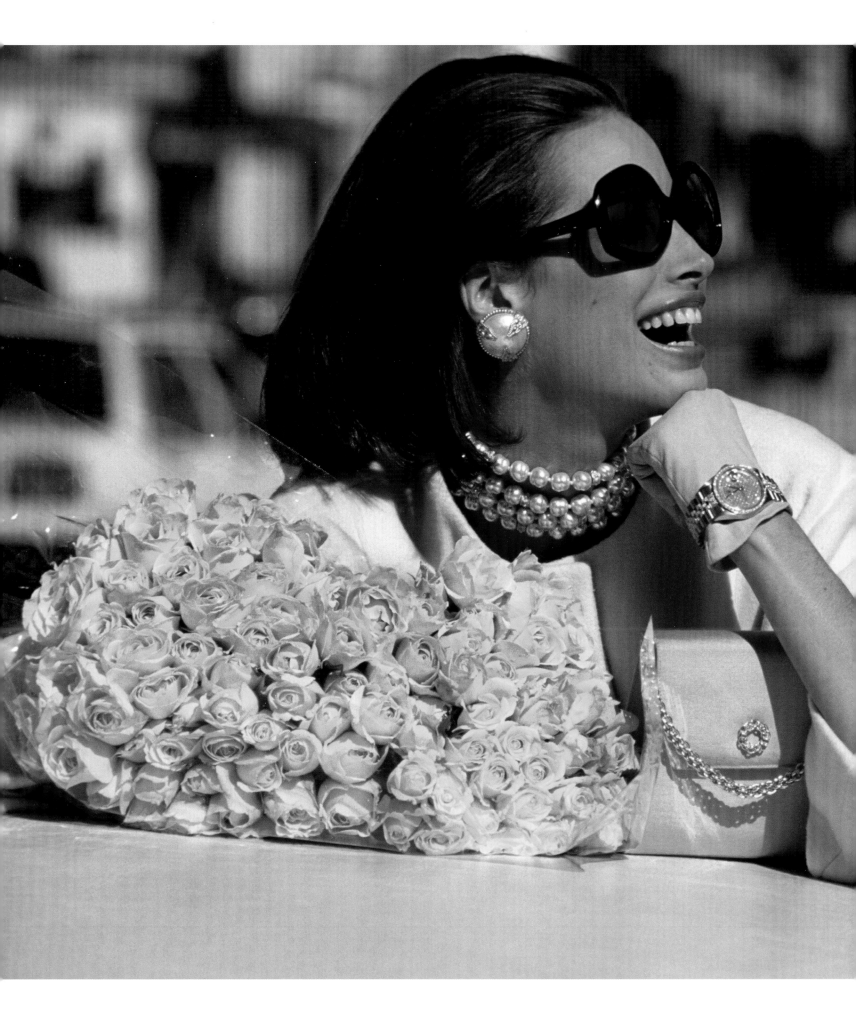

Above:

Christy Turlington as a Jackie O for the
1990s. American *Vogue*, February 1990.
Photograph by Patrick Demarchelier.

Opposite:

Polaroids by Patrick Demarchelier.

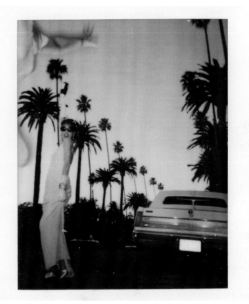

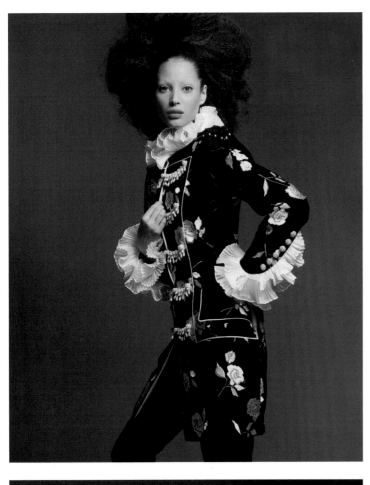

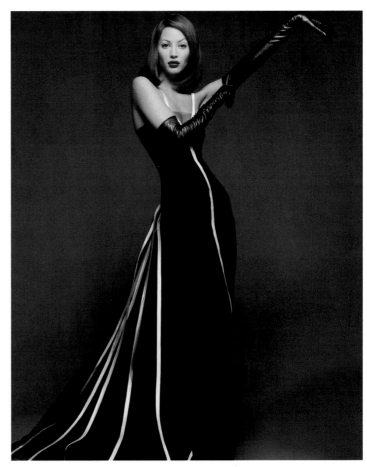

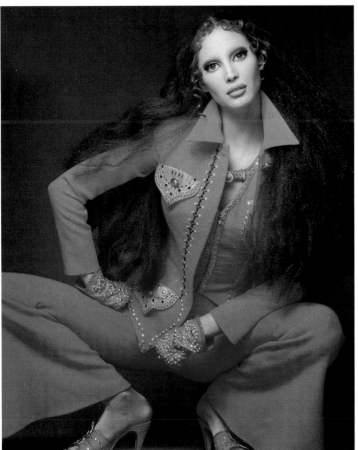

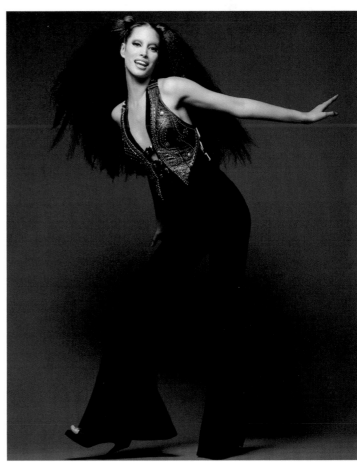

Above:

Christy in a 1970s-inspired shoot using multiple hairpieces. American *Harper's Bazaar*, October 1992.

Opposite:

Italian *Vogue*, March 1992.
All photographs by
Patrick Demarchelier.

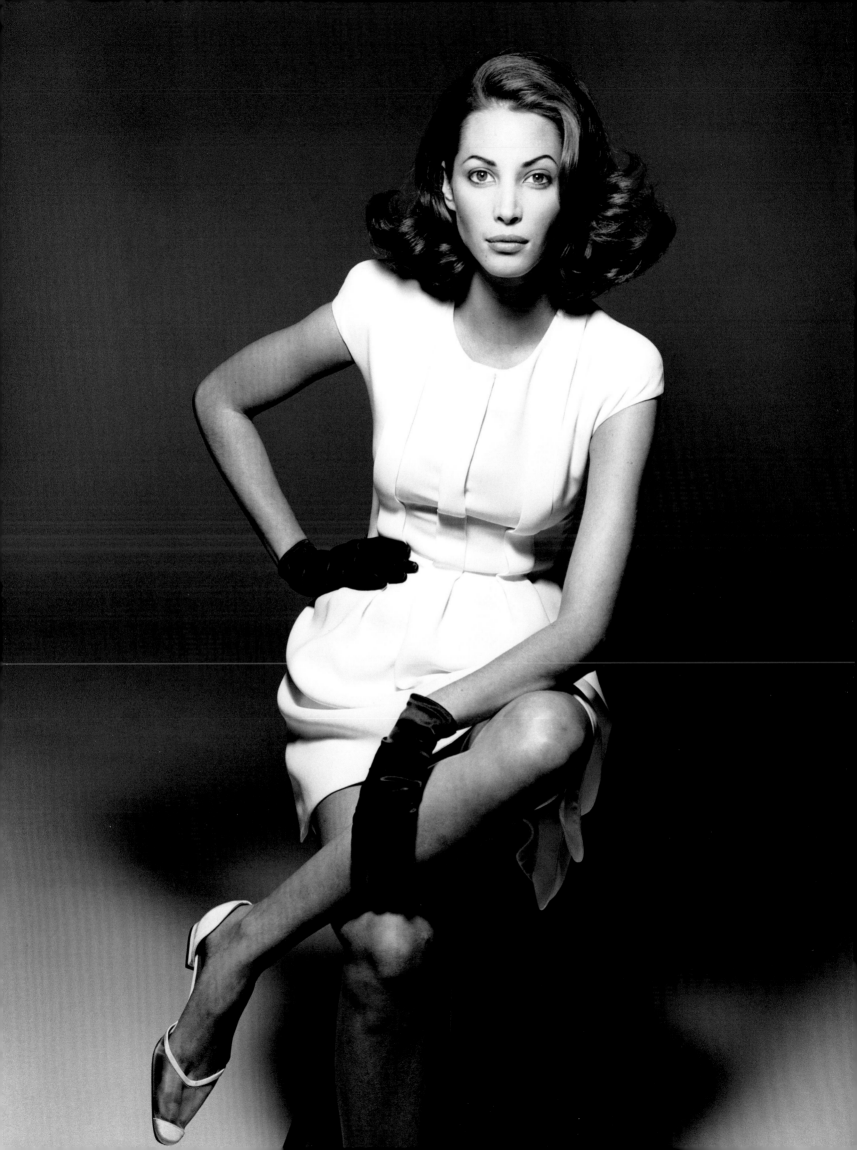

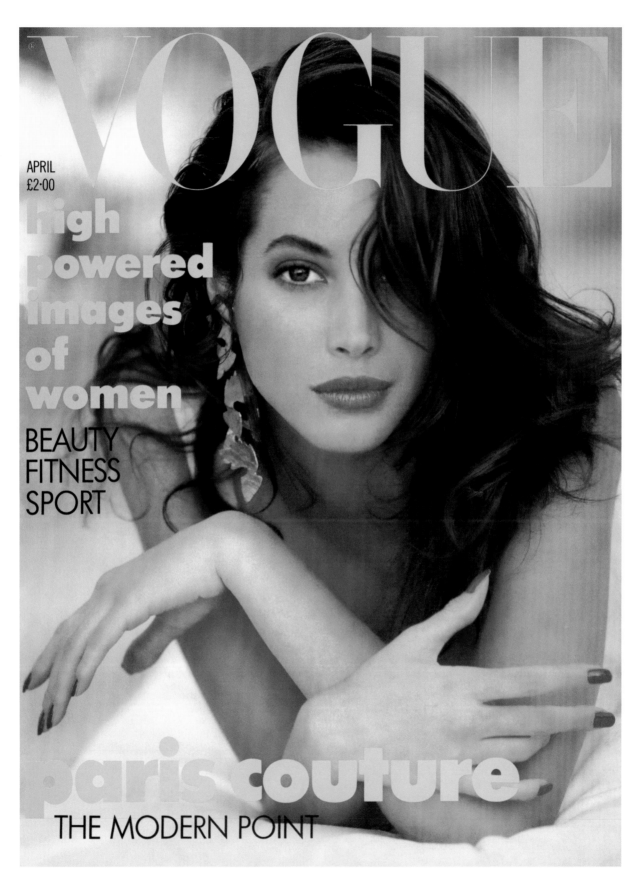

VOGUE

APRIL
£2·00

high
powered
images
of
women

BEAUTY
FITNESS
SPORT

paris couture

THE MODERN POINT

A classic Demarchelier moment: Christy caught relaxing at the end of a shoot in Mexico, so good it became a cover.

"Sam, Sam, where do I start? He creates an atmosphere on set and location that is the very best. We have had the most collaborative and inspired times when things just flow and the results are unforgettable.

Some of my best ever memories are standing with my dear friend while beauty is happening in front of us. All those "super" days when everything was so spontaneous."

—Mary Greenwell

Above:

British *Vogue*, April 1989.
Photograph by Patrick Demarchelier.

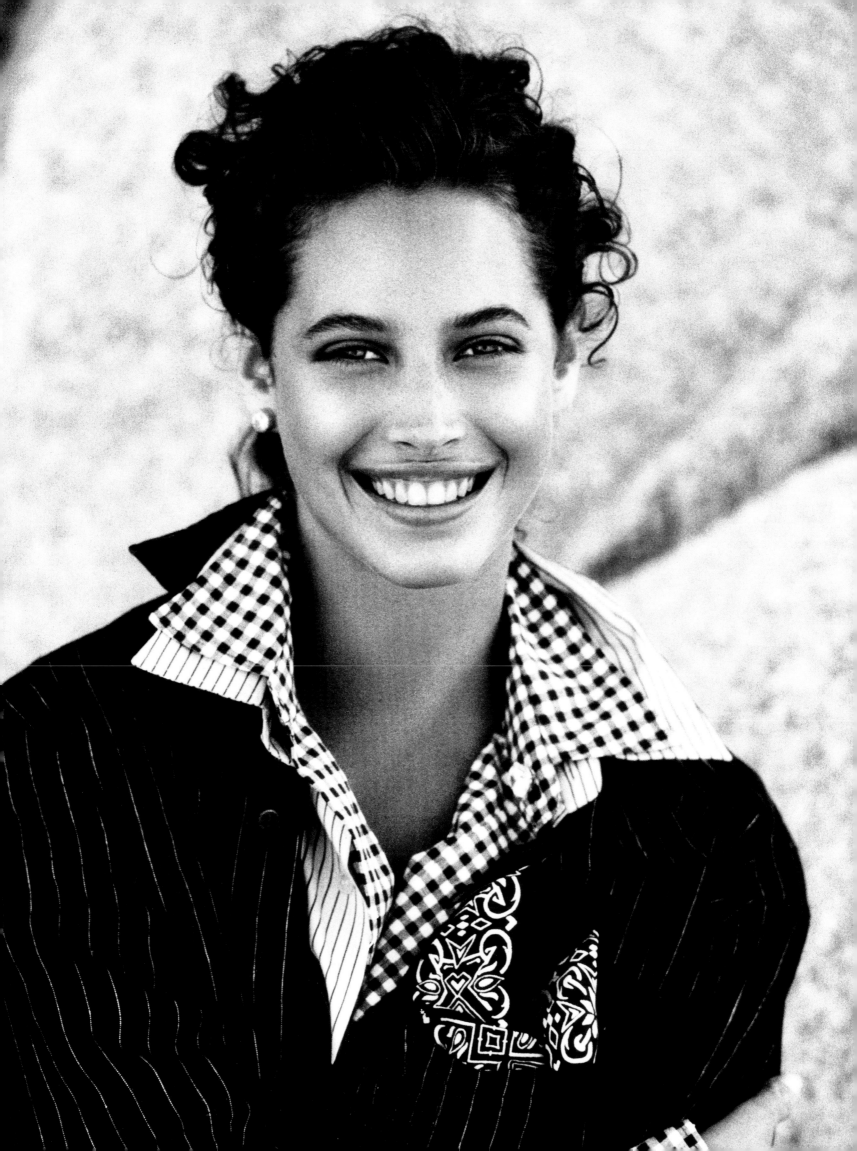

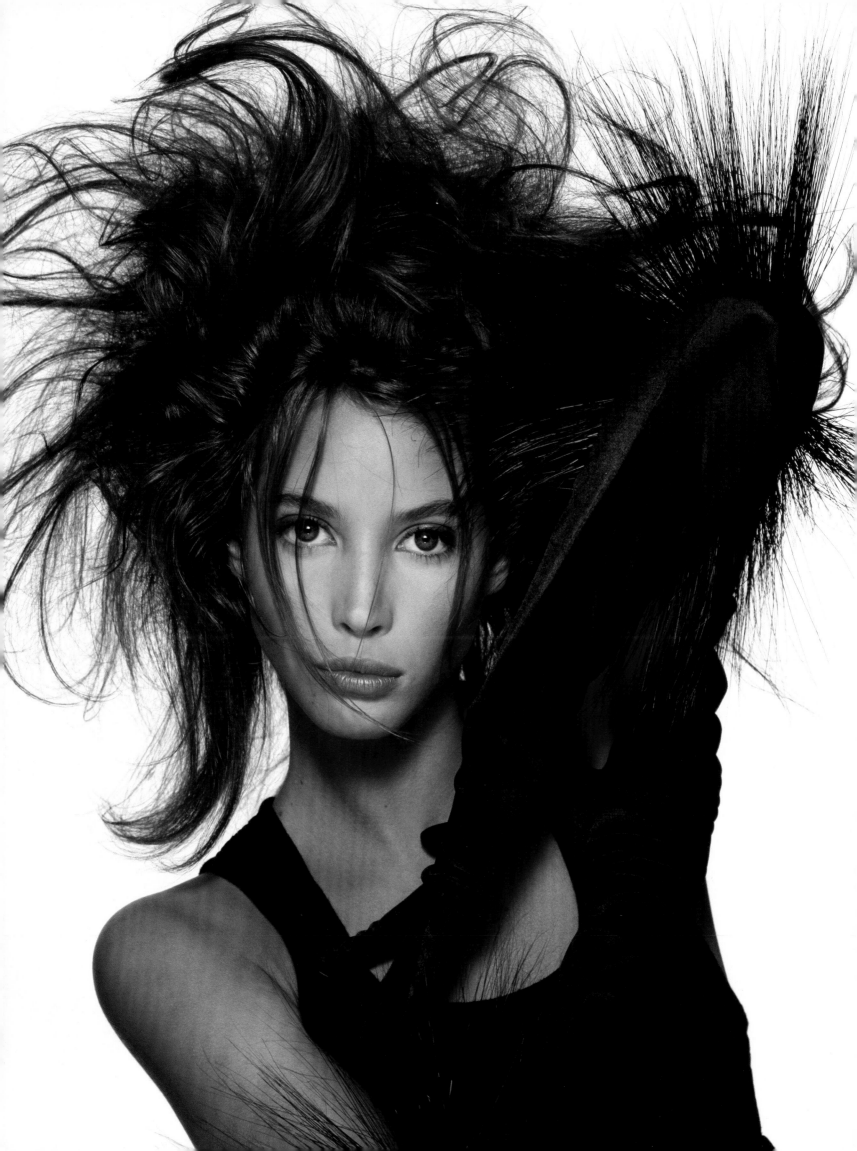

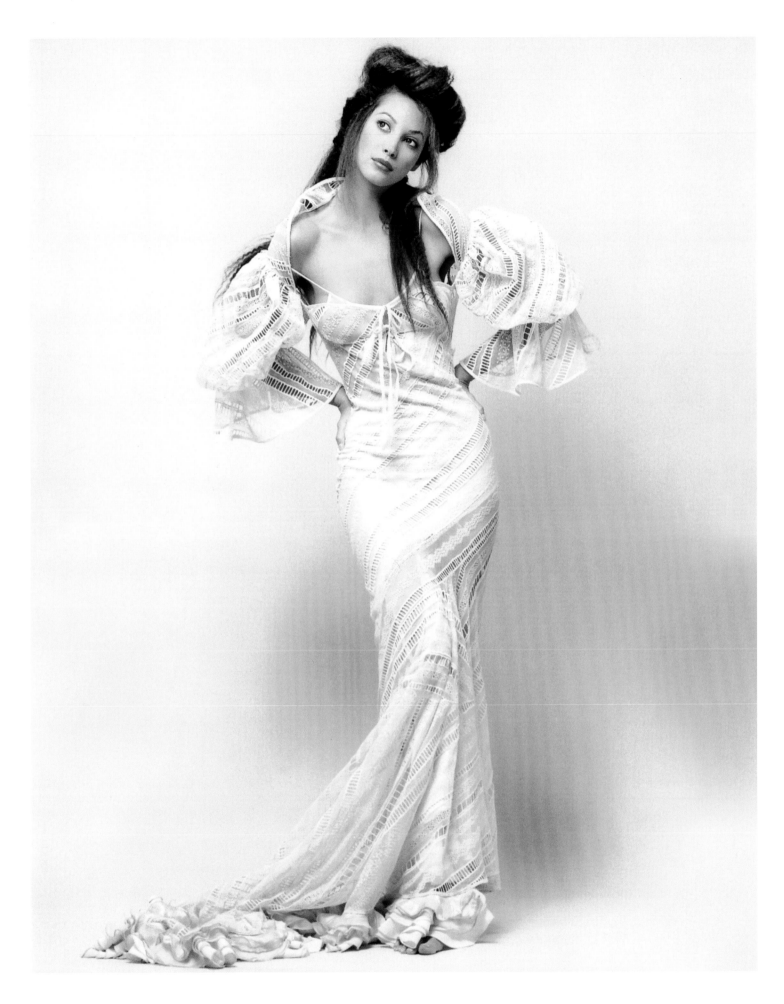

Previous:

American *Vogue*, April 1988.
Photograph by Patrick Demarchelier

Opposite:

British *Vogue*, July 1987. Both
photographs by Patrick Demarchelier.

Above:

American *Harper's Bazaar*, January
1993. Christy in early Galliano with
Victorian rolled and crimped hair.

DIRECTORS · K WAINWRIGHT · L J RUSSELL · K SION · REGISTERED IN ENGLAND · NUMBER 922229
D.O.E. SE 11767

There is only one Naomi Campbell. She is a true icon and I love her to bits. She can be naughty, dangerous, and unpredictable; her willingness to try anything inspires me. For this shoot, rather than straightening or restraining her hair, I gave her an afro hairpiece as big as her personality.

"I don't trust many people, but I do love and trust Sam."

—Naomi Campbell

Above and opposite:

Italian *Vogue*, November 1988.
Photographs by Andrew Macpherson.

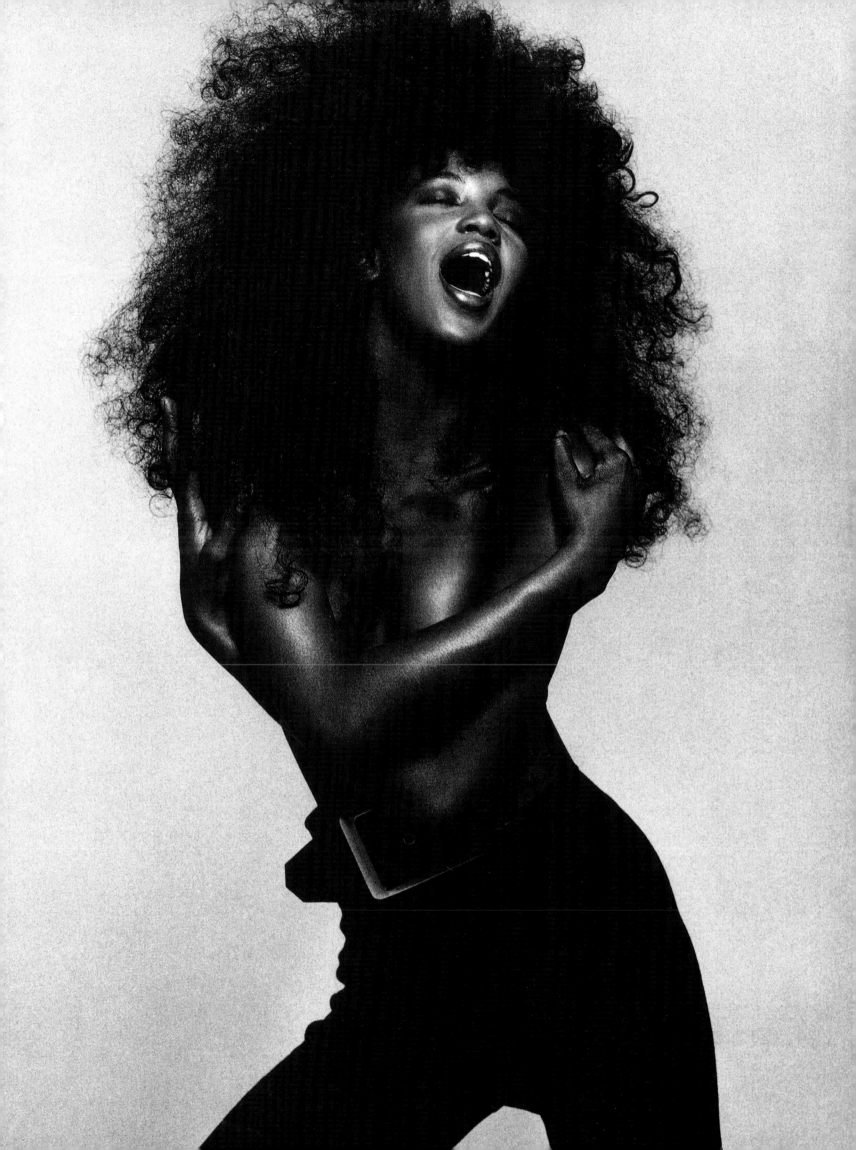

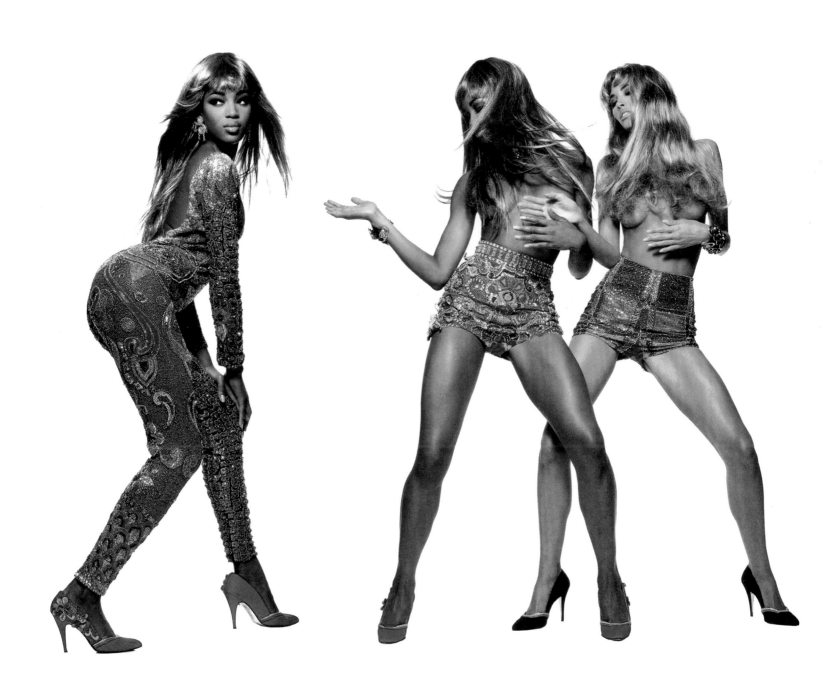

Above:

Italian *Vogue*, September 1991.
Photograph by Patrick Demarchelier.

Opposite:

Italian *Vogue*, April 1990.
Photograph by Ellen von Unwerth.

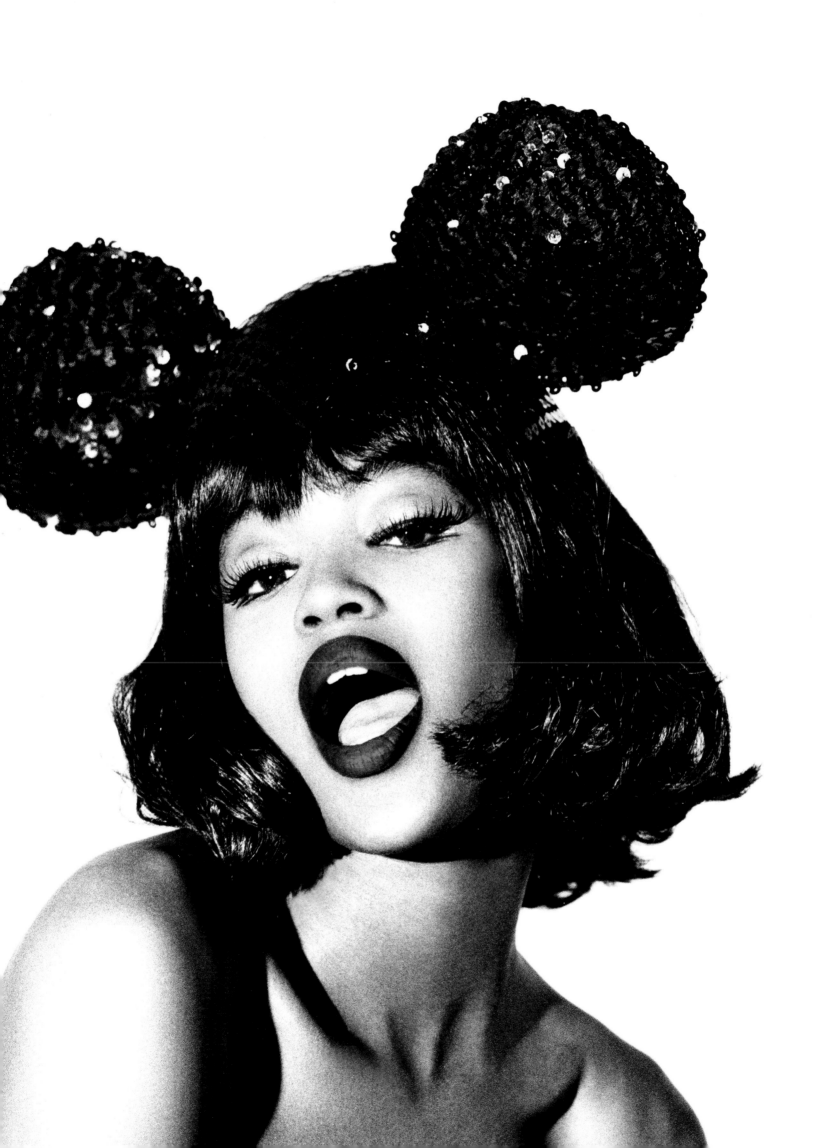

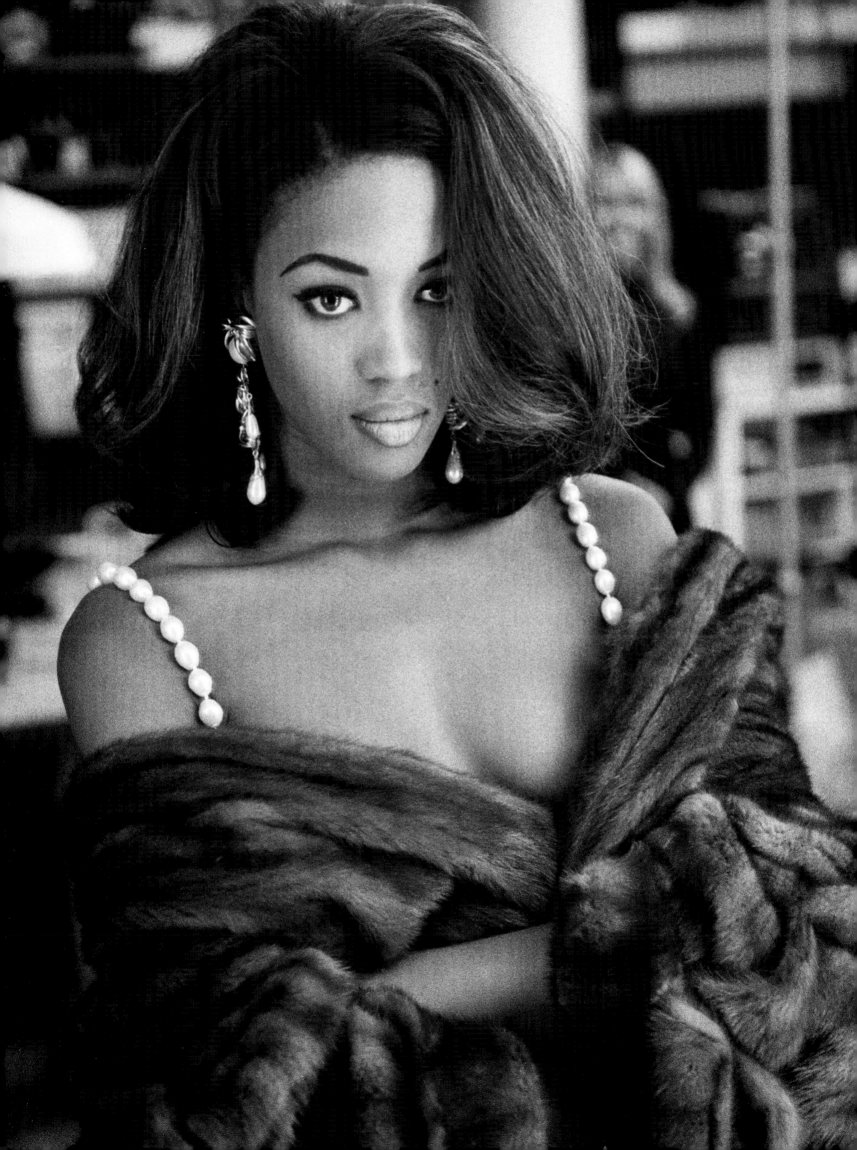

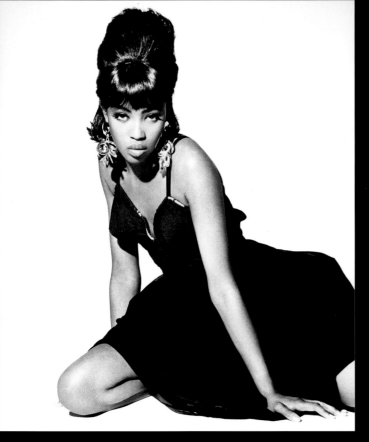

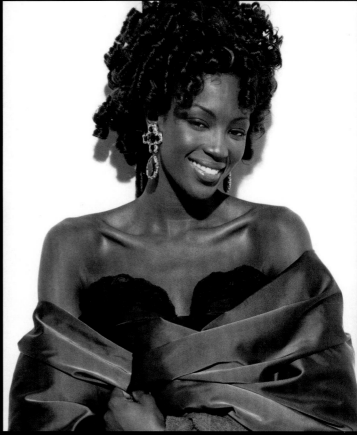

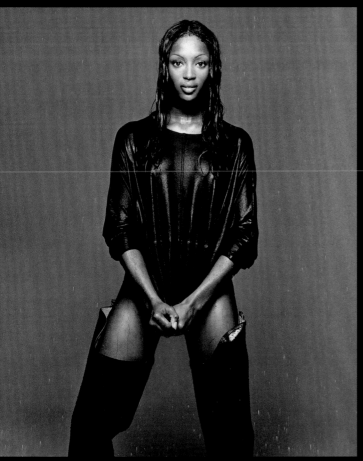

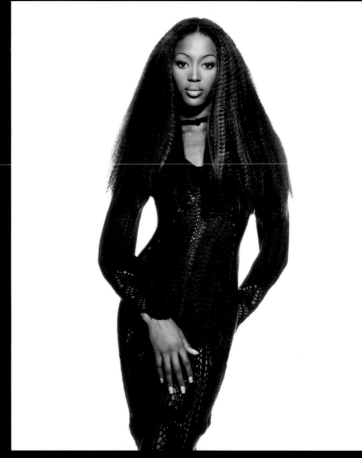

Opposite:

Italian *Vogue*, September 1990
by Patrick Demarchelier.

Above, clockwise from top left:

Ellen von Unwerth for Italian *Vogue*,
April 1990; Michelle Williams for *Elle*,
June 1992; Brad Branson for the *Sunday
Times Magazine*, February 1993; Patrick
Demarchelier for *Harper's Bazaar*,
April 1993.

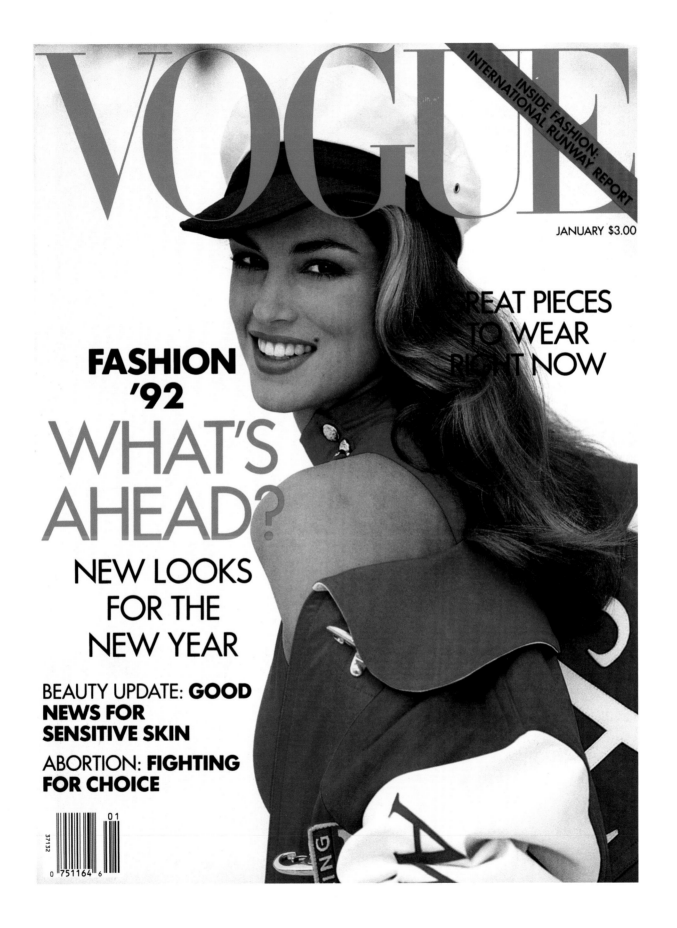

VOGUE

JANUARY $3.00

GREAT PIECES TO WEAR RIGHT NOW

FASHION '92

WHAT'S AHEAD?

NEW LOOKS FOR THE NEW YEAR

BEAUTY UPDATE: **GOOD NEWS FOR SENSITIVE SKIN**

ABORTION: **FIGHTING FOR CHOICE**

37132
0 751164 6
01

Cindy Crawford embodied the American Dream for the MTV generation. Cindy can mix high fashion with sex appeal.

Above:

American *Vogue*, January 1992.
Photograph by Patrick Demarchelier.

Opposite:

Details, December 1992.
Photograph by Albert Watson.

44

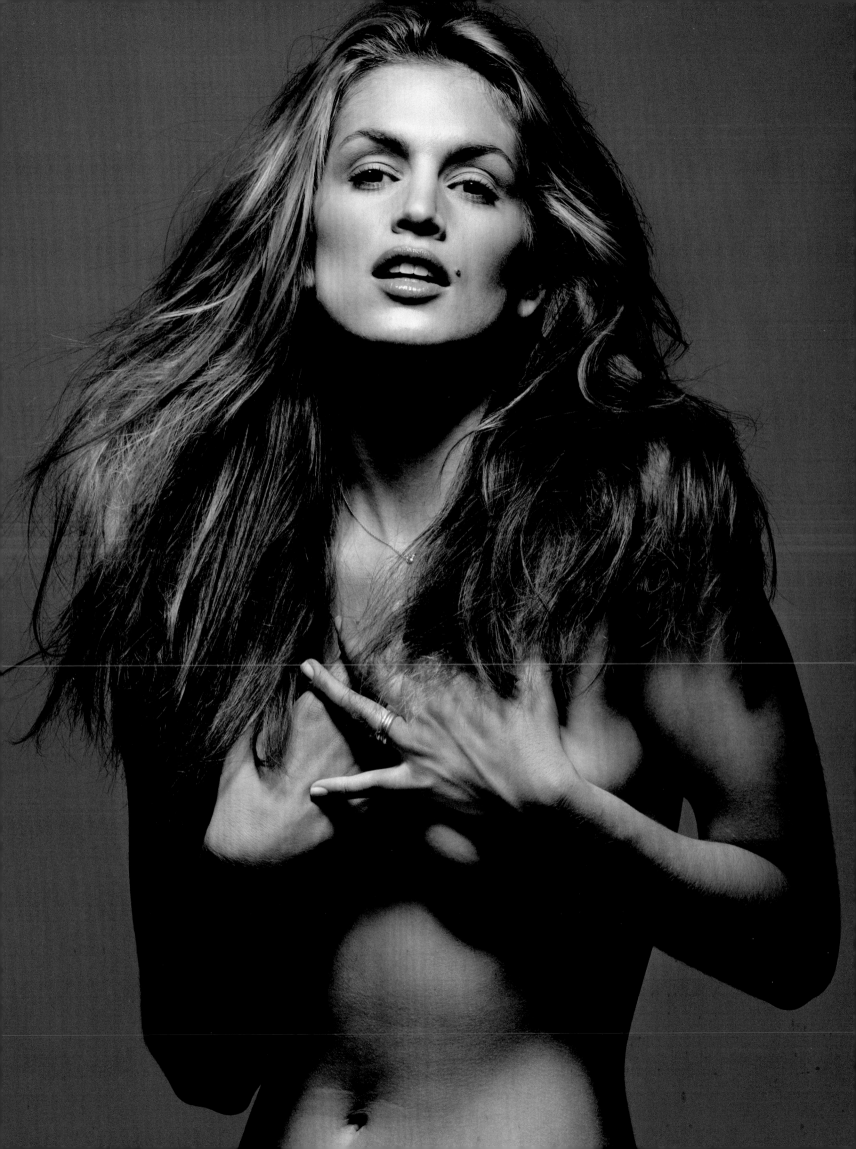

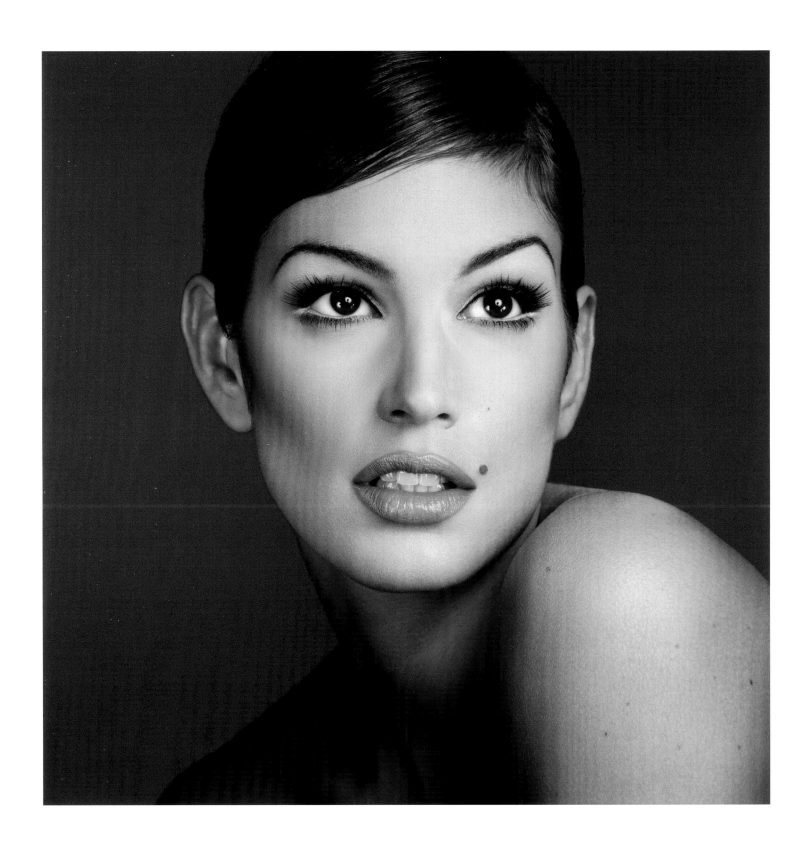

Above:

Cindy in a seldom seen slick look
complemented by Kevyn Aucoin's
makeup. *Allure* magazine,
September 1993. Photograph
by Michael Thompson.

Opposite:

W magazine, November 1996.
Photograph by Michael Thompson.

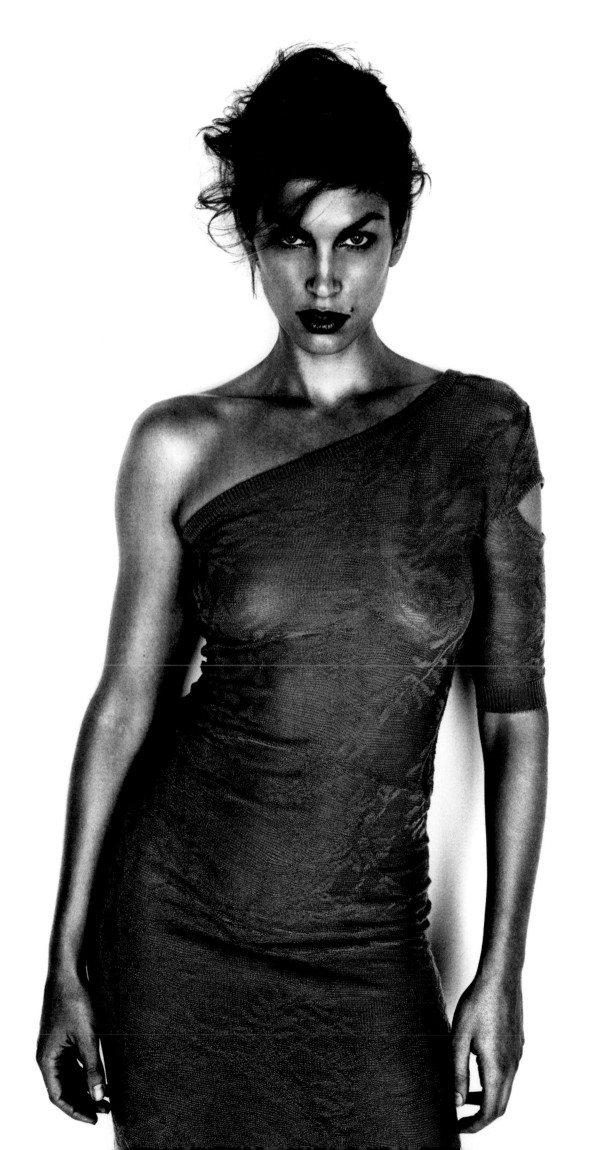

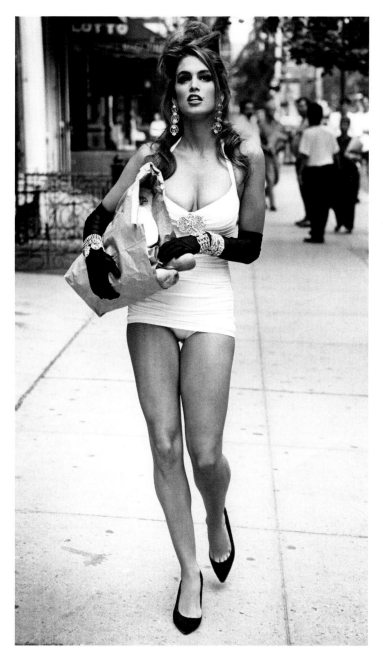

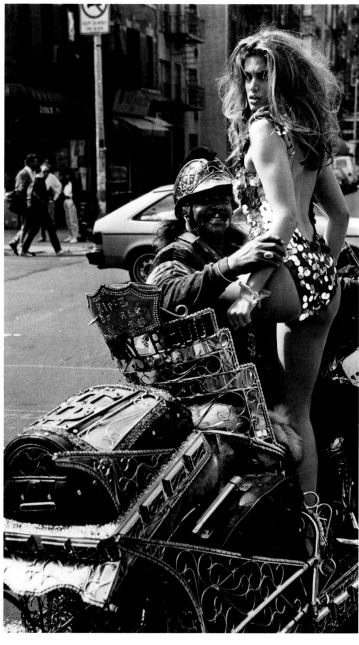

Above and opposite:

These pictures of Cindy were shot on the streets of New York's SoHo. She stopped traffic with a toss of her backcombed hair. British *Vogue*, January 1990. Photographs by Patrick Demarchelier.

Following pages:

Italian *Vogue*, September 1996. Photograph by Arthur Elgort.

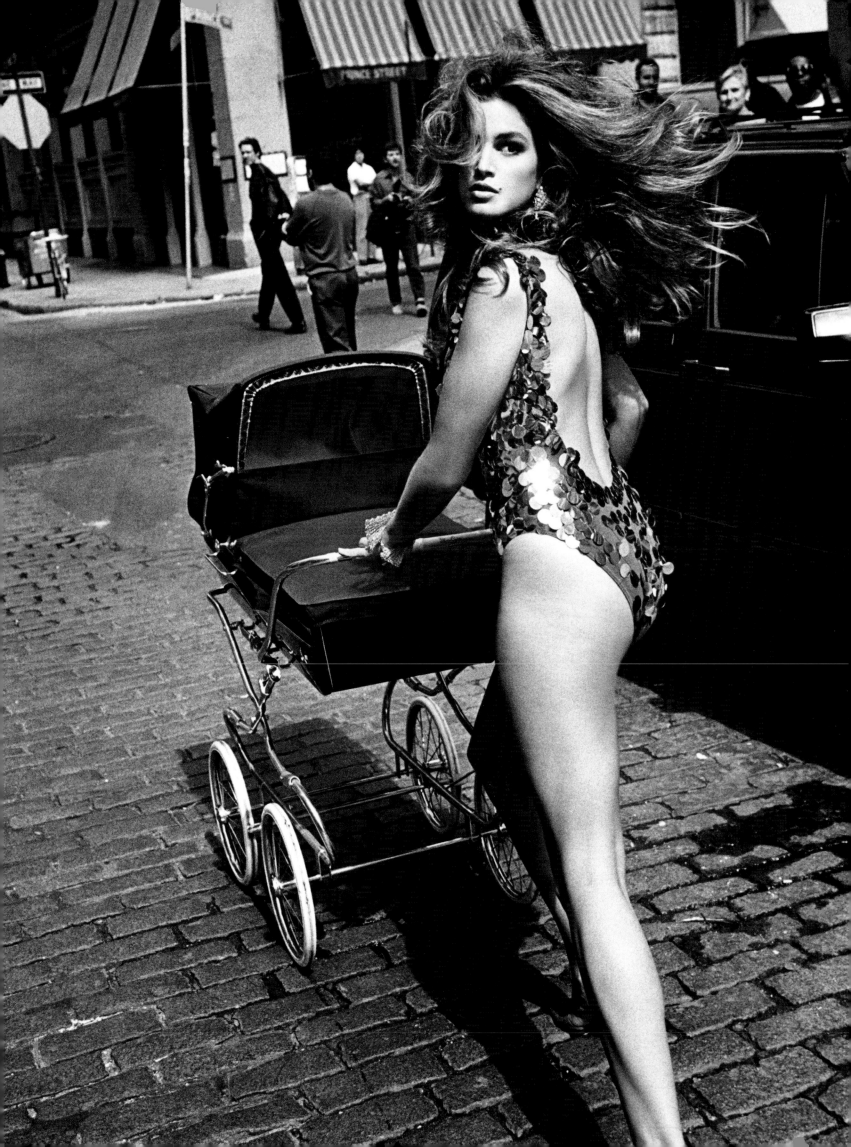

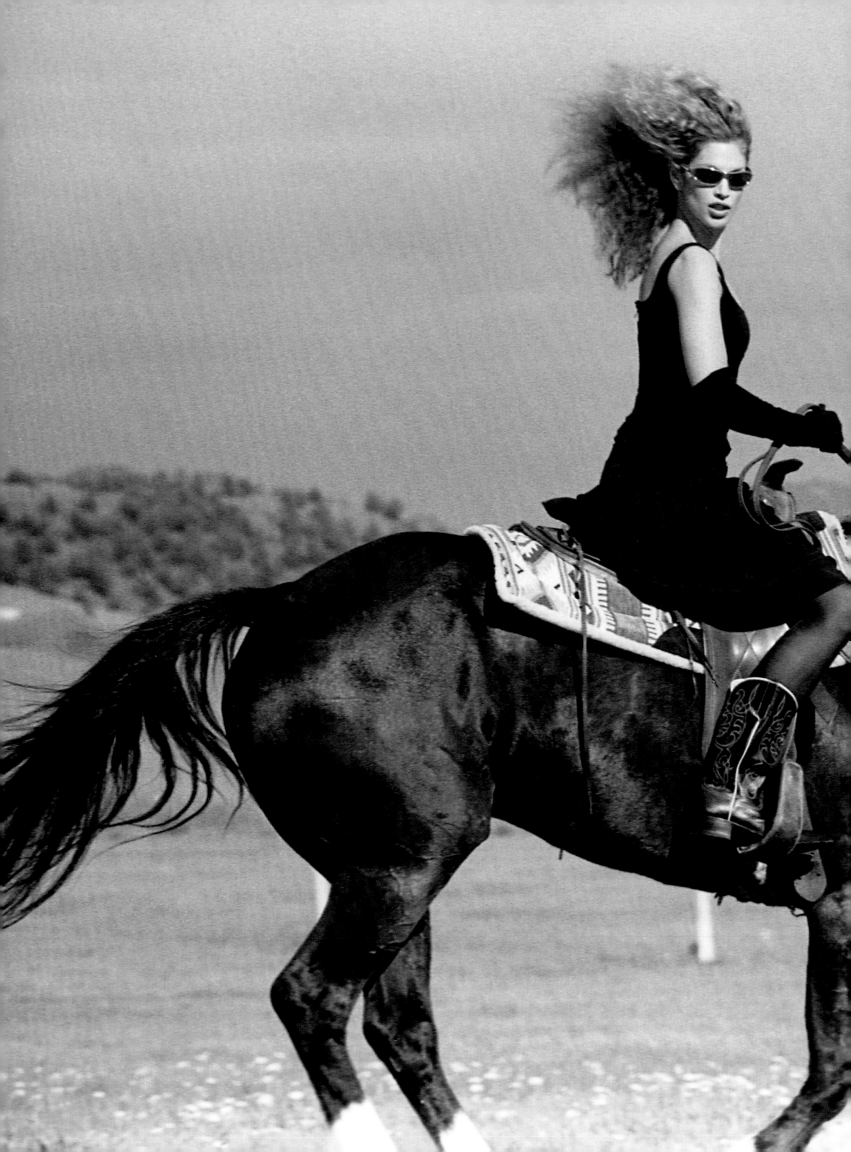

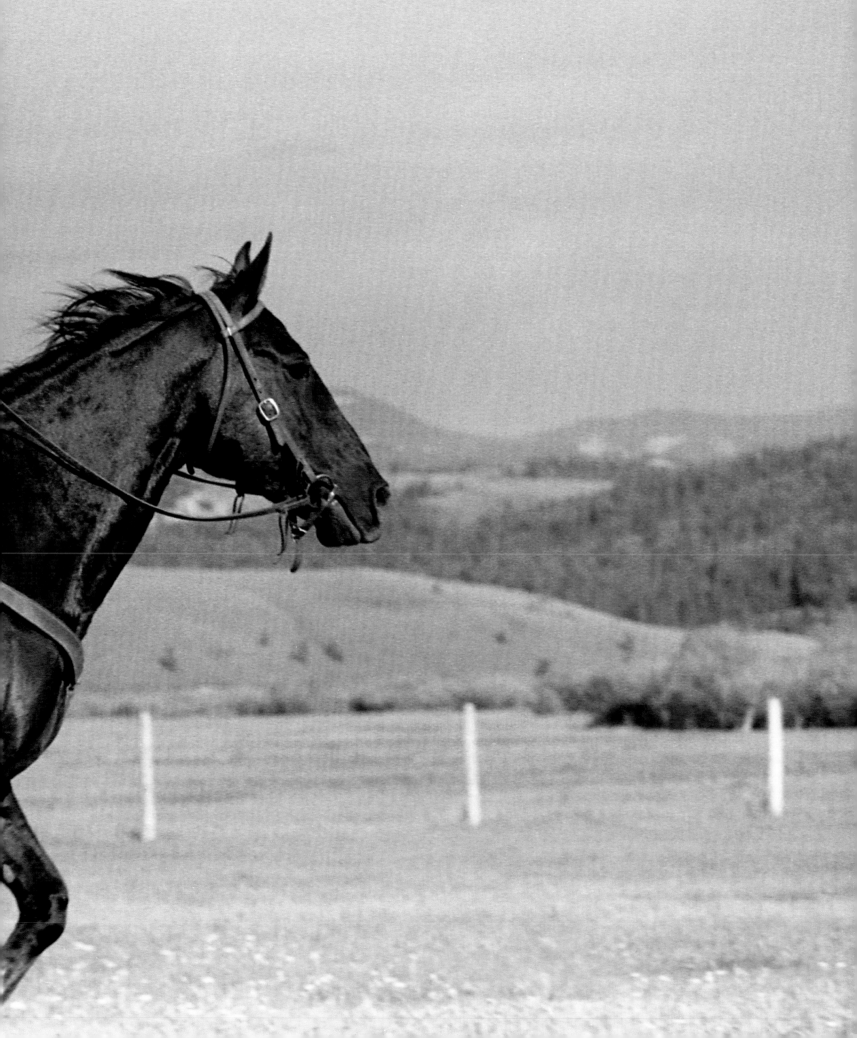

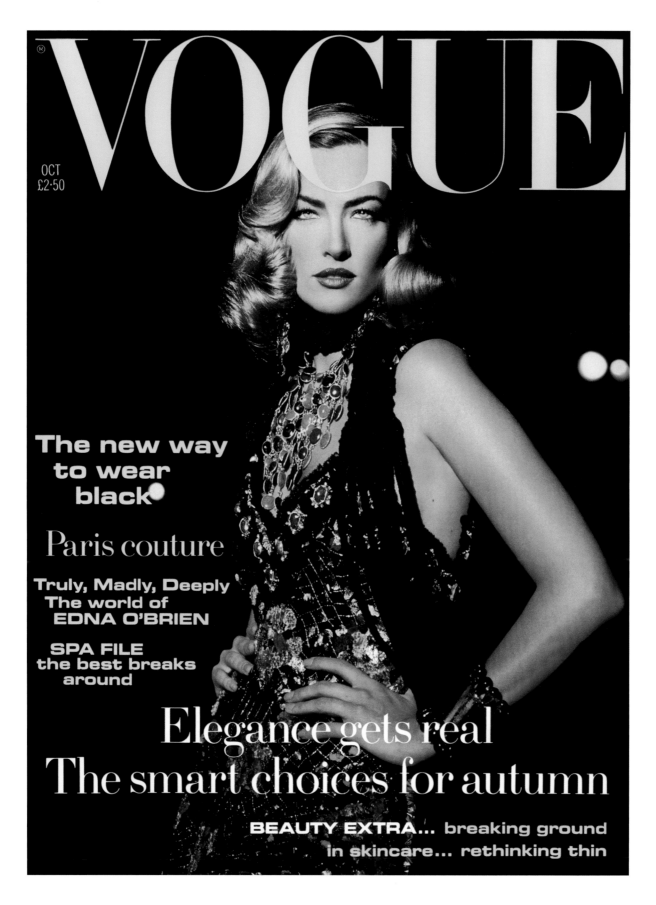

VOGUE

OCT
£2·50

The new way
to wear
black

Paris couture

Truly, Madly, Deeply
The world of
EDNA O'BRIEN

SPA FILE
the best breaks
around

Elegance gets real
The smart choices for autumn

BEAUTY EXTRA... breaking ground
in skincare... rethinking thin

Above:

Tatjana has the face of a screen
goddess and here she is photographed
late at night in Paris, her hair harking
back to Dietrich and Bacall. British
Vogue, October 1992.
Photograph by Max Vadukul.

Opposite:

French *Vogue*, October 1988
by Andrew MacPherson.

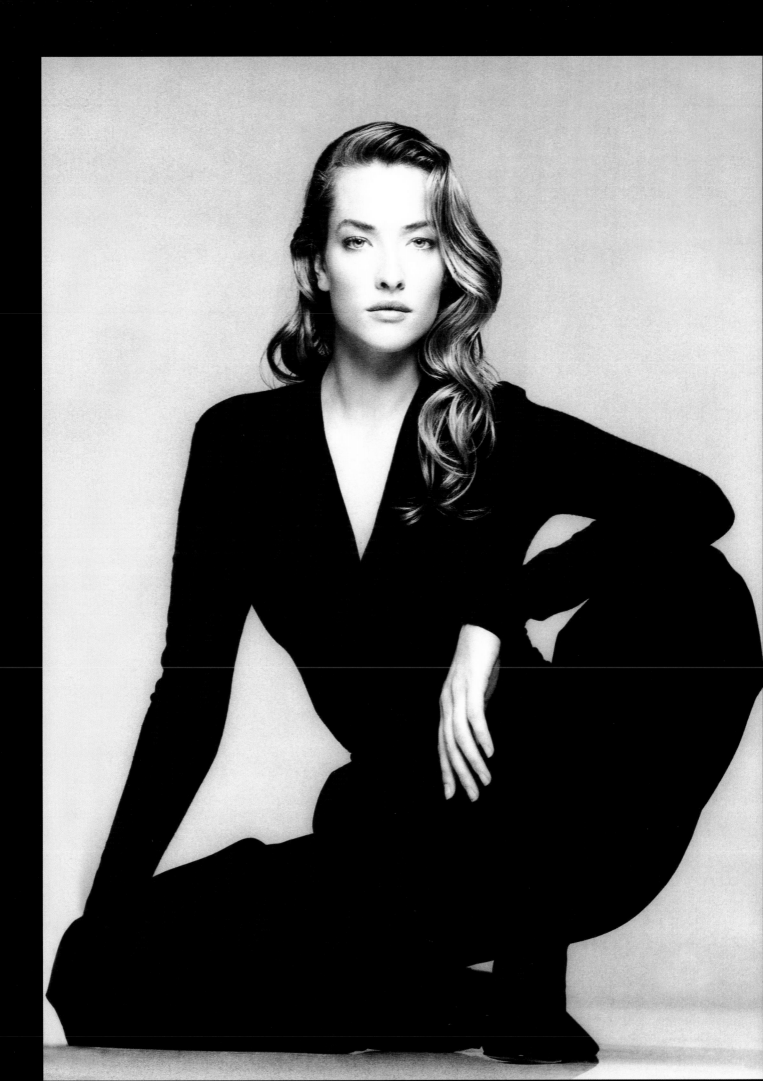

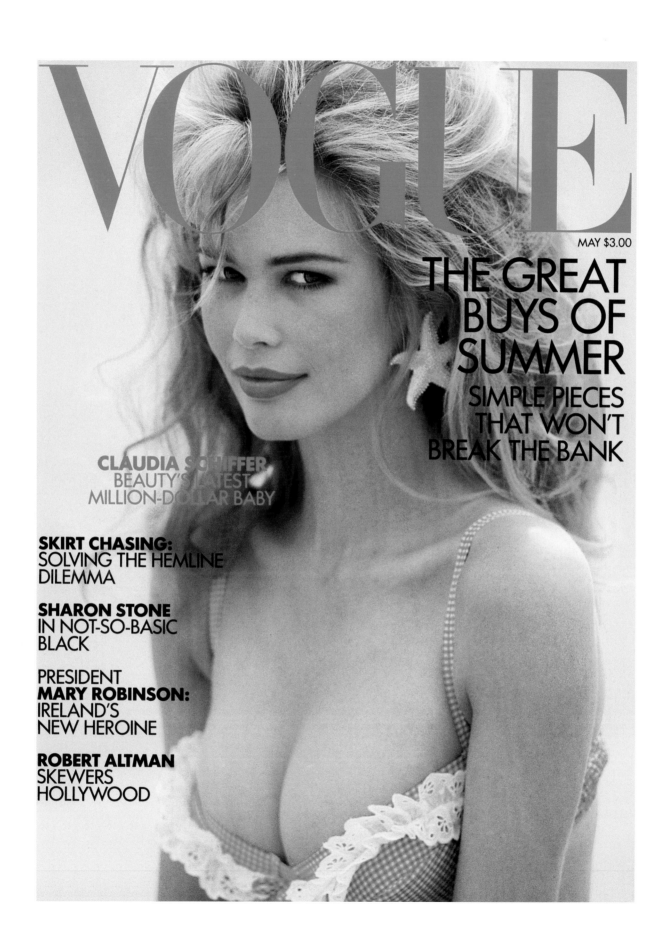

VOGUE

MAY $3.00

THE GREAT BUYS OF SUMMER
SIMPLE PIECES THAT WON'T BREAK THE BANK

CLAUDIA SCHIFFER
BEAUTY'S LATEST
MILLION-DOLLAR BABY

SKIRT CHASING:
SOLVING THE HEMLINE
DILEMMA

SHARON STONE
IN NOT-SO-BASIC
BLACK

PRESIDENT
MARY ROBINSON:
IRELAND'S
NEW HEROINE

ROBERT ALTMAN
SKEWERS
HOLLYWOOD

Above:

Claudia Schiffer, the eternal blond
bombshell. American *Vogue*, May 1992.
Photograph by Patrick Demarchelier.

Opposite:

British *Vogue*, December 2010.
Photograph by Mario Testino.

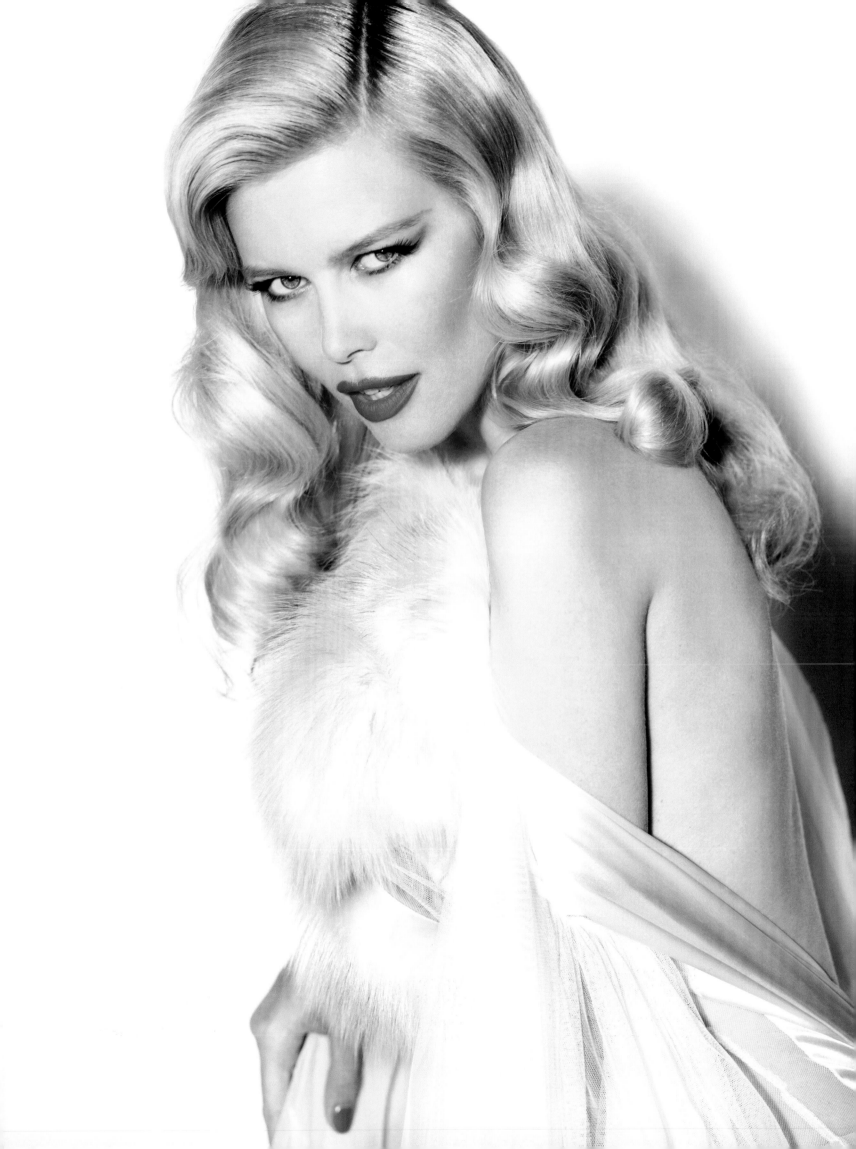

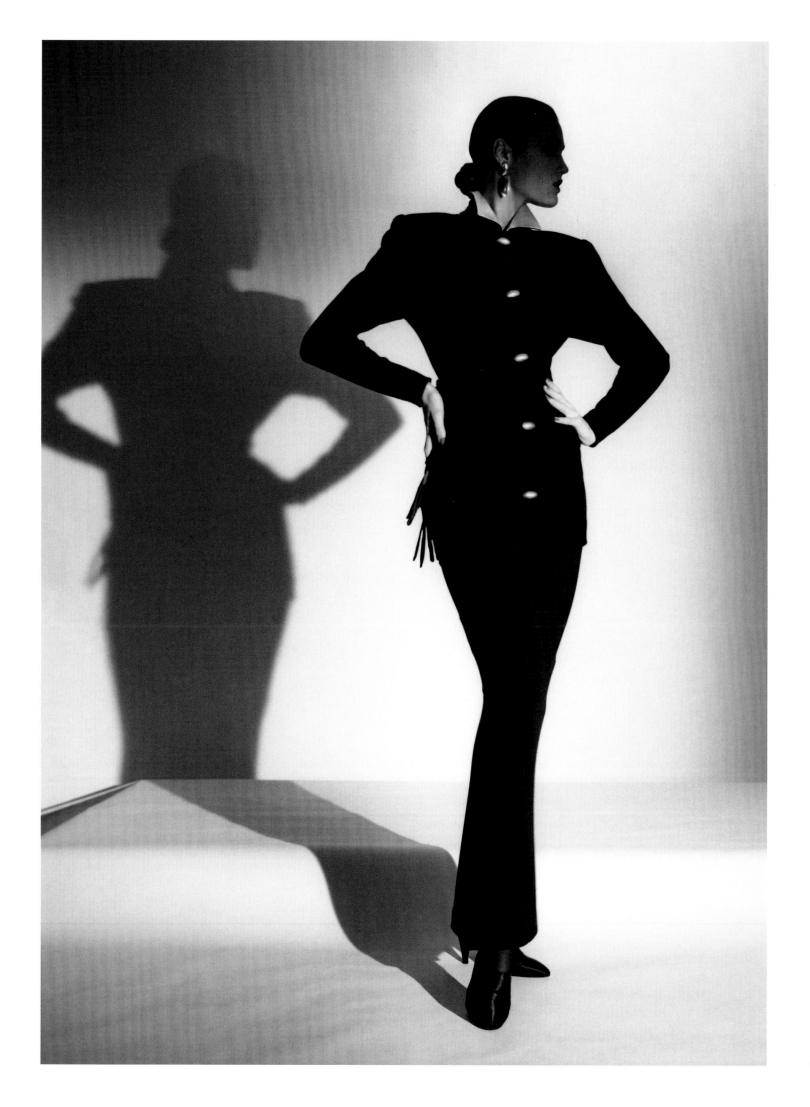

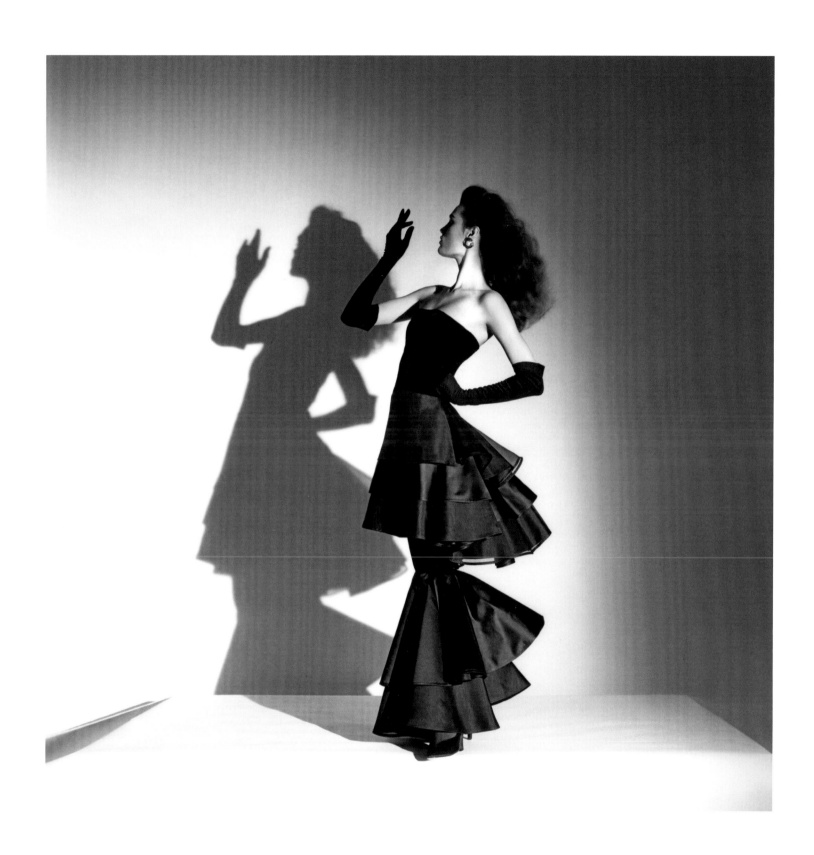

Above and opposite:

We were all thrilled to be working with the legend Horst. On set with Grace Coddington, Mary Greenwell, and Yasmin Le Bon, we were all a little nervous. But he was charming and funny, putting us all at ease. Yasmin's elegance echoed his early years working for *Vogue*, with her hair in a timeless chignon that was unleashed for the final shot. British *Vogue*, November 1986. Both photographs by Horst P. Horst.

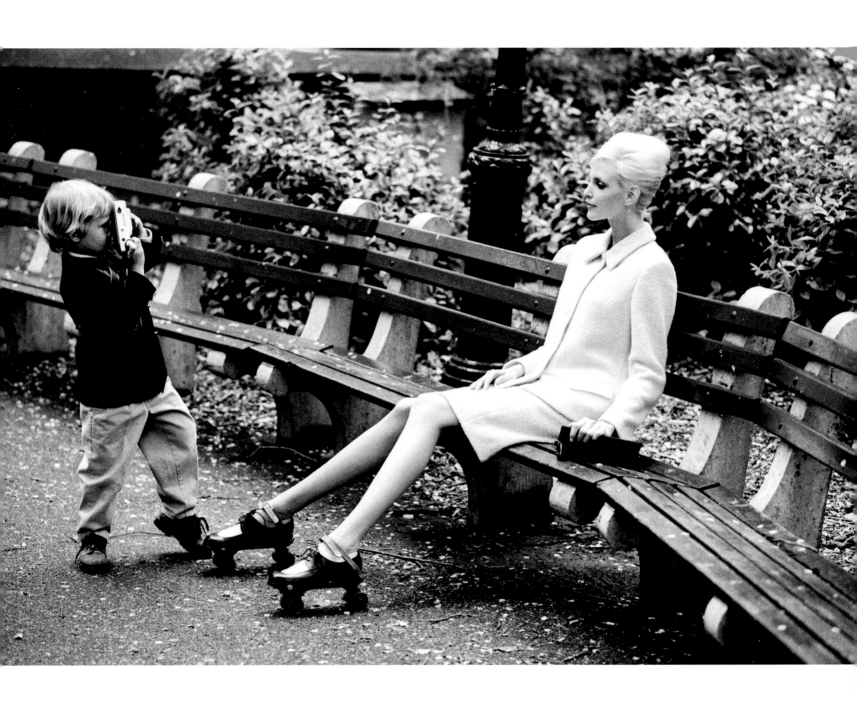

Above:

Nadja Auermann. American *Vogue*,
August 1995. Photograph by
Arthur Elgort.

Opposite:

Stephanie Seymour. Australian *Vogue*,
February 1996. Photograph by Inez van
Lamsweerde and Vinoodh Matadin.

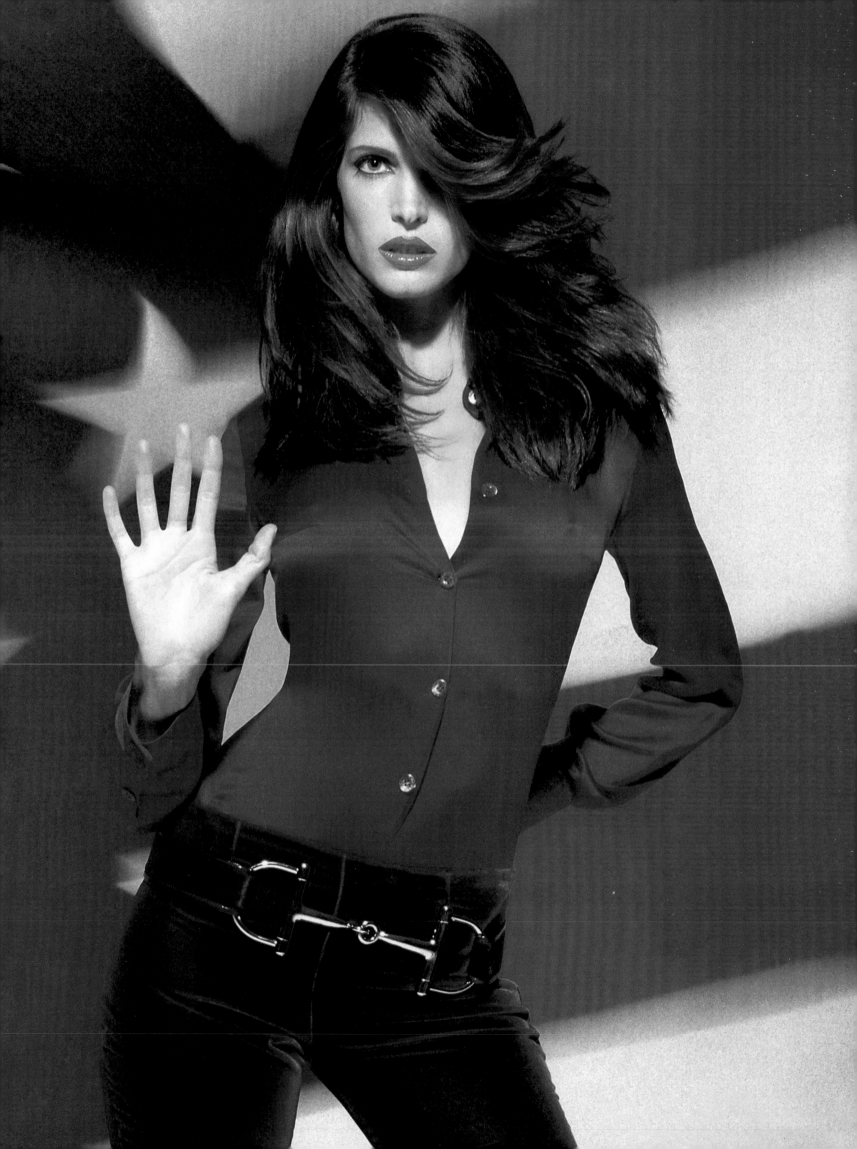

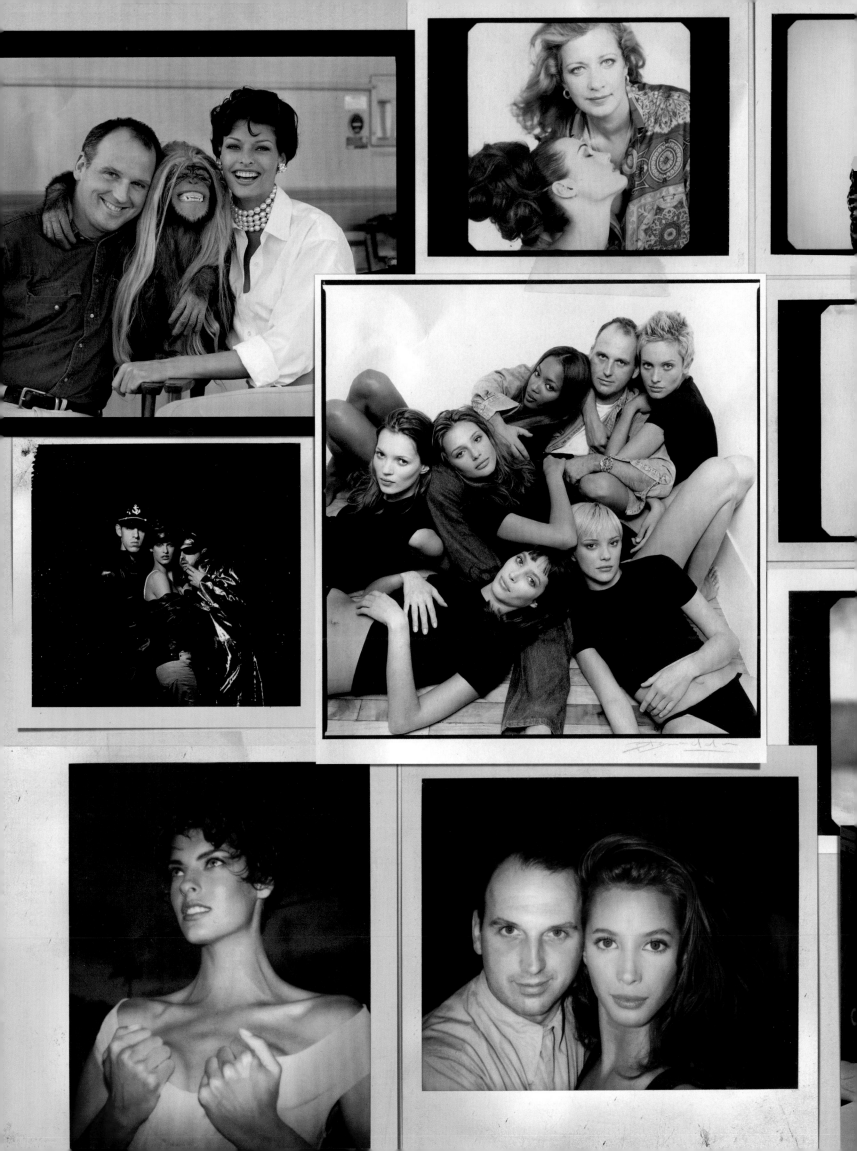

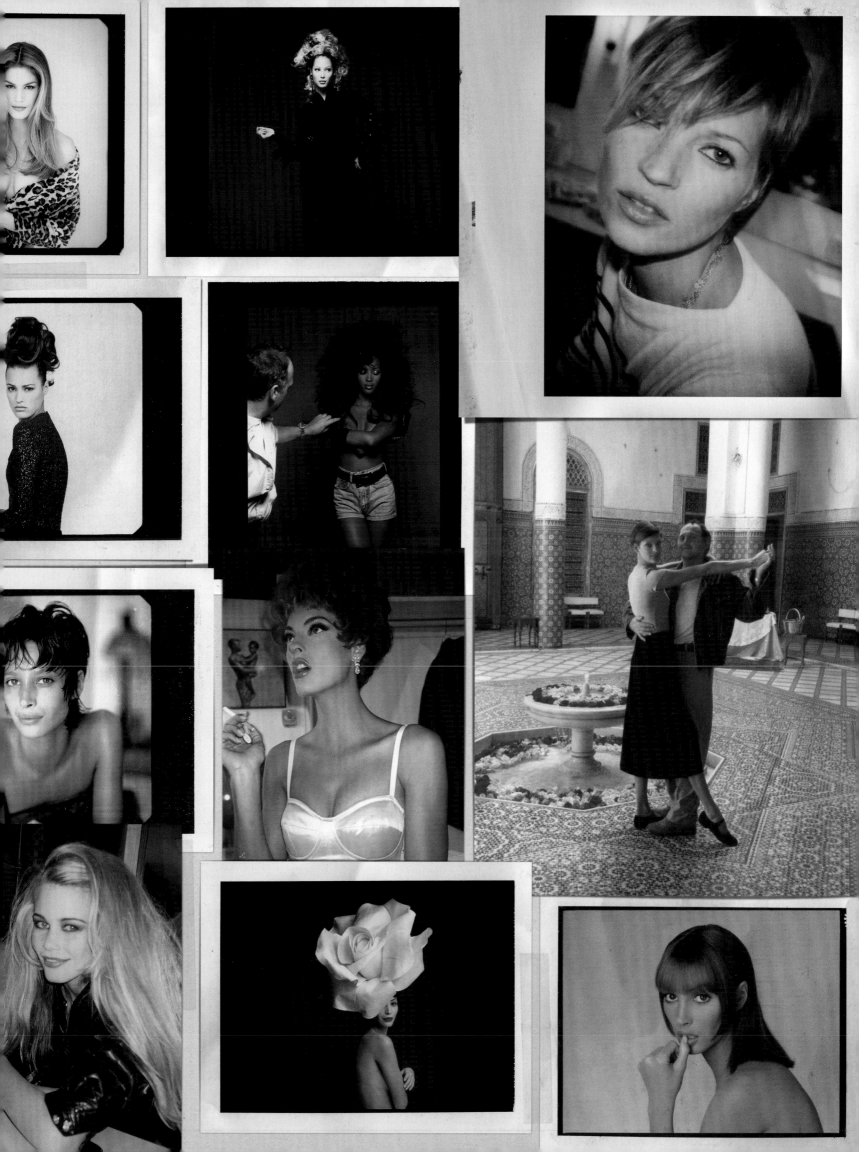

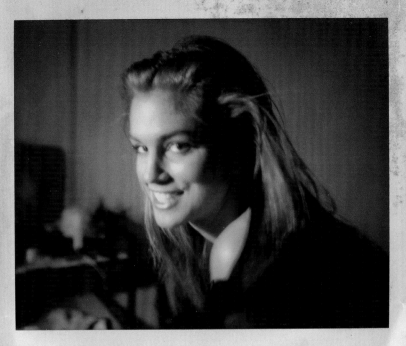

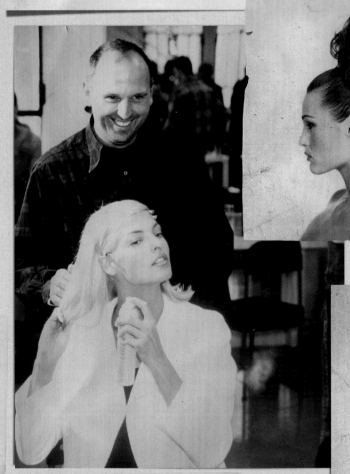
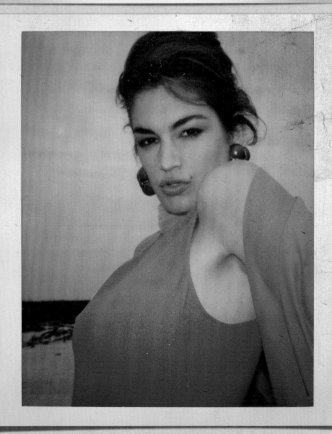
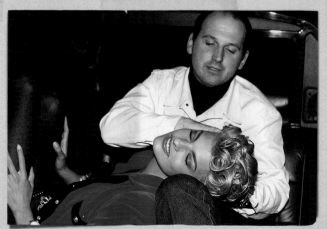

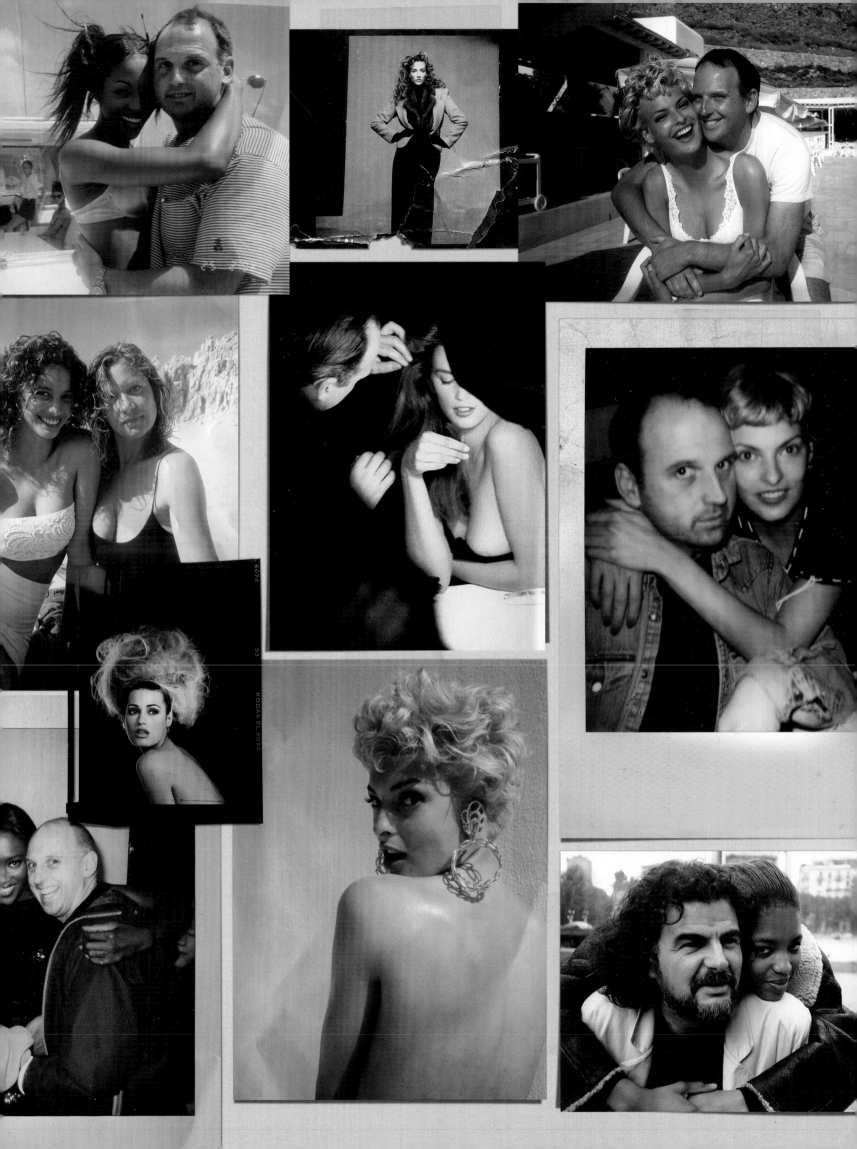

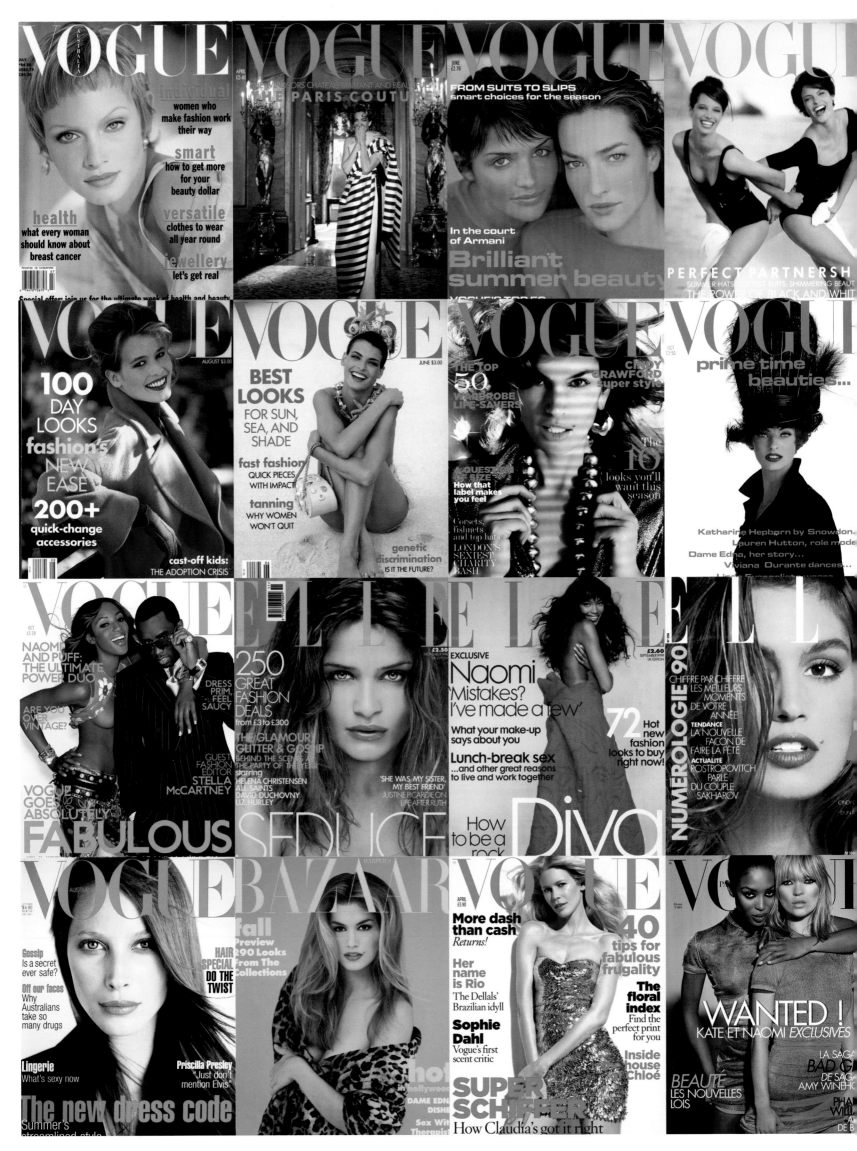

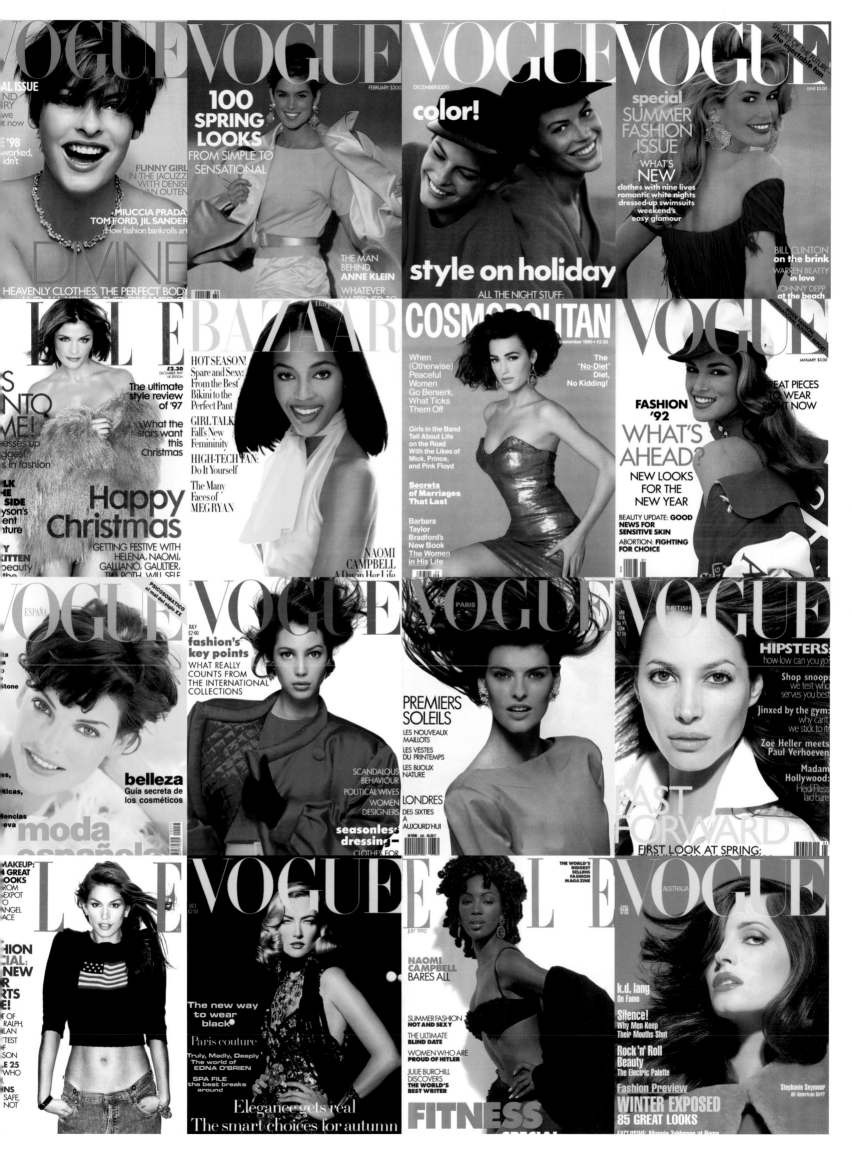

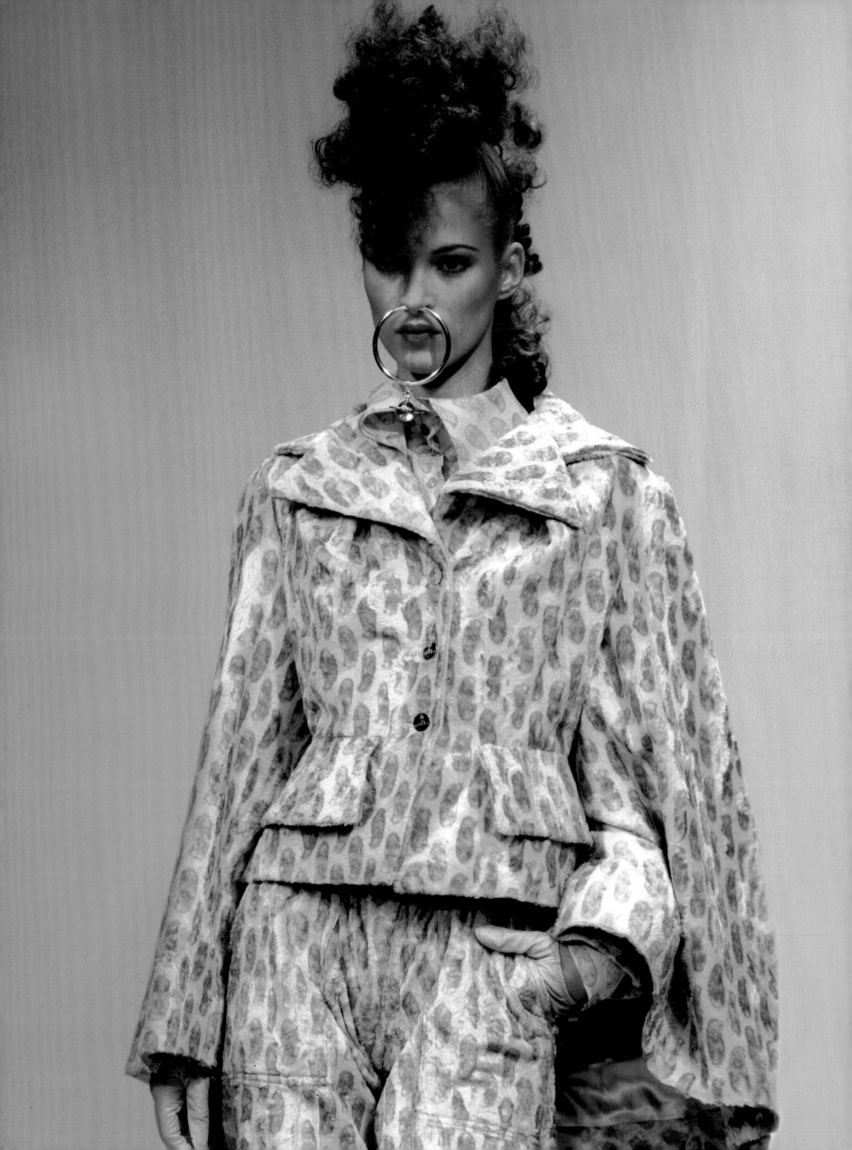

WESTWOOD

The brilliance of Vivienne is undeniable. When I first met Vivienne, she had been on her own journey from her punk beginnings and had emerged as a fully fledged designer. She is a great British rebel with endless ideas and a huge talent. I had and still have a huge admiration for Vivienne.

Having experienced the slick established shows in New York with Donna Karan and Ralph Lauren, I knew how professional things needed to be. The offer to do something as theatrical as Westwood, an experience I had never been part of before, and to work with a British designer, was one I could not turn down.

Working with Vivienne was a lesson in art and historical references. I would bring my hairpieces and we would talk for hours. Sometimes it was a challenge to decipher her codes and give her what she wanted to express but there would often be one particular image she was inspired by, Fragonard's *The Swing*, for instance, but she would break it up with another idea and have it look like it came from the street. That made us creative kindred spirits. She liked everything a little destroyed and she was allergic to perfection. Something I could relate to.

After the first Paris show in 1992, Yasmin Le Bon, Naomi Campbell, and I had a word with the other girls and got them to do the second one, for much less than their usual daily rate, sometimes in return for clothes. Mary Greenwell worked on the makeup and together we created something quite unique, and the historical inspirations began to look and feel modern.

Vivienne wanted the girls to all have characters, but still be within the bounds of Westwood beauty.

The models all loved doing her shows because they were such a spectacle and they could contribute to Vivienne's vision. China white faces but still an ethereal beauty.

I vividly remember watching on the backstage monitor on the day of the soon-to-be infamous 1993 show in Paris. Naomi's walk is mesmerizing, the way she glides… and then the whole thing started to play in slow motion… I watched as the eleven-inch heels turned at an angle… the wobble… the fall. We all froze, hoping she hadn't snapped her ankle. But Naomi hardly blinked; she tossed her head back so her hair practically touched her shoes and gave the most amazing coquettish smile. In that instant, she turned a mistake into one of the great moments of 1990s fashion. She went out a supermodel and came back an even bigger superstar—and she returned with a certain twinkle in her eye that told me she wasn't too upset by the tumble. The next day she was front-page news across the world. The Westwood shows also did wonders for the new girl on the block, too, Kate Moss. I was extremely impressed to see the way that tiny little girl held her own on the runway amongst the Westwood glamazons, letting the world know that she was no one hit wonder.

I ended up working with Vivienne and Andreas on and off for over twenty years and every show was an absolute joy.

"We always think, Thank god Sam's doing the hair. It's something we don't have to worry about."
– Vivienne Westwood

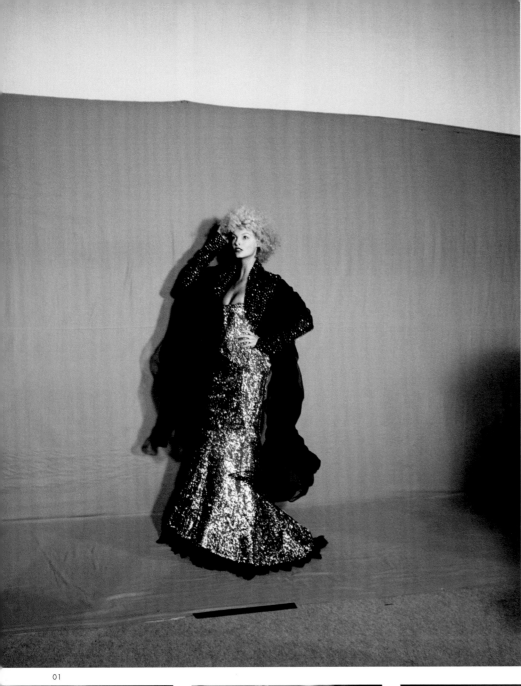

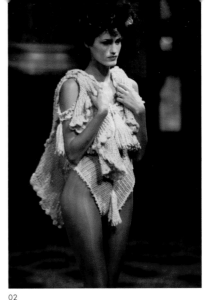

02

03

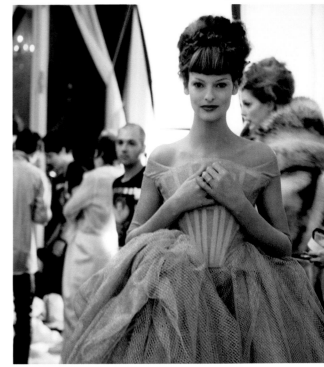

07

01

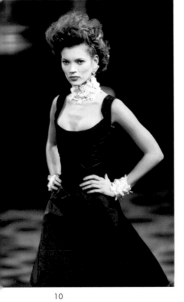

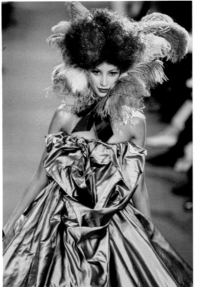

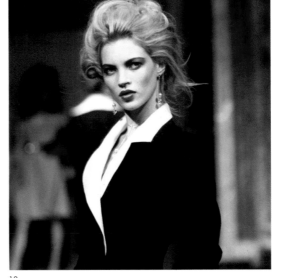

10

11

12

13

Previous spread:

Kate Moss, On *Liberty*
Autumn/Winter 1994/95.

This page:

01 Linda Evangelista,
Erotic Zones Spring/
Summer 1995.

02 Yasmin Le Bon,
Café Society Spring/
Summer 1994.

03 Christy Turlington,
Anglomania Autumn/
Winter 1993/94.

04 Eva Herzigova,
Vive La Cocotte Autumn/
Winter 1995/96.

05 Naomi Campbell,
Anglomania Autumn/
Winter 1993/94.

06 Vivienne and Sam, 1994.

07 Linda Evangelista,
Anglomania Autumn/
Winter 1993/94.

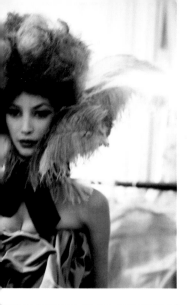

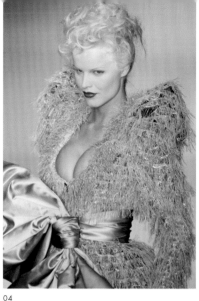

04 05 06

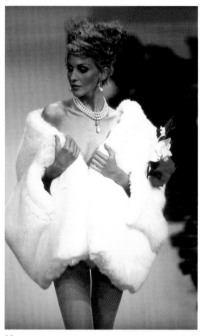

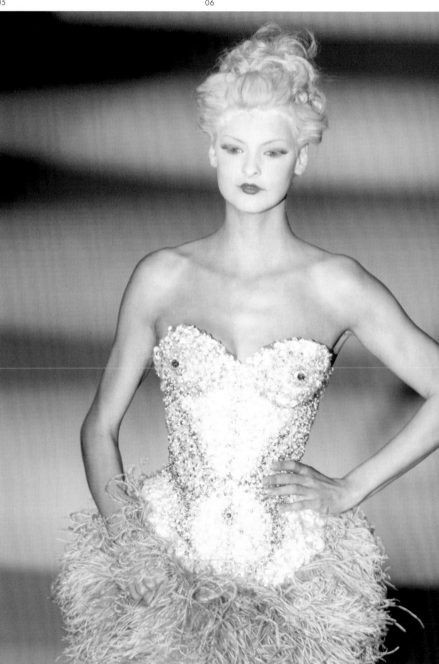

08 09

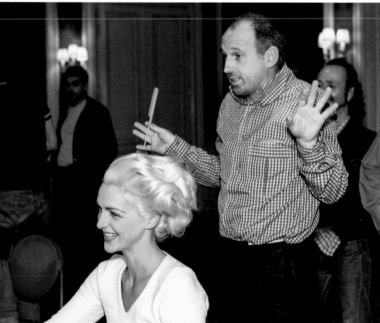

14 15

08 Naomi Campbell, *Anglomania* Autumn/ Winter 1993/94.

09 Susie Bick, *On Liberty* Autumn/Winter 1994/95.

10 Kate Moss, *Café Society* Spring/Summer 1994.

11 Christy Turlington, *Anglomania* Autumn/ Winter 1993/94.

12 Kate Moss, *Les Femmes* Spring/Summer 1996.

13 Helena Christensen, *Café Society* Spring/ Summer 1994.

14 Backstage with Simonetta Gianfelici, *Les Femmes* Spring/Summer 1996.

15 Linda Evangeslista, *Vive La Cocotte* Autumn/ Winter 1995/96.

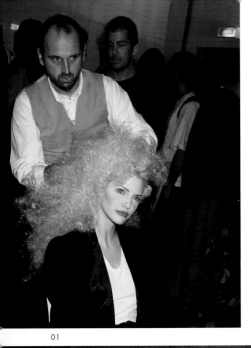

01

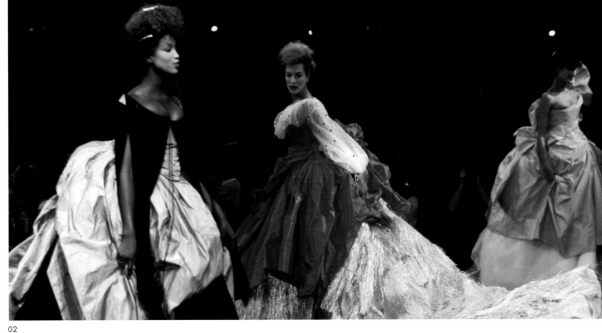

02

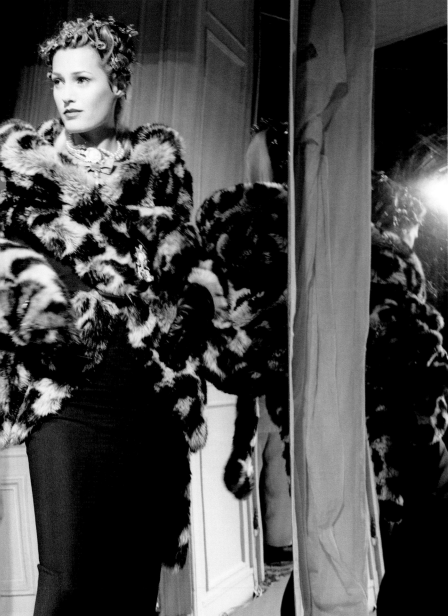

08

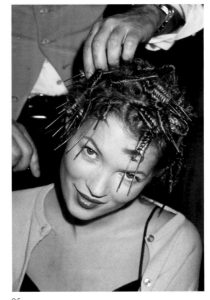

05

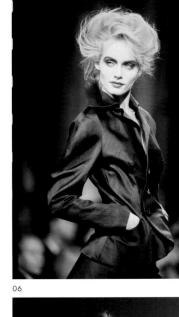

06

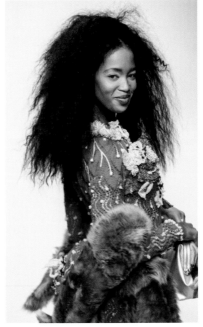

09

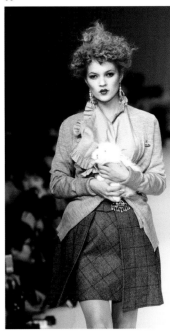

10

01 Nadja Auermann,
 Erotic Zones
 Spring/Summer 1995.

02 Naomi, Tatjana, and
 Yasmin, *Café Society*
 Spring/Summer 1994.

03 Susie Bick, *On Liberty*
 Autumn/Winter 1994/95.

04 Linda Evangelista,
 On Liberty
 Autumn/Winter 1994/95.

05 Kate Moss, *Erotic Zones*
 Spring/Summer 1995.

06 Amber Valetta,
 Les Femmes
 Spring/Summer 1996.

07 *Café Society*
 Spring/Summer 1994.

08 Yasmin LeBon,
 Café Society
 Spring/Summer 1994.

09 Naomi Campbell,
 Erotic Zones
 Spring/Summer 1995.

10 Kate Moss,
 Vive La Cocotte
 Autumn/Winter 1995/96.

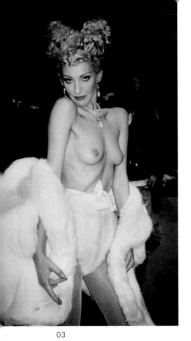

03

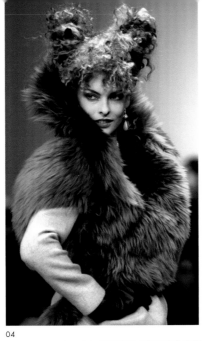

04

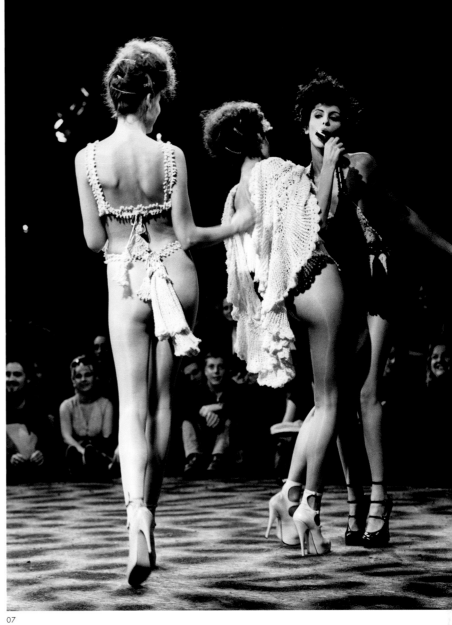

07

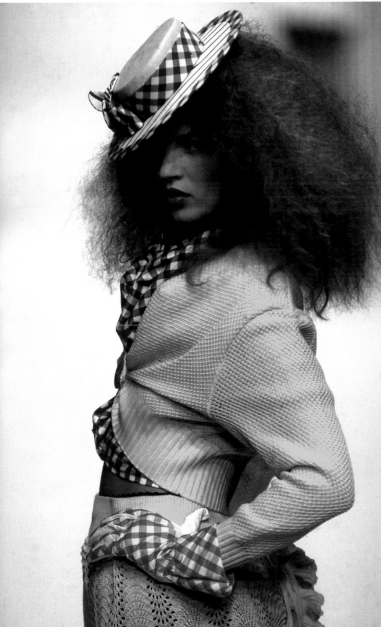

11

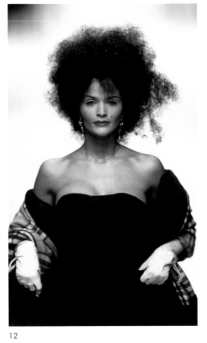

12

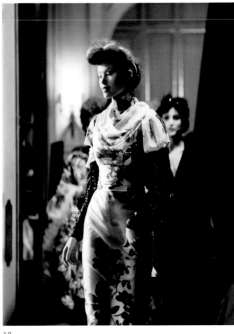

13

11 Kate Moss, *Erotic Zones* Spring/Summer 1995.

12 Helena Christensen, *Erotic Zones* Spring/ Summer 1995.

13 Tatiana Sorokko, *Café Society* Spring/ Summer 1994.

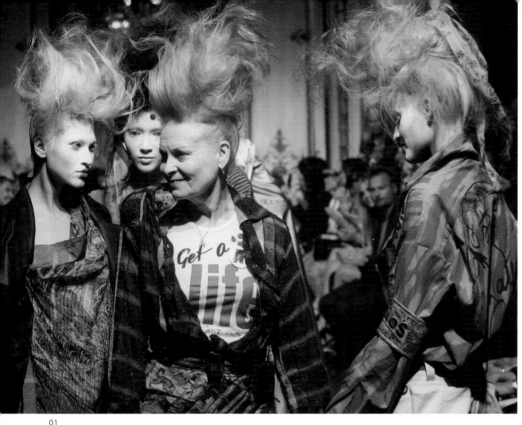

01

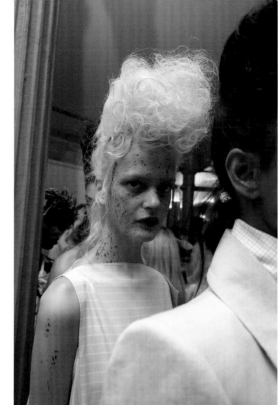

02

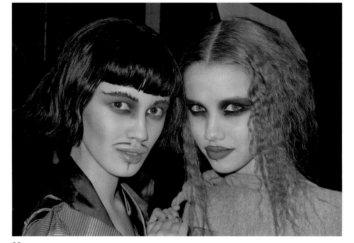

08

09

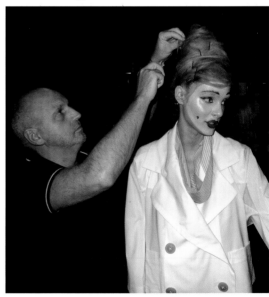

07

11

12

13

01 *Get a Life* Gold Label
Spring/Summer 2010.

02 *Everything is Connected*
Gold Label
Spring/Summer 2014.

03 *Gaia the Only One*
Gold Label
Spring/Summer 2011.

04 *War and Peace*
Gold Label
Spring/Summer 2012.

05 *Everything is Connected*
Gold Label
Spring/Summer 2014.

06 *UNISEX Time to Act*
Gold Label
Autumn/Winter 2015/16.

07 *Save the Arctic*
Gold Label
Autumn/Winter 2013/14.

08 *Prince Charming*
Gold Label
Autumn/Winter 2010/11.

09 Gwedoline Christie at
UNISEX Time to Act
Gold Label
Autumn/Winter 2015/16.

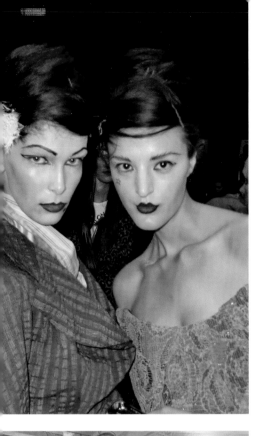

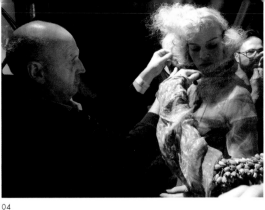

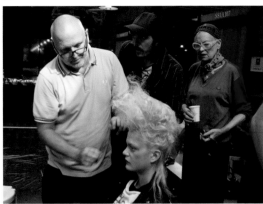

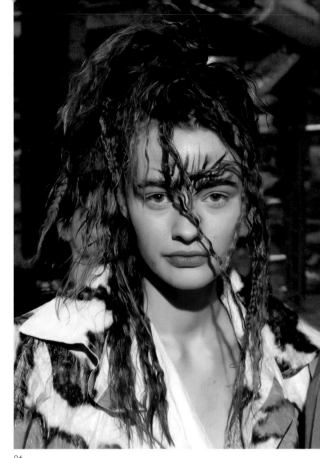

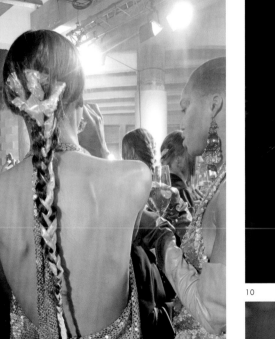

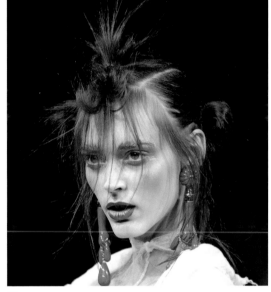

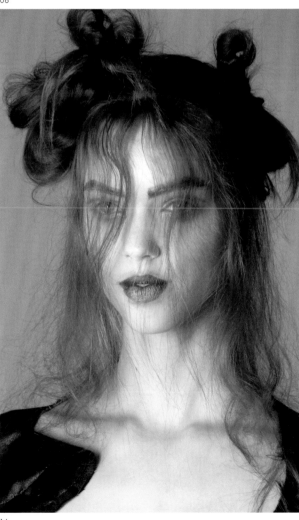

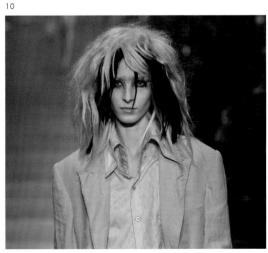

04

05

06

10

14

15

16

10 *War and Peace*
Gold Label
Spring/Summer 2012.

11 Rehearsal with
Val Garland, Vivienne,
and Andreas.

12 Sam with Andreas.

13 *Gaia the Only One*
Gold Label
Spring/Summer 2011.

14 *Save the Arctic*
Gold Label
Autumn/Winter 2013/14.

15 *Mirror the World*
Gold Label
Spring/Summer 2016.

16 *War and Peace*
Gold Label
Spring/Summer 2012.

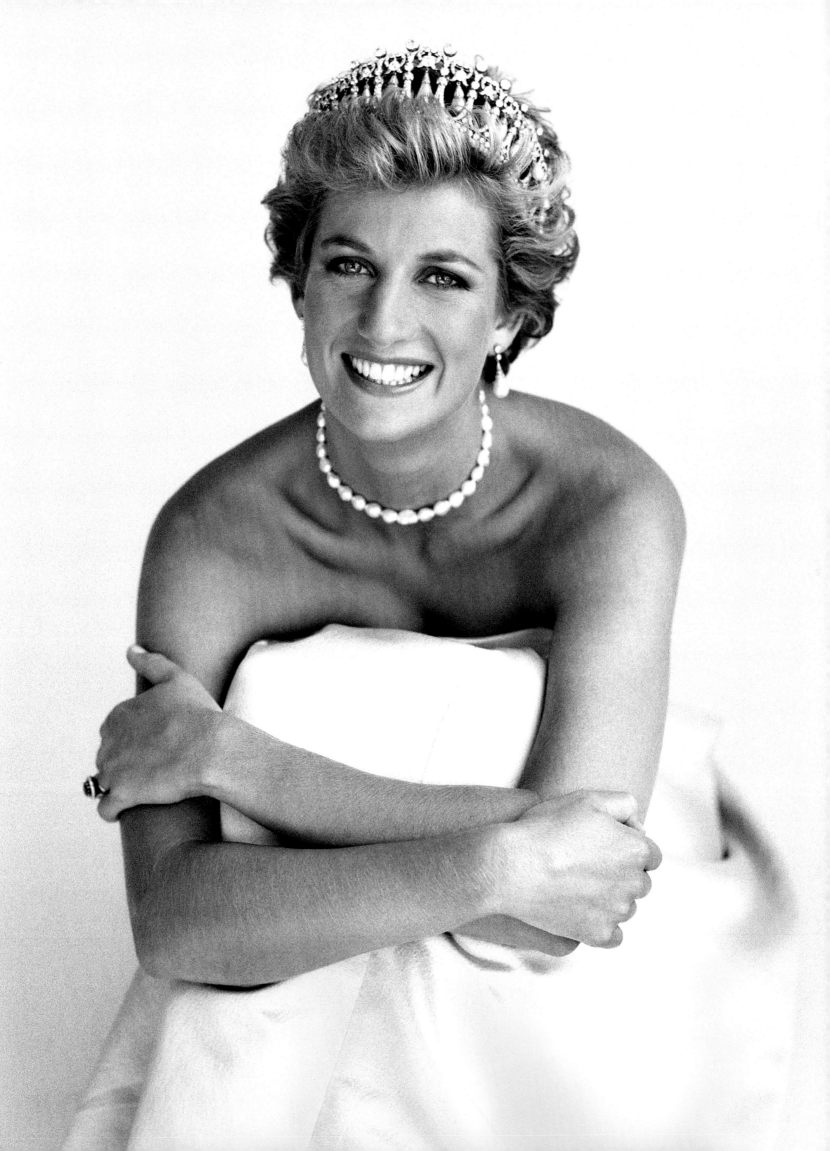

DIANA,
PRINCESS OF WALES

When Patrick Demarchelier was asked to photograph Princess Diana for British *Vogue*, he requested to bring his own hair and makeup team. Mary Greenwell and I were told it was someone important, but we had no idea who. We guessed it might be Margaret Thatcher, and then in walked Diana. Patrick has a wonderful way of putting his subjects at ease. Diana was laughing about being asked to sit on the floor wearing a tiara and ballgown, and that was when he captured this iconic shot (opposite). I made her hair look short in the tiara for the shoot and she decided she liked it. As she was leaving Diana asked, if I had free reign what would I do to her hair. I suggested cutting it short and she, to my surprise, agreed, and we did it there and then.

We bonded because we laughed together so much, and that lasted for seven years. I saw her every week when I was in London. I would go in the morning to do her hair, and then sometimes go back in the evening if she had a function. We'd watch *Brookside* together while I styled her hair. Sometimes her beloved boys would be there and I would cut their hair, too. I remember Prince William respond in glee when I put gel in his hair for the first time. She would often show me what she was going to wear for the evening and I once brought her a Polaroid of Christy Turlington wearing a Versace couture dress that Patrick had photographed her in. We both felt it would look great on Diana. I spoke to Anna Harvey at *Vogue* and Anna called Donatella and made the introduction.

"Diana had a charming way where if she trusted you, she let you do anything with her. Sam had a very good eye for fashion and he guided her away from the bad choices towards the good ones. She had a very strong mind but she trusted him. He helped her see herself in a different way. She grew up, grew older, grew wiser and he was there guiding her in the background. I don't think anyone should ever underestimate his influence on her style. After he started to work with her, she became so much more confident and self-assured. And she looked so much better." — Anna Harvey

During this time I was so busy working with all the supers that Diana grew curious of my world. We had done a private sitting together with Patrick and Mary on the previous day and Liz Tilberis had heard how wonderful the pictures were. So when Diana asked if she could meet with Linda Evangelista, Liz and I got Joe's Café in Knightsbridge to open up the following morning. She would have been horrified if she had known they had opened specially, so Liz got the staff of *Vogue* to pretend to be customers. During the conversation, Linda, Liz, and I discussed how wonderful the pictures were from the private sitting and how great one would be as a *Vogue* cover. Diana gave her permission for one to be used as the cover. She looked simply stunning with her new shorter hair cut in a black turtleneck resting on her beautifully manicured hands.

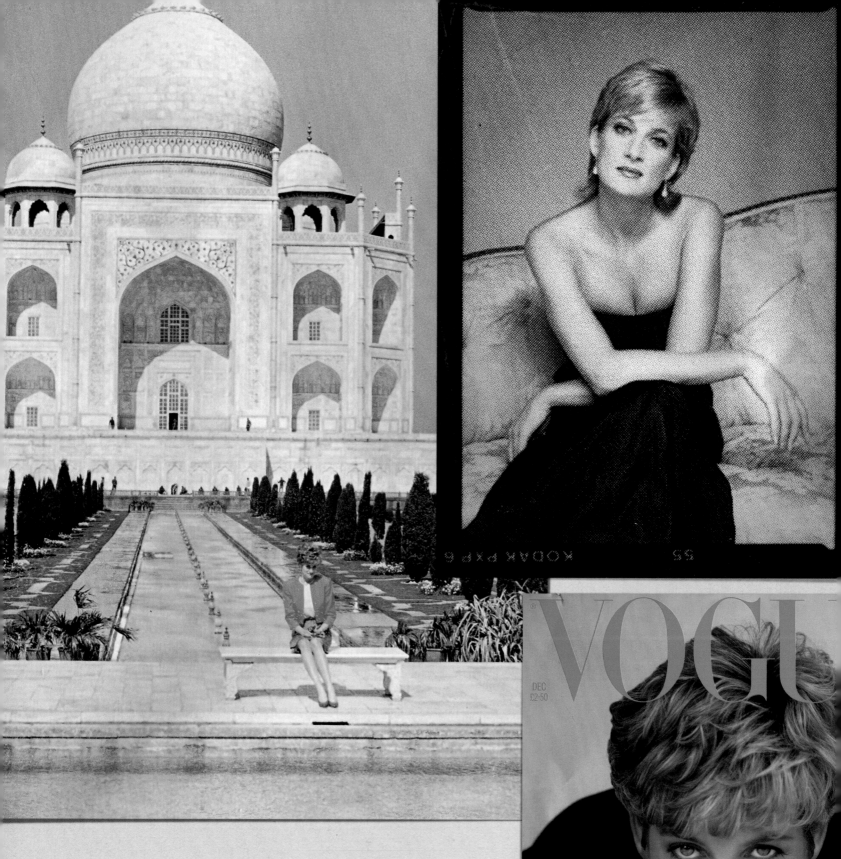

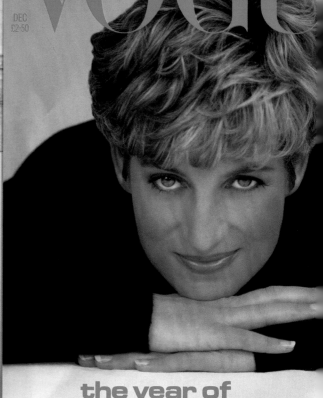

I traveled often with Diana during our seven-year relationship. She would request for me to join her on official trips. And as I introduced her to my world, she, in turn, introduced me to hers and her charity work. My eyes were truly opened whilst visiting Pakistan, India, and Argentina, learning of her landmines campaign and visiting Mother Teresa's hospices in Calcutta. She had a great natural empathy and her ability to put people at ease was inspiring.

Page 74:

British *Vogue*, December 1990.
Photograph by Patrick Demarchelier.

Above, clockwise from top left:

In front of the Taj Mahal in 1992. Portrait by Patrick Demarchelier. A gentle royal reminder. The first time I cut Diana's hair, 1990. Liz Tilberis and Diana at the Met Gala in New York, 1996. Princess Diana with her sons, Prince Harry and Prince William, in a sitting with Patrick Demarchelier. Cover of British *Vogue*, December 1991, by Patrick Demarchelier.

VOGUE

DEC
£2·50

the year of
danc
A CHRISTMAS CELEB

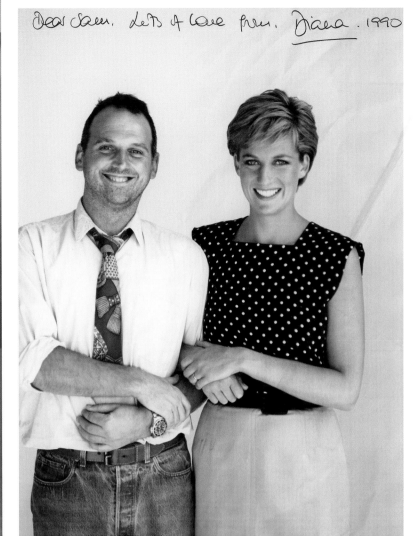

Dear Sam. Lots of love from. Diana. 1990

BUCKINGHAM PALACE

SAM

THE BOSS NEEDS A HAIRCUT when YOU RETURN

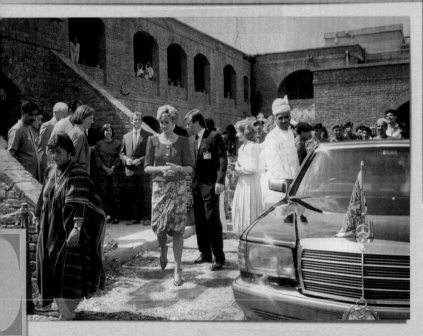

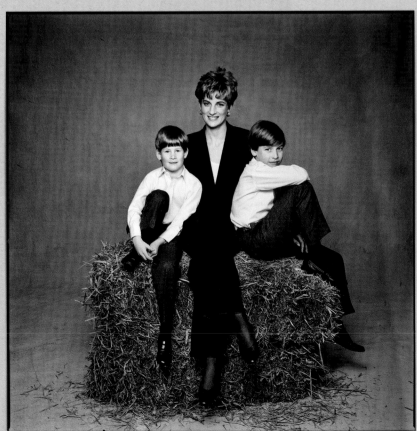

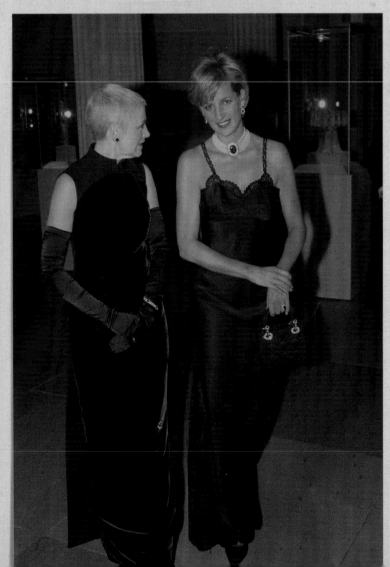

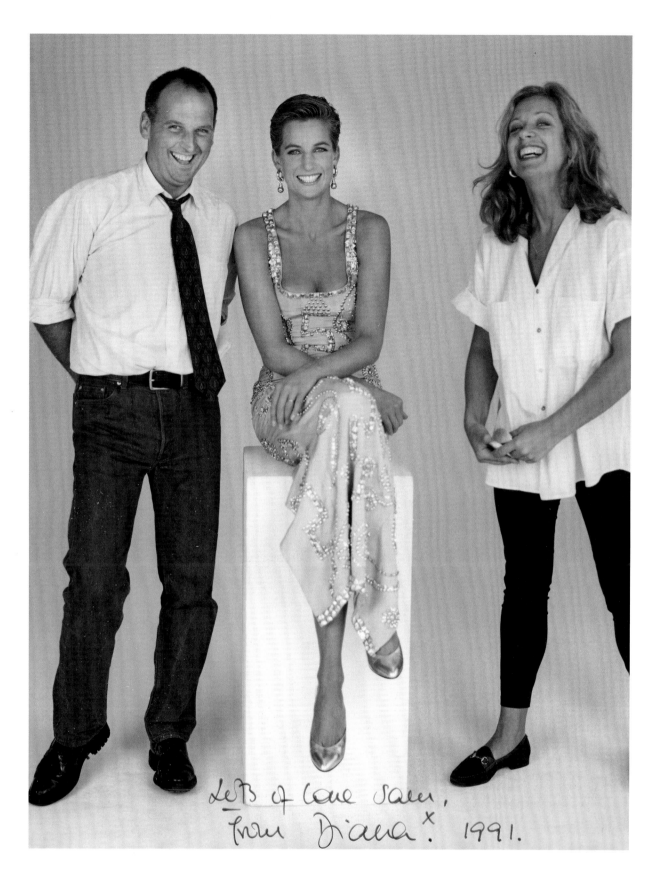

*Lots of love Sam,
from Diana.* ˣ *1991.*

A hairdresser's relationship with his clients is based on trust, and of all such relationships, trust was critical to Diana and I. I guess she was the kind of person who made you fall in love with her a little bit. I know I did. And so did my mum! Diana once went to visit a factory in a small village in Scotland near to my mother's. My mother and her friend went to stand in the crowd to wave and cheer her on. As Diana bounded out to meet the crowd, she happened to head straight over to where my mother stood waiting, and not knowing who she was, my mother's friend quickly introduced them. It was only when Diana spoke of me so fondly that my mother finally thought I had a "proper" job.

Above:

Diana in *the* Versace dress with Mary Greenwell and me. Photograph by Patrick Demarchelier, 1991.

Opposite:

Slicked-back hair in a private session in 1995. Photograph by Patrick Demarchelier.

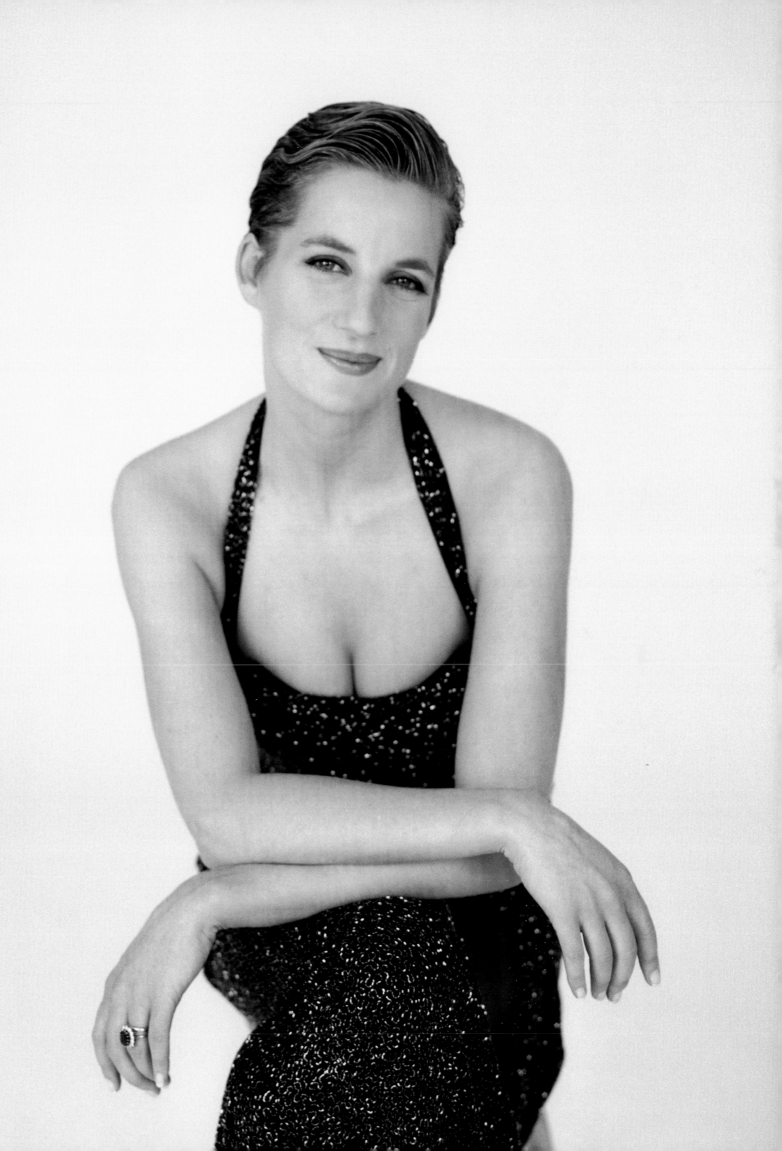

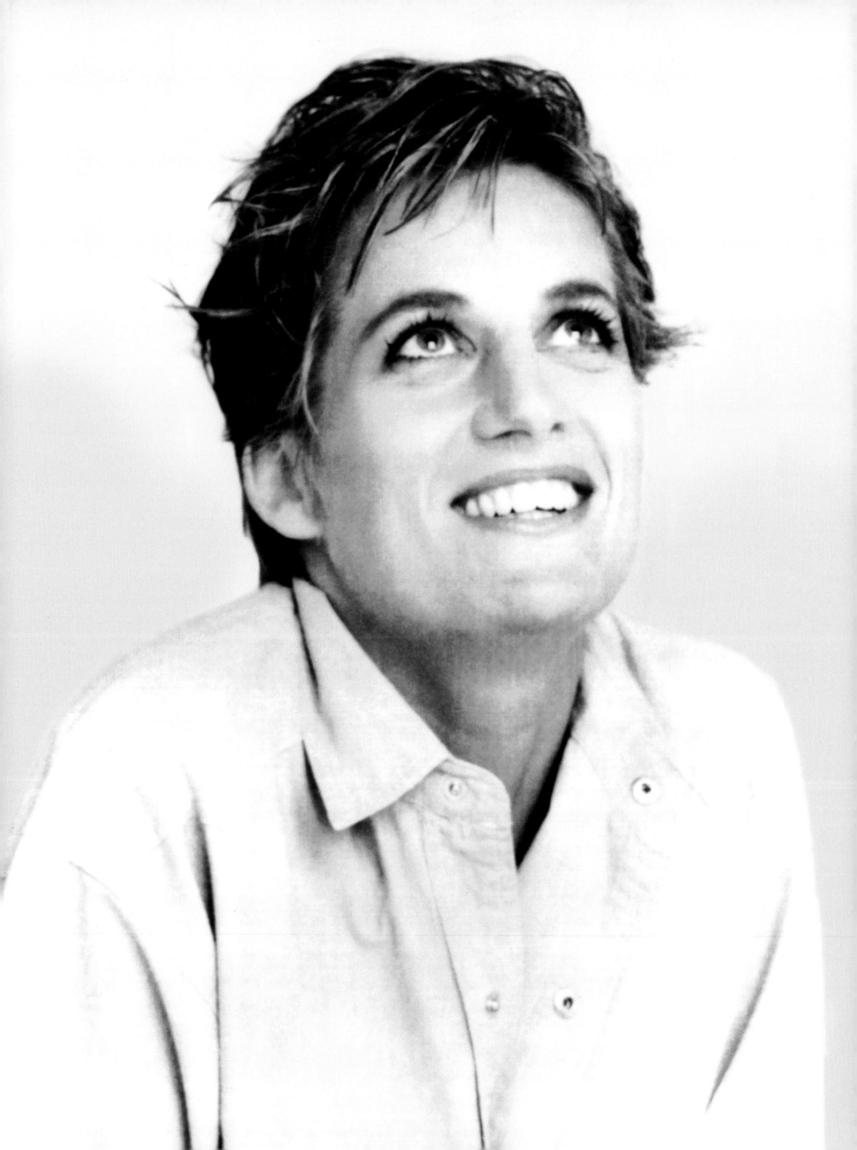

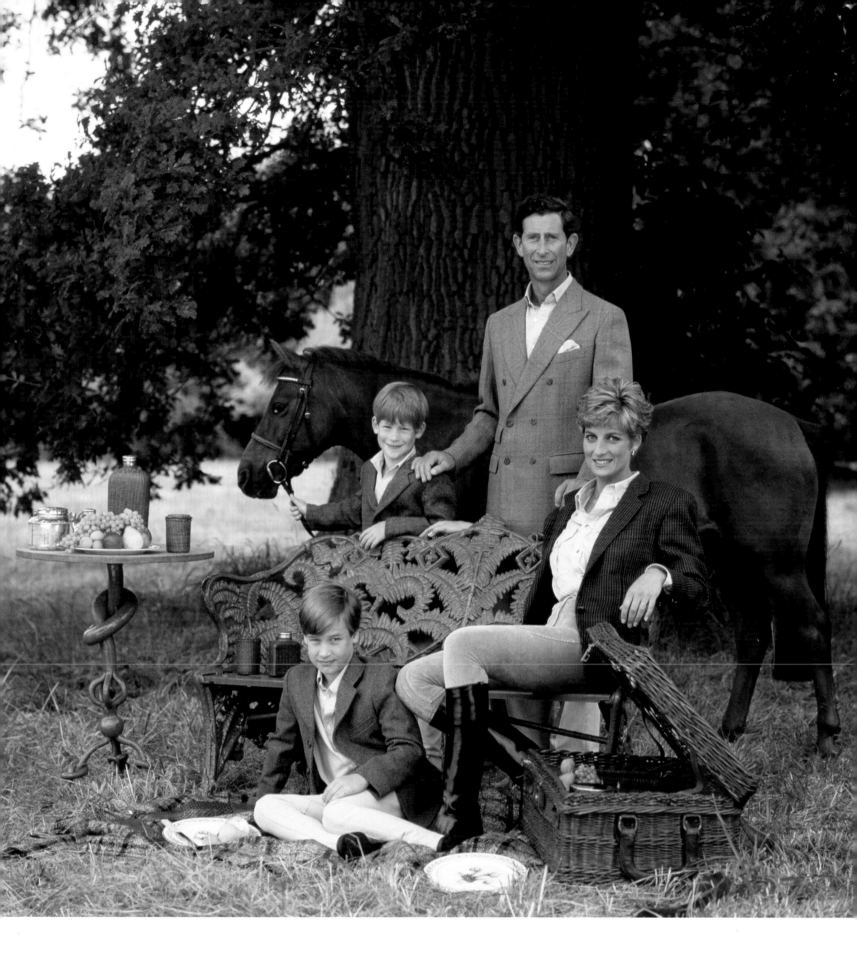

I loved Diana looking more spontaneous; she even looked great coming out of the gym with freshly showered hair. During one particular portrait we worked on, Lord Snowdon had the inspired idea to photograph her with wet hair. I first tried slicking her hair back in a private shoot (see page 79)

and she looked incredibly chic. Even though she was a bit nervous, she was still open to new ideas regarding her look. So for the Council of Fashion Designers Awards in New York, we decided she would try it out in public—the following day the front pages spoke volumes.

Opposite:

Portrait of Diana, 1991.

Above:

A royal family portrait, 1991. Both photographs by Lord Snowdon.

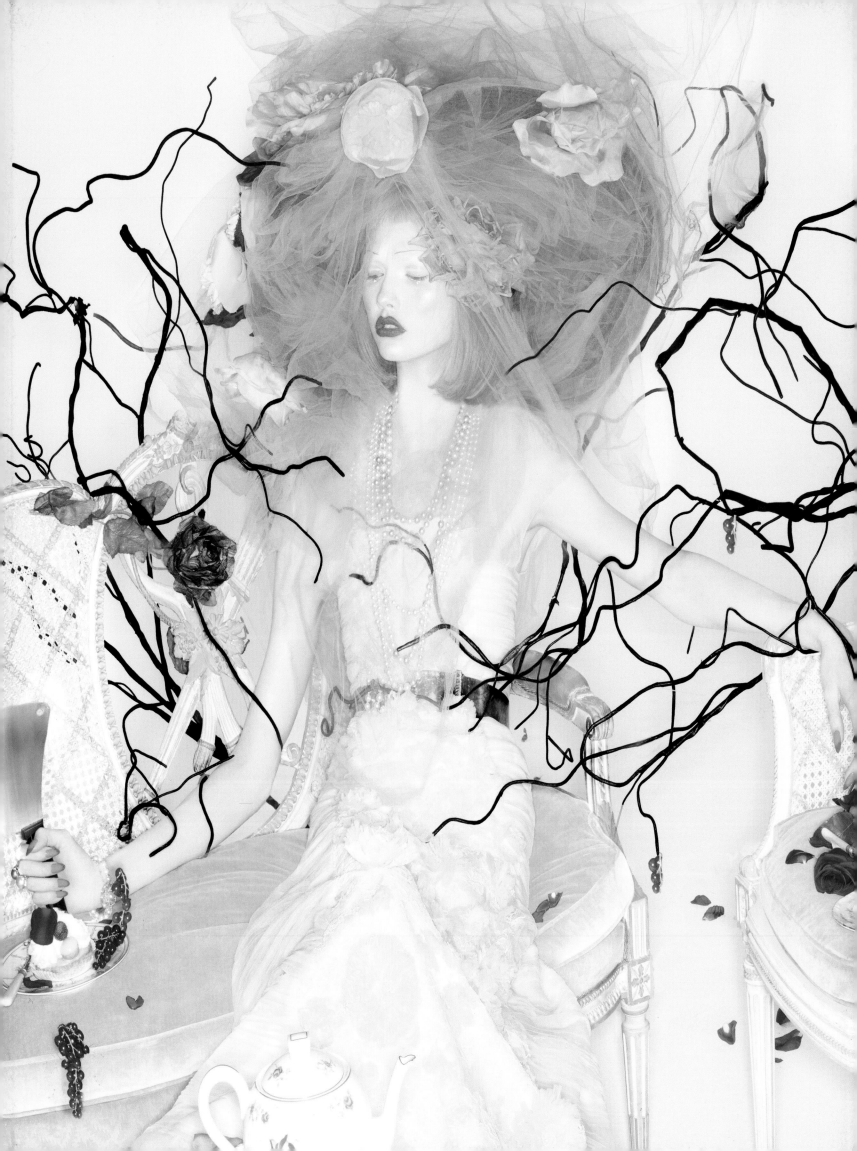

NICK KNIGHT

There are lots of good hairdressers, but finding someone who you really have empathy with doesn't come along so much. Sam feels like family. I'll always ask for Sam.

Sam has a very pronounced technical ability—he can do things that other people cannot do, physically. When you look and think, Oh, he simply tousled the hair. Try getting someone else to do "tousled" and it doesn't work. See Sam work a wind machine, and he knows that you have one at the back pointing towards the floor, one at the front pointing towards the face. He's able to *sculpt*, with wind, these incredible hairstyles. He likes hair that moves.

Sam is very cutting edge in what he likes. If the image is too "done," he hates it. You'll show him an image that you're carefully constructing, making it into this photographic "sculpture," and Sam will pull a face. When you make a mistake, do something wrong, different, he'll love it. He's very good at liking new things—which I think is very important. Lots of hairdressers can get set in their ways. No pun intended. Sam continually wants to see new things. And when there's a mistake—it could be in the lighting, in the way the girl's moved, how the hair's stayed—he loves that. He likes things when they're different, new, which is good, to move you forward. You know that he likes things that haven't been seen before.

Sam is very technically skilled. He also has this huge history of working with everybody, from Richard Avedon to Irving Penn, so he has a massive knowledge of how to work in a studio with those great photographers. He's seen a master work. To some degree you're performing to impress him,

as much as Penn must have impressed him. He sets the bar high.

And Sam has this way with models, which is *brilliant*. The hair and makeup will take three hours—that's a normal, reasonable time. So Sam puts them in such a great mental space. It's like fashion fluffing! They come to me completely enthused. That psychological preparation is so important. Most of the model's preparation time, they're being touched by Sam. It's incredibly intimate. It's quite a physical thing—that whole *Shampoo* thing! I'll often try and take a picture as soon as Sam lets go. When Sam's hands touch the model, you can see her expression completely change. Often I'll take the picture literally as Sam takes his hands off her head, before she can revert back to "modelling." I have so many pictures of Sam's hands, split seconds after he's let go of he model's head—she's in a different place. Whether it's Uma Thurman or Kate Moss or Naomi Campbell or Gemma Ward. You get emotions from the girls that you wouldn't get. He will transform these models into characters, which I love.

Sam's not at all one of those people who acquiesce. He will challenge you in your concept of what the girl should look like. Often, he'll come up with exactly the opposite answer. I'll say I think she'd look great with jet-black hair, and she'll walk down in a blonde wig.

And he'll just say, "She looks amazing."

And she does.

— Nick Knight in conversation with Alexander Fury

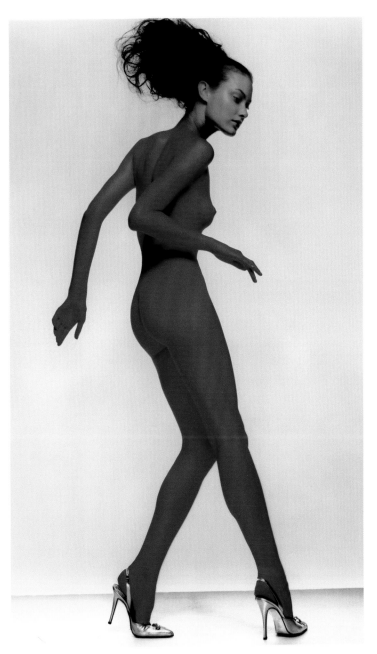

Page 82:

Karlie Kloss, *V Magazine*, October 2012. All photographs in this chapter by Nick Knight.

Above

Left: Shalom Harlow in *Sweet Dreams*, my first shoot with Nick Knight for British *Vogue*, October 1995.

Right: Illustration by François Berthoud.

Opposite:

From *Past, Present & Couture*, a series of images created in collaboration with John Galliano to mark his fifth anniversary at the house of Dior. Ai Tominaga for Galliano/Dior 2001.

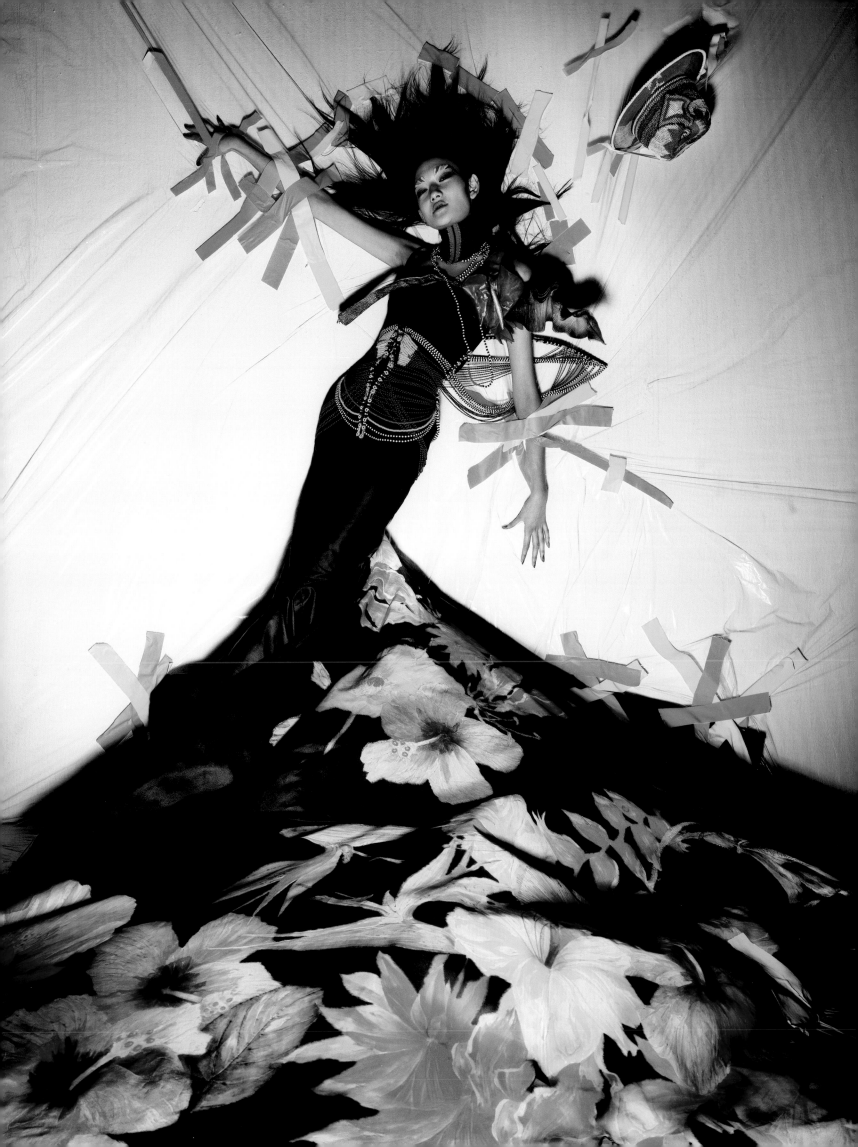

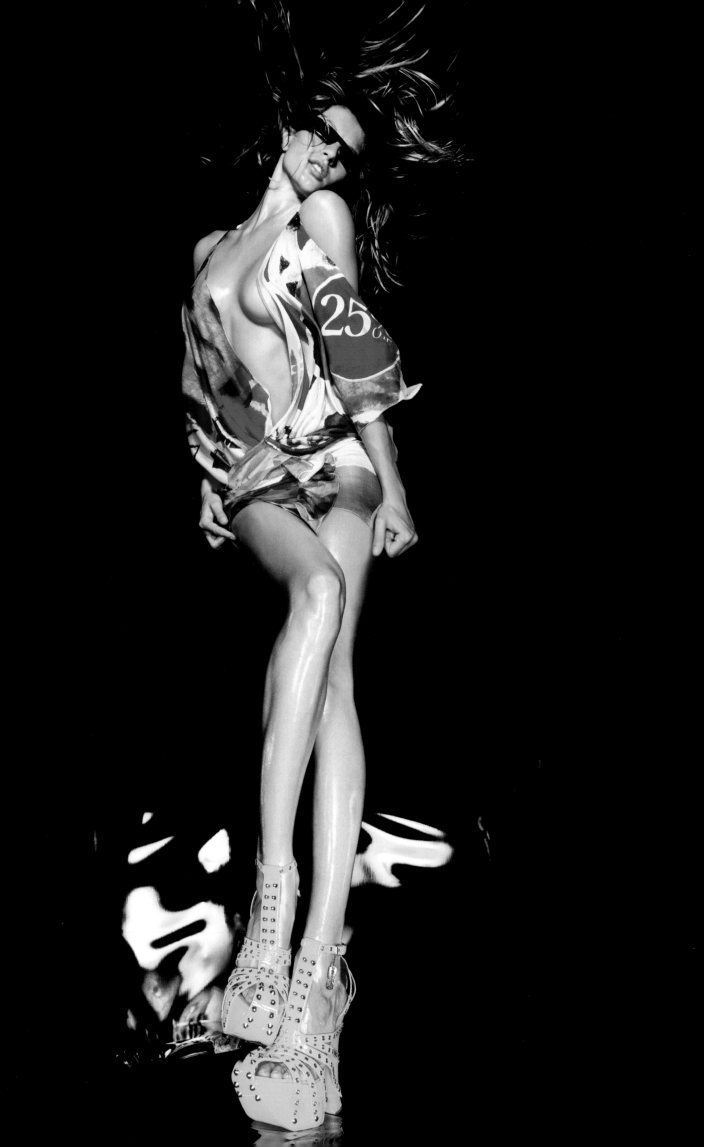

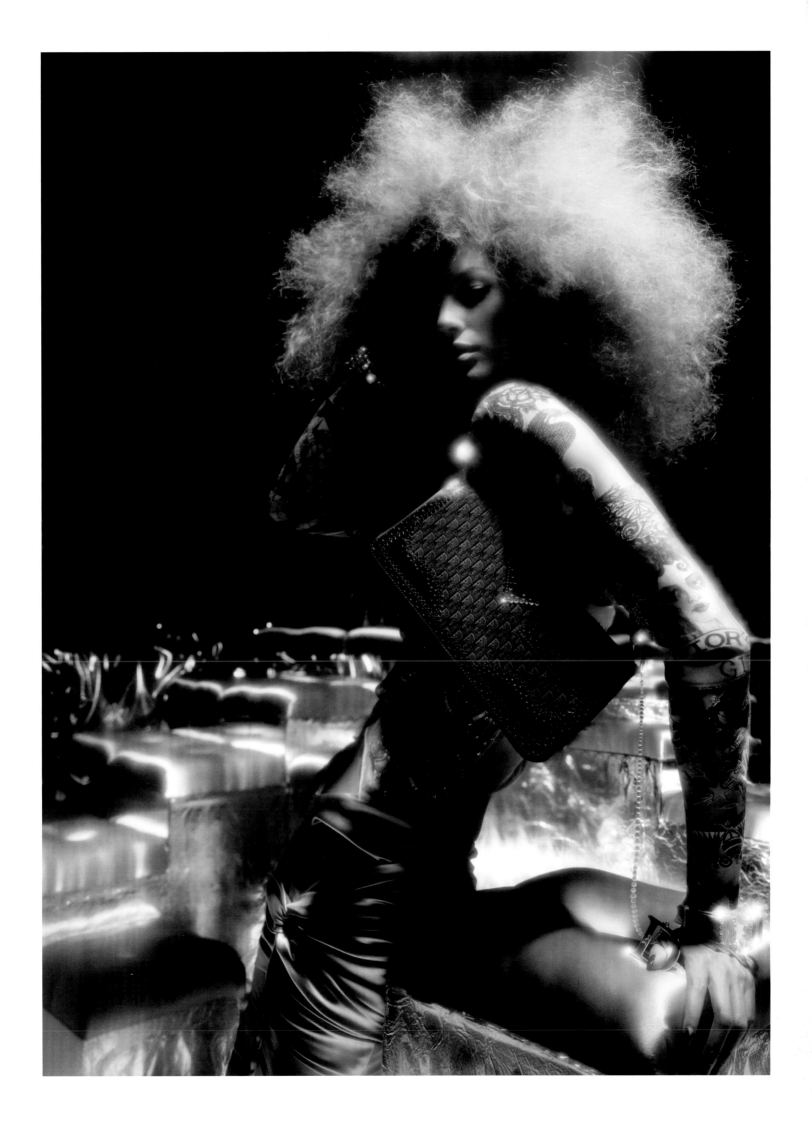

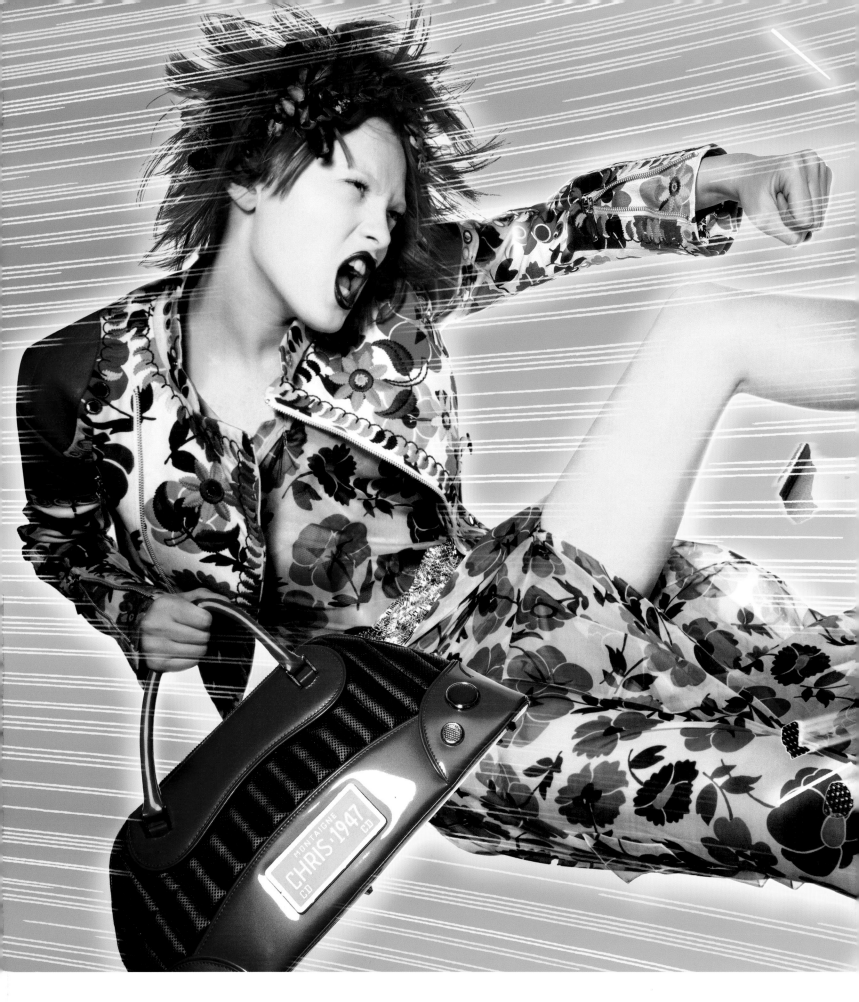

The Dior decade—collaborating with John Galliano, Val Garland, Marian Newman, Michael Howells, Steven Robinson, and Jane How. We all worked as a team to capture the "Dior energy." These were hardworking campaigns where the girls worked long days, back when Nick was still shooting on Polaroid. Karen spent five exhausting days swinging through the air in a harness.

Previous pages:

One girl, two very different looks: Gisele Bündchen for the Dior Autumn/Winter 2005 campaign (*left*) and for the Dior Spring 2004 campaign (*right*).

Above:

Karen Elson for Autumn/Winter 2001.

Following pages:

Left: Mickey Hicks in *Dolls*. SHOWStudio 2000.

Right: Styled by Katy England to coincide with the Alexander McQueen: Savage Beauty exhibition launch. Stella Lucia for AnOther Magazine, Spring/Summer 2015.

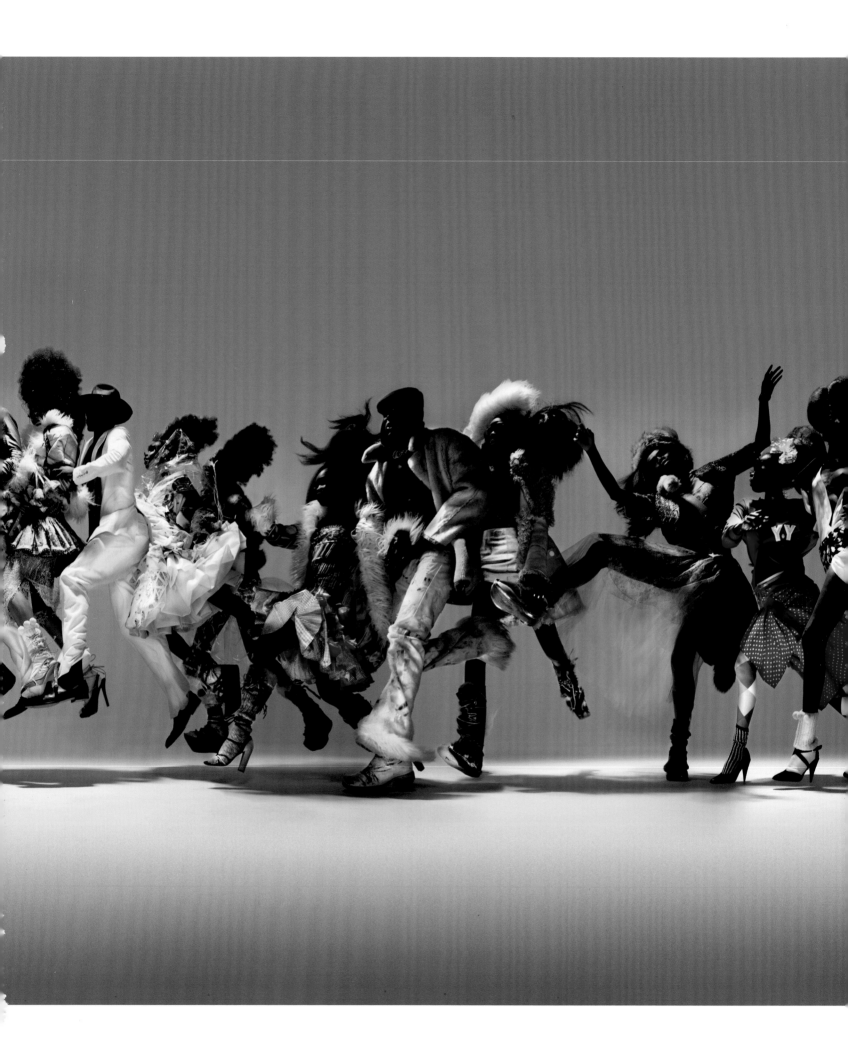

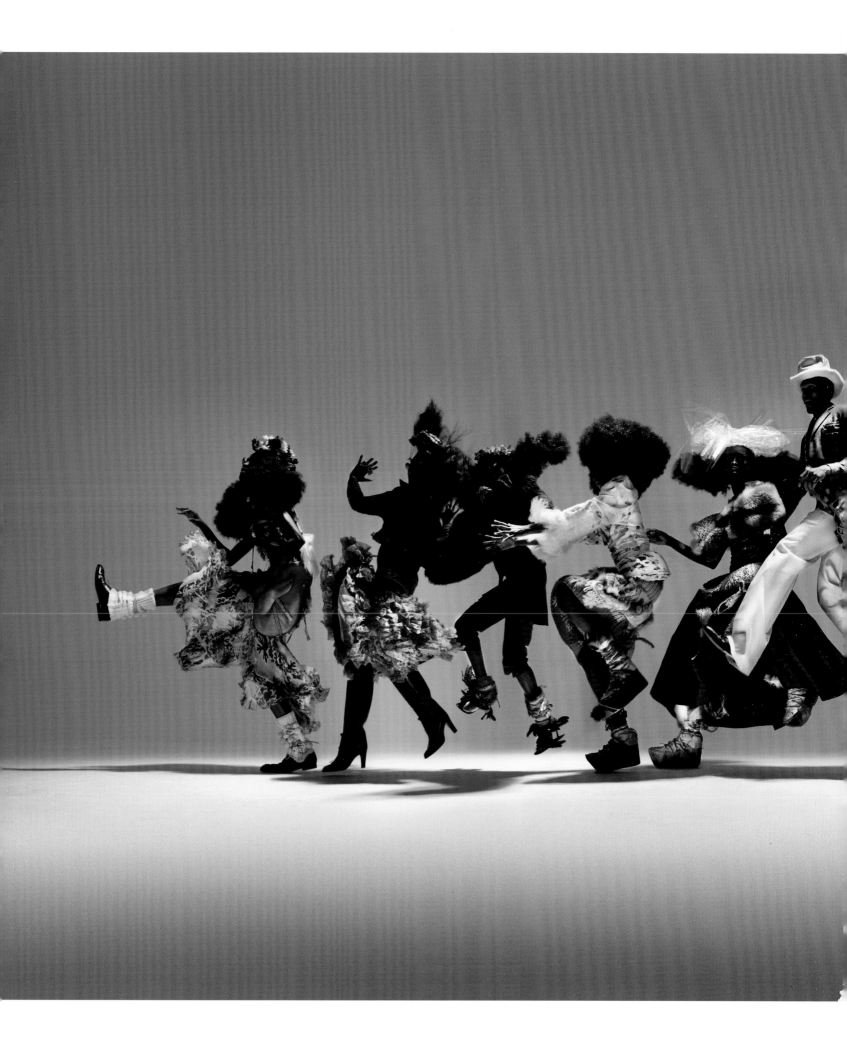

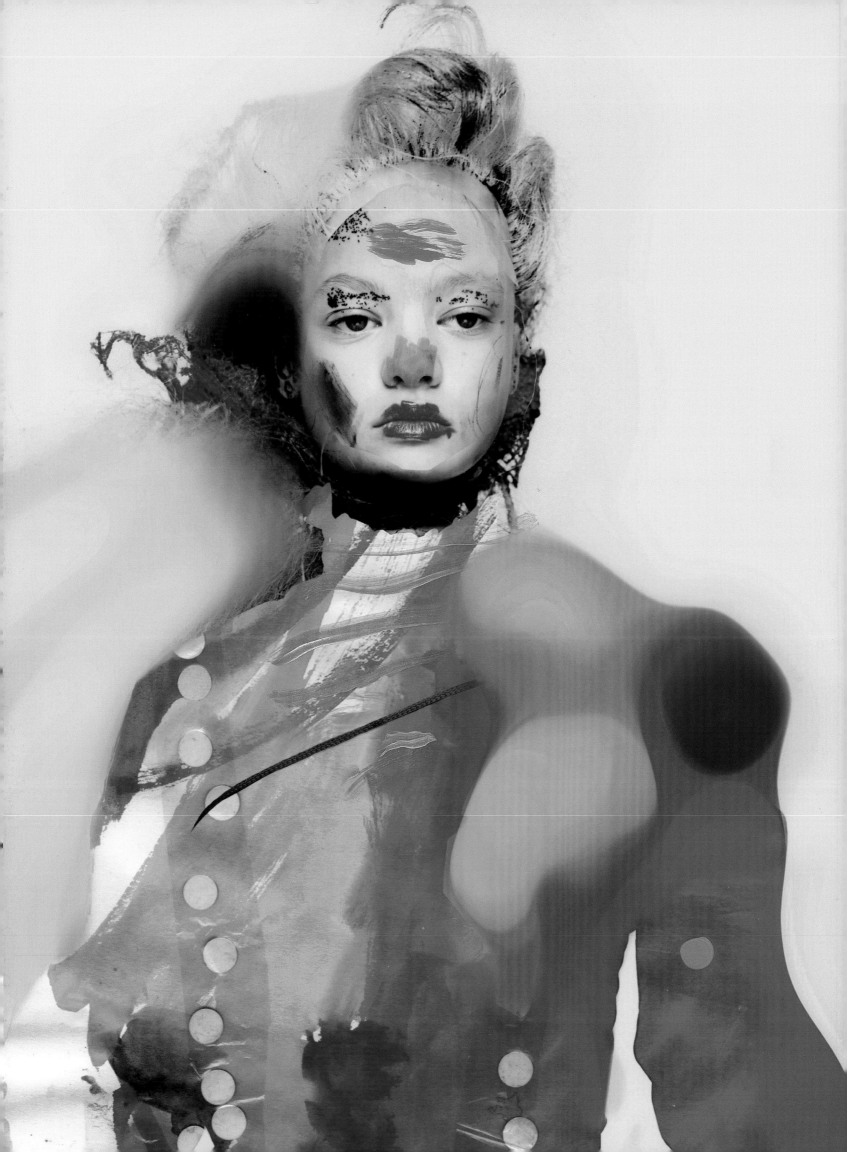

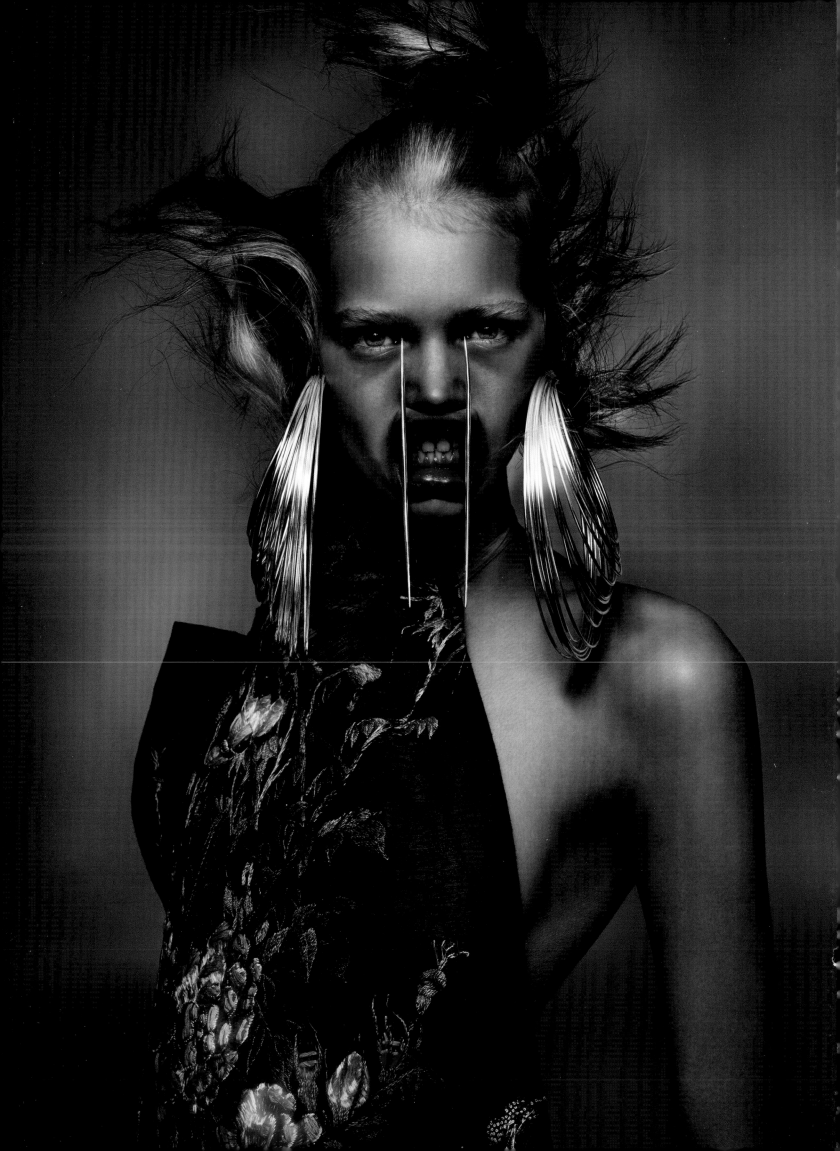

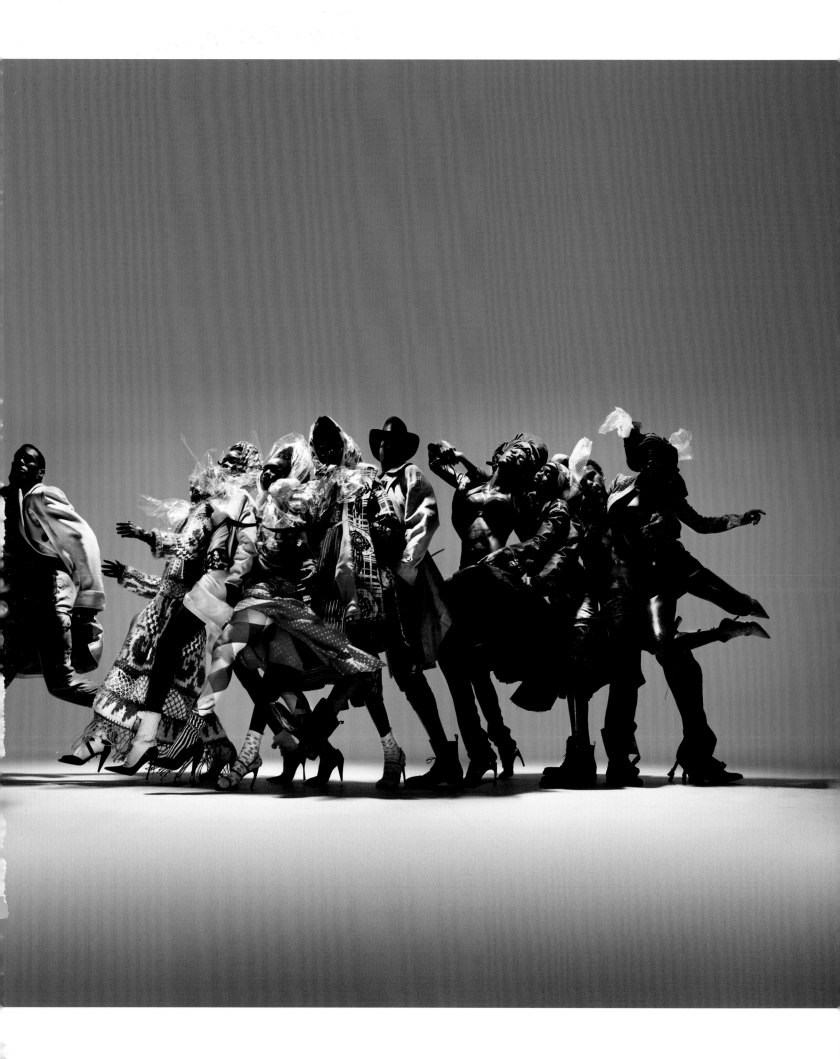

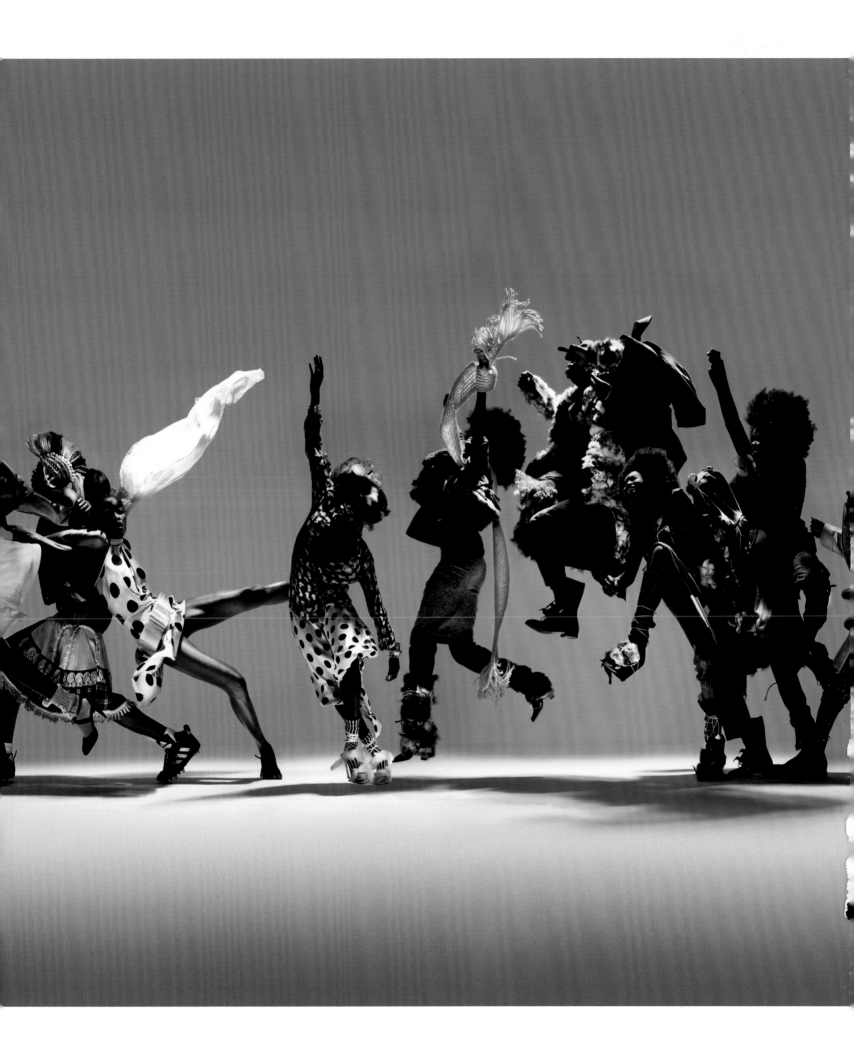

Nick blazed a trail for a new generation in 2000 as an early Internet pioneer with his groundbreaking website, SHOWstudio. He was also one of the first photographers to have cameras filming everything on set and in the studio during a shoot.

Above and opposite:

Whaam! pop art with Lindsey Wixson for *Garage* magazine, Fall/Winter 2012.

Gatefold:

Citizen K magazine, Autumn 2002. Photograph by Nick Knight.

Opposite:

Always & Forever with Karlie Kloss
and Cara Delevingne, *Garage* magazine,
Spring/Summer 2014.

Above:

Georgia May Jagger, *Garage* magazine,
Spring/Summer 2014.

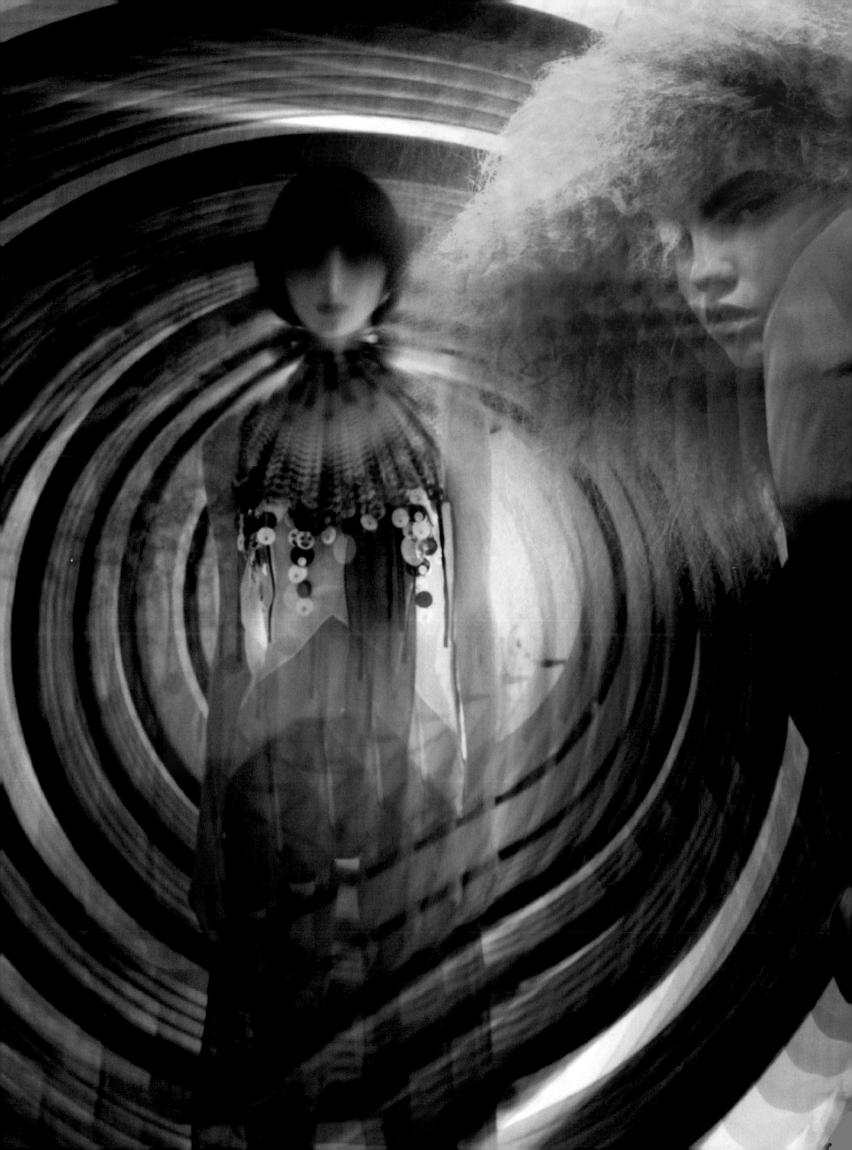

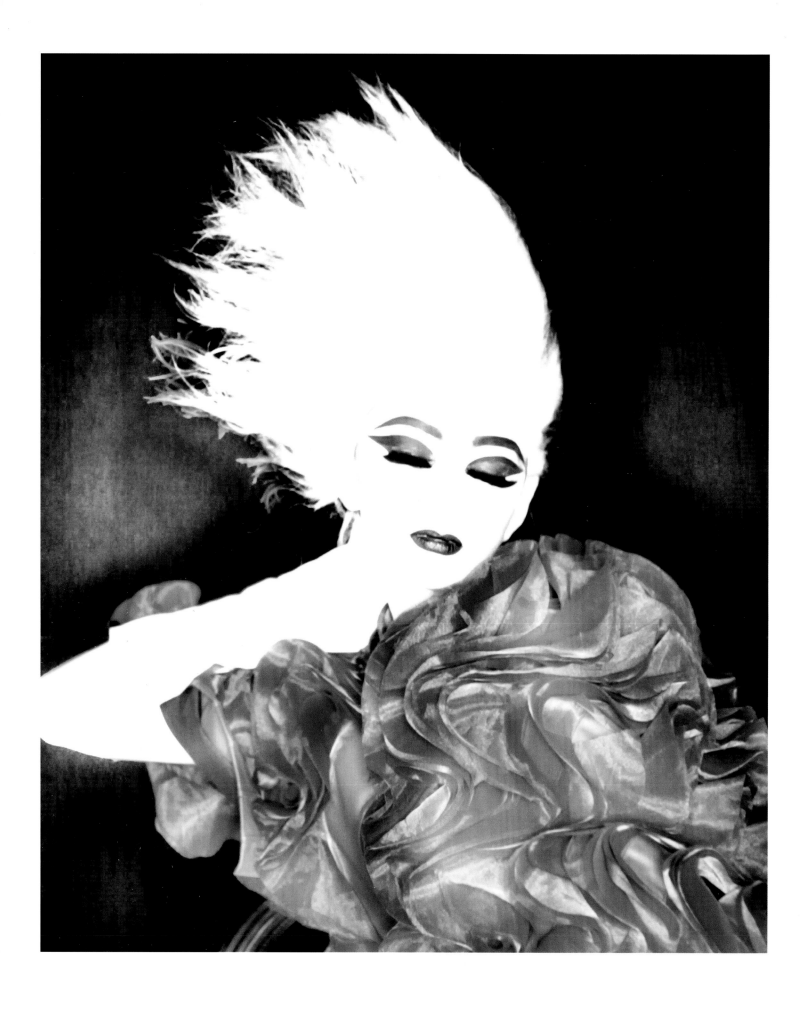

Previous pages:

The Moon and the Cat's Eyes with Molly
Bair and Cierra Skye for *V Magazine,*
January 2016.

Above:

Alexia Wight in *Hauteur Space*
for *W* Magazine, January 2012.

Opposite:

A classically elegant Nick Knight
shot of Kim Kardashian for *V Magazine,*
September 201

102

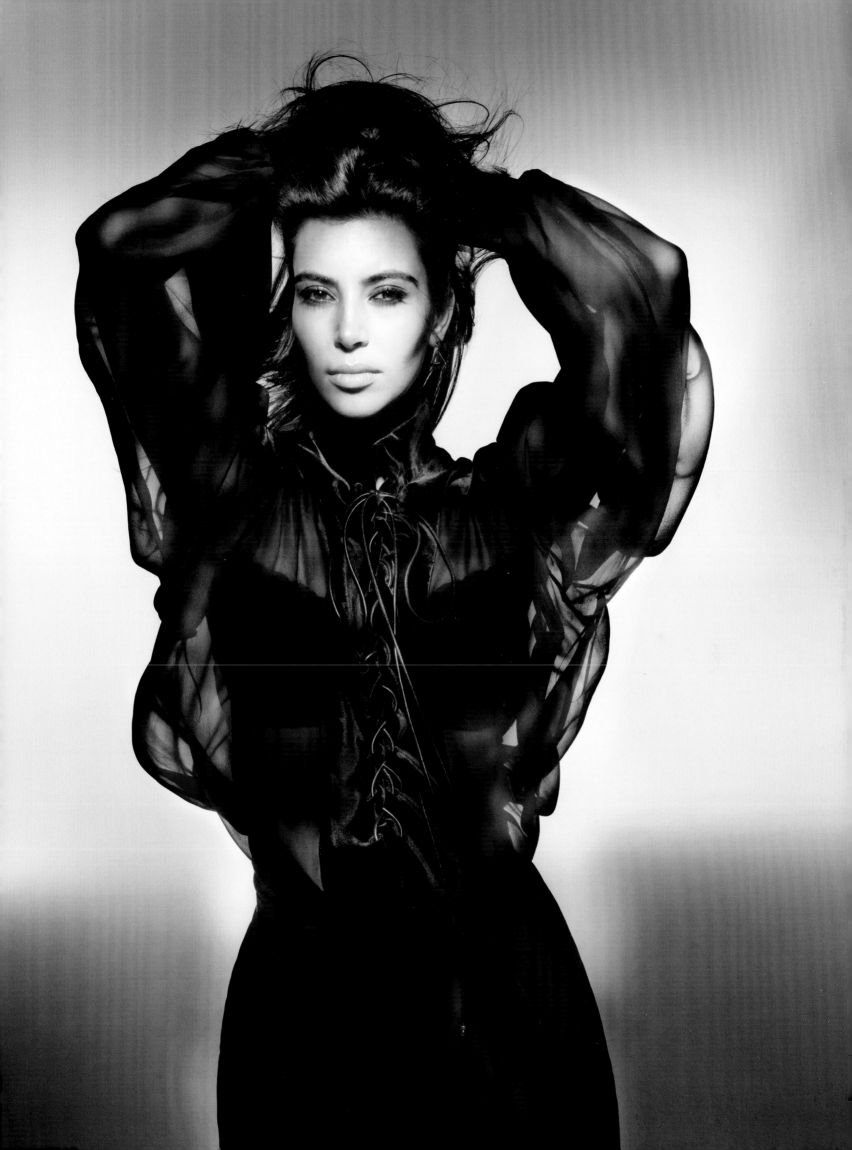

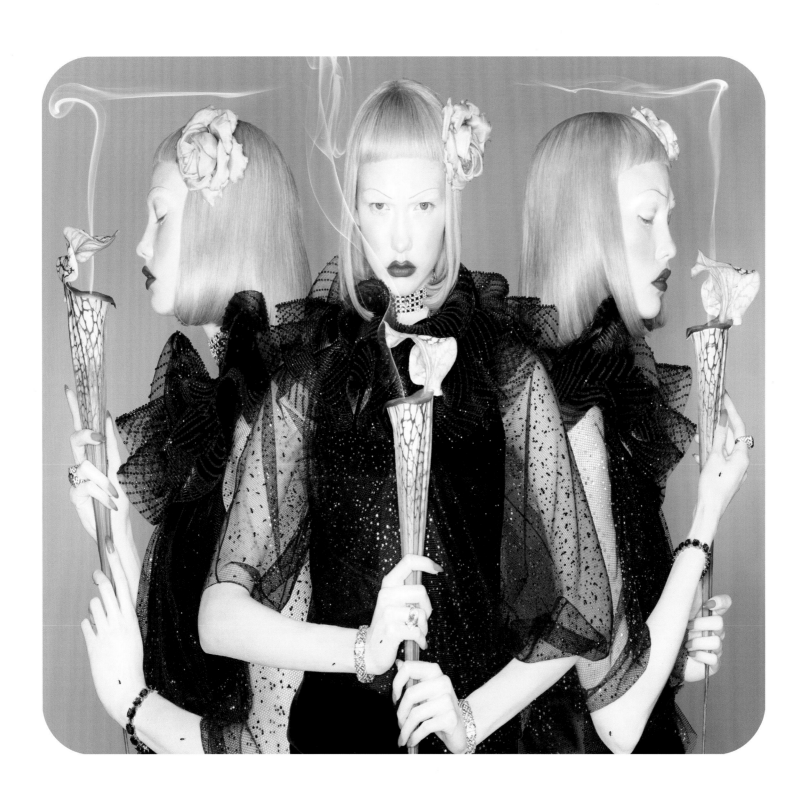

Opposite and above:

Sweet Escape, a romantic fantasy
with Karlie Kloss changing characters
and wigs with every look, *W Magazine*,
October 2012.

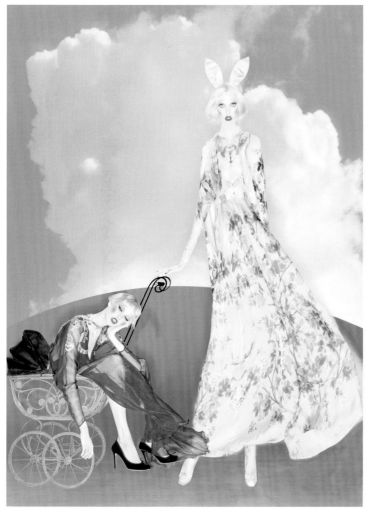
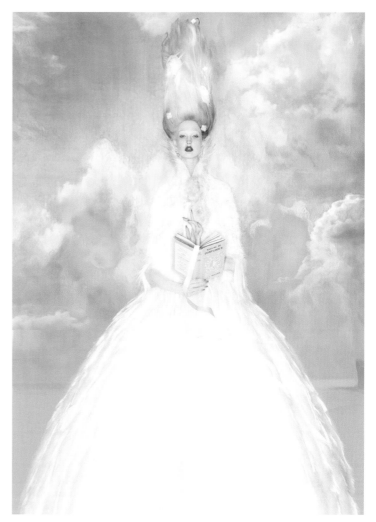
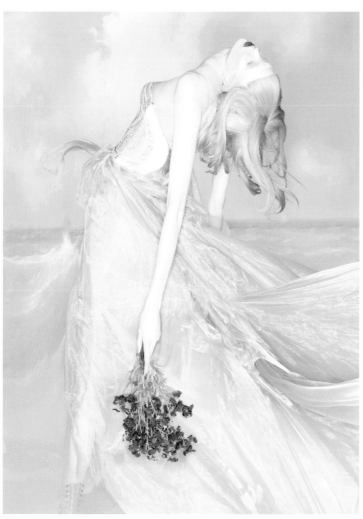
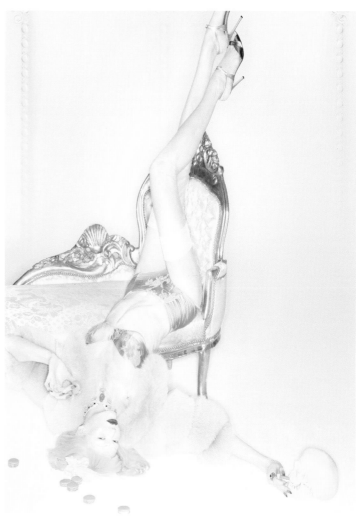

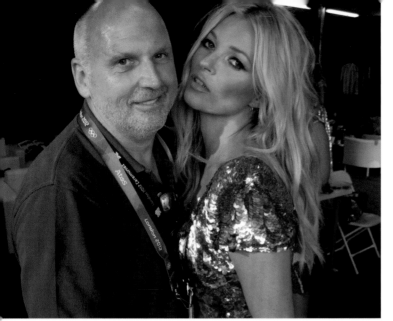

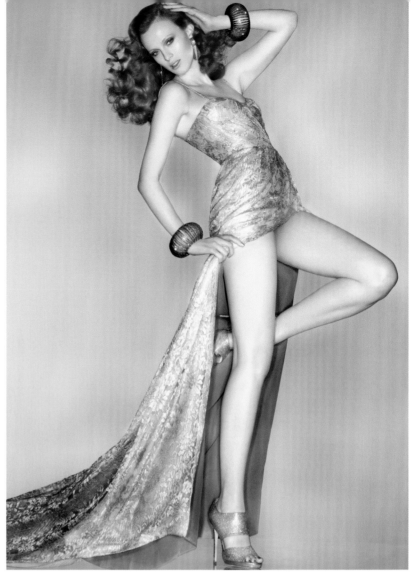

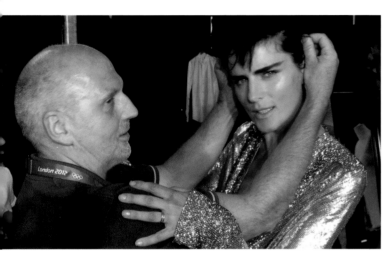

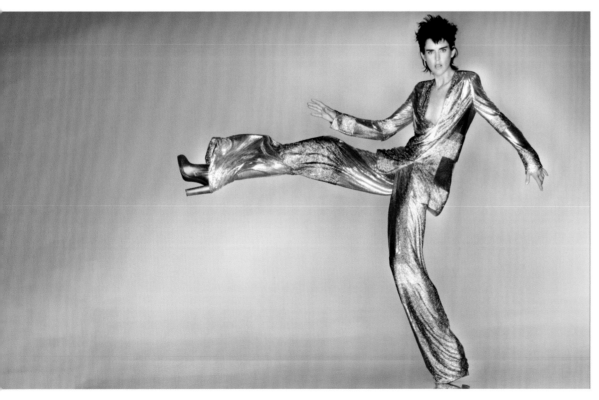

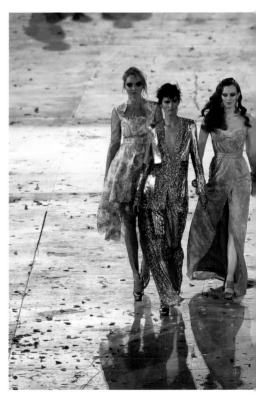

A proud moment to be involved in the London 2012 Olympic closing ceremony. Nick was asked by British *Vogue* to shoot ten iconic British models, dressed by Lucinda Chambers in ten British designers. I worked on the models for both the shoot and ceremony, and it was an honour to be included in the best of British fashion.

Models: Kate Moss, Naomi Campbell, Stella Tennant, Lily Cole, Karen Elson, Lily Donaldson, Jourdan Dunn, Georgia May Jagger, and David Gandy.

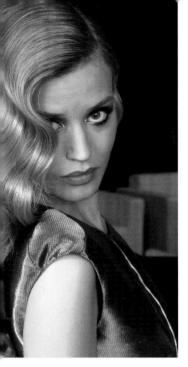
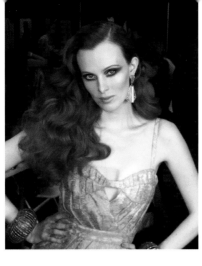
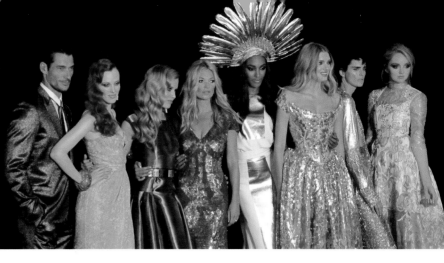

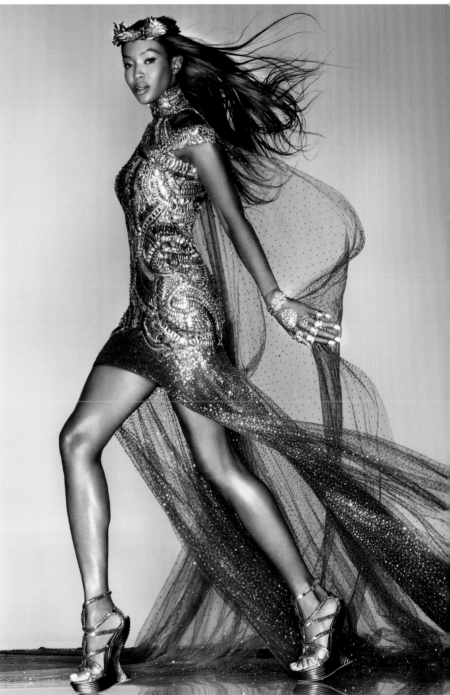
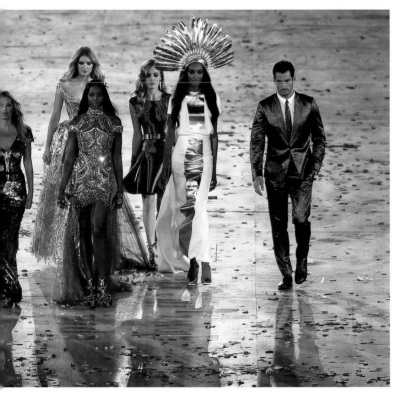

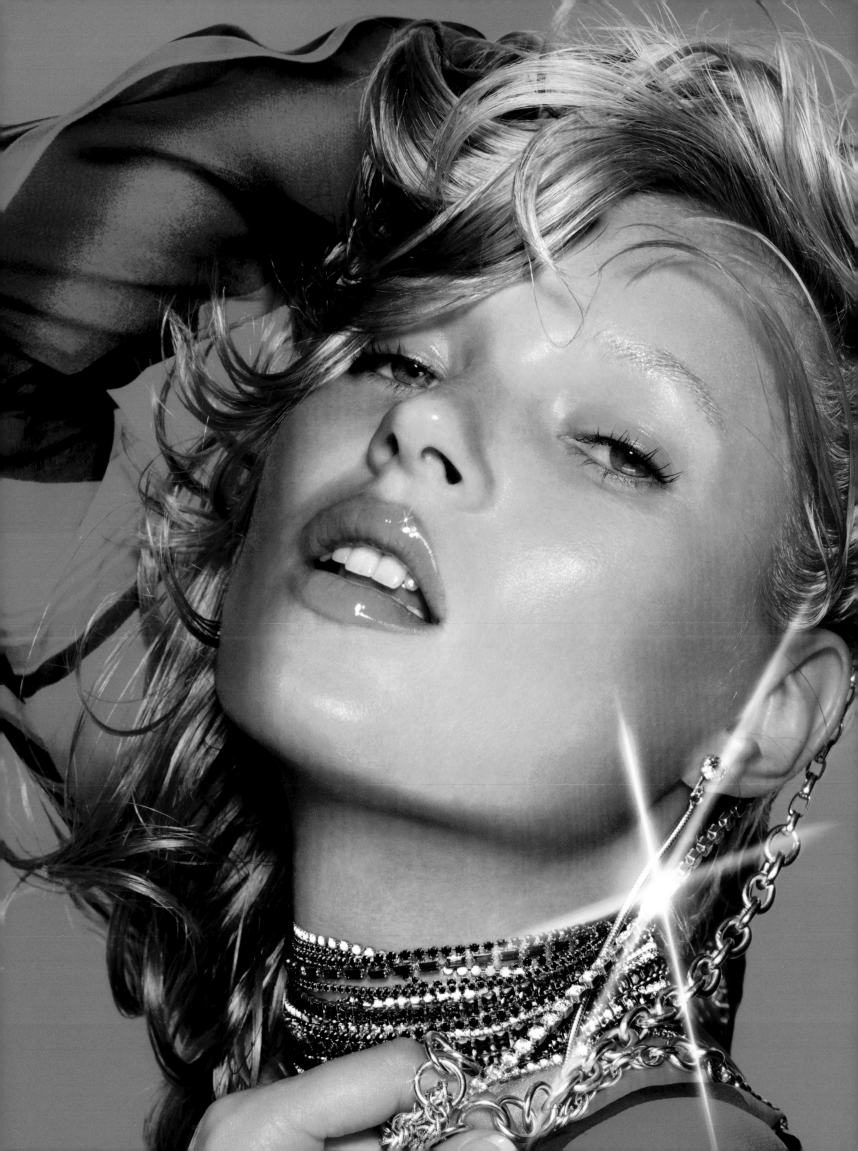

KATE

I've been with Kate Moss from the beginning—*her* beginning. Kate was on a go-see—and I was working with Steven Klein for *Harper's Bazaar*. We photographed her against the wall. Even then, the camera loved her. Needless to say, she got the job for Liz Tilberis's first issue at *Bazaar*. And boom! That was it.

Kate is amazing to work with. She's the ultimate cool girl, and to this day, when you do a shoot, or work on a show, whether she's there or not, there's always a picture of Kate as "inspiration." She is that cool girl they all want to capture. Signature Kate style is unmistakable, modern, undone hair, but it's 100 percent Kate.

We have the best working relationship—and more than that, we've become great friends. She's fun, loyal, and inspiring, and she knows how to switch it on and work the hair. She has her own innate sense of style, of what to do, of who she is and has incredibly good taste. Whatever she's doing, she puts her stamp on it. She's always worked hard, and she knows how to use the camera and the light and how to angle her face. It's the same with all the great models—when they learn how to catch it, that's when it reaches another level.

Kate can perform and will always give a fresh interpretation, from Bardot to Bowie, androgynous to couture. It's about knowing the girl, working with her throughout your career and developing a creative shorthand. That's when you can push each other and that's when it becomes exciting and you get the best pictures. I like taking risks and being spontaneous, and there is no better collaborator than Kate to do this with.

She always had "It," but who would have guessed when she started out that she would have such a phenomenal career? In many ways, Kate is the same giggling Croydon girl I first met many years ago, but she took the challenge and she ran with it and created a phenomenon. She is the face, and image that generations want to emulate. Her "effortless" style endures, with perfect cheekbones, and a face that's one moment otherworldly and the next the girl next door. She made it all happen and I am so proud to have been a part of her adventure.

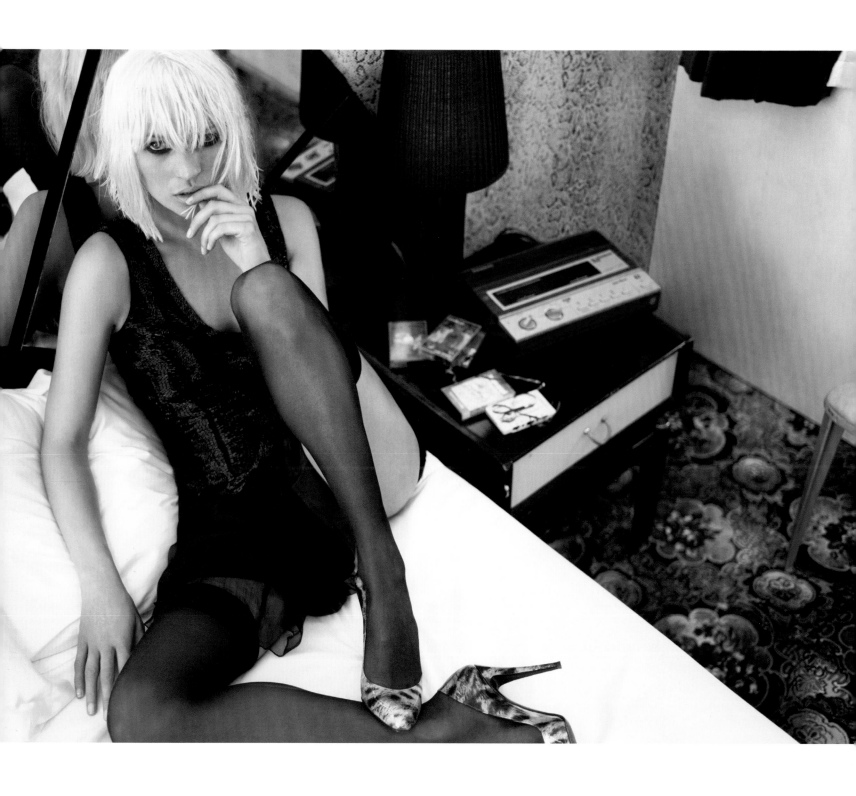

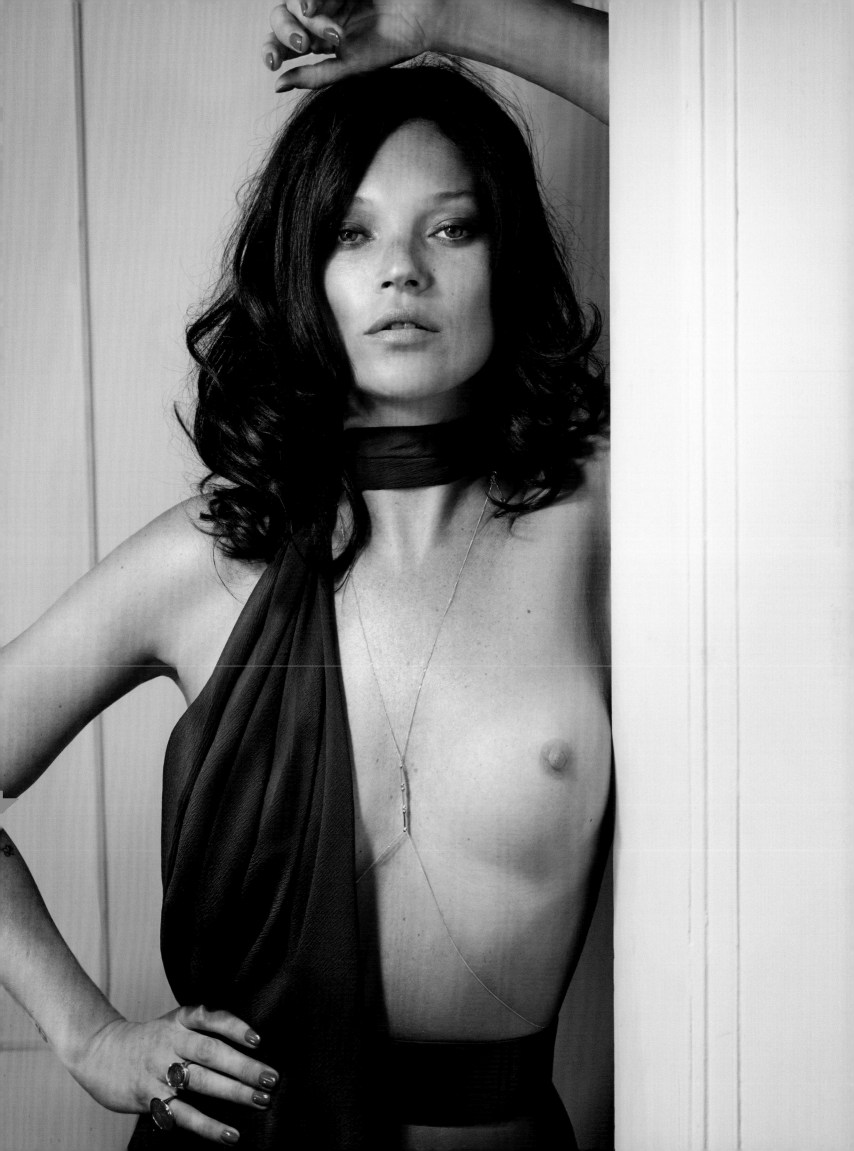

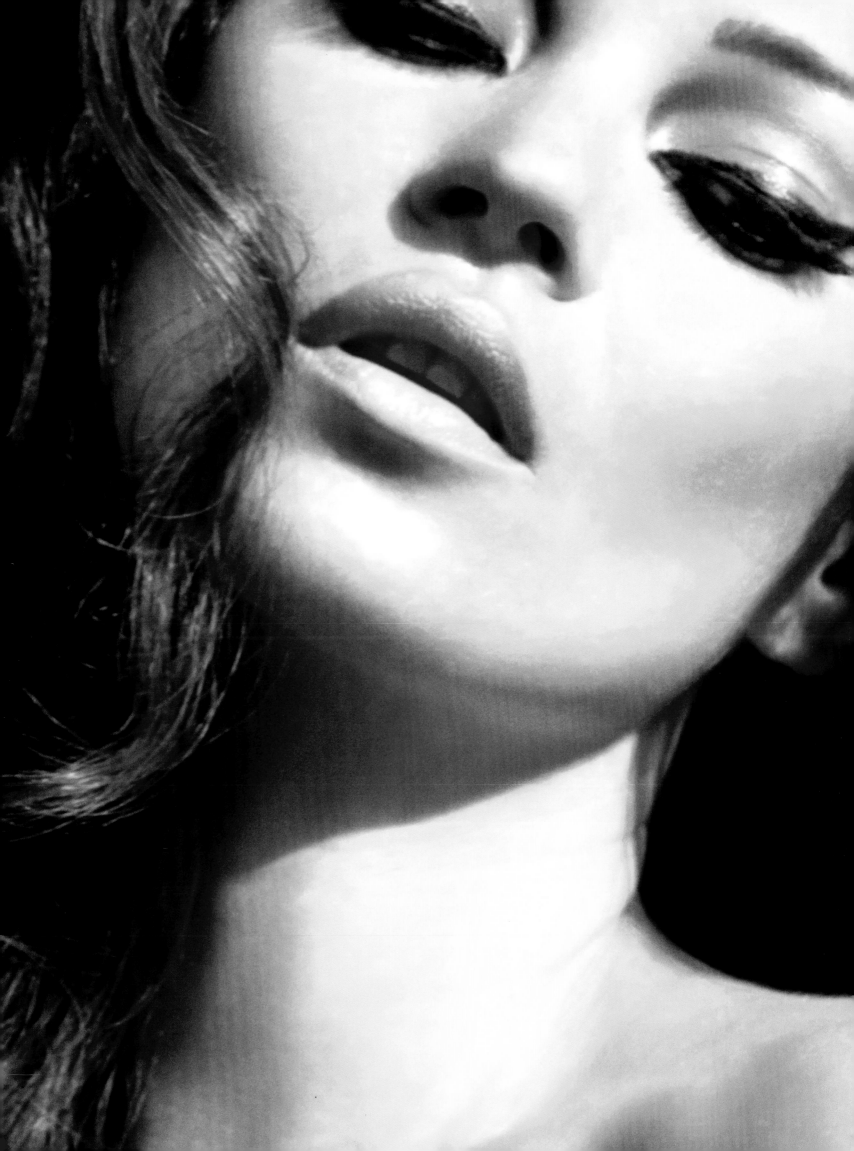

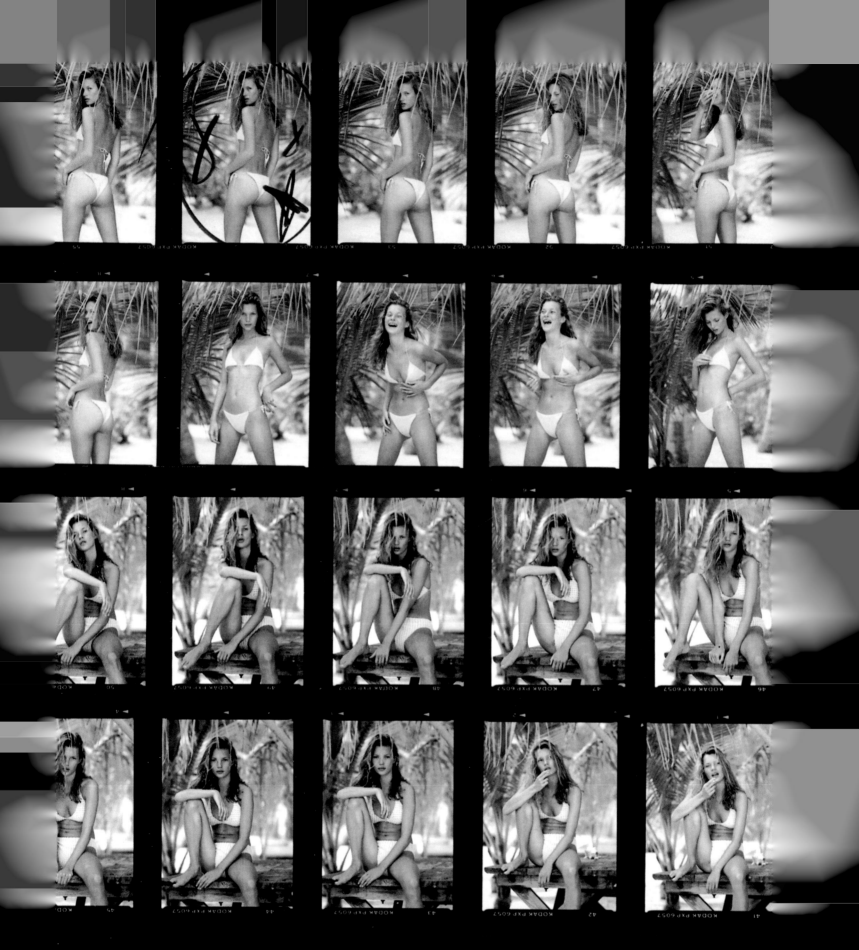

"Sam has been doing my hair since I was a waif. I've grown up with him. When we work together, it's like working with family or your best friend. I love him. Over the years we have built a strong relationship based on trust and respect. After fifty million years in the fashion business you would think he'd be jaded, but he's not. Back in the day we used to talk about clubbing, and where we were going out that night; now we talk about gardening, what to plant and when to plant it—he regularly sends me boxes of bulbs with planting instructions! We have created so many different characters together, some of them appear in this book, but there are many, many, more.... And many stories attached to them."
—Kate Moss

Above and opposite:

One of my first shoots working with a young Kate in St. Barts for *Harper's Bazaar*, June 1994. Photographs by Patrick Demarchelier.

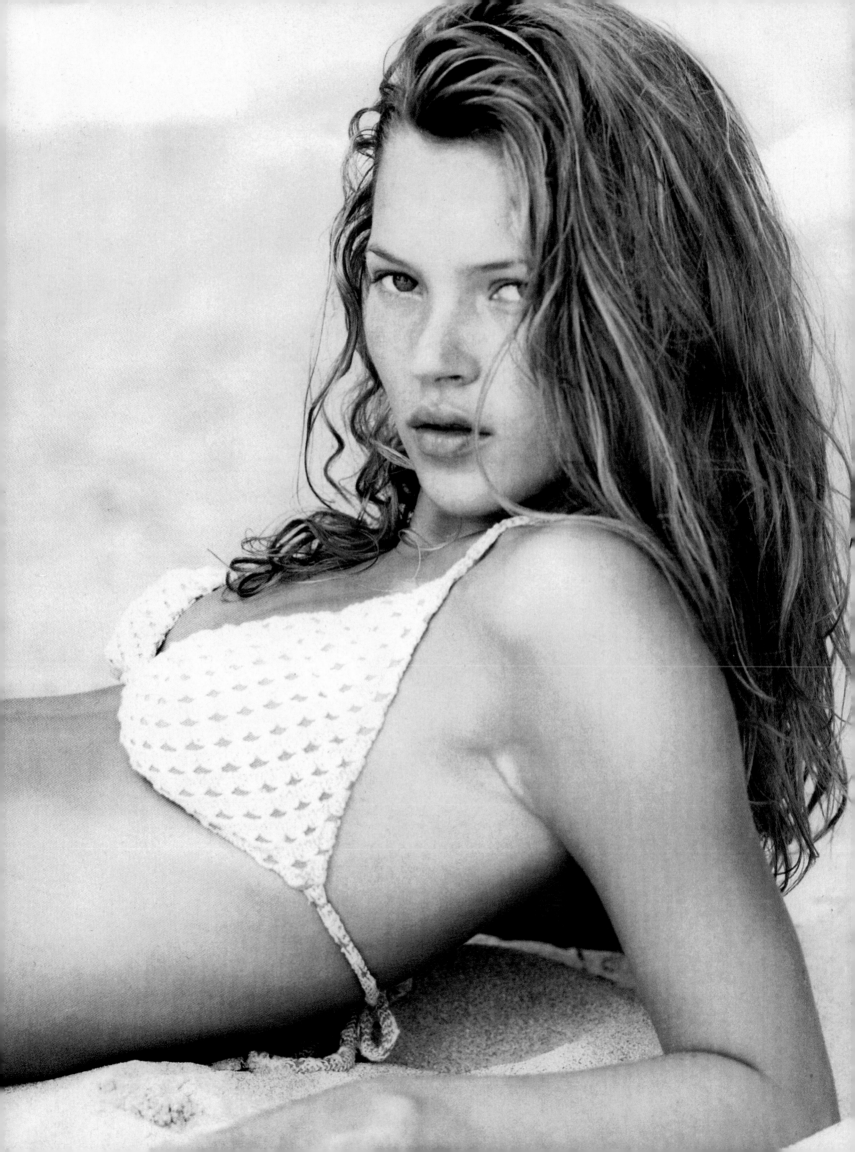

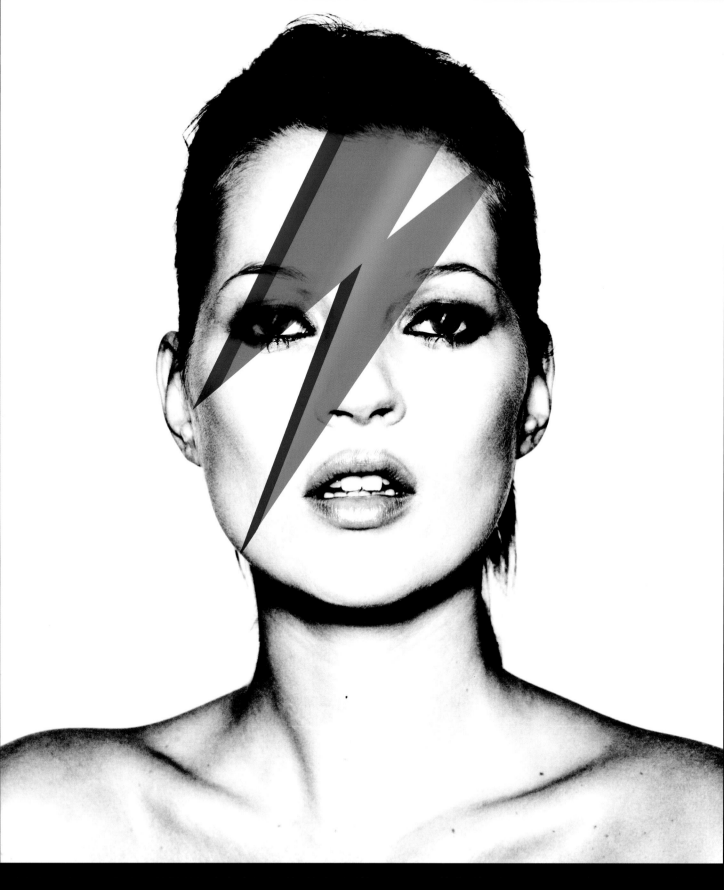

Above

For the music issue of British *Vogue*, May 2003, I kept it simple, clean, and modern. Photograph by Nick Knight.

Opposite:

British *Vogue*, September 2010. Photograph by Patrick Demarchelier.

Following pages:

This is signature Kate: undone, effortless, and cool. It's all in her attitude and eye contact with the camera.

Left: An iconic photograph by Mario Testino for British *Vogue*, October 2008.

Right: British V*ogue*, May 2016.

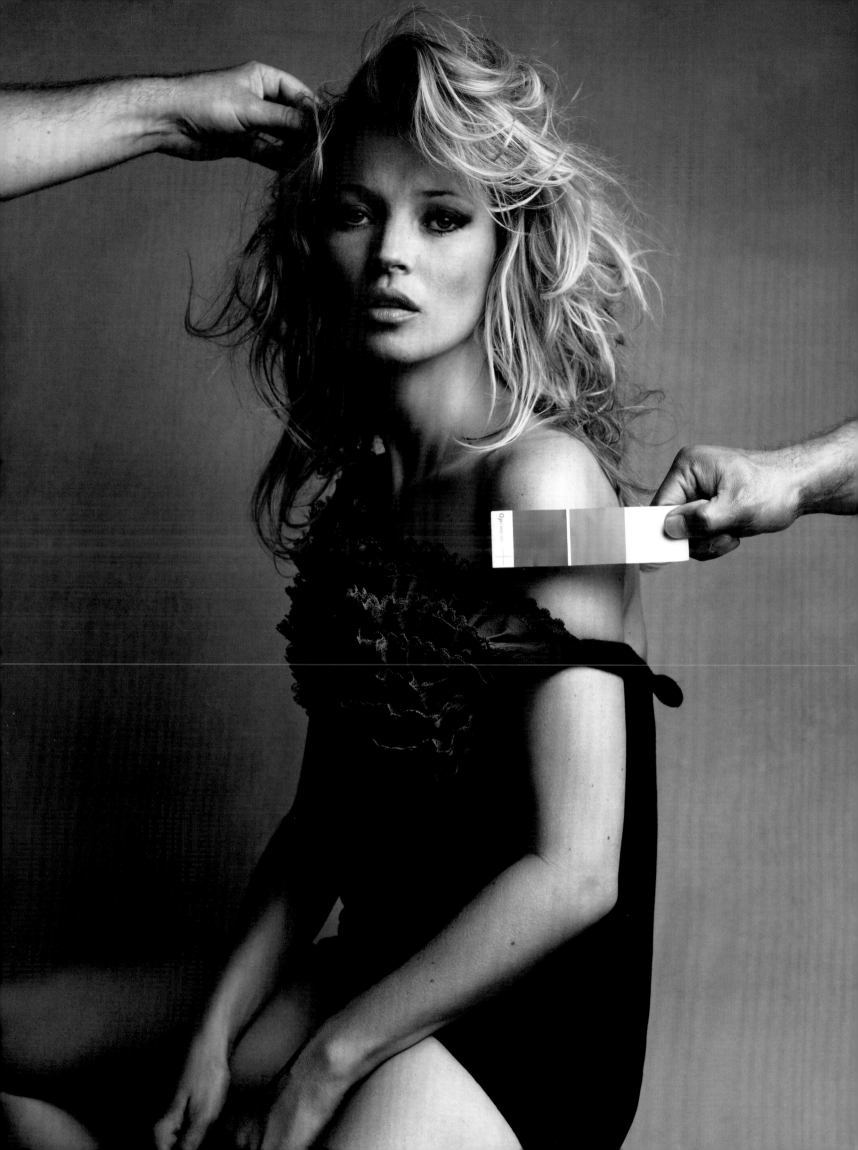

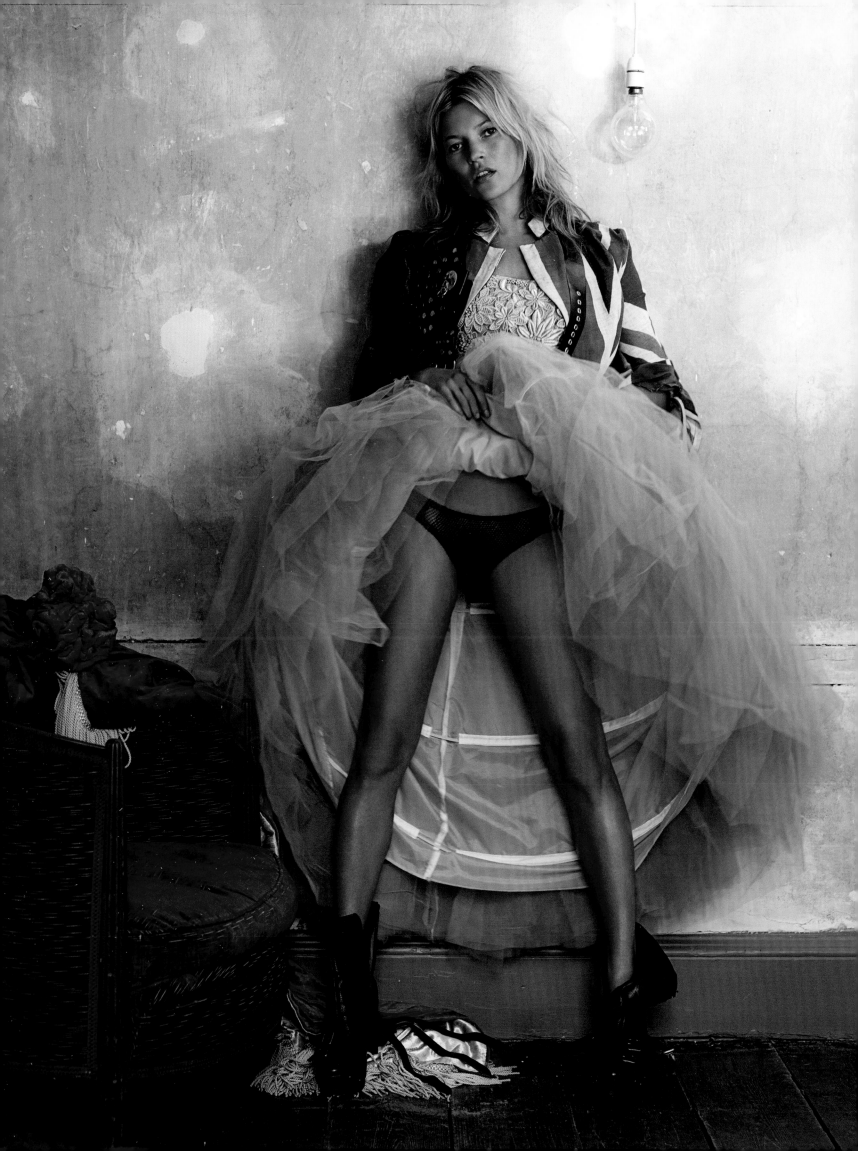

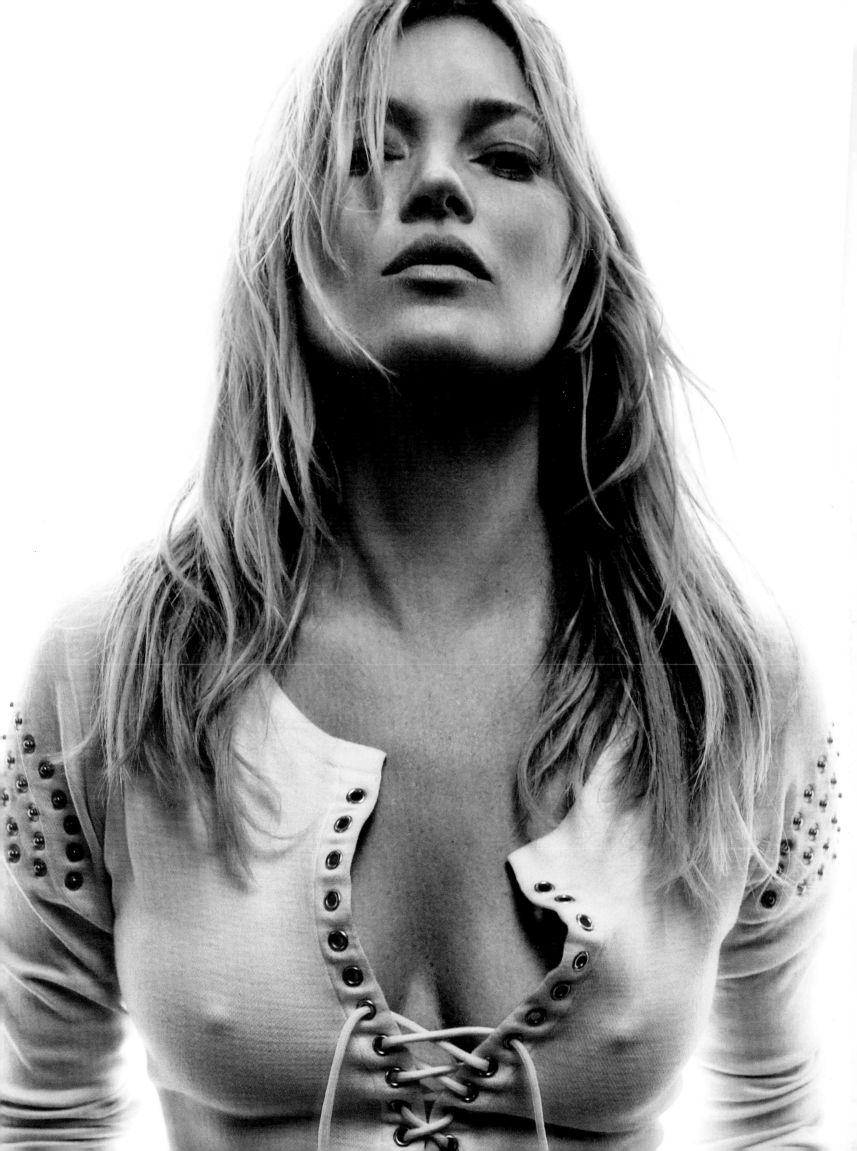

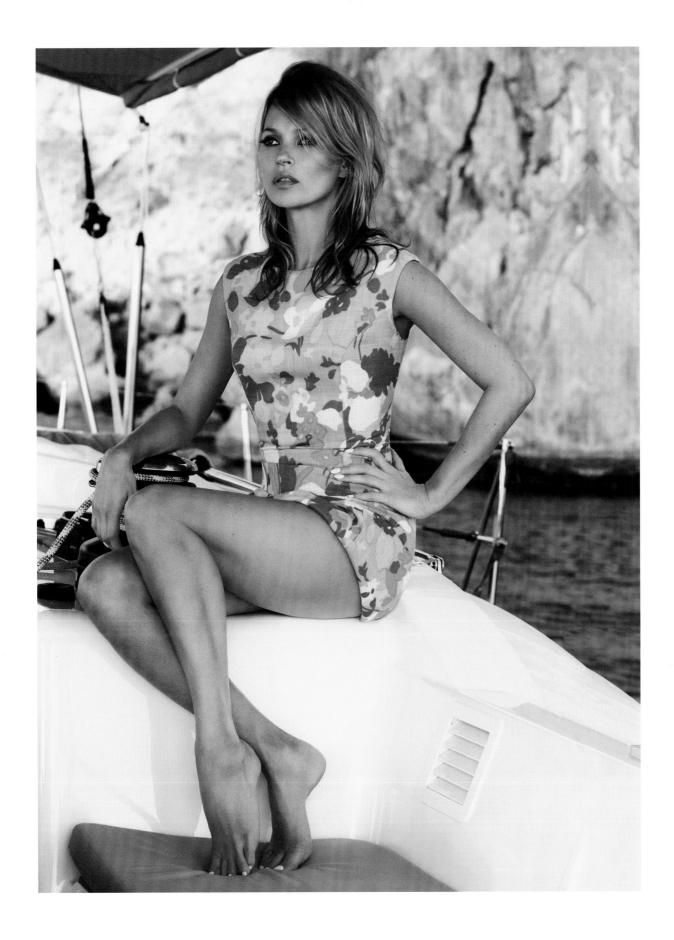

Above:

Three days in St. Barts for British
Vogue. The airline lost my luggage
and kit, so I found a spray bottle
in the hotel and filled it with sea water,
and with a bit of backcombing it gave
me the perfect texture to create this
soft beachy Bardot look. Photographs
by Patrick Demarchelier.

Opposite:

I have worked on more than thirty
Vogue covers with Kate... impossible
to pick a favourite.

121

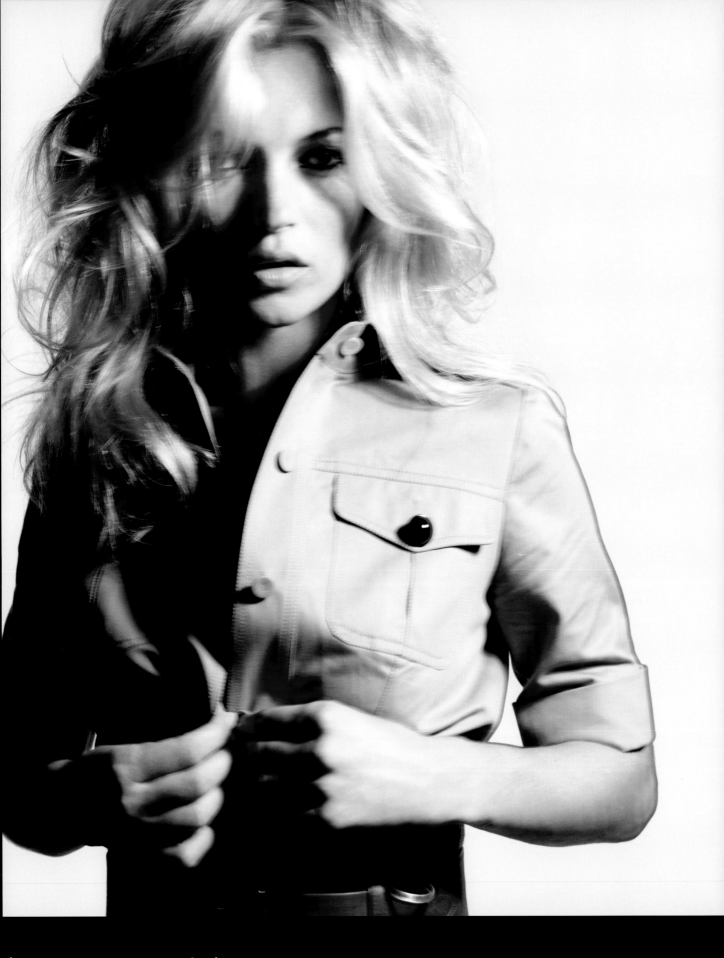

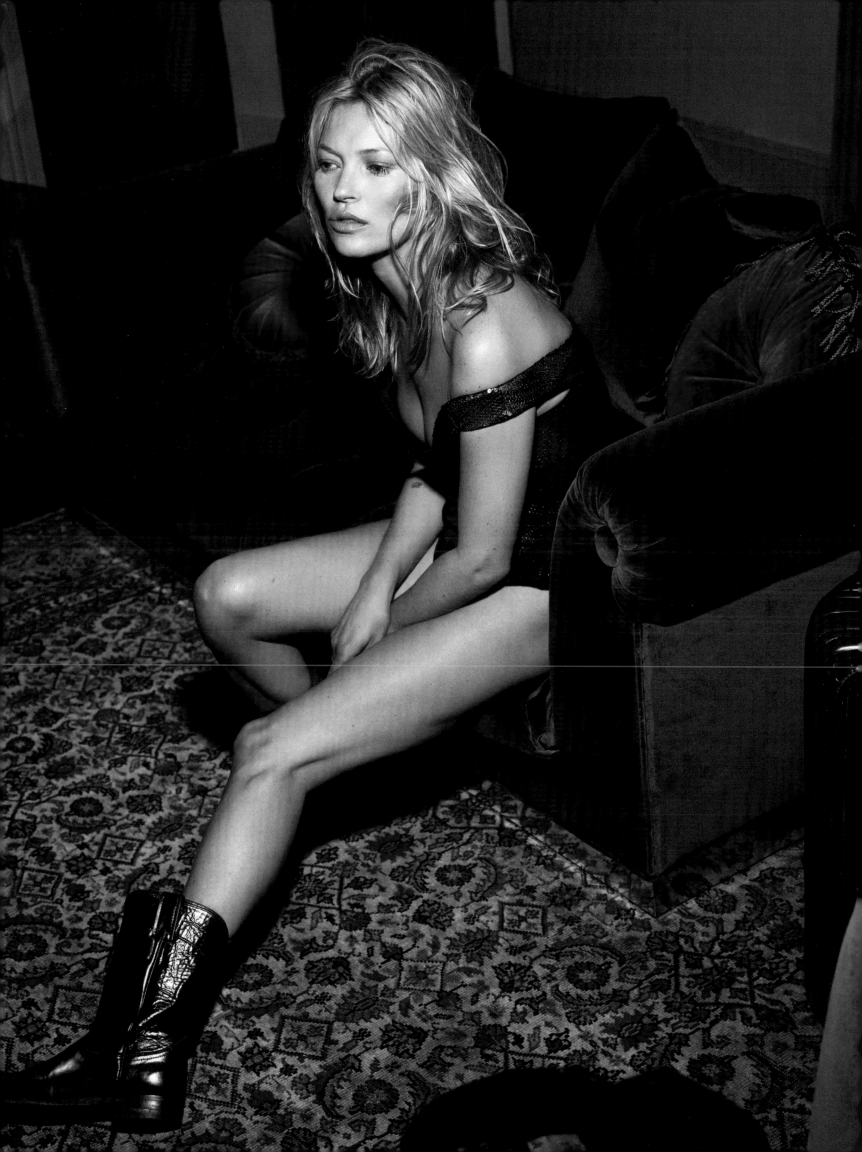

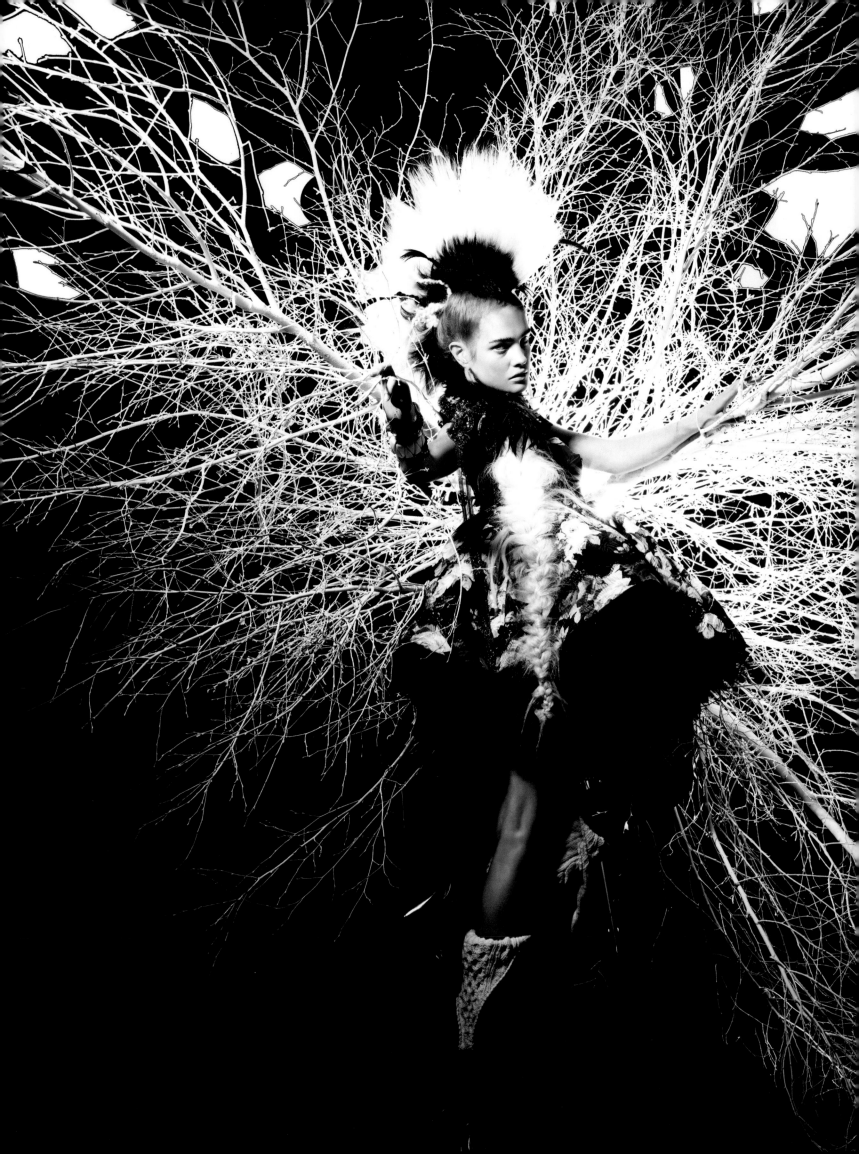

POETIC FANTASY

The genius of a great hairstylist is the ability to create emotion through colour, texture, volume. In that sense, a great hairstylist is not unlike a visionary landscape gardener. Sam senses the focus of the photographer, the haiku of abbreviated references from the stylist or art director, and the impact of the set or the location on a shoot. He looks at the fashion, sees where the direction might lie, and transforms the model into a lyric of tangible feeling. His sense of the source of that spring, his feel for modernity, and his talent for avoiding pastiche and pure costume drama launch the final image into the stratosphere of the unforgettable. His nuanced sensitivity to light and shade creates the visions that bring fashion dreams to life—romantic, haunted, feral, fragile. You can read his work like poetry:

The raised heckles of a Mohican, defiance pinned in the headlights. Decadence. An overblown rose. Distraction. The simmering Southern belle. Come hither, hair teased, frustrated, desperate. Feral. Tentative. Untameable. Surreal. Free. A dreamscape. Tribal. Elizabethan. The siren unleashed.

– Amanda Harlech

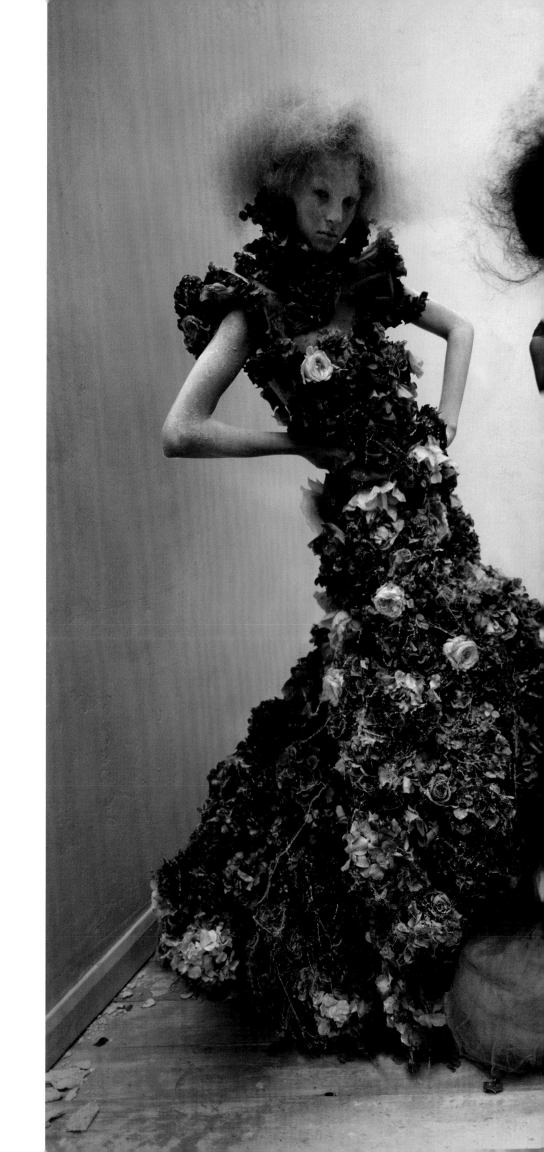

Page 124:

Natalia Vodianova in a floor-length Mohawk hairpiece. British *Vogue*, February 2010. Photograph by Nick Knight.

Opposite:

Dark Angel by Tim Walker for British *Vogue*, 2015, to coincide with the Alexander McQueen *Savage Beauty* exhibition. Models (left to right): Nostya Sten, Aya Jones, Harleth Kuusik, and Yumi Lambert.

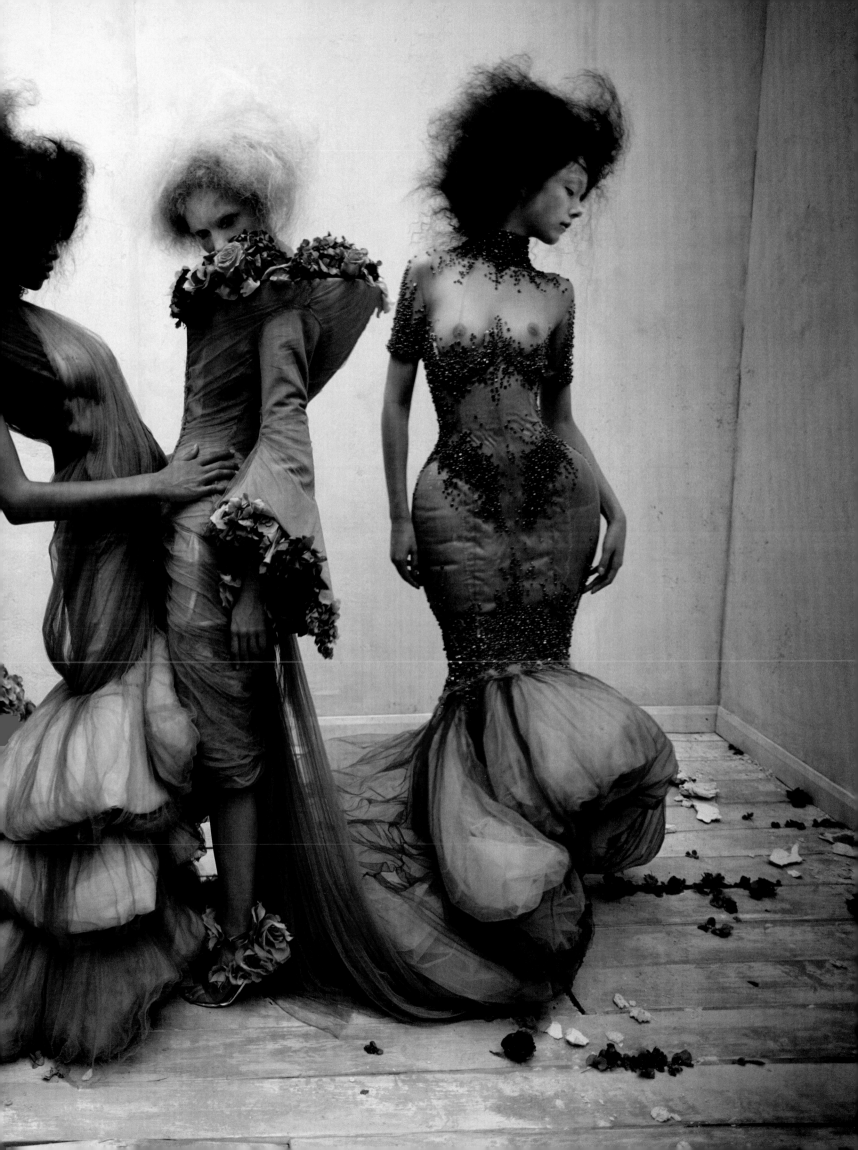

Paolo Roversi is a romantic and
poetic painter of light

Above:

Lida Egorova, British *Vogue*,
September 1998. Both photographs
by Paolo Roversi.

Opposite:

Emilia Clarke for British *Vogue*,
May 2015.

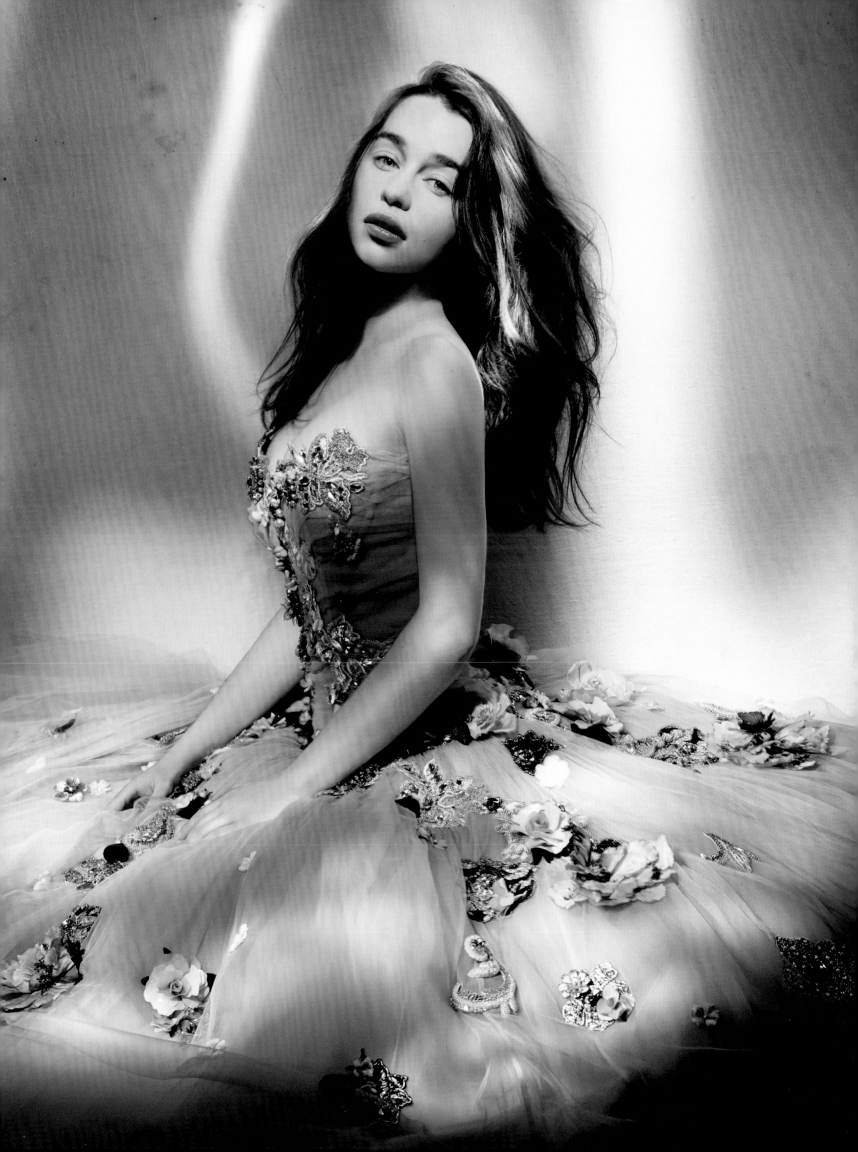

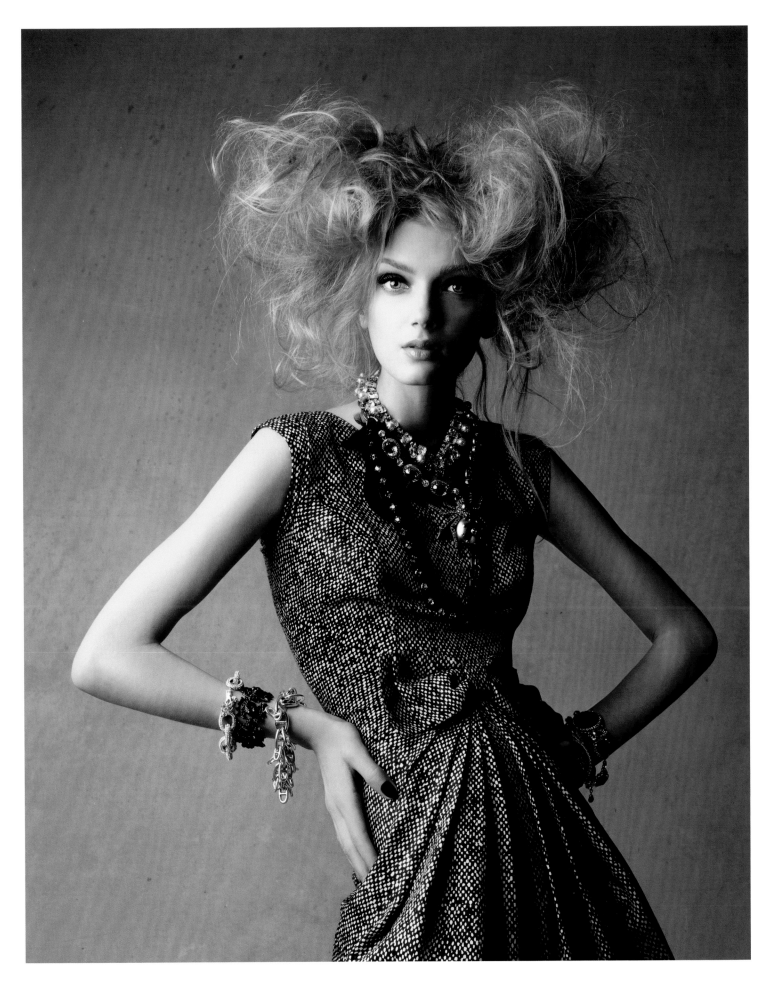

Above:

Lily Donaldson for British *Vogue*, July 2008. Photograph by Patrick Demarchelier.

Opposite:

Masha Novoselova for Russian *Vogue*, 2009. Photograph by Jem Mitchell.

Following spread

Custom-made braided tailed Mohawks for Othilia Simon, British *Vogue*, September 2010. Photograph by Paolo Roversi

130

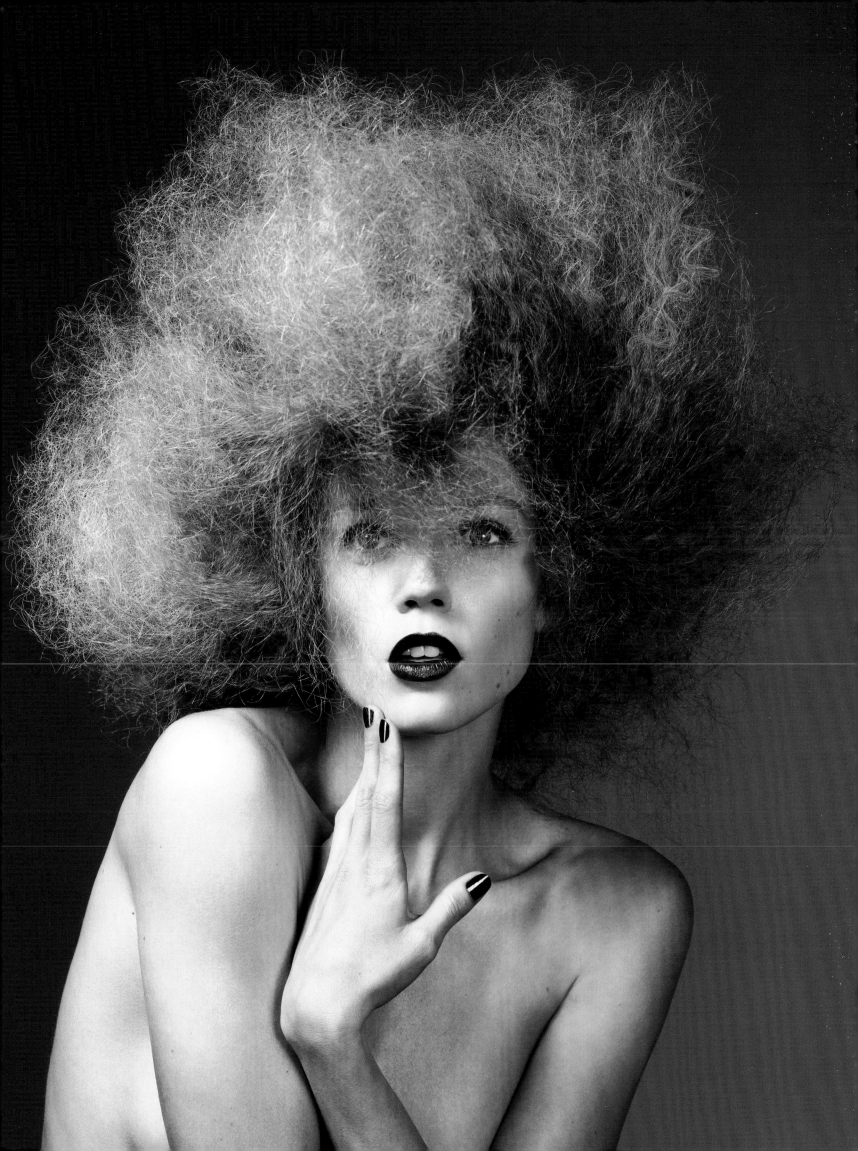

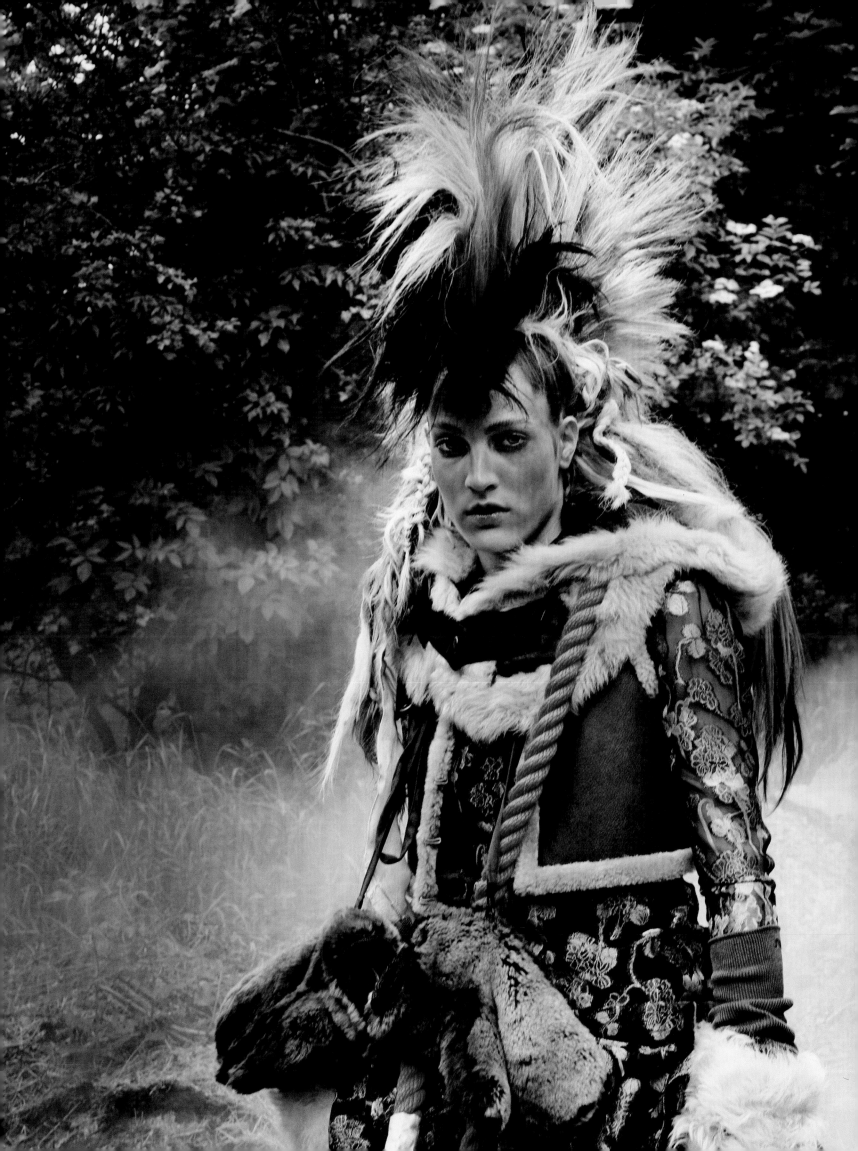

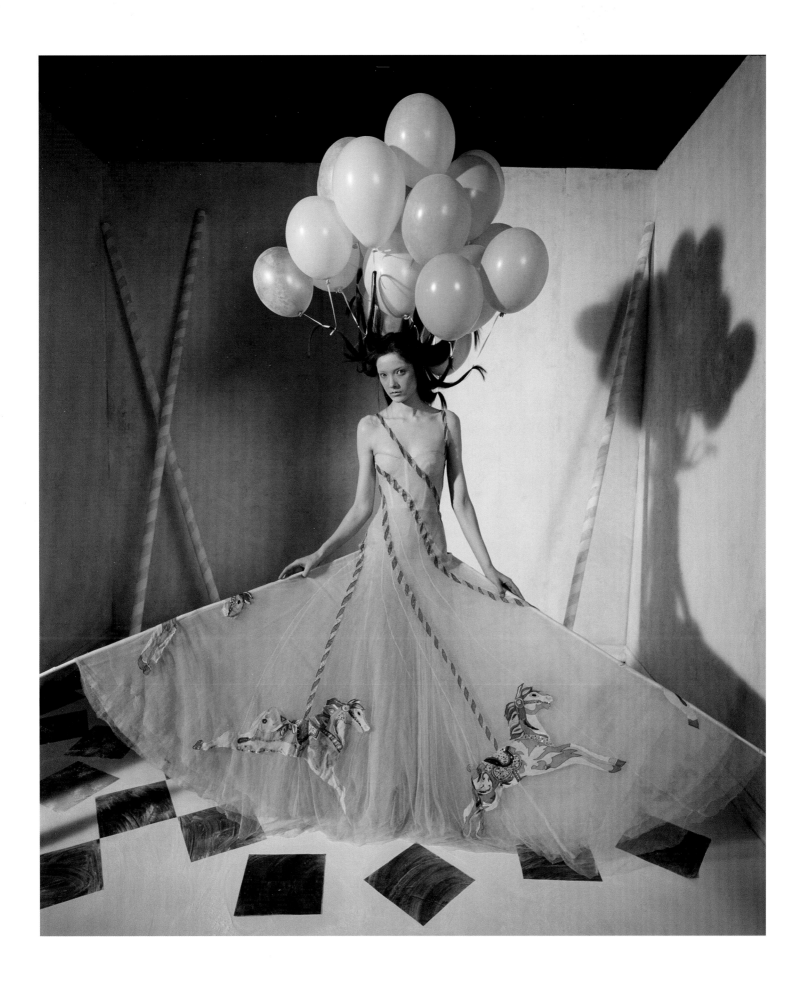

It is always a pleasure to be invited into the fantastical world of Tim Walker, where I get to interpret his stories with wigs, hairpieces, and even twenty balloons in the hair.

Above:

Unpublished photograph of Yumi Lambert by Tim Walker for British *Vogue* to coincide with the *Alexander McQueen: Savage Beauty* exhibition at the V&A in 2015.

Opposite:

Edie Campbell for *LOVE* magazine, Fall/Winter 2014. Photograph by Tim Walker.

Following pages:

Left: Chinese *Vogue*, March 2014. Photograph by Simon Emmett.

Right: Teen *Vogue*, April 2013. Photograph by Scott Trindle.

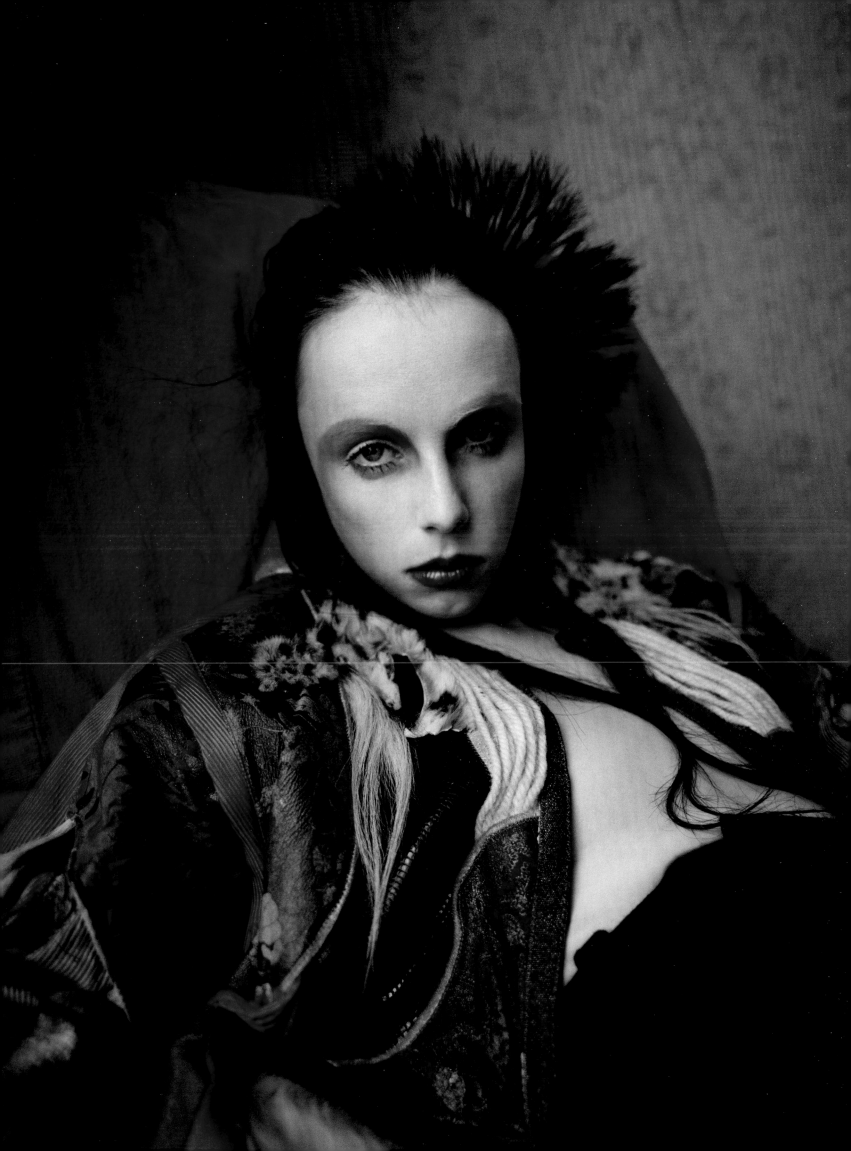

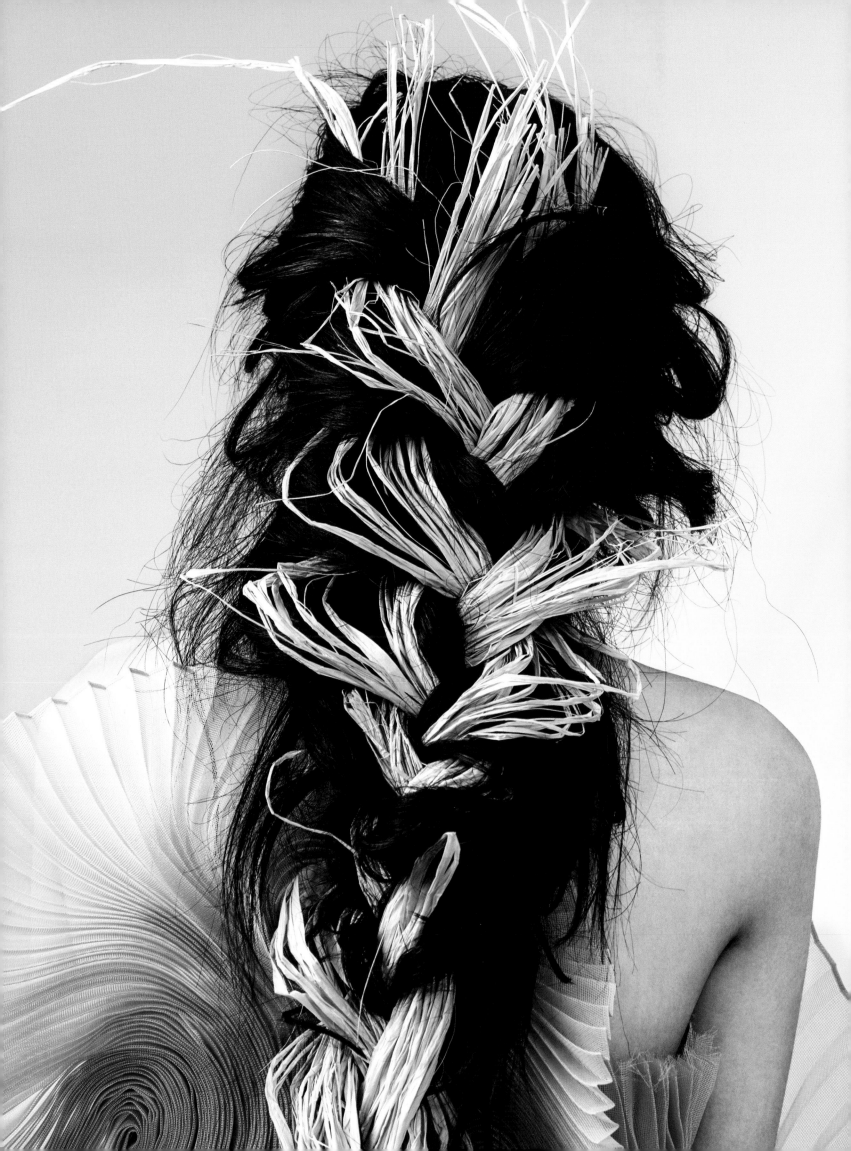

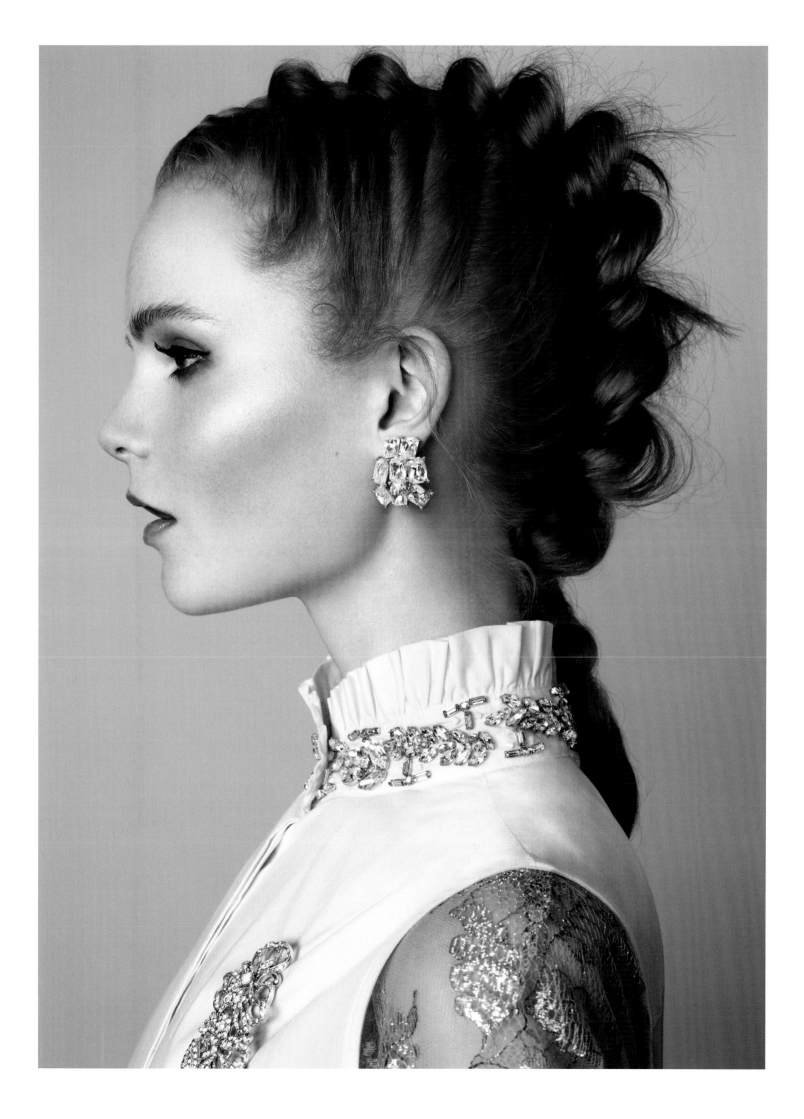

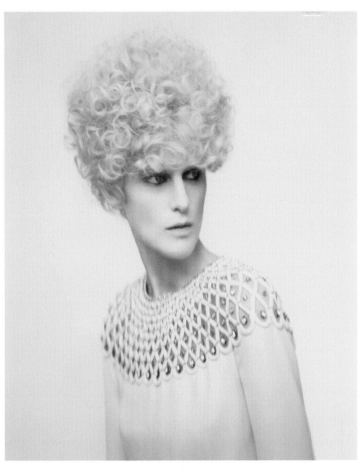

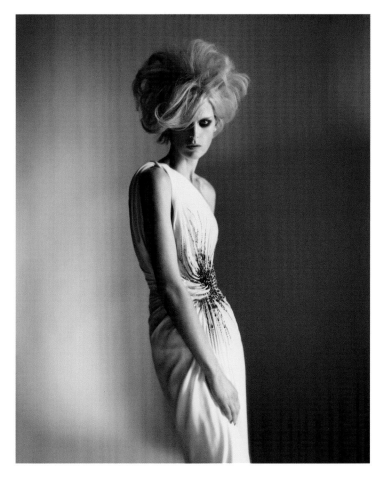

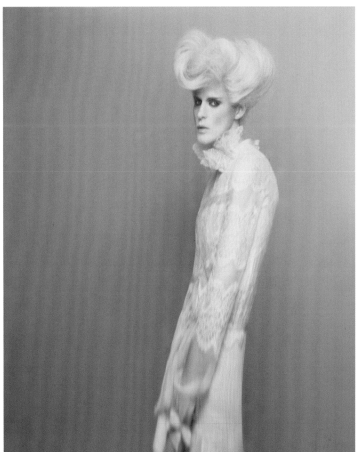

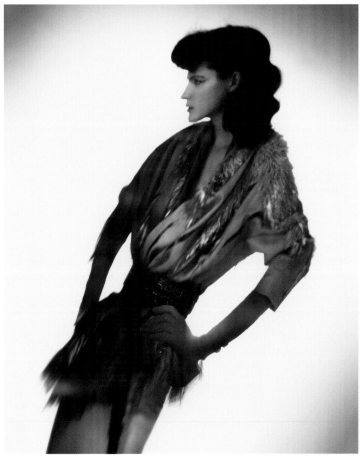

"From pompadours to Pocahontas straight hair, 1960s bobs to luscious curls, hair is a crucial part of the overall character when constructing a fashion image. Sam understands the transformative power of hair and wigs.

The right hairstyle or wig can make or break a fashion image, and Sam intuitively knows what's right for the woman in the picture."
—Edward Enninful

Above and opposite:

A journey of fantasy with Stella Tennant. A custom-made wig for each shot for the couture supplement of Italian *Vogue*, styled by Edward Enninful and makeup by Linda Cantello,

March 2011. Paolo shot everything through a distorted mirror. Stella Tennant for Italian *Vogue*, March 2011. Photographs by Paolo Roversi.

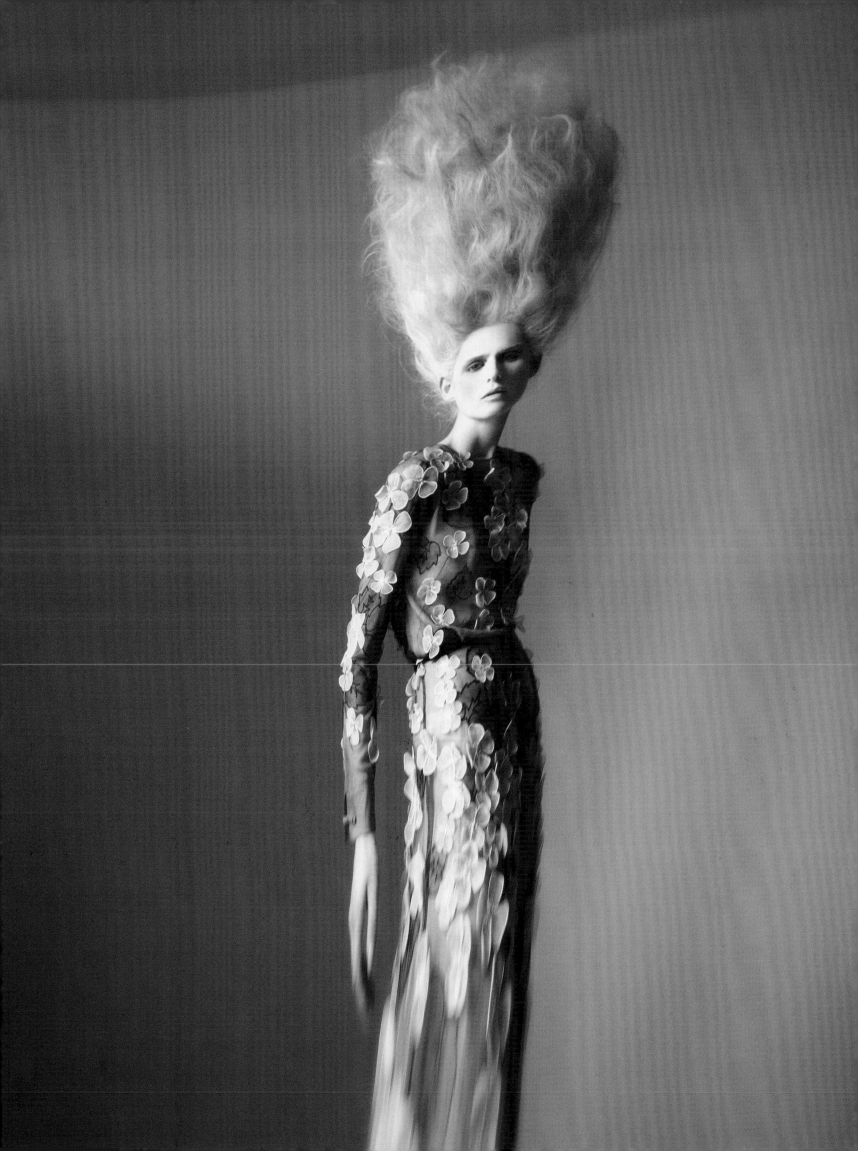

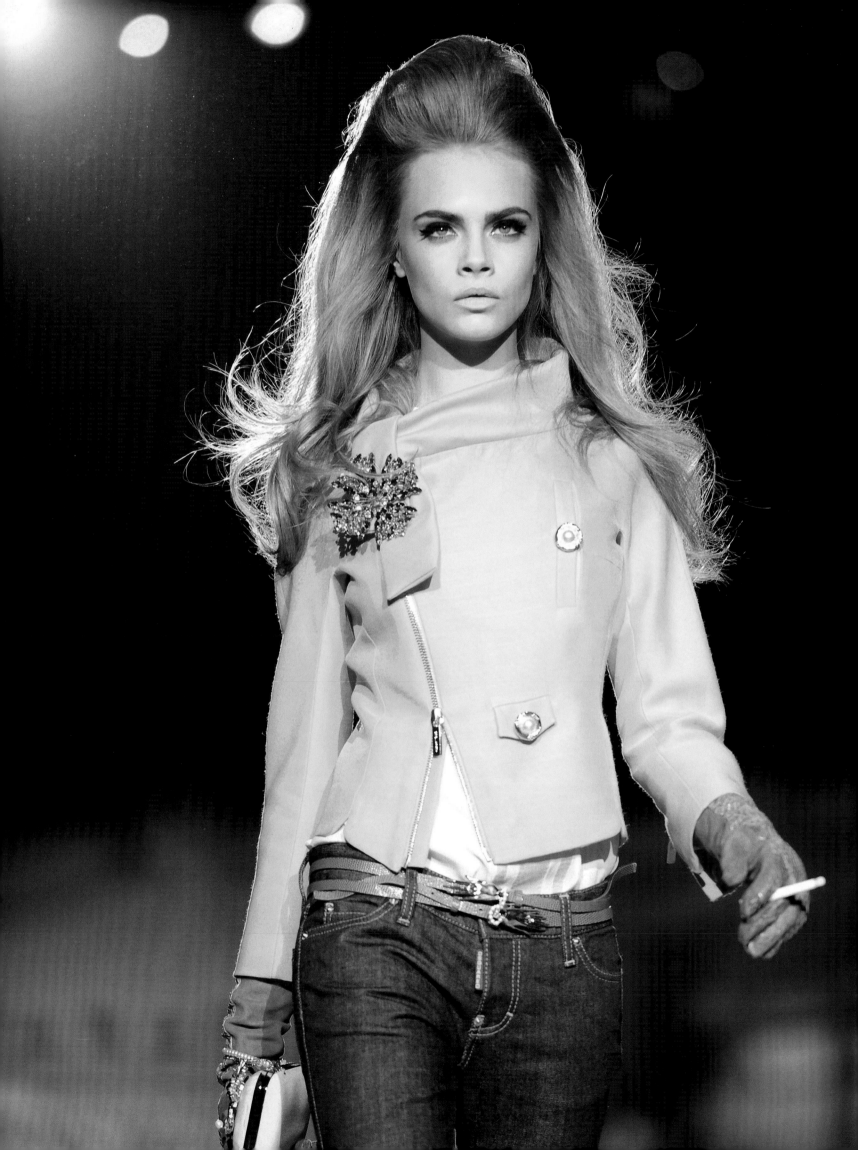

SHOWS

The first rule of show hair: deep breathing. When the designer calls for sixty identical black wigs in the final run-up and you have less than half that number, when a model arrives on her moped from a previous show with hair coiled into tiny braids and you have ten minutes to transform her into an '80s Glamazon, when you've spend the last twenty-four hours dying and cutting those wigs and there are splashes of black splattered across your all-white Milanese suite...

Second, third and fourth rules: preparation, preparation, preparation. "With forty to one hundred girls on the runway, and overlapping schedules, it has to be meticulously planned," says Sam McKnight.

Picture the scene when the models do arrive—and the creative choreography that unfolds around them: the makeup artists, the manicurists, the dressers, the stylists, the hairdressers, and the journalists prowling for instant quotes on next season's (make that this season, NOW) trends.

It's a different world from his first fashion show—in 1978 for the Emanuels. "I think there were four of us in total working on that production, in conditions best described as makeshift."

These days he travels with a core team of twenty assistants that expands for bigger shows. Ideally he likes to have a discussion with the designer three weeks before. "It can be relatively specific—Tom Ford saying he wants an L.A. punk look—or it can be more obscure." Vivienne Westwood might email him a portrait of Marie Antoinette, a Victorian child, and an African vase made from Coca-Cola cans in the expectation he'll pull the strands together in a single, exquisite, front-page holding image. And he does. "The finished results might end up having nothing to do with the original brief. What's helpful is to have a concept you can play with."

Fendi's fauxhicans were the culmination of a riff that began when Karl Lagerfeld, a long-time collaborator with McKnight, said he wanted to incorporate some fur in the models' hair. A plait turned into the world's chicest feral Mohawks woven with mink... that's why it's important for hair and makeup teams to work together and not be in competition. They'll add a black eyebrow and you'll think that would look great if the Mohawk was purple... you build, and sometimes you take away."

But not that often because bold statements work on social media and nowadays, hair is frequently a catalyst for an instant global conversation. When Olivier Rousteing asked McKnight to style Gigi Hadid in a dark wig and Kendall Jenner in a blonde one, the images were bouncing across social media before the show was over.

Punks, princesses, pagans—Sam has created runway versions of them all, and always found a way to make them look beautiful. Nor is he fazed by today's pace. "Years ago shows were for press and buyers only. Now they're instant entertainment. Our work has become much more accessible." He likes that, too. As much as he loves an historical allusion, relishes research, and understands the cultural complexities of hair, he's just as happy creating simple, mussed up bed-head that any woman can copy—if she has forty years experience and magic hands. In McKnight's world, simple is never that simple.

— *Lisa Armstrong*

01

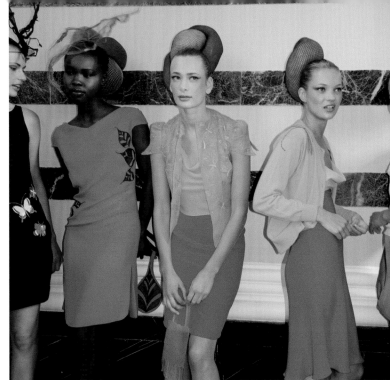

02

05

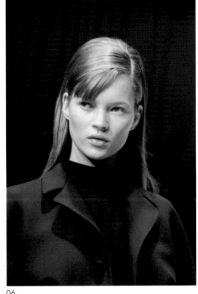

06

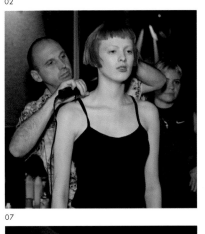

07

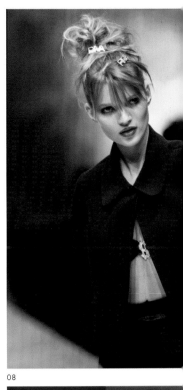

08

12

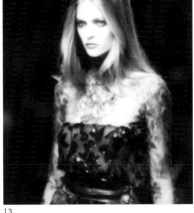

13

14

15

Previous spread:

Cara Delevingne at
Dsquared2 Fall 2012.

On this page:

01 Backstage with Stella
McCartney for her debut
collection at Chloé
Spring/Summer 1998.

02 Matthew Williamson's
London Fashion
Week debut, Spring/
Summer 1998.

03 Backstage with
Paul Smith, 1998.

04 With Naomi Campbell
and Mary Greenwell,
1998.

05 John Rocha Spring/
Summer 1997.

06 Kate Moss, Prada
Autumn/Winter 1995/96.

07 Karen Elson, Sportmax
Spring/Summer 1998.

08 Kate Moss, Blumarine
Autmn/Winter 1995/96.

03

04

09

10

11

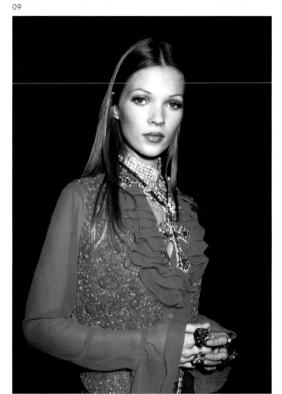

16

17

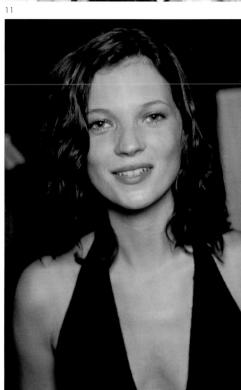

18

09 Betsey Johnson
 Autumn/Winter 1997/98.

10 John Rocha
 Spring/Summer 1997.

11 Ellen Tracey
 Autumn/Winter 1996/97.

12 Jodie Kidd at Valentino
 Autumn/Winter 1997/98.

13 Valentino
 Autumn/Winter 1997/98.

14 Backstage with Stella
 Tennant at Ferragamo
 Autumn/Winter 1995/96.

15 Devon Aoki
 backstage 1998.

16 Kate Moss, Blumarine
 Spring/Summer 1992.

17 Backstage with Helena
 Christensen, 1995.

18 Kate Moss, Blumarine
 Autumn/Winter 1995/96.

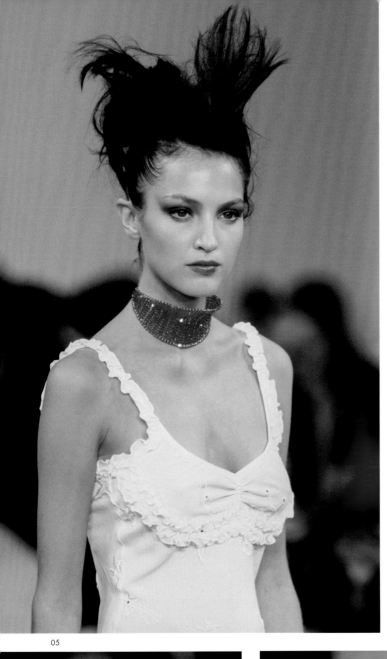

01

02

03

06

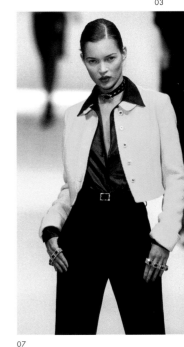

07

05

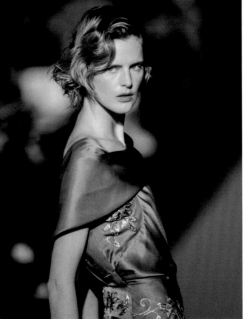

11

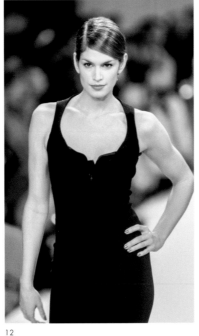

12

13

14

01 Ghost
Spring/Summer 1997.

02 Miu Miu
Fall/Winter 1995/96.

03 With Honor Fraser
at Ellen Tracey
Spring/Summer 1997.

04 Blumarine
Spring/Summer 1997.

05 Ghost
Spring/Summer 1996.

06 Antonio Berardi
Spring/Summer 1997.

07 Kate Moss, Blumarine
Spring/Summer 1995.

08 Amber Valetta Chloe
Spring/Summer 1998.

09 Backstage with
Naomi Campbell, 1995.

10 Kate Moss, Chloé Spring/
Summer 1998.

144

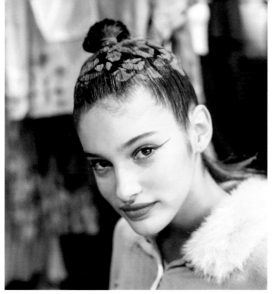

04

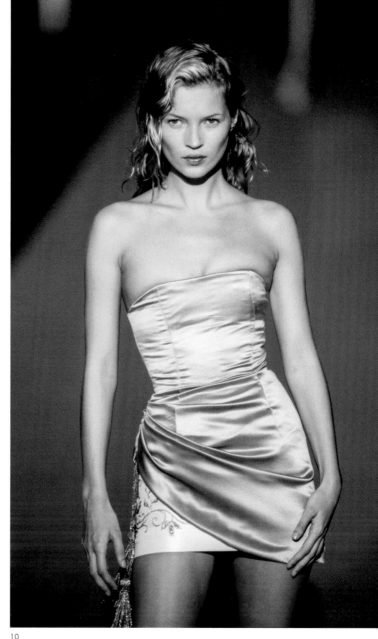

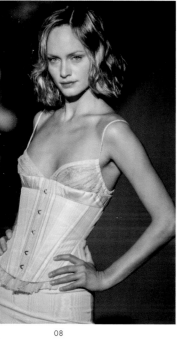

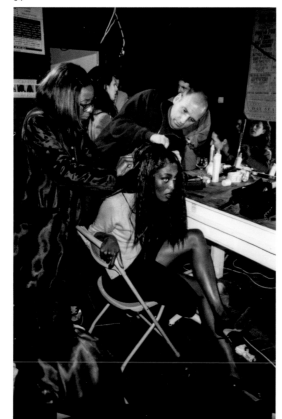

08

09

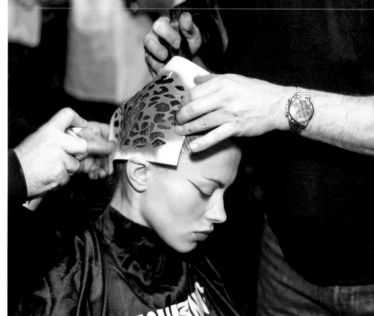

10

15

16

11 Stella Tennant, Chloé
 Spring/Summer 1998.

12 Cindy Crawford
 at Richard Tyler
 Spring/Summer 1995.

13 With Jodie Kidd
 at Valentino
 Autumn/Winter 1997/98.

14 Honor Fraser
 at Ellen Tracey
 Spring/Summer 1997.

15 Backstage with Kristen
 McMenamy 1997.

16 Blumarine
 Spring/Summer 1997.

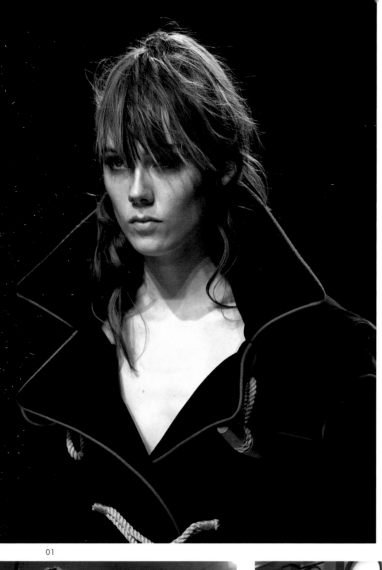

01

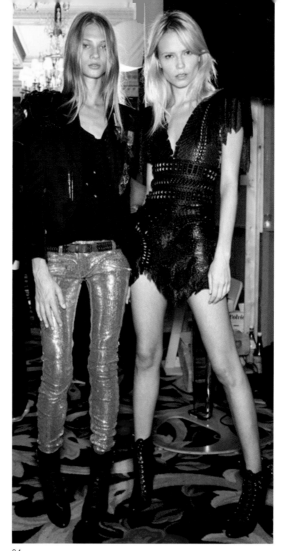

04

02

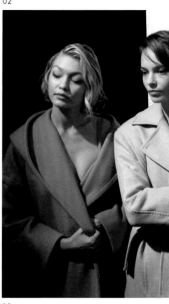

05

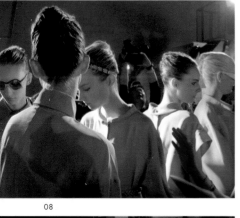

12

08

09

13

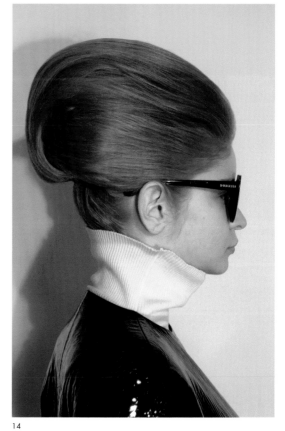

14

01 Kiki Willems for
Burberry Autumn/
Winter 2016.

02 Balmain 2015.

03 Paul Smith
Autumn/Winter 2015.

04 Balmain
Autumn/Winter 2012.

05 Maxmara
Autumn/Winter 2015.

06 Dries Van Noten
Spring/Summer 2016.

07 Valentino Couture 2007.

08 Fendi
Spring/Summer 2012.

09 Hair swap with Gigi
Hadid and Kendall
Jenner at Balmain
Autumn/Winter 2016.

10 Balmain
Spring/Summer 2015.

11 Fendi
Spring/Summer 2012.

03

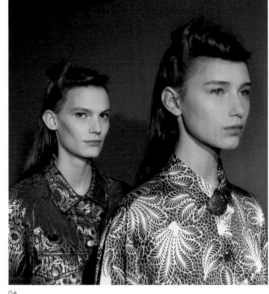

06

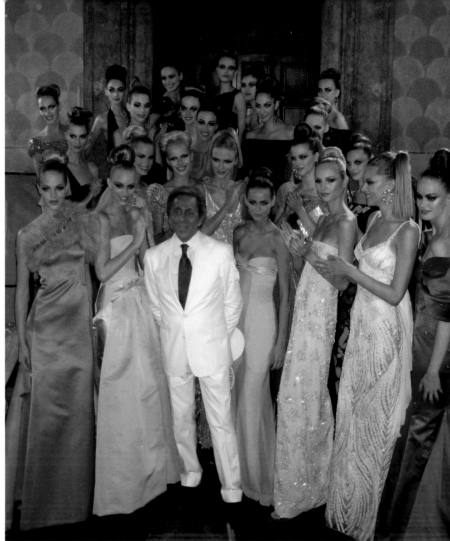

07

15

10

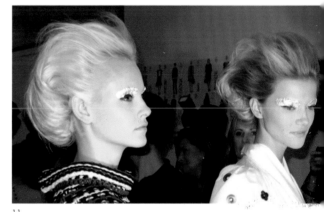

11

16

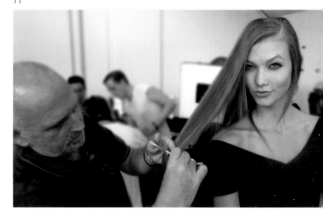

17

12 L'Wren Scott
Autumn/Winter 2013.

13 Tom Ford
Spring/Summer 2015.

14 Mugler hair test, 2012.

15 Valentino Couture 2007

16 Iceberg
Spring/Summer 2013.

17 With Karlie Kloss
at Fendi Spring/
Summer 2010.

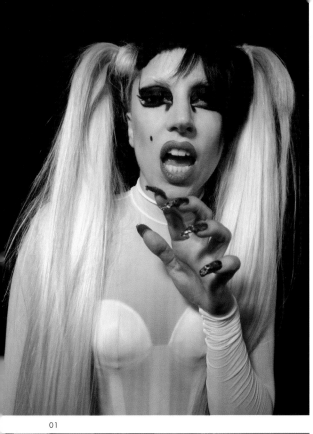

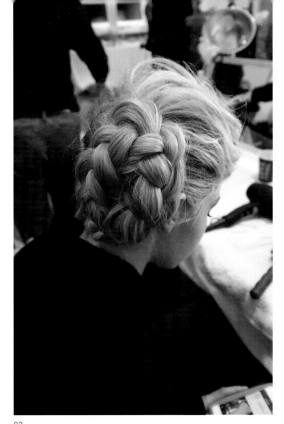

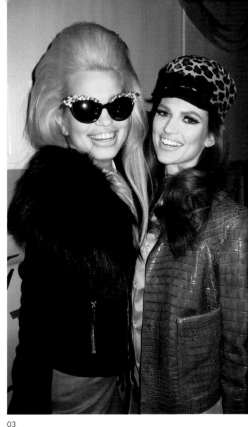

01

02

03

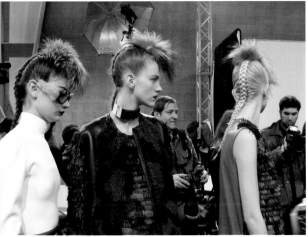

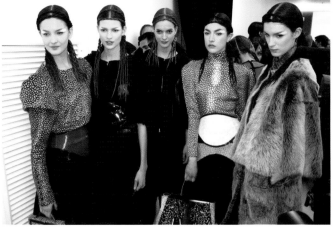

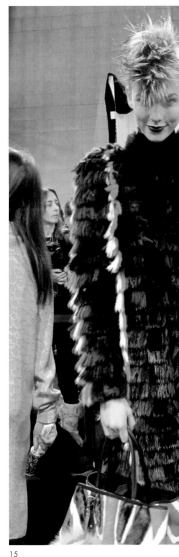

08

09

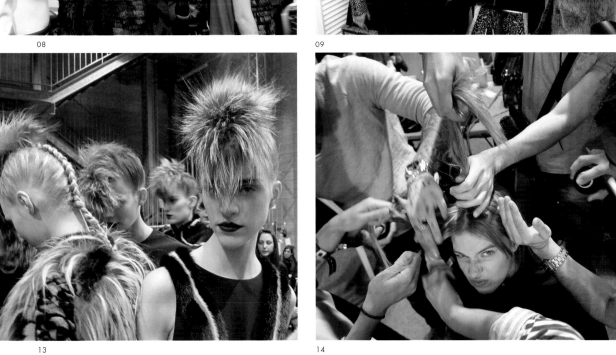

13

14

15

01 Lady Gaga for Mugler
Autumn/Winter 2011.

02 Tom Ford
Autumn/Winter 2015.

03 Dsquared2
Autumn/Winter 2012.

04 Lady Gaga for Mugler
Autumn/Winter 2011.

05 Fendi
Autumn/Winter 2012.

06 Dsquared2
Spring/Summer 2016.

07 Fendi
Spring/Summer 2014.

08 Furhawks for Fendi
Autumn/Winter 2013.

09 Fendi
Autumn/Winter 2012.

10 Balmain hair test, 2009.

04

05

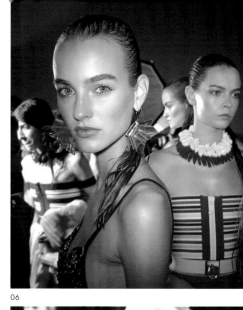

06

07

10

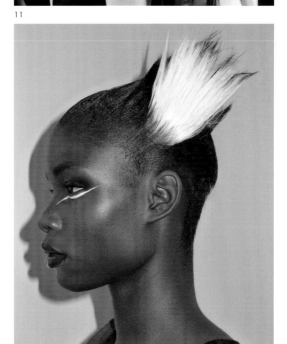

11

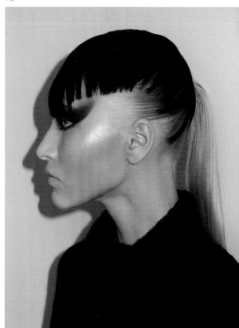

12

16

17

18

11 Mugler
Autumn/Winter 2011.

12 Sam Rollinson
backstage, 2015.

13 Fendi
Autumn/Winter 2013.

14 Isabel Marant
Spring/Summer 2016.

15 Karlie Kloss for Fendi
Autumn/Winter 2013.

16 Mugler
Autumn/Winter 2011.

17 Mugler
Autumn/Winter 2011.

18 Mugler
Autumn/Winter 2011.

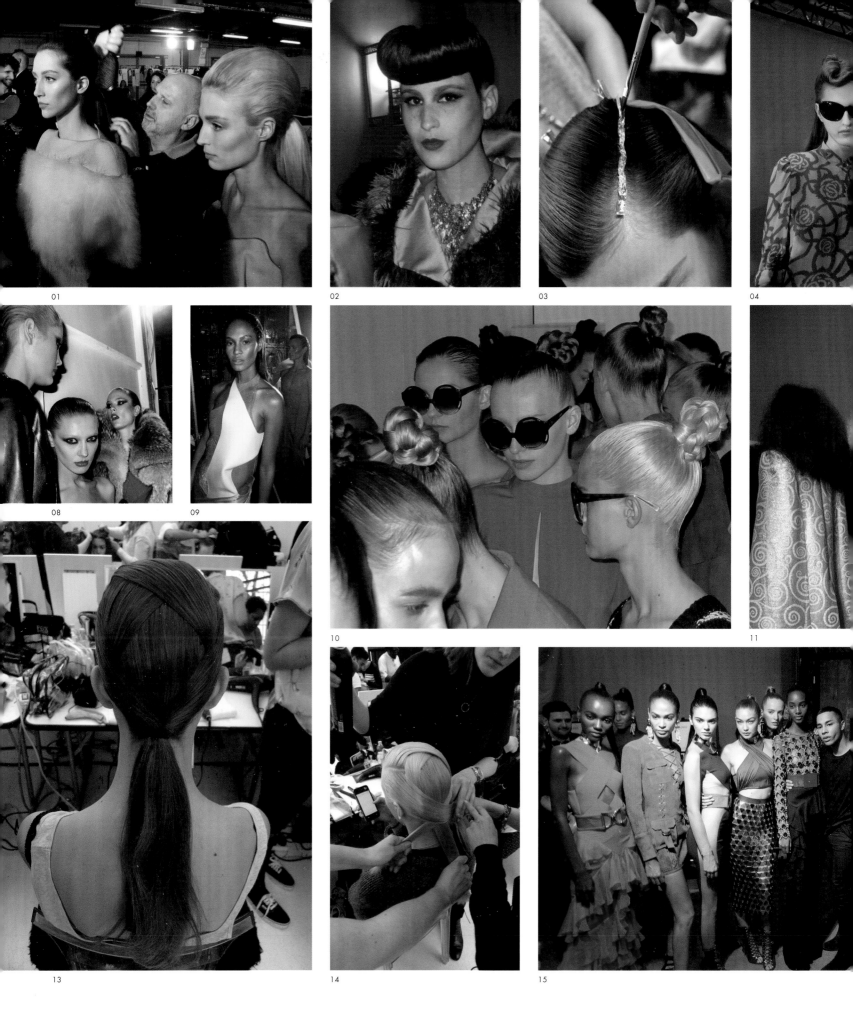

01 Mugler
 Autumn/Winter 2013.

02 Graeme Black
 Autumn/Winter 2009.

03 Gold leaf partings
 for Dries Van Noten
 Spring/Summer 2014.

04 Dries Van Noten
 Spring/Summer 2016.

05 Georgia May Jagger for
 Fendi Fall/Winter 2014.

06 Lindsey Wixson
 Balmain Spring/
 Summer 2015

07 Fendi Fall/Winter 2015.

08 Dsquared2 Autumn/
 Winter 2009.

09 Joan Smalls for Mugler
 Spring/Summer 2012.

10 Jaeger Spring/
 Summer 2010.

150

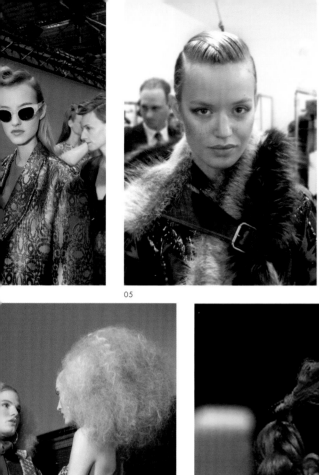

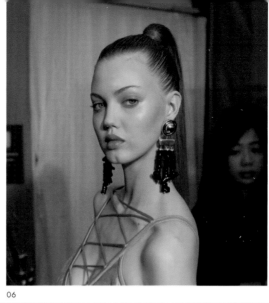

05

06

07

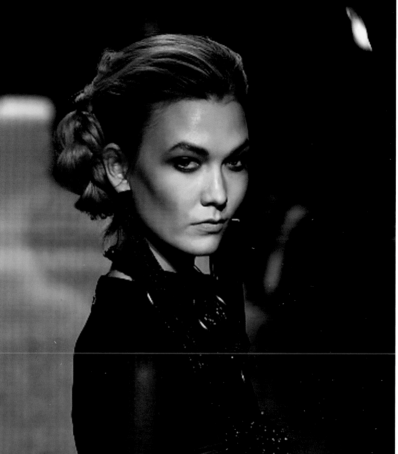

12

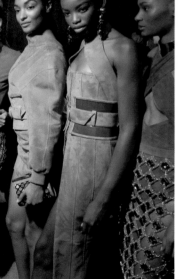

16

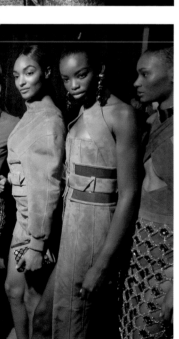

17

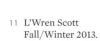

11 L'Wren Scott
 Fall/Winter 2013.

12 Dries Van Noten
 Spring/Summer 2014.

13 Fendi Autumn/
 Winter 2014.

14 Fendi Autumn/
 Winter 2014.

15 Olivier Rousteing
 and models backstage
 at Balmain, 2015.

16 Karlie Kloss
 for Tom Ford Autumn/
 Winter 2015.

17 Jamie Bochert
 for Dries Van Noten
 Fall/Winter 2015.

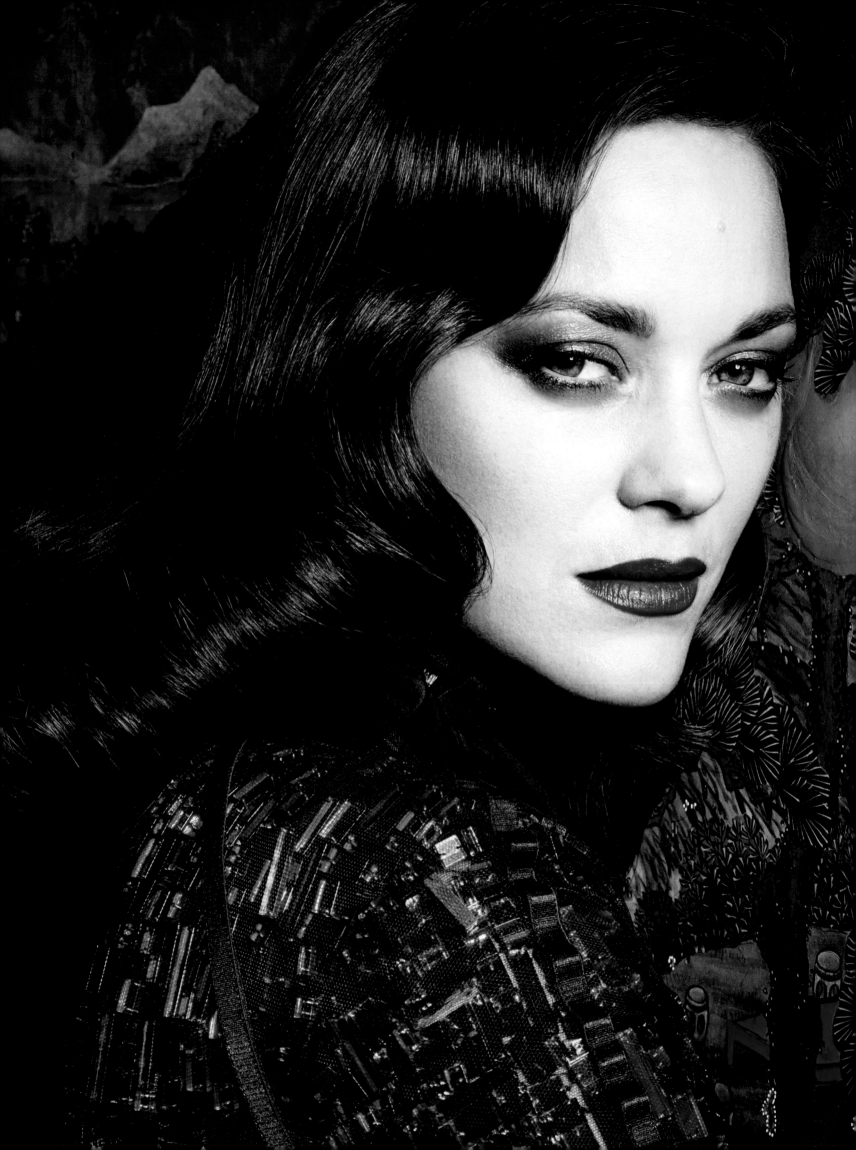

MODERN RETRO

A twist on a classic. A reinvention. Making the old new again. This is what it means to be a creative—taking references from the past and calling upon them to inspire work in the present. As image-makers, we will often purposely reference what has come before to create something new. This can be the singular decision of the photographer on the day of a shoot or a device I use as a hairstylist purely to craft something that we recognize, but in a new context. We live in a world where a sense of history guides us forward into what is new and, thanks to the visual medium of photography and film, we have a clear idea of what came before and can celebrate it now in a very modern way.

Think Veronica Lake with a twist; Rita Hayworth as a blonde; Brigitte Bardot, but brunette; a distressed version of Marilyn Monroe... The possibilities are endless. These simple, or even intricate, reinventions can transform the girls into characters from another time and place. The photographs in this chapter exemplify the hairstyles that have been invented throughout our time, and modernized for a new generation. Take this image of Marion Cotillard (opposite) for *Interview* magazine— it was inspired by a David Bailey picture of Marie Helvin from the '70s, which, one presumes, had in turn been inspired by the 1940s. It was a celebration of the past. The image feels powerful, fresh, and relevant.

In the same way fashion is cyclical, so is beauty. It is an ever-developing arena where new icons are being created and becoming part of our cultural tapestry to be later referenced and reinterpreted by the next generation of creatives. What will be the hairstyles of the future? No one can say for sure, but what we can say is that they will be inspired by the beauty we see today.

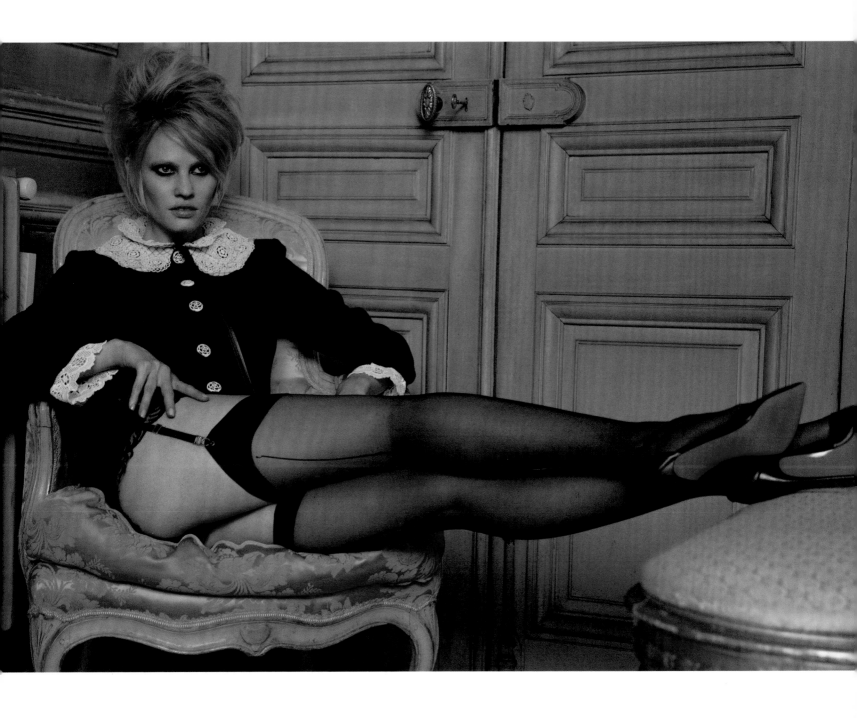

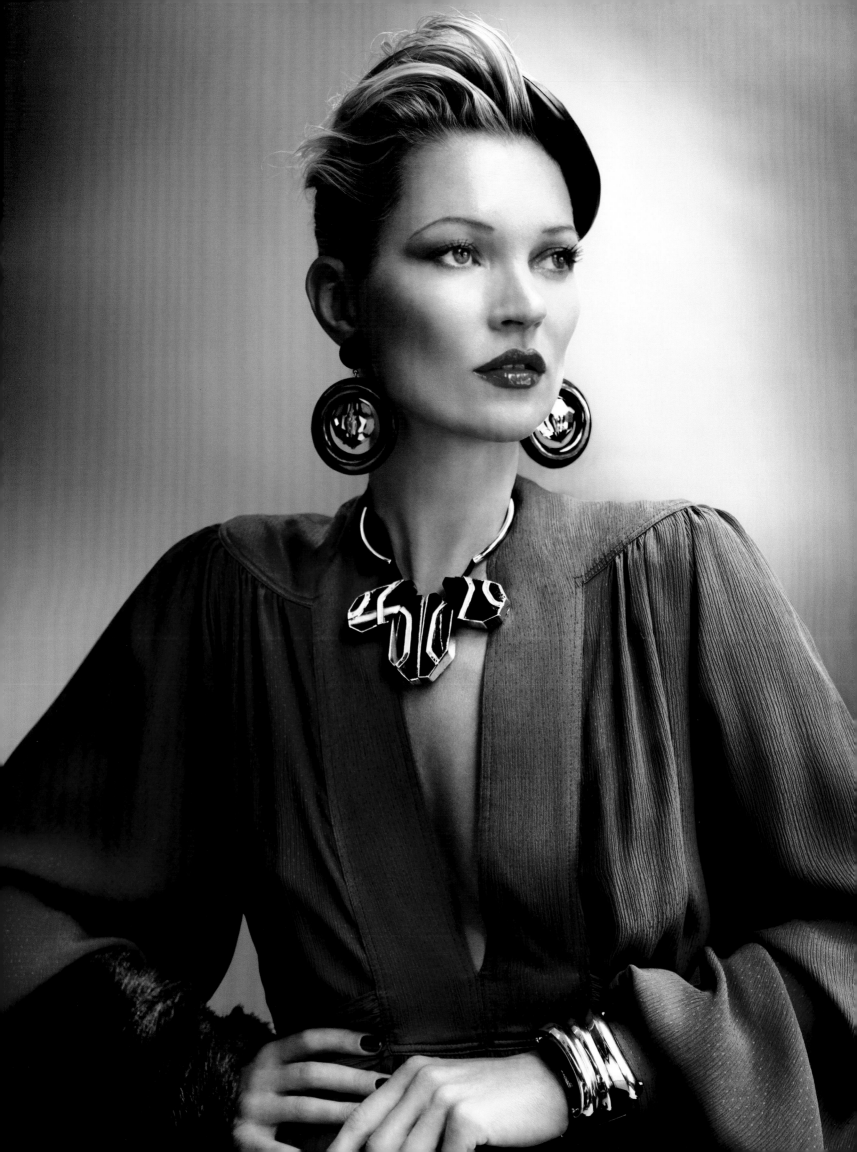

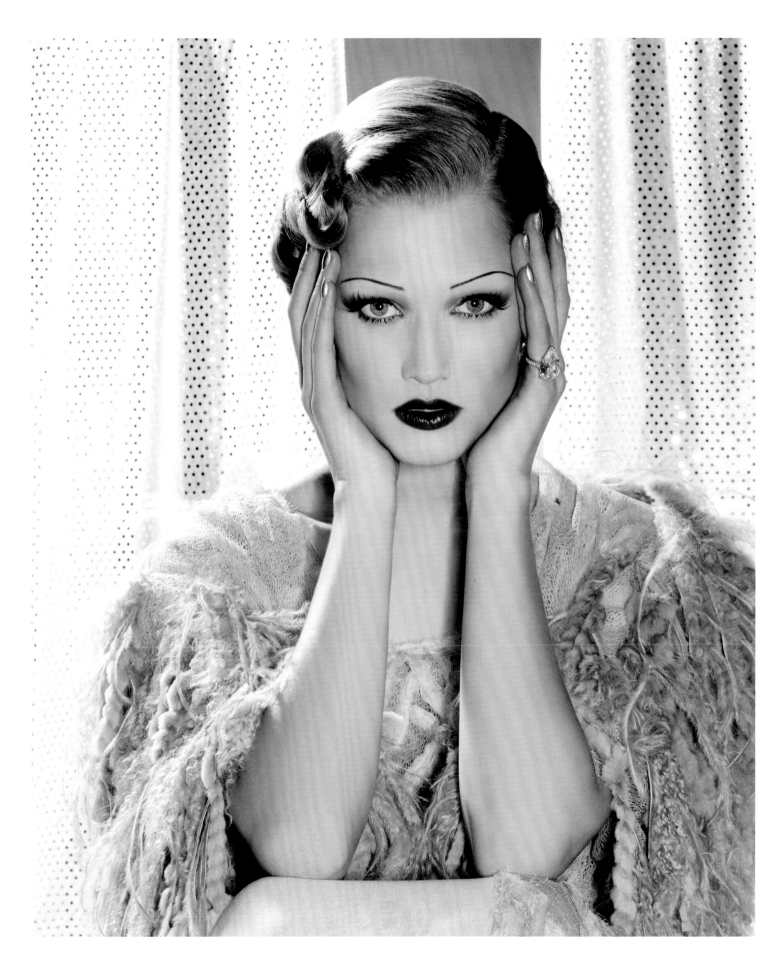

Opposite:

Mario wanted to shoot Kate in a classic retro style with this 1950s updo. British *Vogue*, August 2011. Photograph by Mario Testino.

Above:

Karl Lagerfeld was inspired by the actress Brigitte Helm in Fritz Lang's 1927 silent film, *Metropolis*, for this photo of Toni Garrn. German *Vogue*, February 2010. Photograph by Karl Lagerfeld.

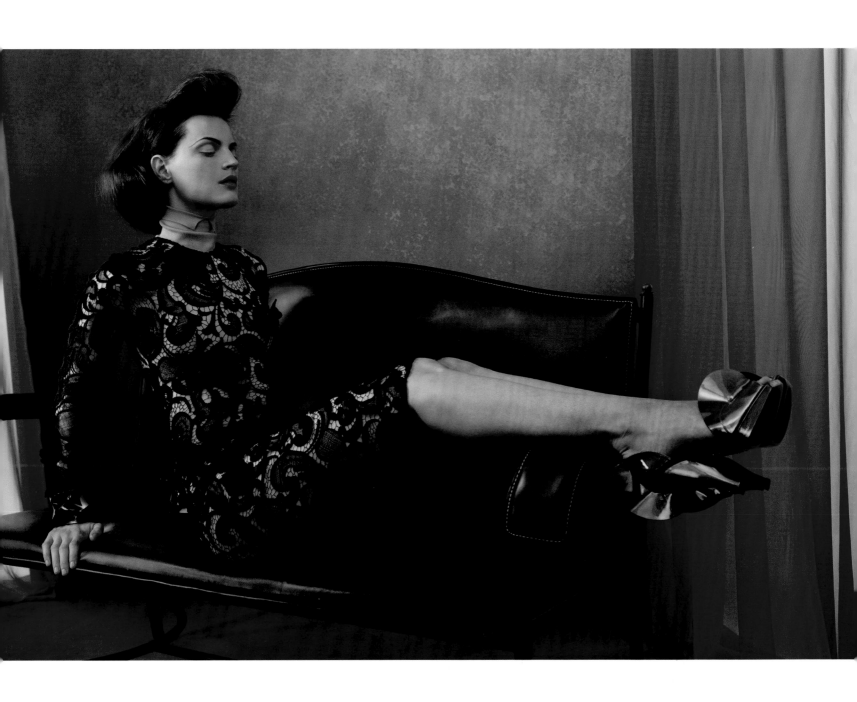

Above:

Guinevere Van Seenus, British *Vogue*,
September 2008. Photograph
by Javier Vallhonrat.

Opposite:

Karen Elson, British *Vogue*, September
2008. Photograph by Nick Knight.

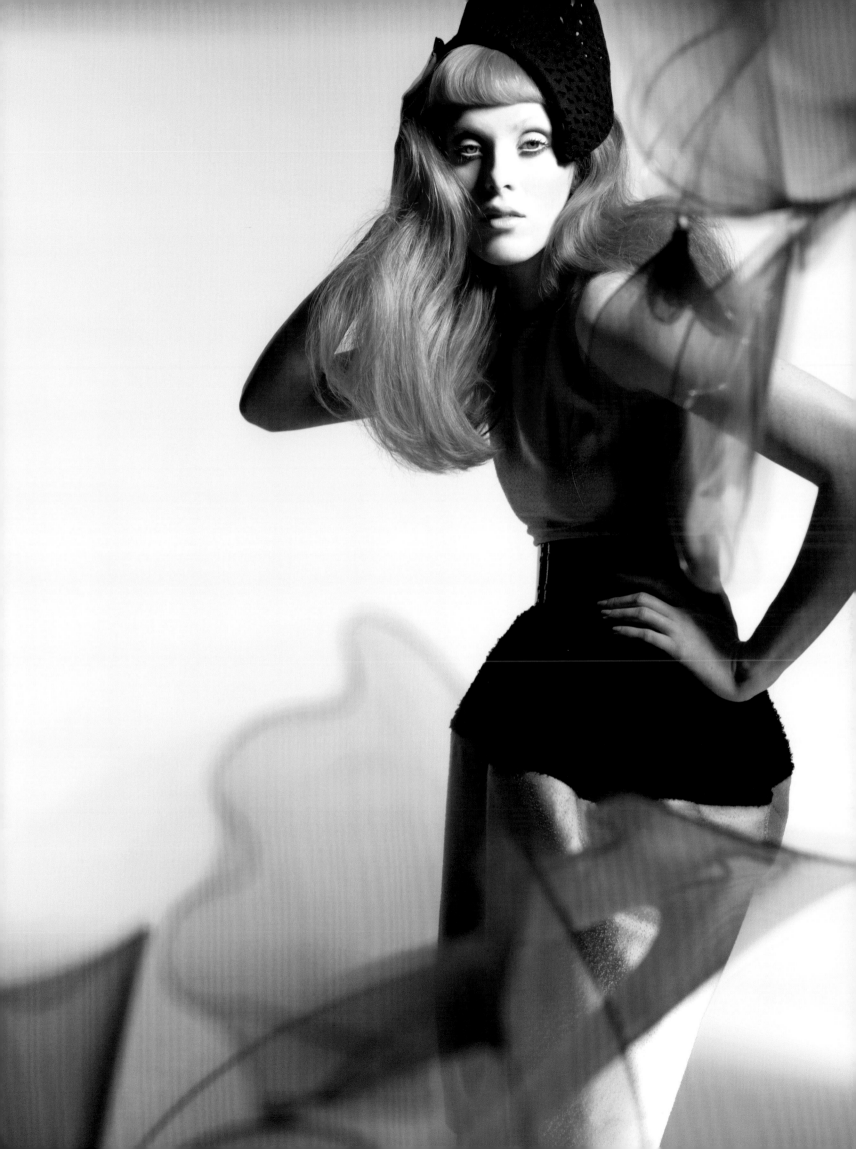

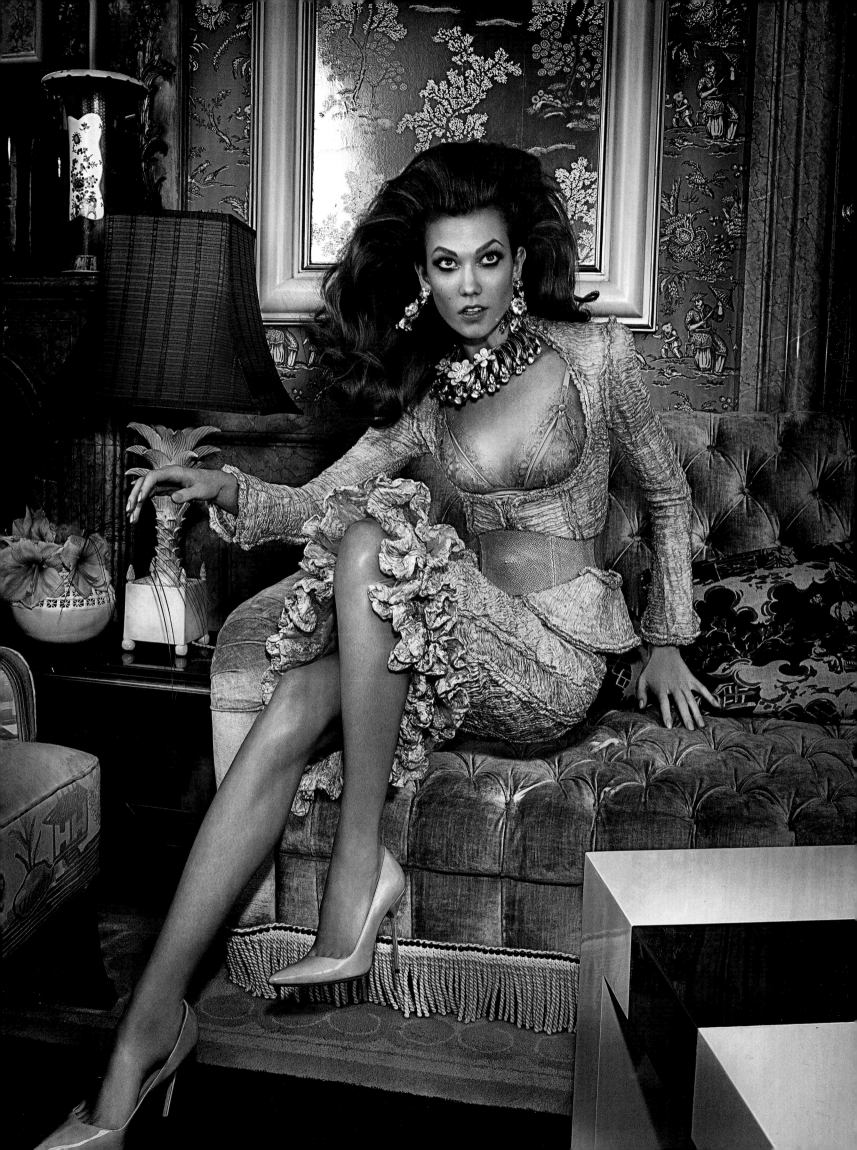

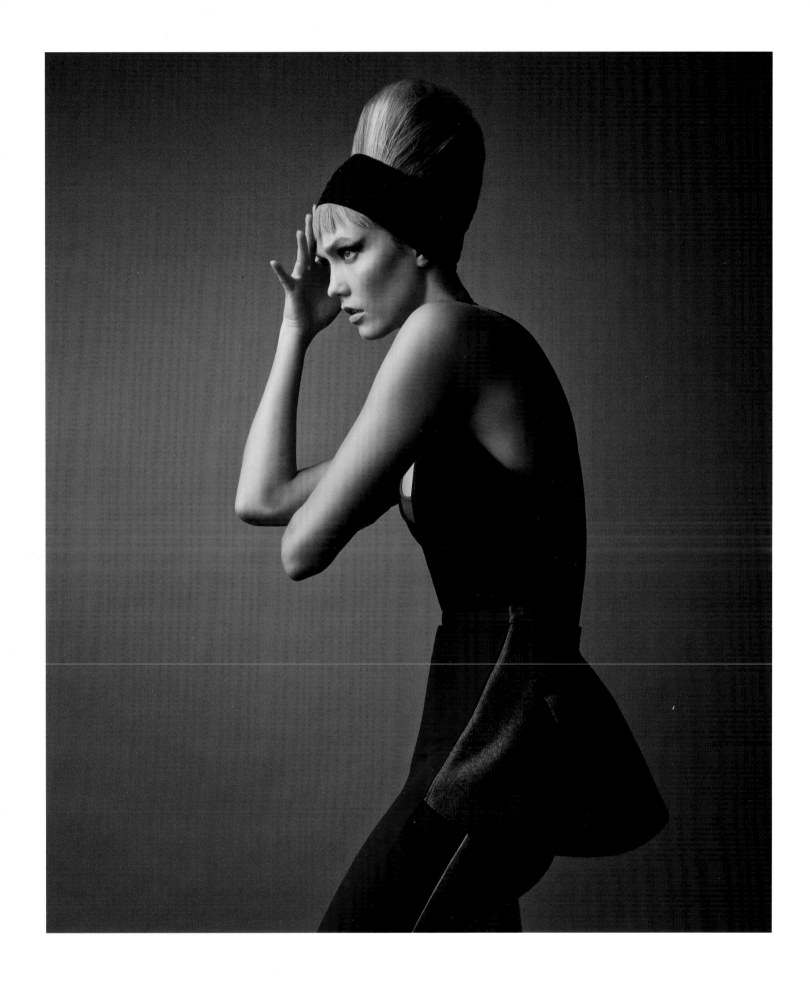

"Often when I overload with colour, pattern, and texture, as in Madrid with Karlie, Sam will calm it down, simplify and dignify. He once said I had kitchen-sink styling... he's not wrong... only Sam can say that without upsetting me... it made me laugh. What I really appreciate and love about working with Sam is that he takes everything on board, your thoughts and the process, he never dominates with ego, it is about team, and no one is more team-spirited than Sam."
—Lucinda Chambers

Opposite:
All-American luxury with Karlie Kloss. Mario shot her leaping through the air for two days. British *Vogue*, March 2012. Photograph by Mario Testino.

Above:
Karlie Kloss for British *Vogue*, November 2015. Photograph by Patrick Demarchelier.

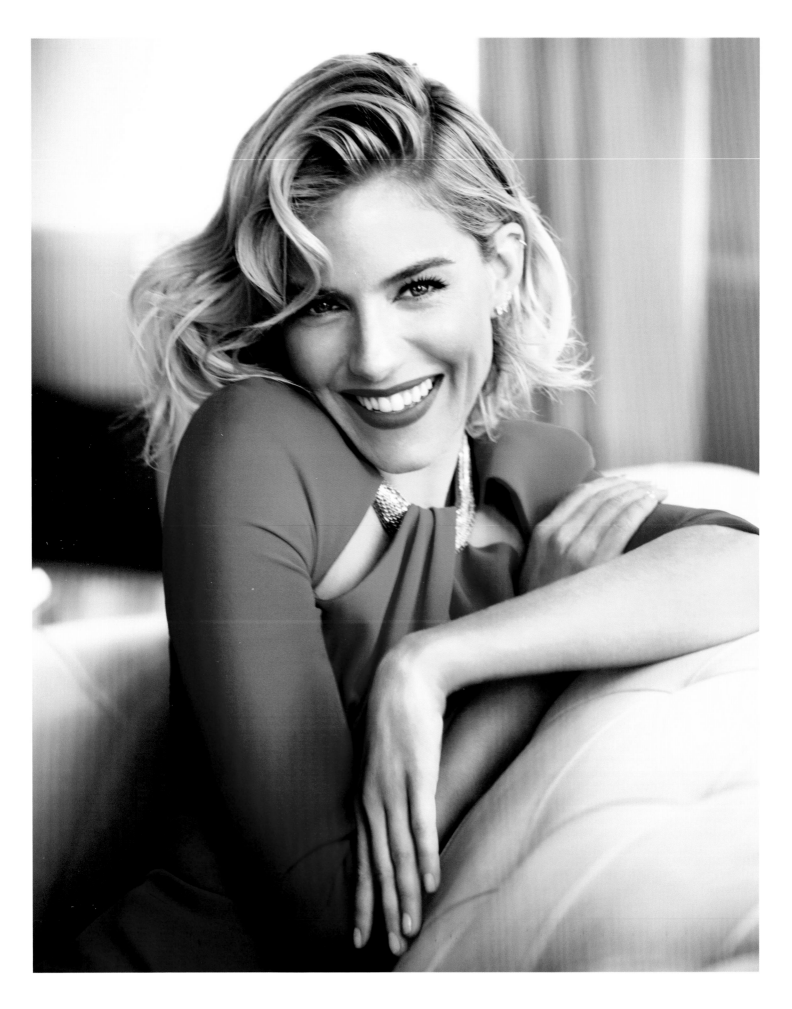

Above:

My signature modern glamour for Sienna Miller. British *Vogue*, October 2015. Photograph by Mario Testino.

Opposite:

A 1960s-inspired Alicia Vikander, *W* magazine, April 2015. Photograph by Willy Vanderperre.

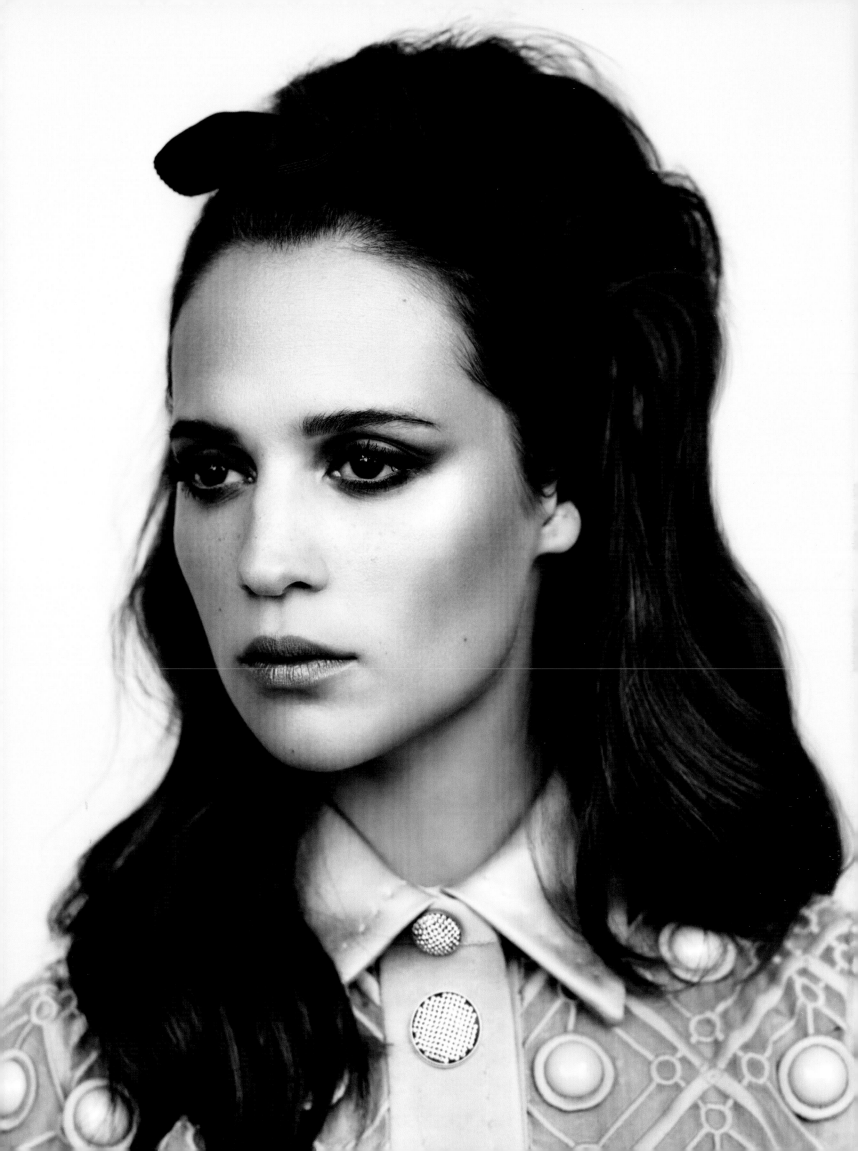

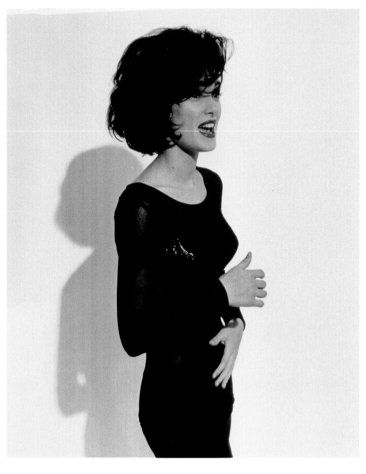

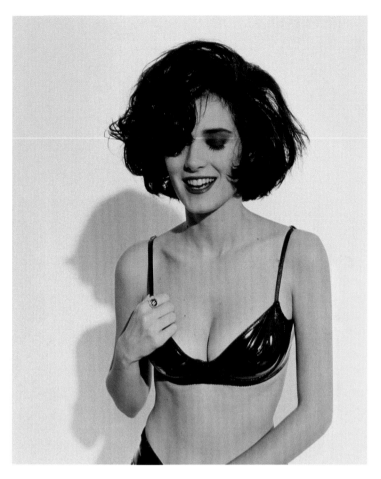

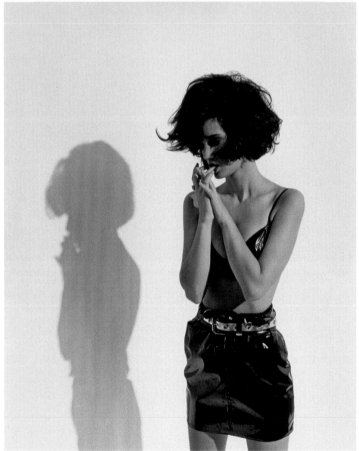

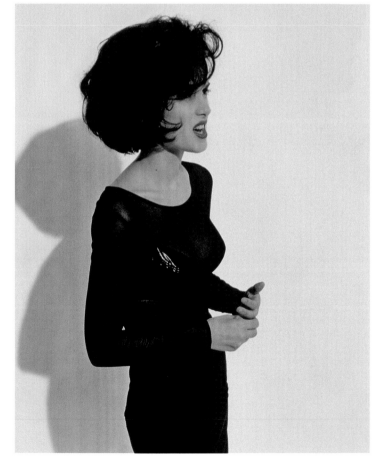

Above:

Winona Ryder does sexy 1960s for *Interview* magazine, December 1990. Photographs by Michel Haddi.

Opposite:

A Bruce Weber story with Stella Tennant shot at her ancestral home, Chatsworth. Italian *Vogue*, October 1995. Photograph by Bruce Weber.

164

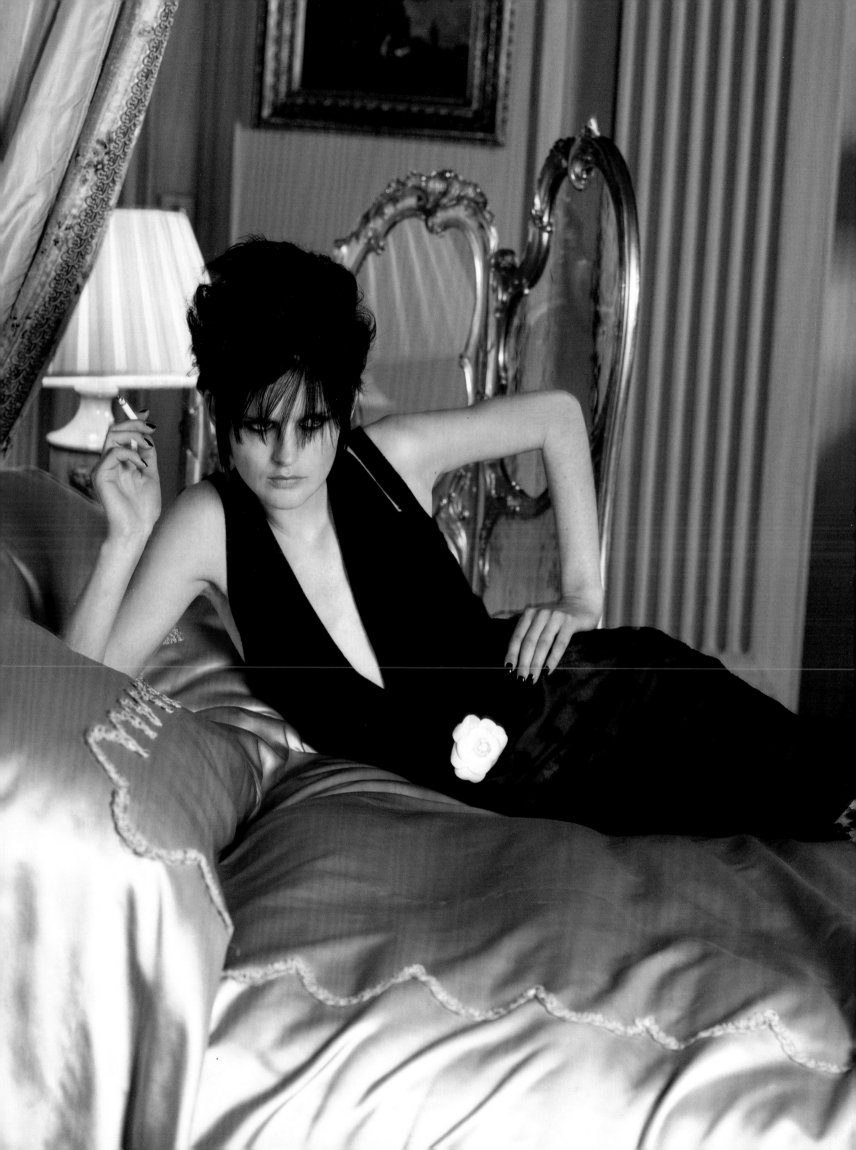

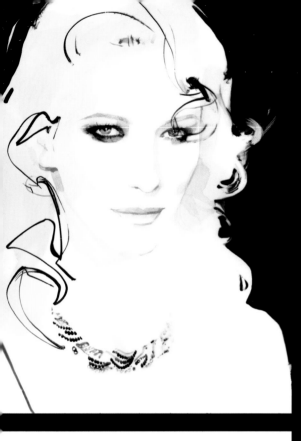

It is always a pleasure to work with
Cate Blanchett. She's an unequalled
beauty with an incredible sense
of style, and great fun, too.

Above: Australian *Vogue*, September
2009. Illustrations by David Downton.

Right: American *Vogue*, January 2014.
Photograph by Craig McDean.

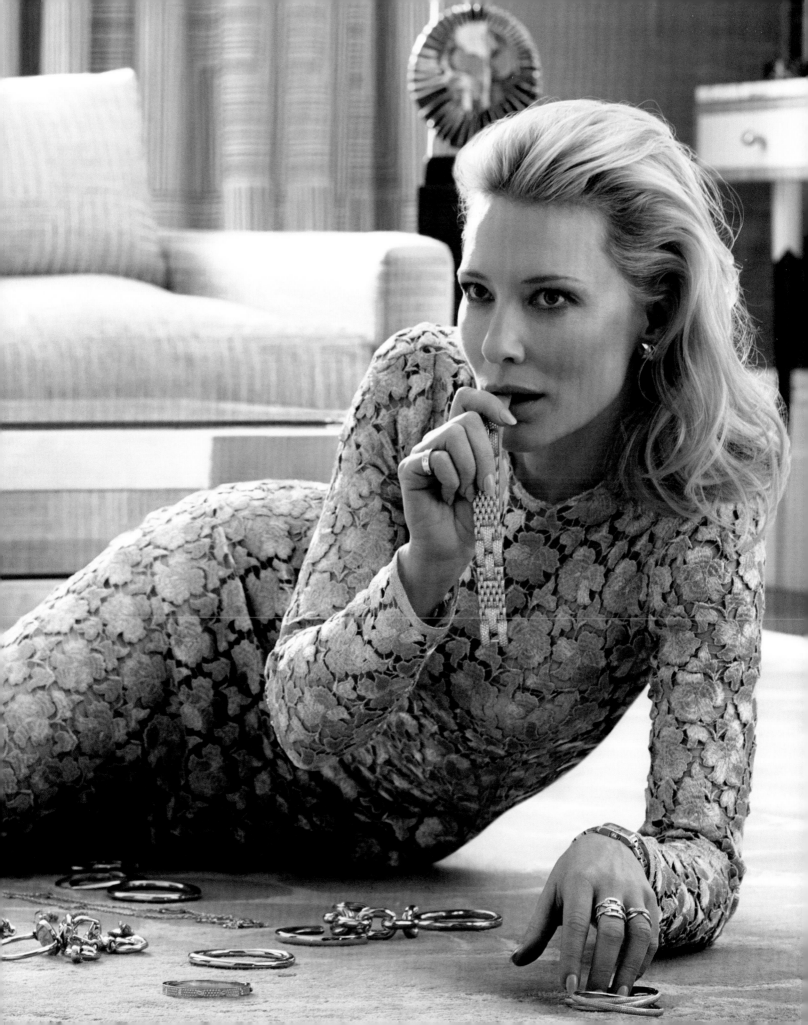

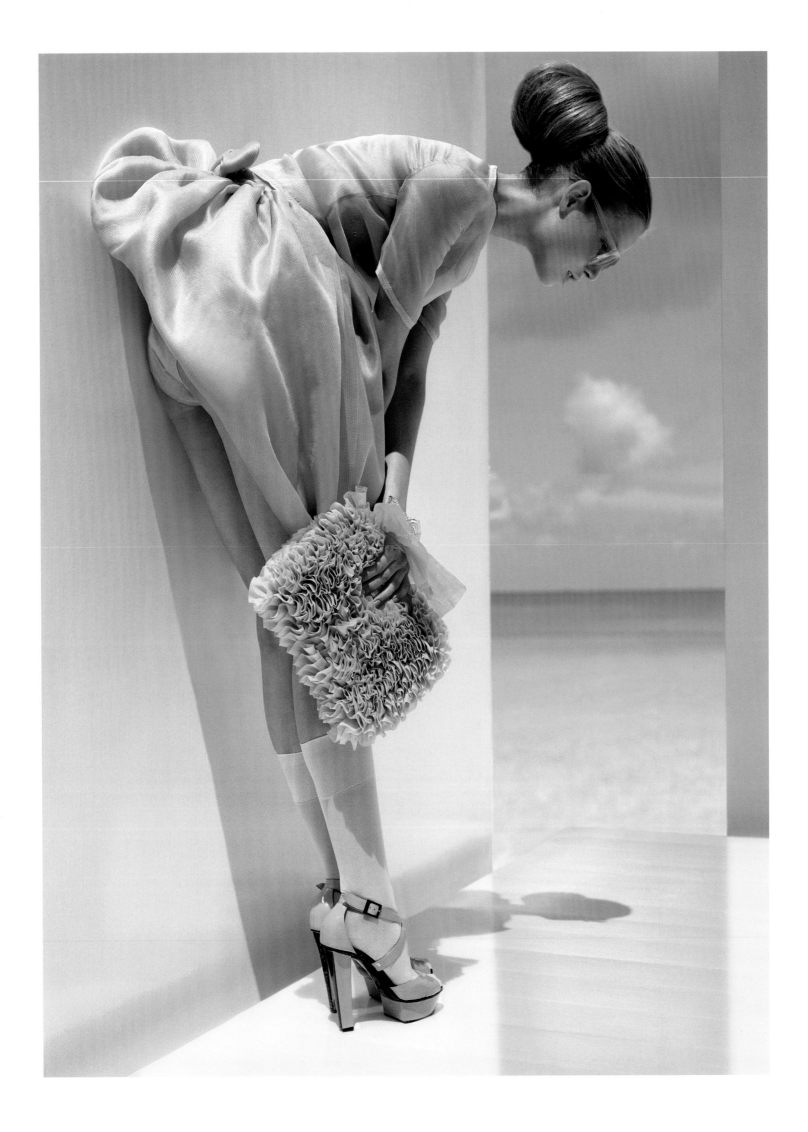

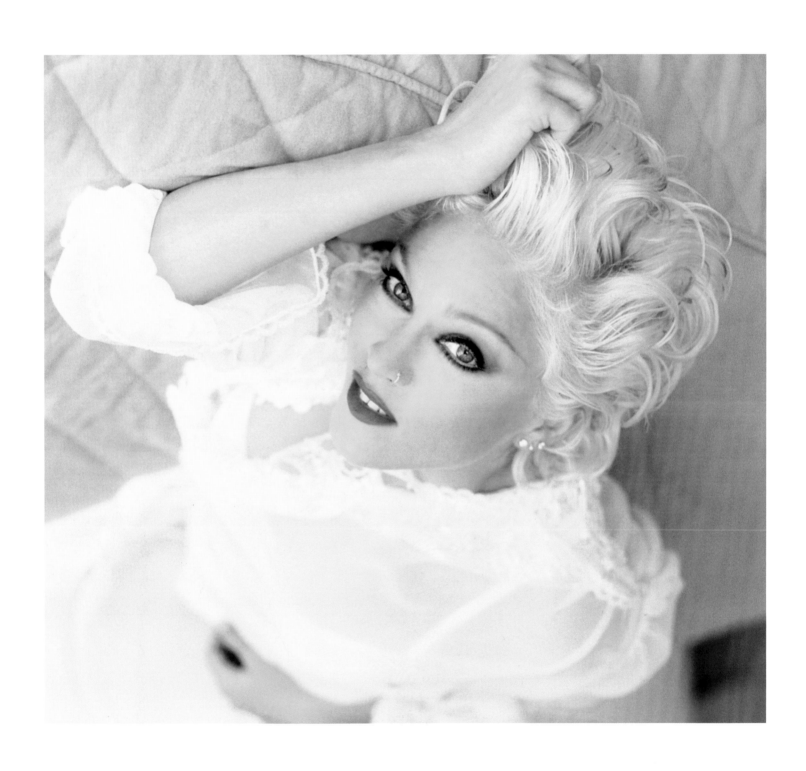

Opposite:

Suvi Koponen for British *Vogue*, March
2008. Photograph by Javier Vallhonrat.

Above:

Madonna photographed in Miami
by Patrick Demarchelier for her 1994
Bedtime Stories album.

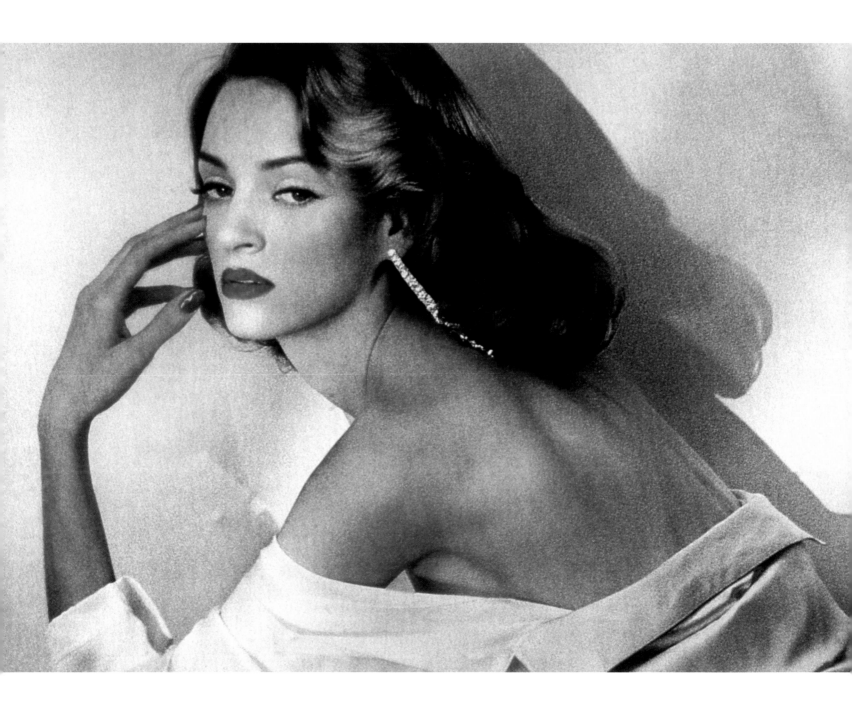

Above:

Uma Thurman is a goddess. I met her when she was a tall, gangly sixteen-year-old model and have loved her ever since. One of the most serenely beautiful creatures I have had the pleasure of working with, and we both have the same wicked sense of humour. This shot by Sheila Metzner for German *Vogue* in 1992 is one of my favourites.

Opposite:

Actress Léa Seydoux for British *Vogue*, November 2015. Photograph by Craig McDean.

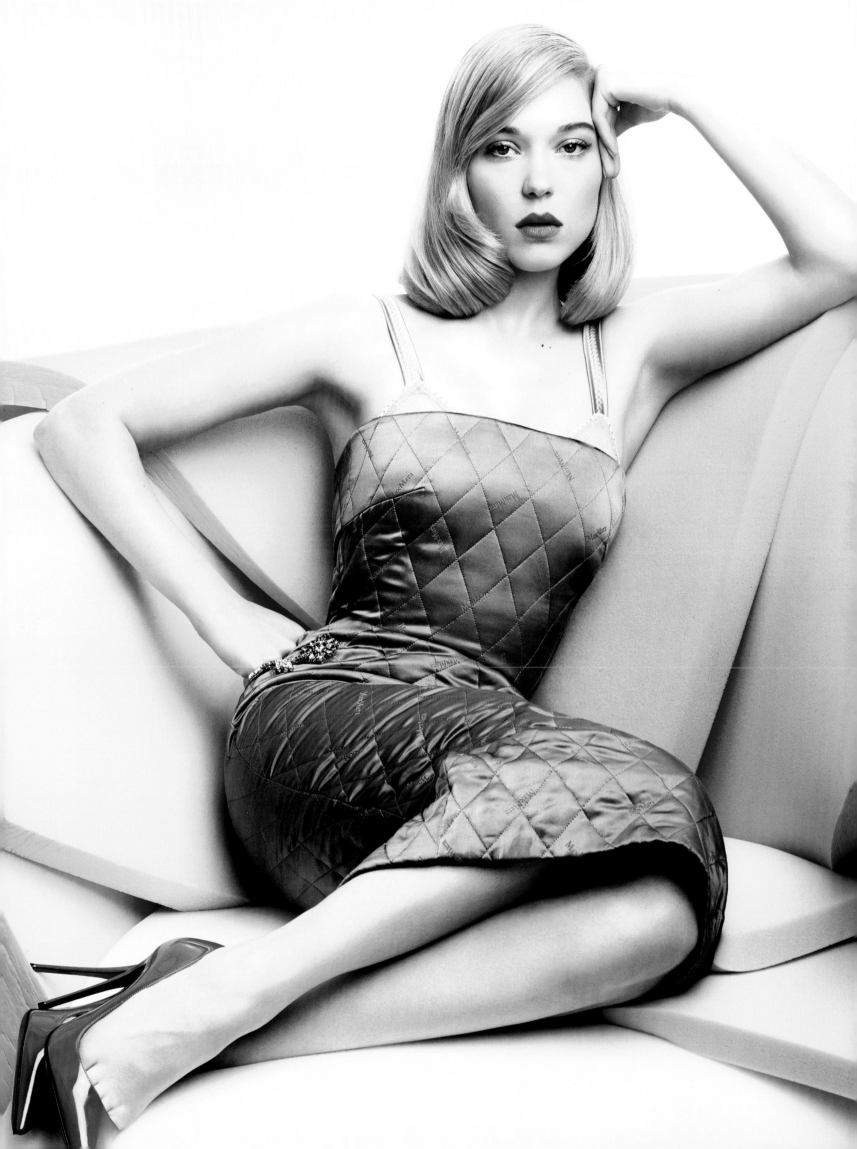

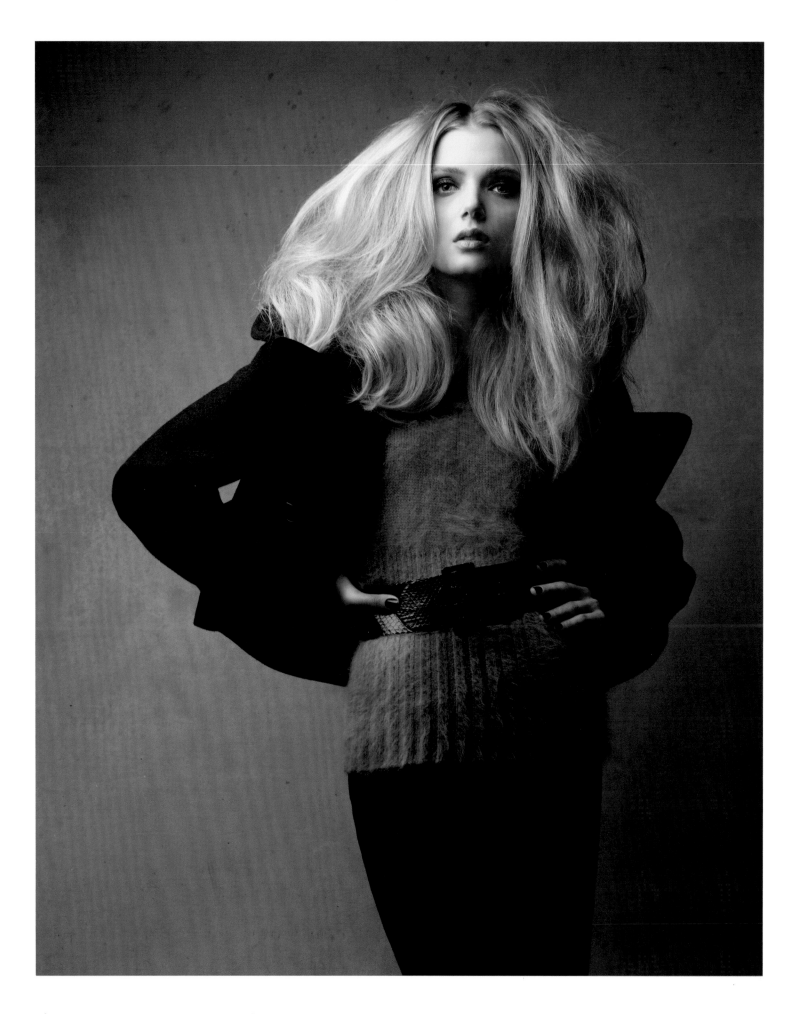

Above:

Patrick shoots British Supermodel
Lily Donaldson in the studio for
British *Vogue*, July 2008.

Opposite:

Arizona Muse for *Vogue* India,
August 2011. Both photographs
by Patrick Demarchelier.

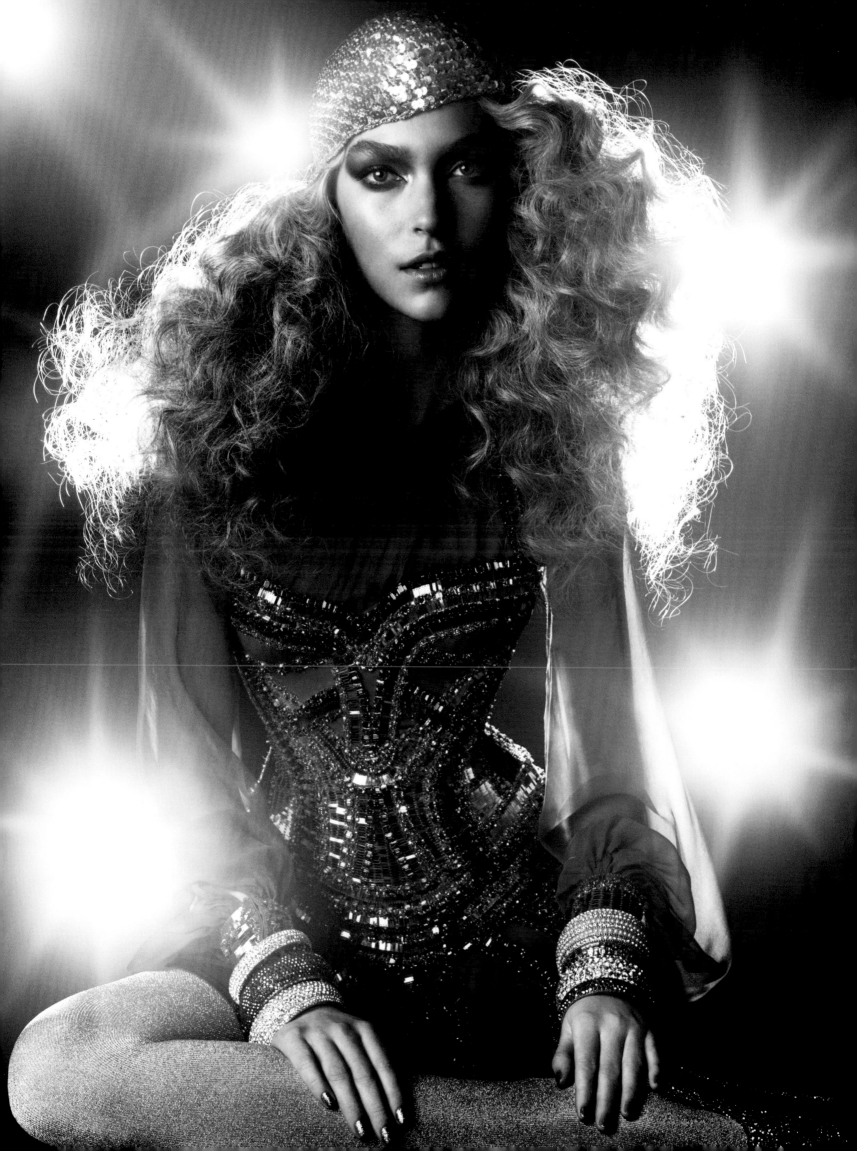

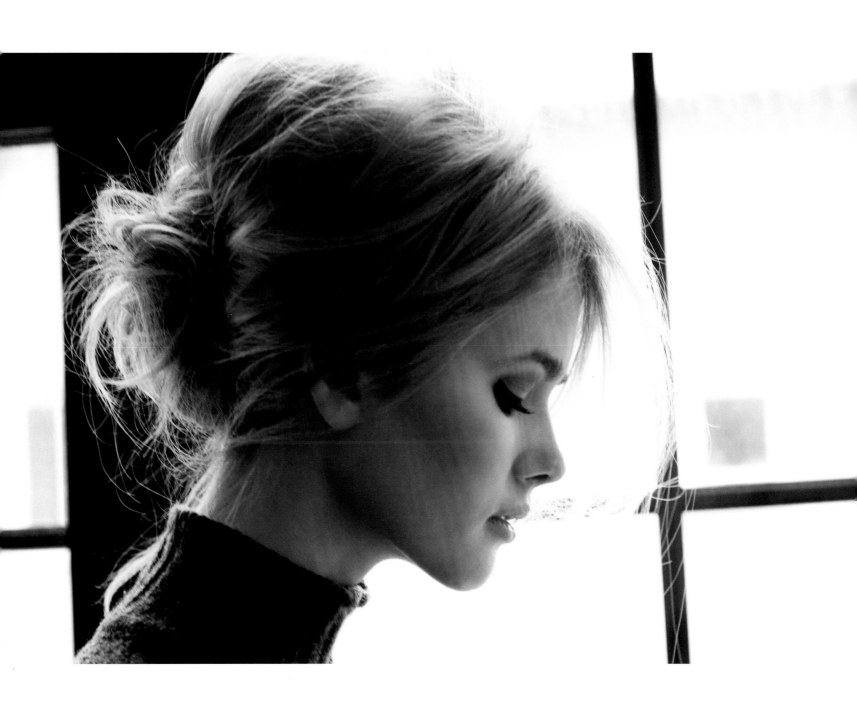

"You can always tell from Sam's work
that he really is on the woman's side.
He loves women, but is never taken in by
them. He makes them look as strong and
as spirited as they are, and then more
so with his magic fingers."
—Lucinda Chambers

Above:
Tetyana Tudor for British *Glamour*,
December 2006. Photograph
by Patric Shaw.

Opposite:
Victoria Beckham's first shoot
for British *Vogue*, styled by
Lucinda Chambers and photographed
by Nick Knight. British *Vogue*,
April 2008.

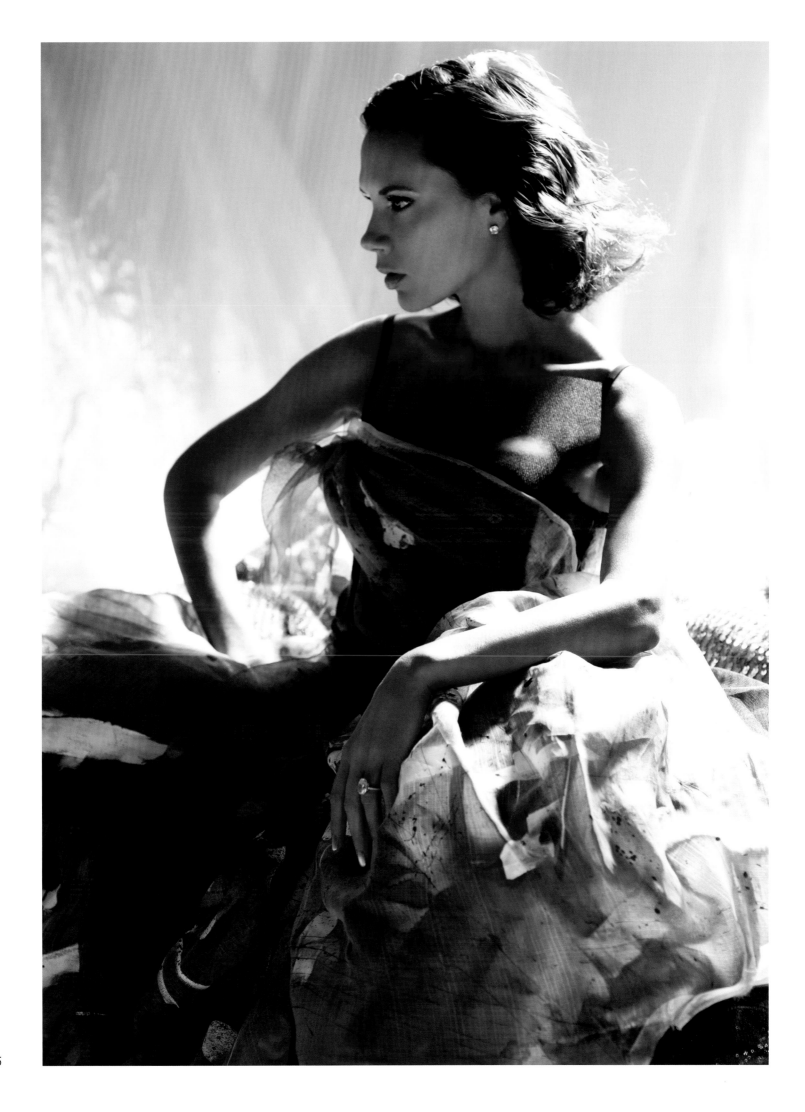

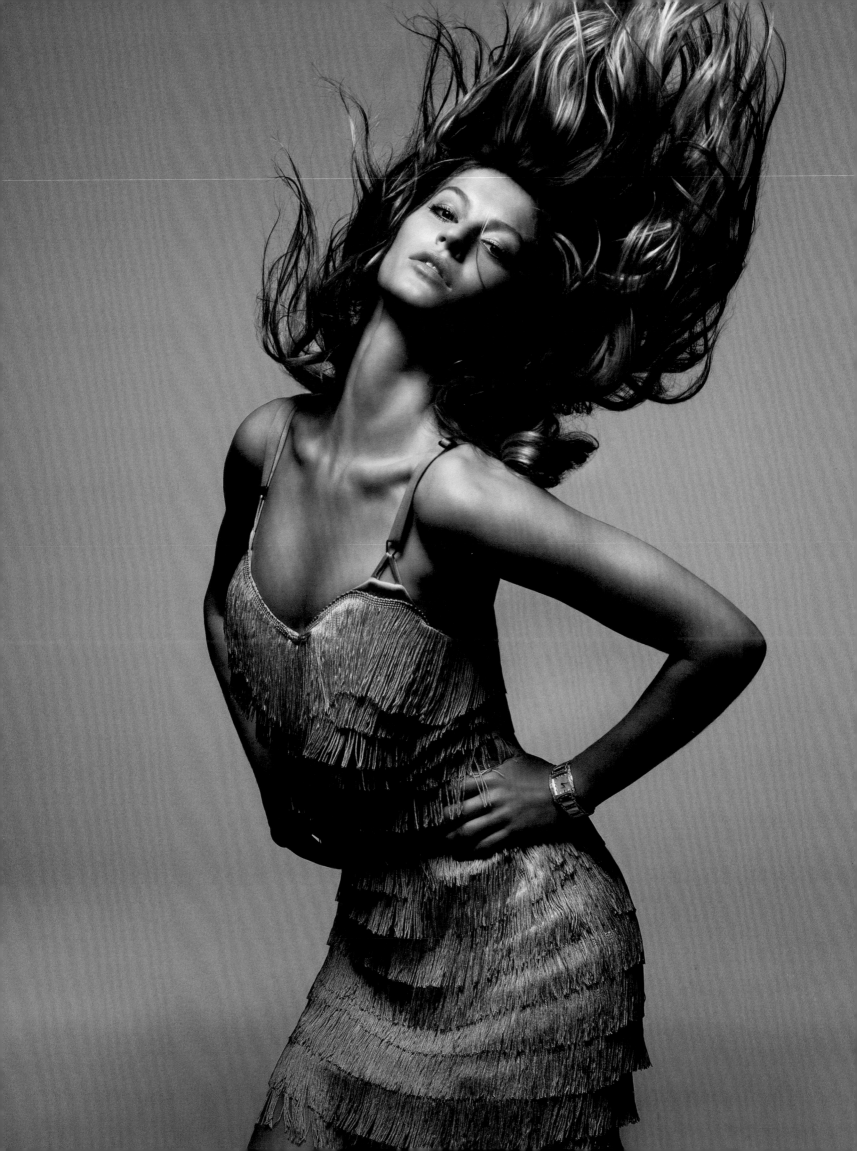

ENERGY

I love a wind machine. I love what air does to the hair. I love the effect of sculpting and moving it to capture a moment. When you turn on a wind machine, hair instantly gains energy. If an image looks flat—or the hair looks flat—wind provides lift. When hair is moving it looks real. It looks like you can touch it. Also, when a fan is being used at a shoot or even when there is a strong wind, you can see it in the girl's eyes in the resulting photos. The wind may even be annoying her, but that creates a spark and you can see the reaction in her eyes. Wind shakes everything up, as the model has to move and throw her head about to keep the hair out of her face.

There are no hard-and-fast rules when it comes to setting hair in motion. The focus is on creating texture, and movement is secondary. Sometimes you set it. Sometimes you use extensions, and sometimes you run your fingers through it and then you turn on the machine. No matter the specific method, getting hair moving is one of my favourite techniques.

Often motion turns out to be the secret ingredient for an eye-catching cover. It fills the page with hair and movement. Gisele Bündchen was fantastic—the all-time champion hair thrower. Look at that *Harper's Bazaar* cover (opposite). She is the best in the business.

"When I see Sam's name on the call sheet I know it will be a fun day! I love being around him and I love hearing how passionate he now is about his garden. He is a master of his craft, but most importantly he has a heart of gold." — Gisele Bündchen

"A wind machine is an extension of Sam McKnight's personality; it has energy and motion and adds glamour and emotion to the image. It's an amazing tool when shooting, as the hair will never exactly fall again in that place, and it gives the model something to play against and brings the moment to life as it adds the unpredictable.

I have never worked with anyone who understands how to play with the wind and air, how little, how much, and how to choreograph it like Sam. He can look at the hair and understand just how much or how little movement it needs from the slightest wisp to the complete washing machine. I never feel Sam can be described as just a hairdresser—you can't compare—as he brings absolute pure creativity." — Kate Phelan

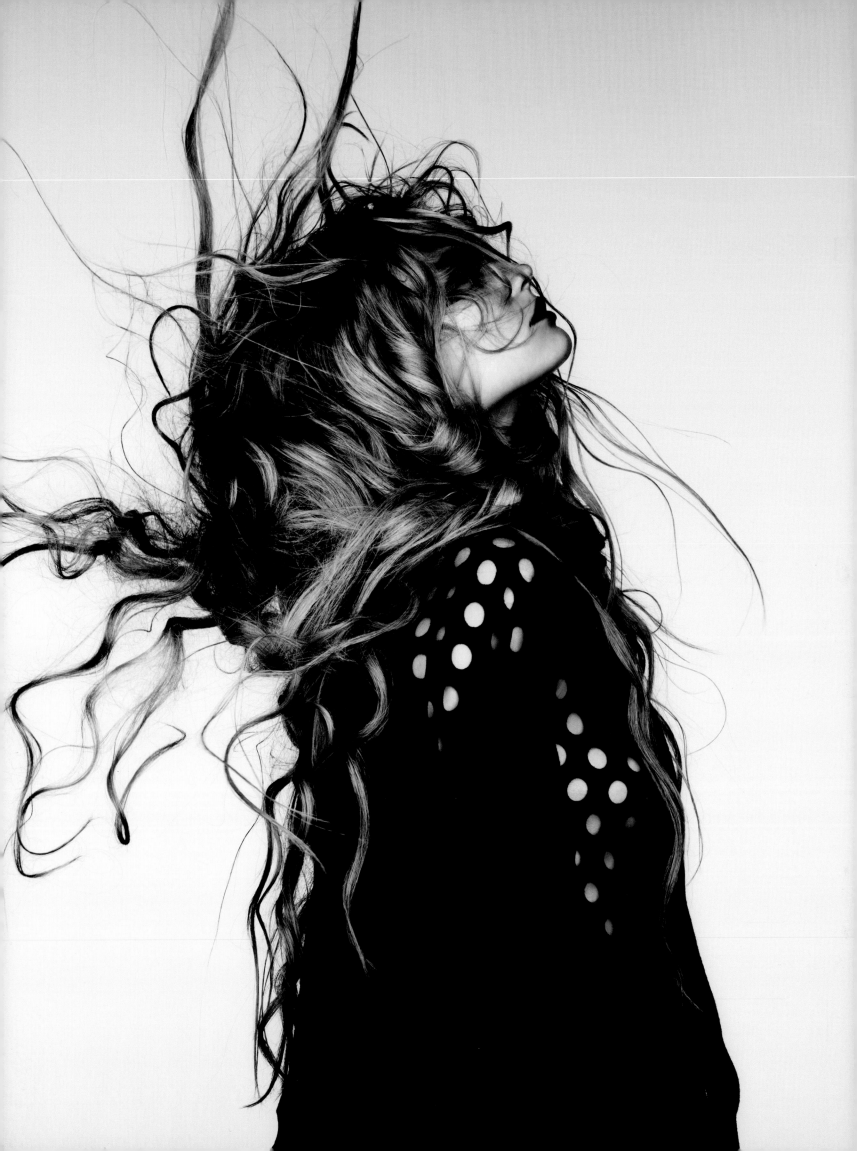

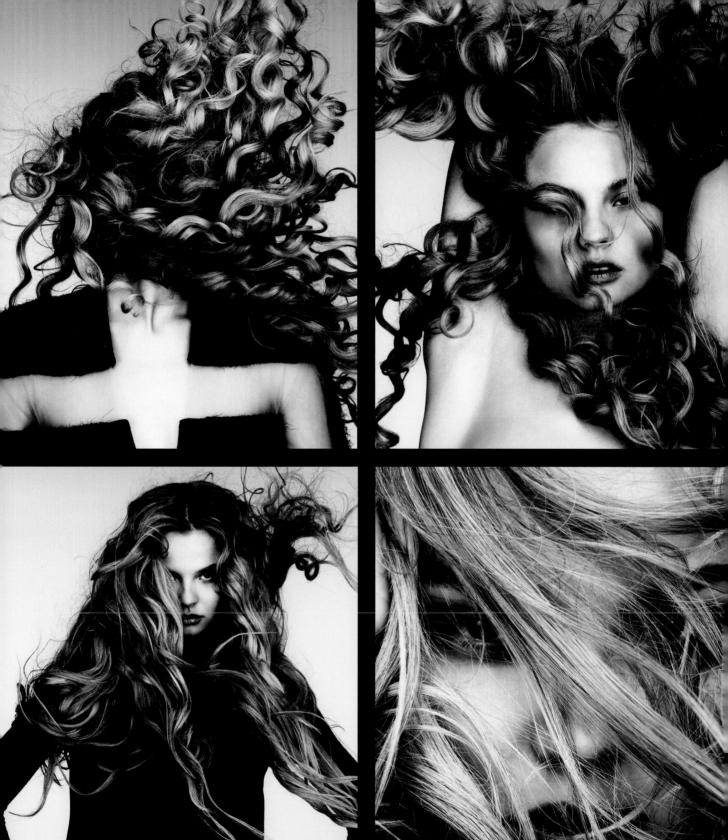

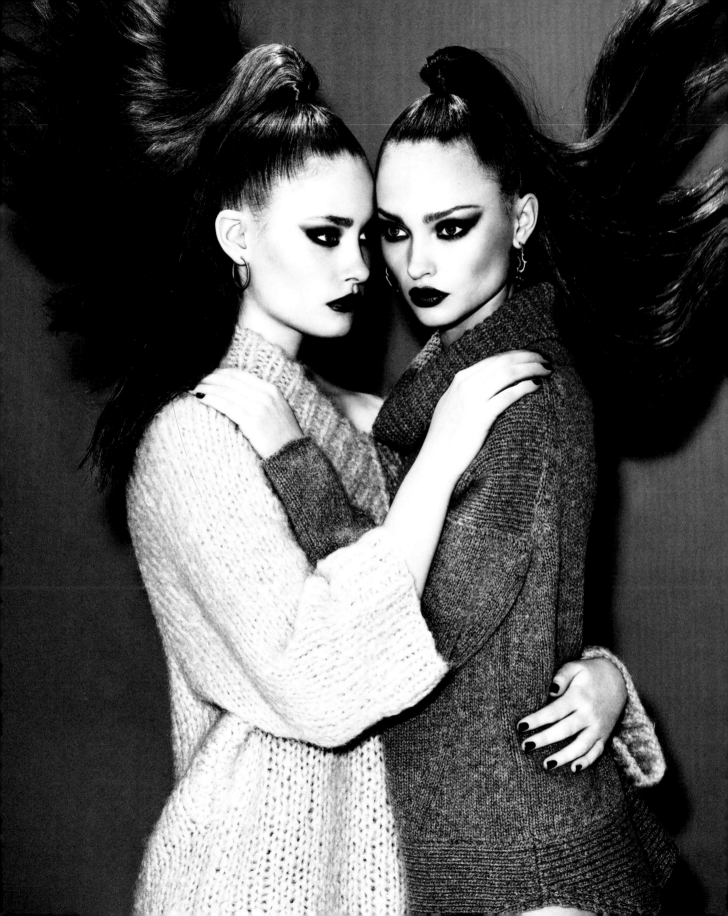

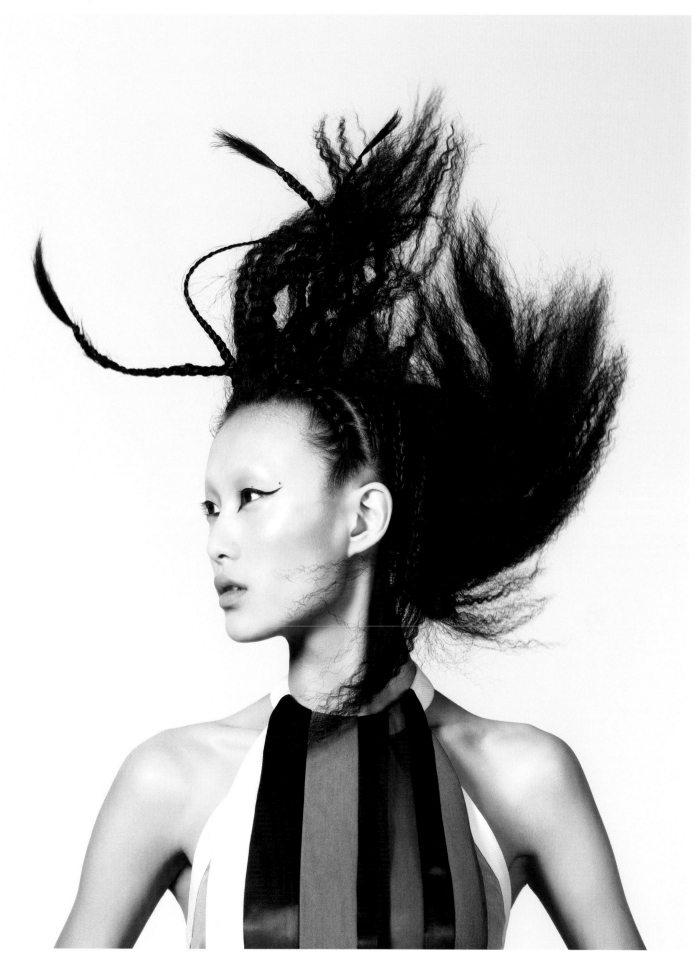

Opposite:

My assistant and I are just out of shot, throwing the girls' ponytails up into the air. Russian *Tatler*, October 2014. Photograph by Simon Emmett.

Above:

Shu Pei for Chinese *Vogue*, April 2009. Photograph by Jem Mitchell.

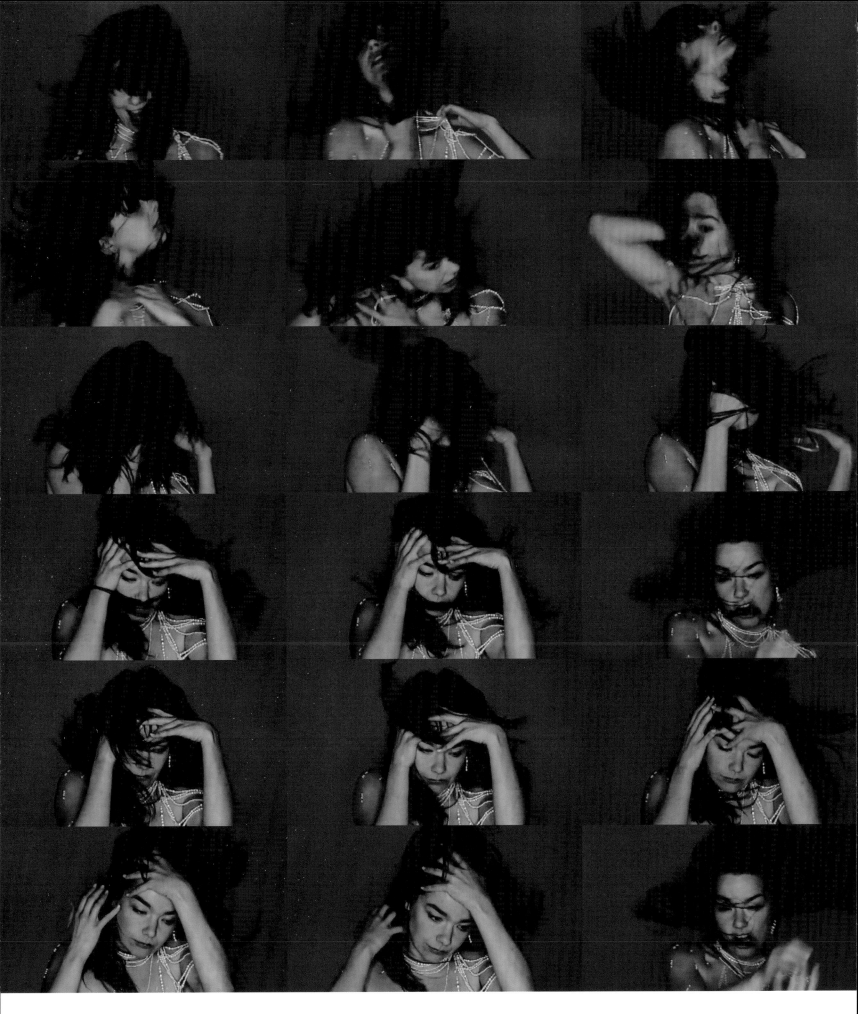

Above:

Captured moments of Bjork in her
Pagan Poetry video, directed by Nick
Knight in 2001.

Opposite:

Lily Donaldson in the slow-motion
short film *Flying Hair*, directed
by her father, Matthew Donaldson,
for Nowness.com in 2010.

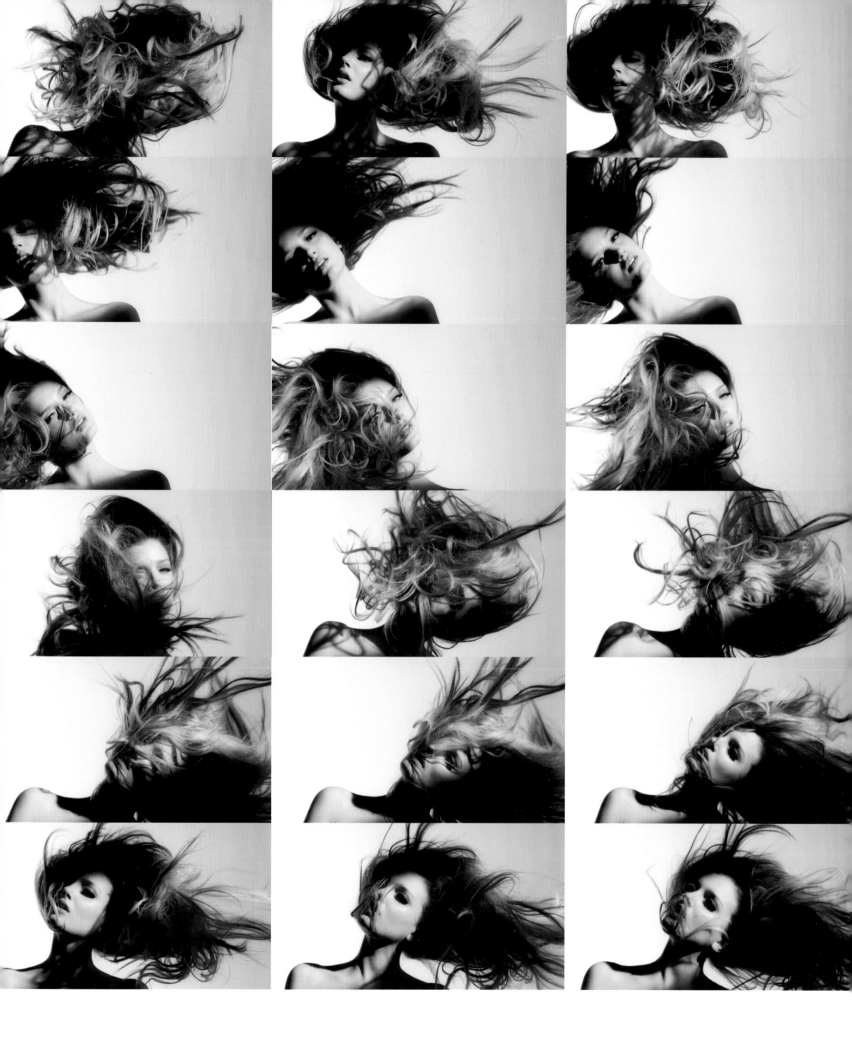

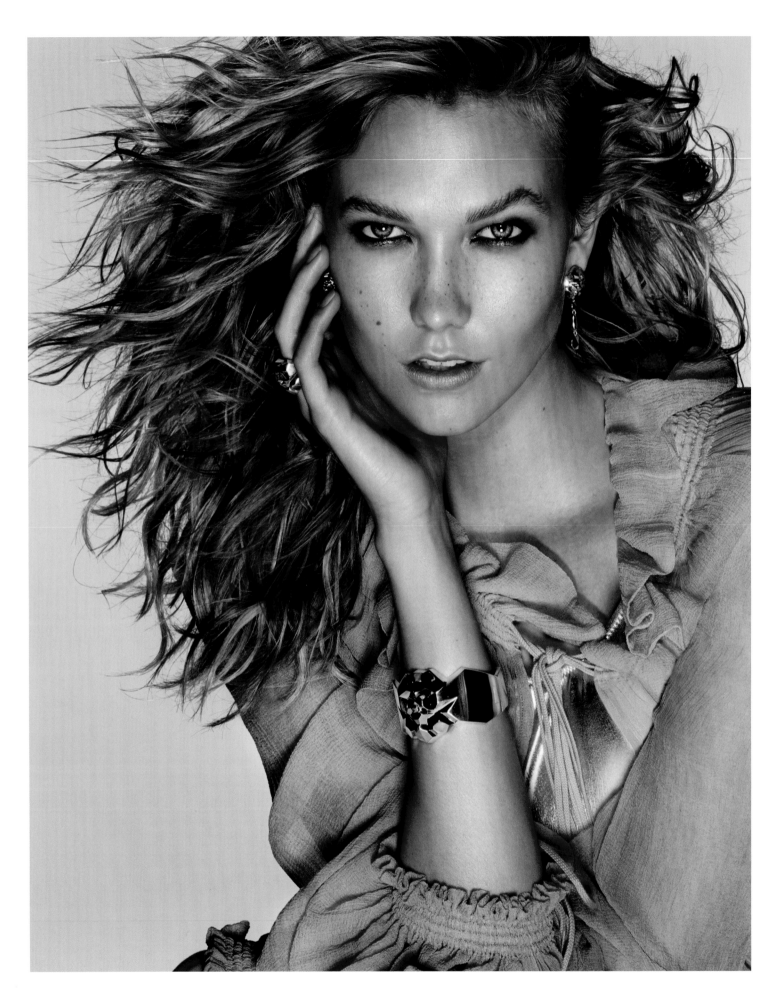

Above:
Karlie Kloss on the cover of Chinese *Vogue*, October 2015. Photograph by Mario Testino.

Opposite:
Lily Donaldson for British *Vogue*, March 2009. Photograph by Nick Knight.

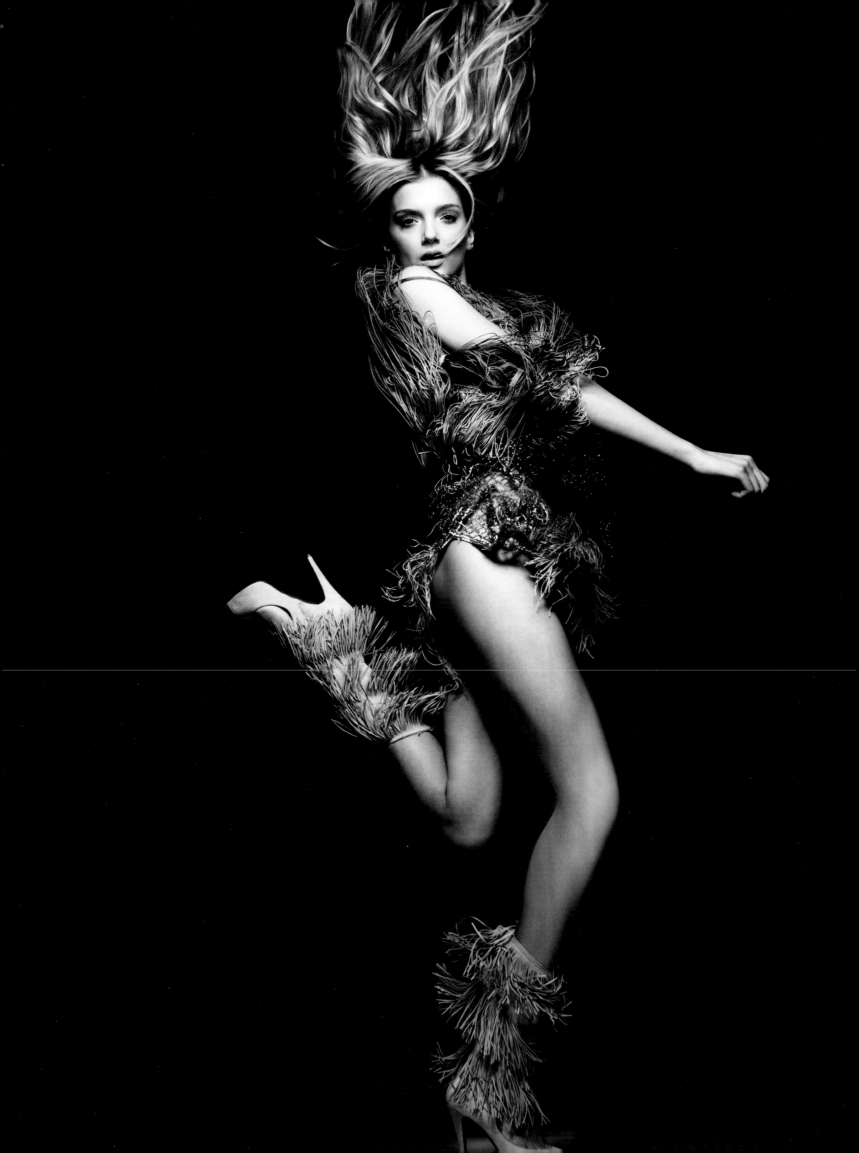

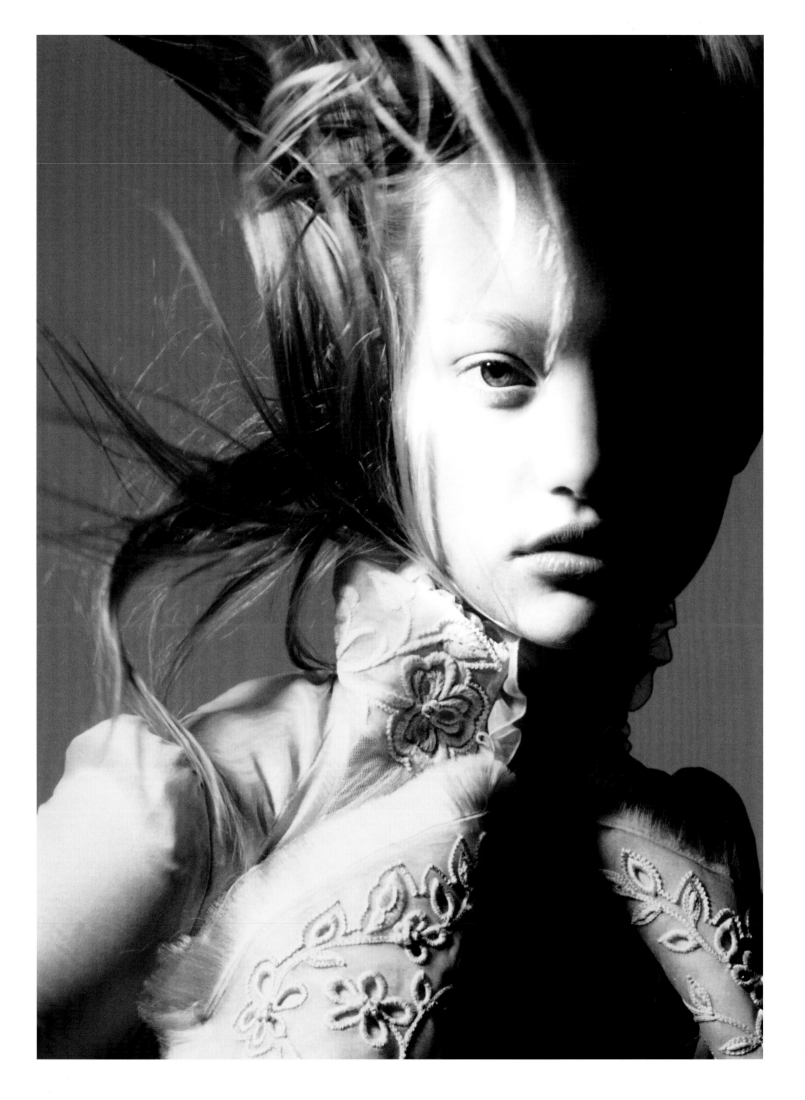

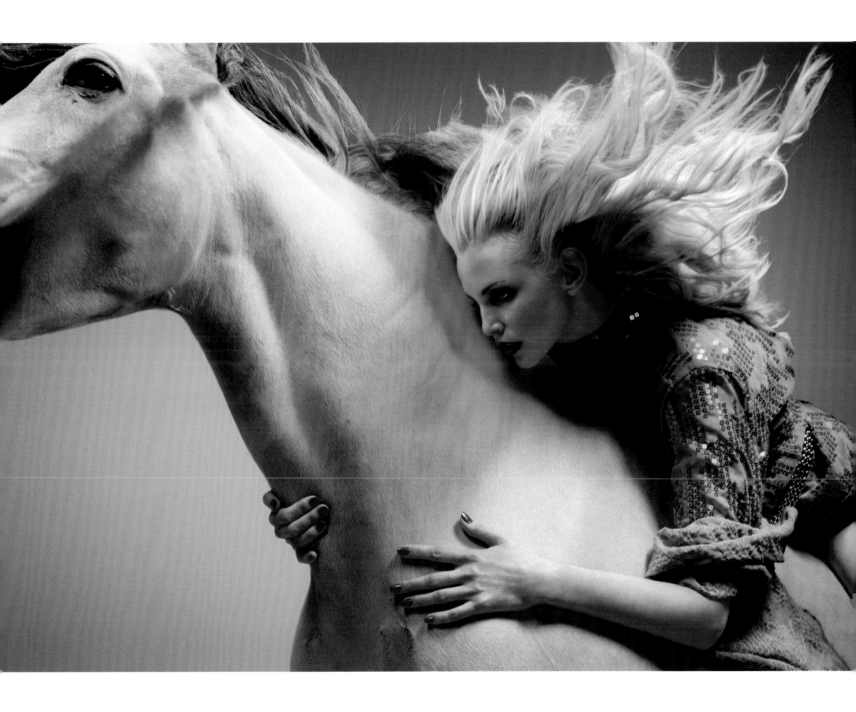

Opposite:

Gemma Ward for *Pop Magazine*,
June 2006. Photograph by Nick Knight.

Above:

Nadja Auermann for the Joop Autumn/
Winter 2000 campaign. Photograph
by Vincent Peters.

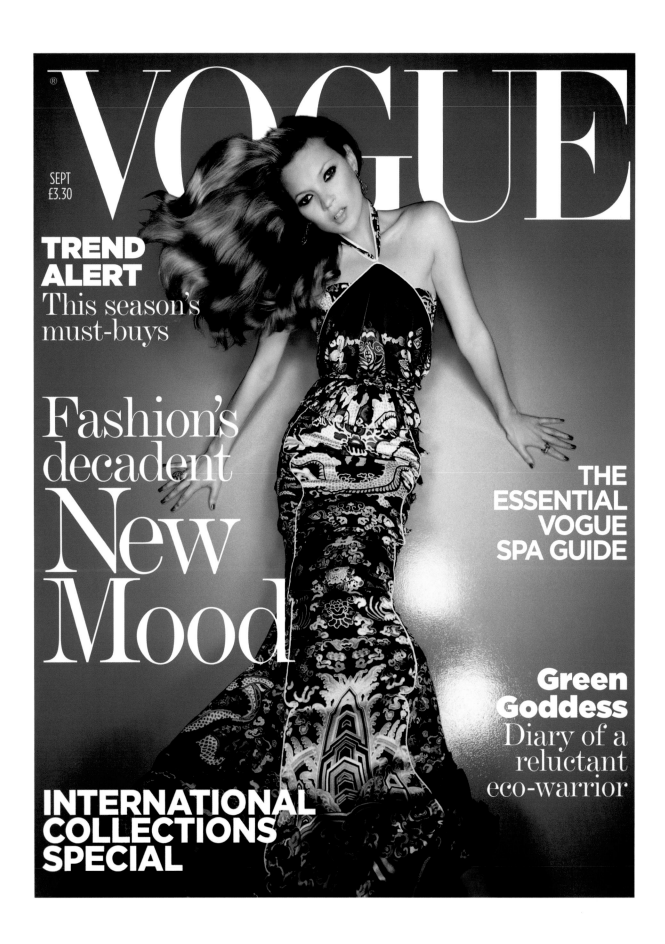

Above:

Kate Moss for British *Vogue*, September
2004. Photograph by Nick Knight.

Opposite:

Vivien Solari for W Magazine, October
2001. Photograph by Nick Knight.

Following pages:

Emma McLaren for German *Vogue*,
April 2009. Photograph by Patric Shaw.

188

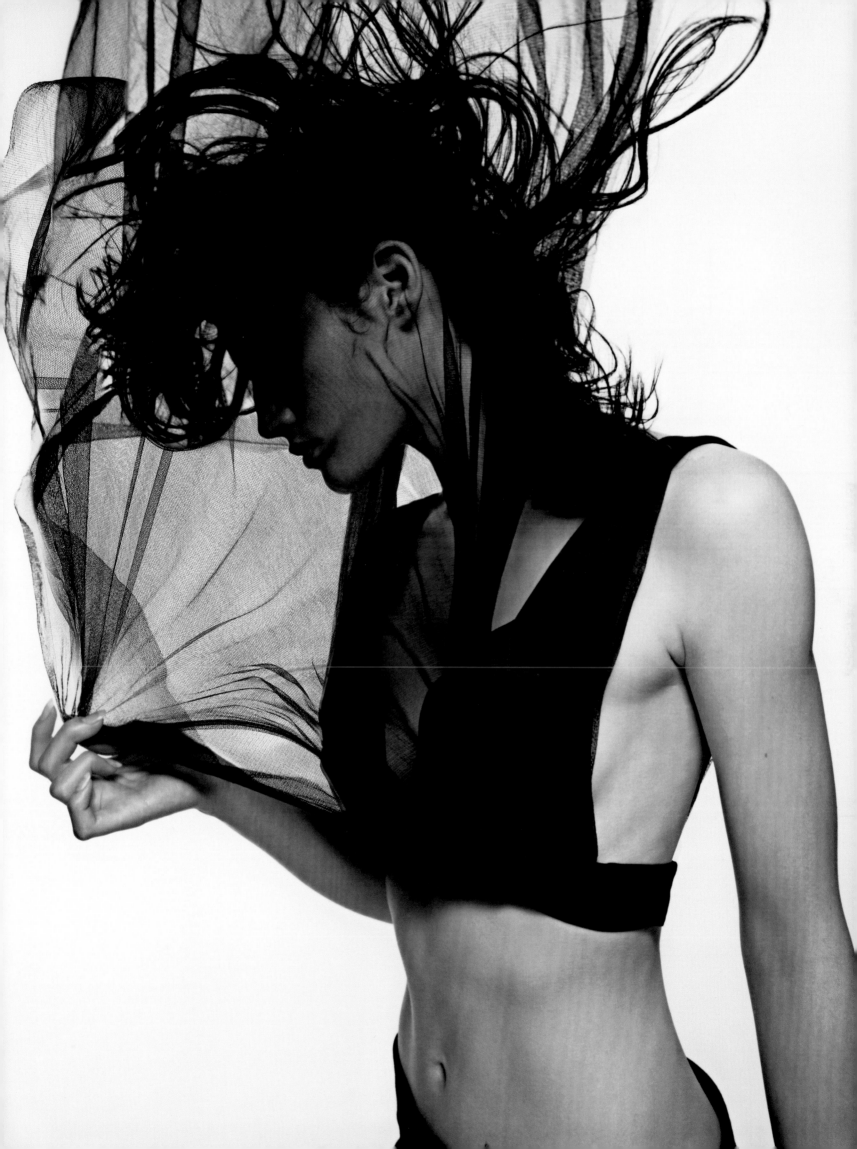

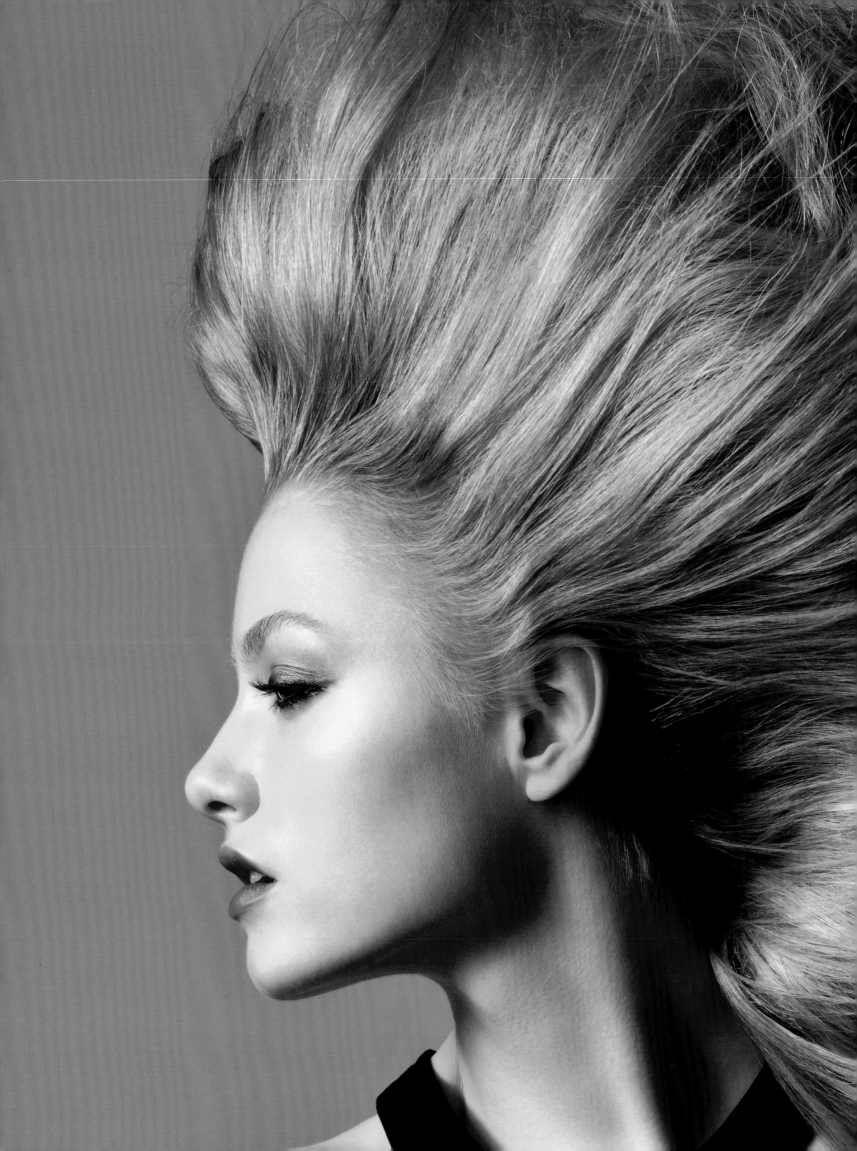

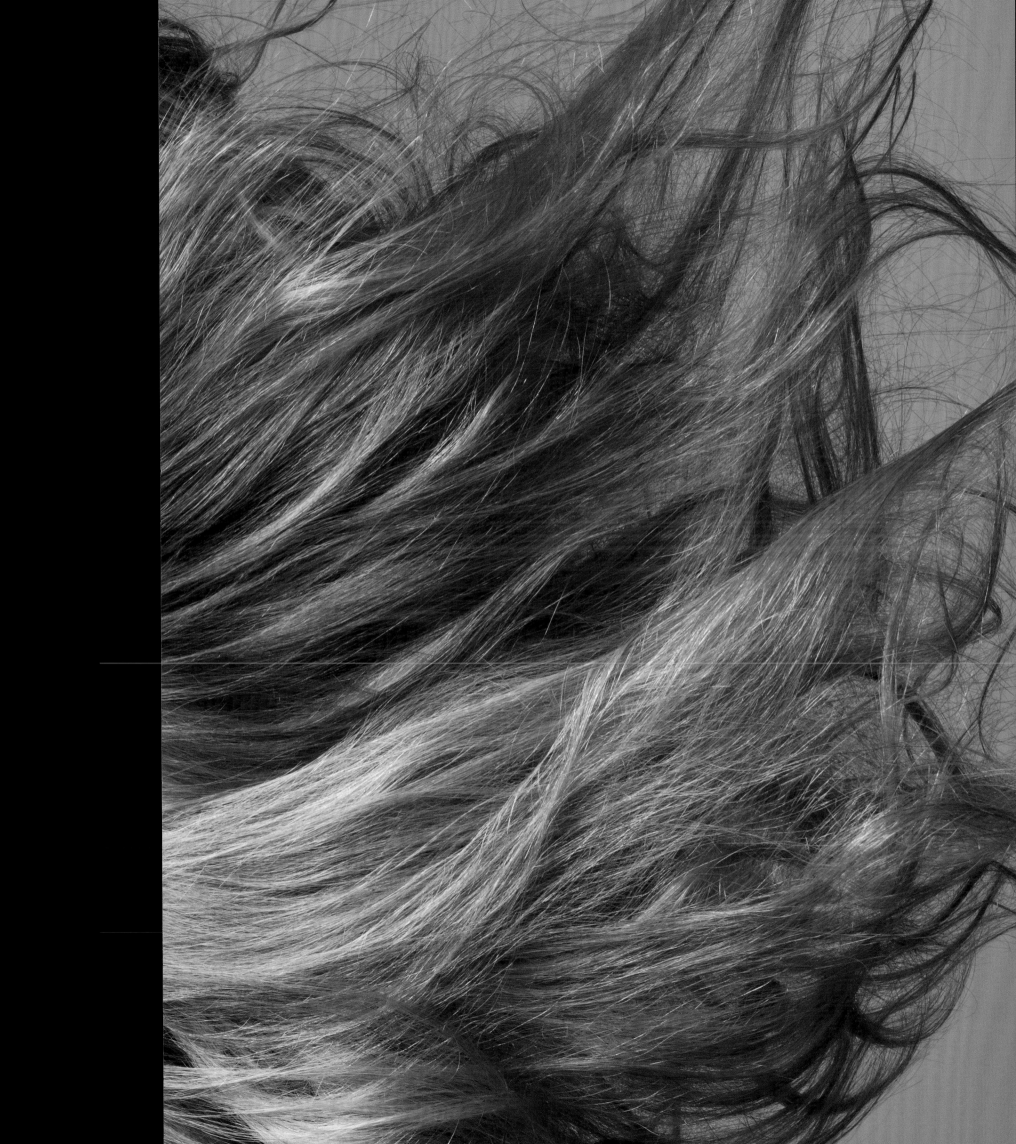

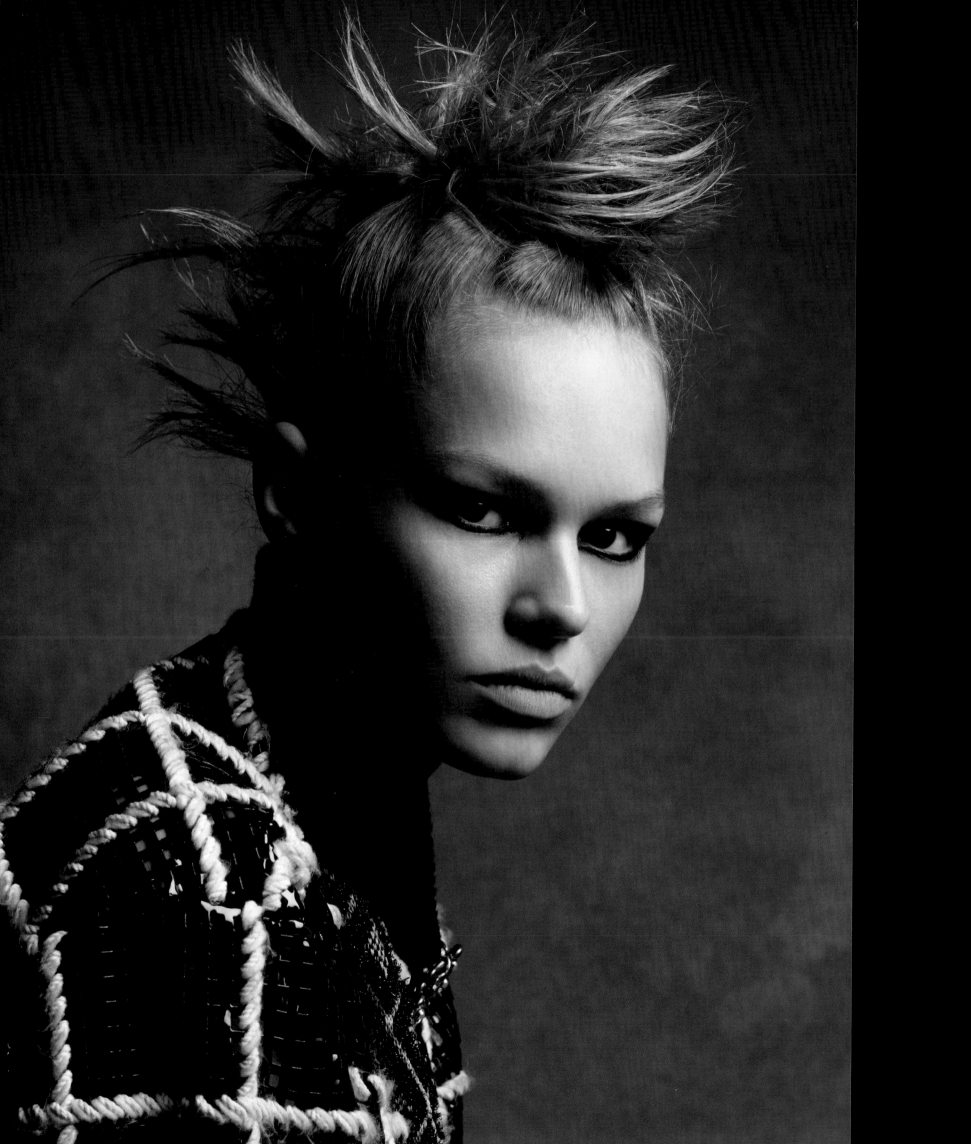

KARL LAGERFELD

Sam has worked alongside Karl Lagerfeld for years. They have a unique dialogue that works on a level beyond words—adjectives and adverbs filter in after the concept has been created between them. Karl always has an incandescent epiphany about the next collection, usually just as his last one is being sent into the stratosphere. His are fully realized imagined worlds: a Midsummer Night's Dream forest or a monochrome Rive Gauche in Rome, a Zen garden or a Corbusier drawing room open to the skies. The process begins with Karl's idea for the next collection, which in turn is driven by his finely tuned radar, his telepathic sense of what will touch us, affect us in six months' time or a year or even two years.

The lead time for developing a set in a location such as, for example, Havana, is more than one year. And just as the fabrics for a collection must be researched, developed, reworked, embroidered, overpainted or unravelled and rewoven, the attitude—the look of the show—evolves. It begins with a sketch. Karl sketches the sense of the girl in the clothes. His sketches are more like watercolours—evocative and precise. He will have a clear idea of the hair and the makeup as he makes his first inroads into designing the whole collection. Virginie Viard, his right hand at Chanel, sends this sketch to Sam. The same happens at Fendi with Mariaelena Cima and Charlotte Newson acting as a fulcrum between Sam and Karl. With a collection like Paris in Scotland, for instance, Sam and his team tried variations on Karl's specific idea—experimenting with braids and volume. Photographs are sent back to Paris and the dialogue goes into full swing.

A week before the show, Chanel has its dossier de presse shoot—an important shoot, photographed by Karl, in which he investigates a spectrum of the looks that are finished and best express the arc of his collection. It is an important dress rehearsal for hair, makeup, and the attitude of the whole show. This is also the time to establish which accessories work best—a certain shoe with a certain look, and so on. The images, contained in iconic folders—reflecting the set and, more deeply, the meaning of the whole collection—are given to the press and VIPs before the show and the images are used worldwide. It's a sort of pre-advertising, pre-Instagram moment. Sam works on the hair before Karl arrives for the shoot. There are questions to be asked: With a hat? Without? Higher? Flatter? The questioning continues on set, but this time Sam's fingers ask more of each strand and curl.

Sam has an incredible sense of the final image, not only on a vast Chanel set, but also in a photograph. He calibrates the hair for each, as well as perfecting the look as the shoot unfolds. Two days before the show, Chanel has its accessorisation: Each girl stands in her outfit with hair and makeup in front of Karl, so that he can see the balance of the whole, whether it works on the girl, and how her outfit should be accessorized—pearls here, pins there. Often Sam will suggest a pin or a bandana that can add to the look. Showtime is showtime—early call times and rehearsals when he still has forty girls to finish. Sam is meticulous and his team, led by Eamonn Hughes, is phenomenal. As each girl lines up for her exit, Sam is there to make sure the hair is exactly as Karl wants it.

The advertising is the chance to push the collection in another direction. Karl loves improvised perfection. Sam's understanding of where he took the look of the hair for the show serves as a springboard for the look of the campaign. The rule: Never repeat, but go further, dare higher, make iconic, unforgettable images. Witnessing the artistic trust between Sam and Karl is like watching two dancers perfectly in time with each other, each anticipating the other's next step.

— *Amanda Harlech*

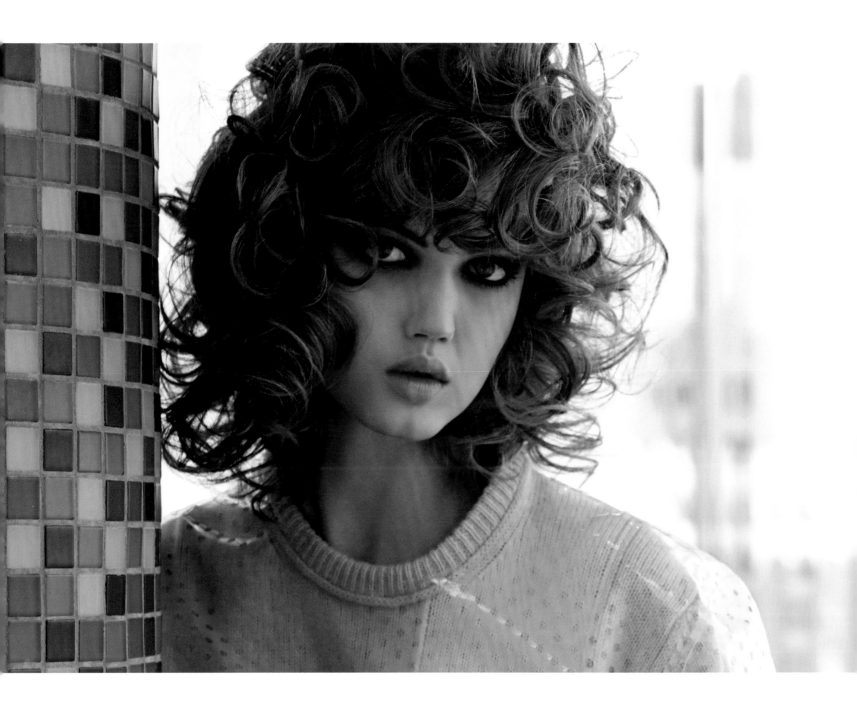

Page 192:

Anna Ewers for Chanel Fall/Winter 2015 campaign.

Pages 194–205:

All photographs by Karl Lagerfeld

Above:

Lindsey Wixson for Fendi Fall/Winter 2015 campaign.

Opposite:

Cara Delevingne for Chanel Pre-Fall 2015 campaign.

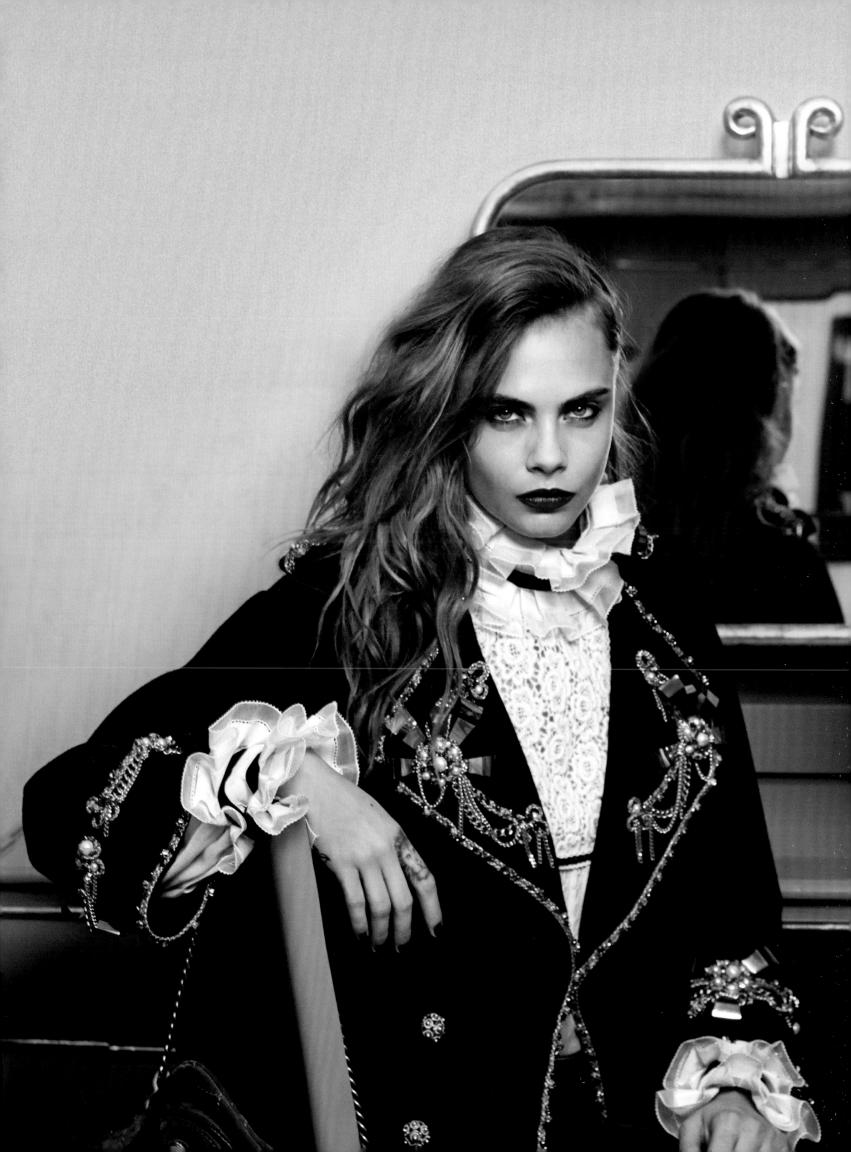

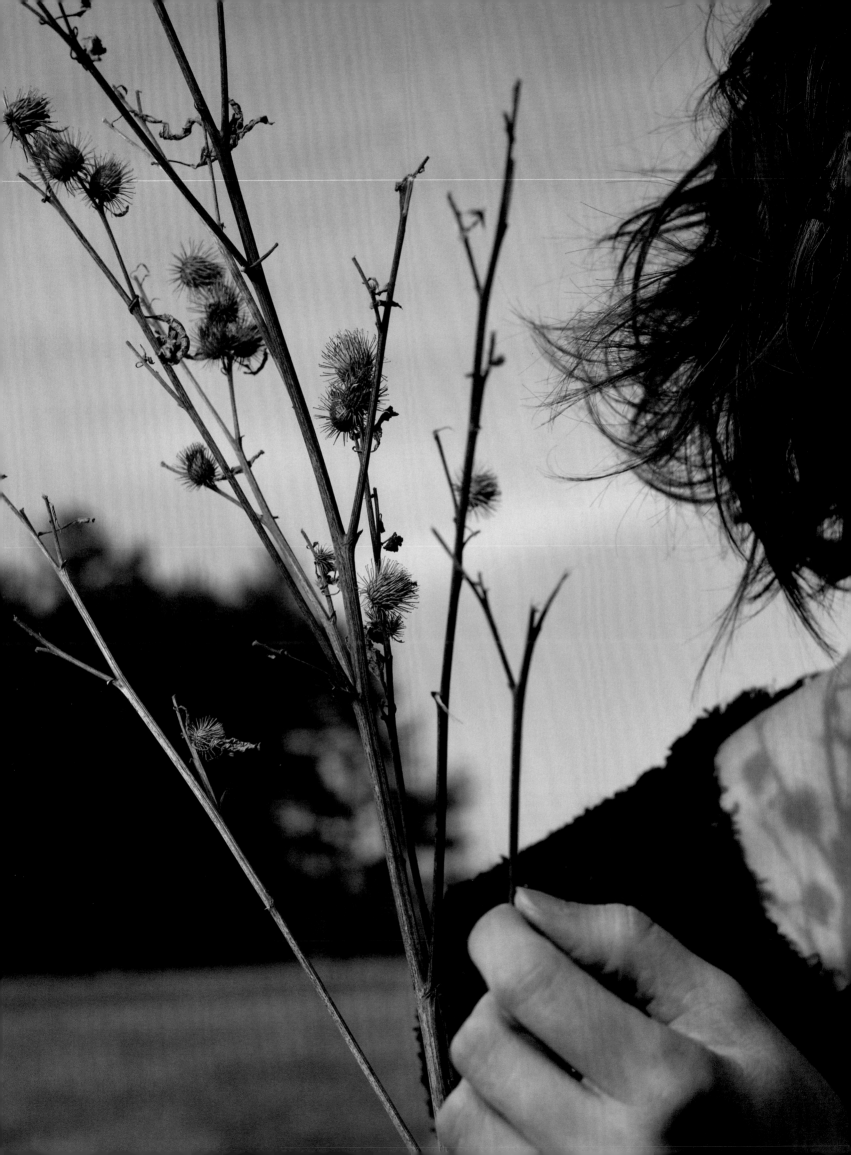

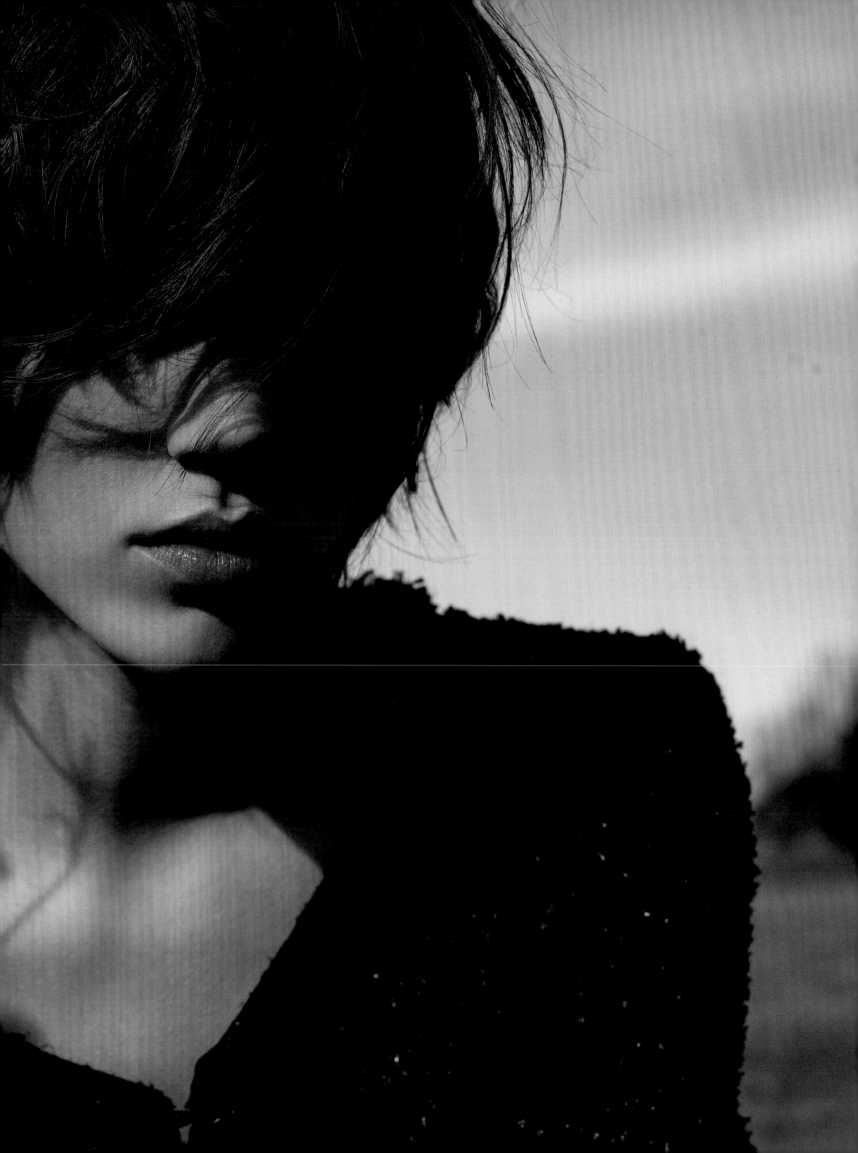

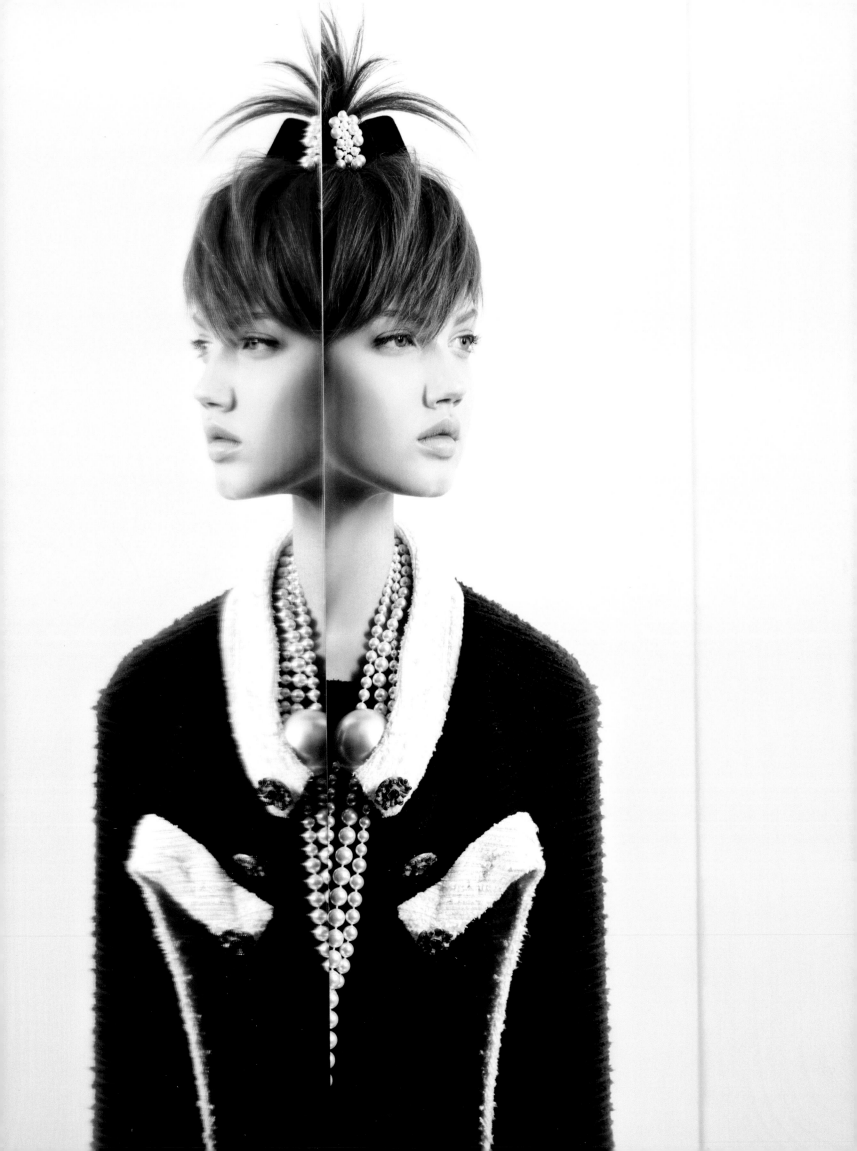

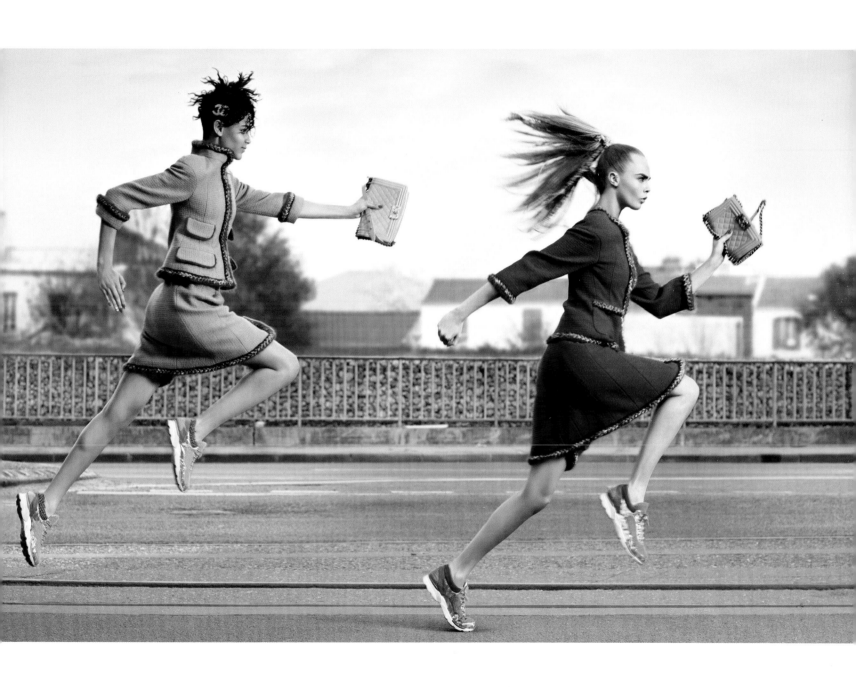

Previous spread:

Freja Beha Erichsen for Chanel
Fall/Winter 2010 campaign.

Opposite:

Lindsey Wixson for Chanel
Spring/Summer 2014 campaign.

Above:

Binx Walton and Cara Delevingne
for Chanel Autumn/Winter 2014.

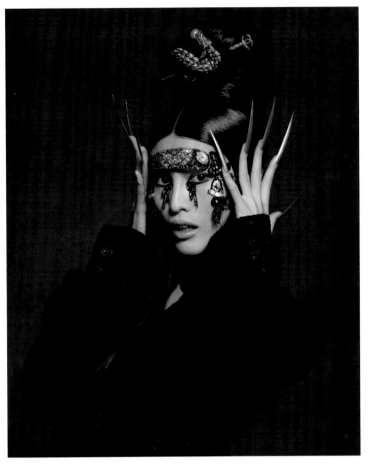

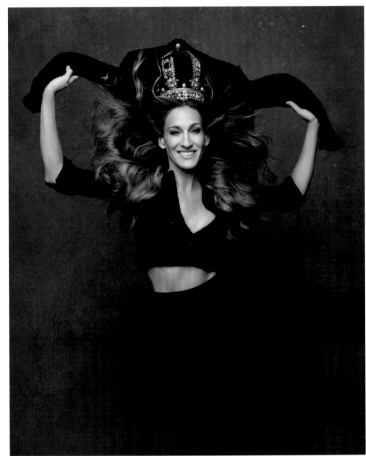

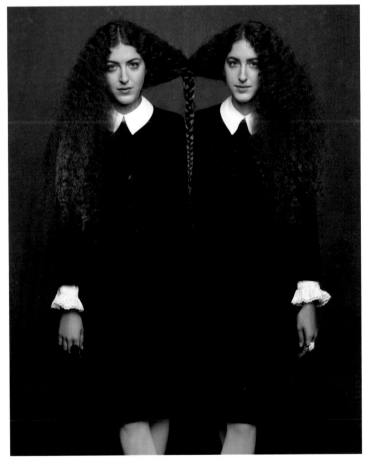

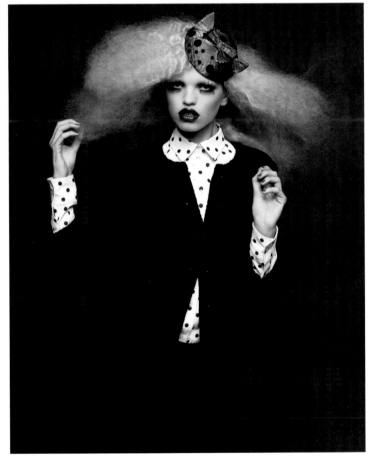

A selection from the 2012 Chanel
The Little Black Jacket project.
Karl and Carine Roitfeld reinterpreted
the iconic little black Chanel jacket
on one hundred models and celebrities.

Above, clockwise from upper left:

Sui He, Sarah Jessica Parker,
Daphne Groeneveld, and Haze
and Simi Khandra.

Opposite:

Xiao Wen. All photographs
by Karl Lagerfeld.

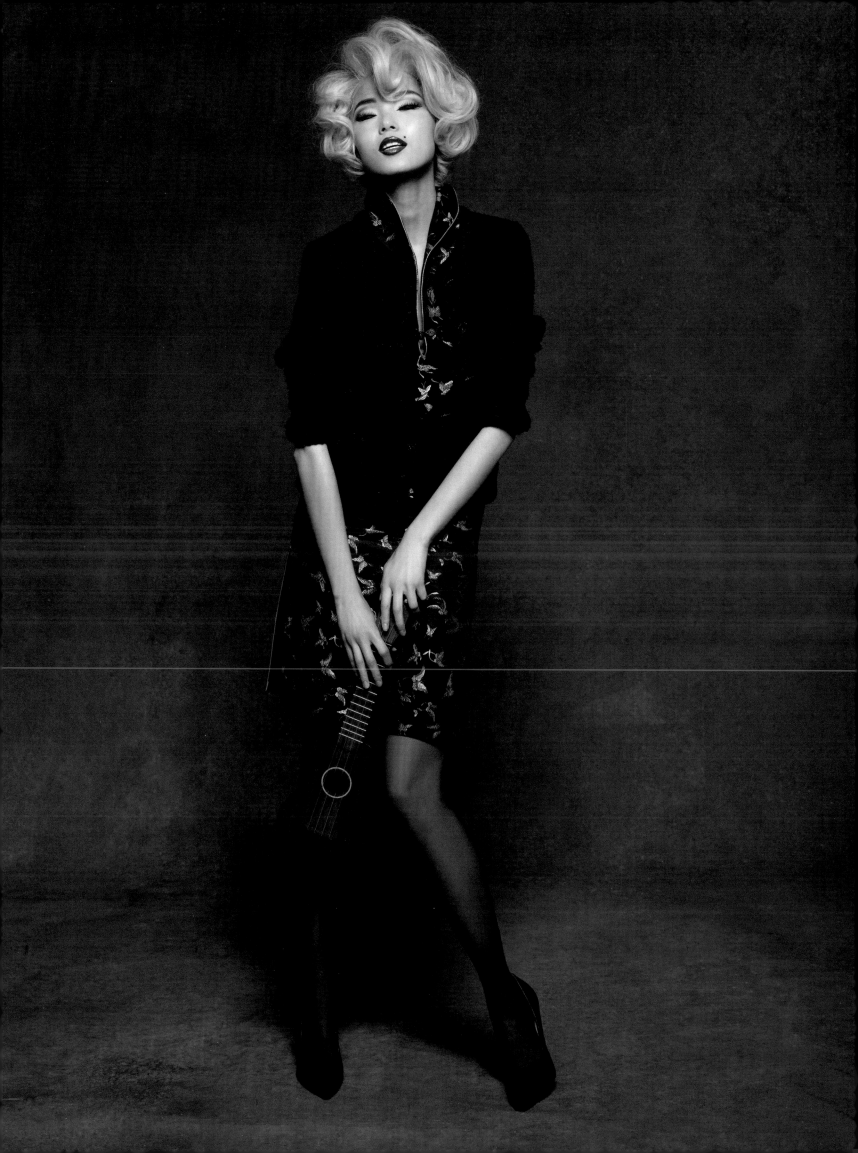

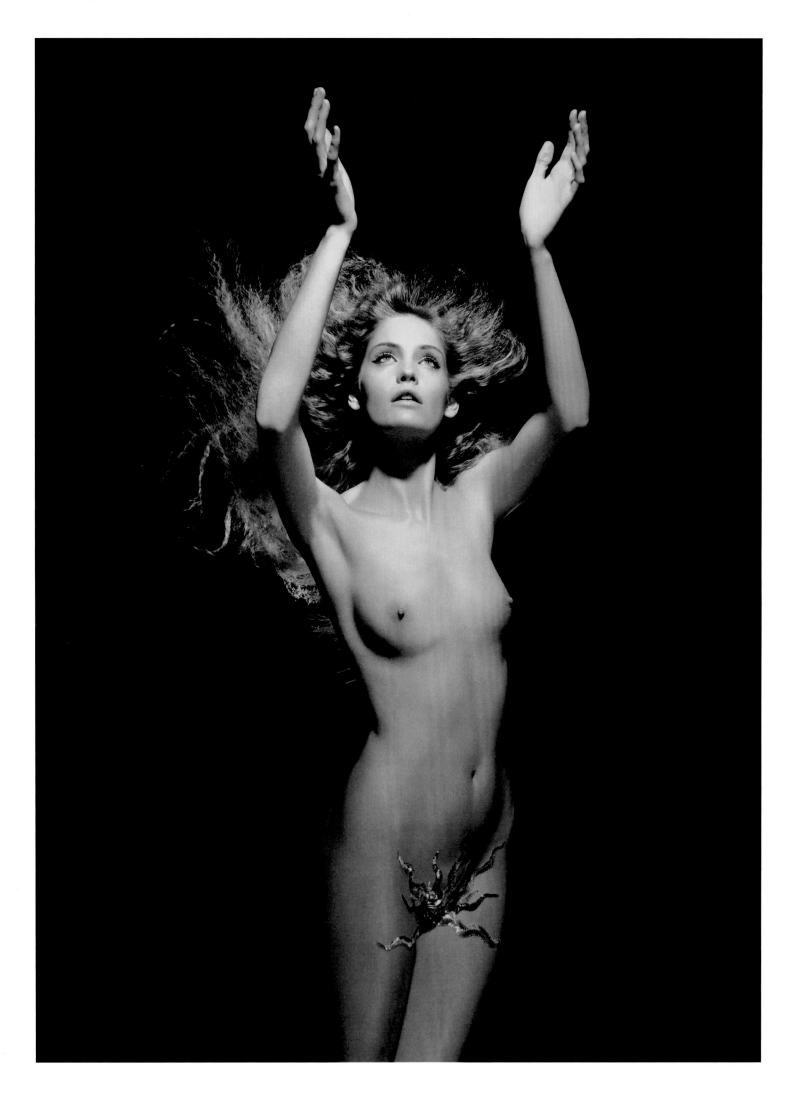

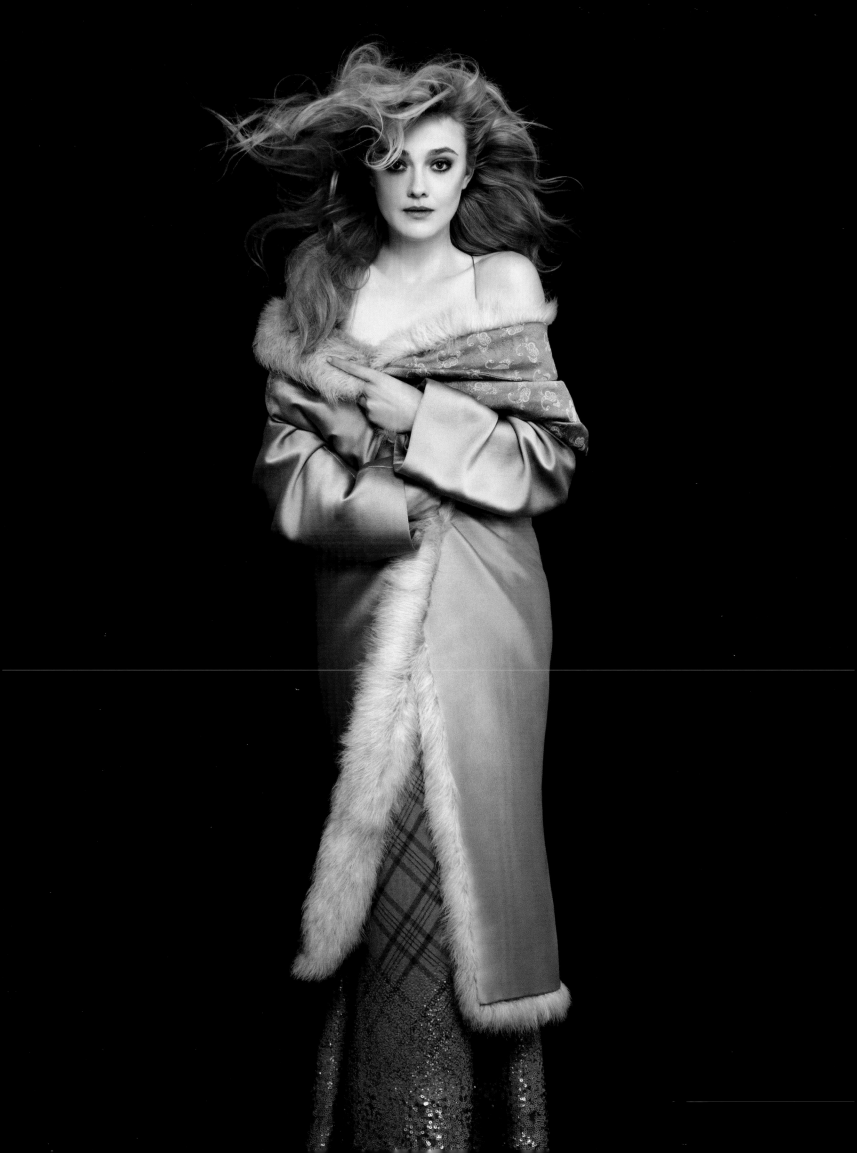

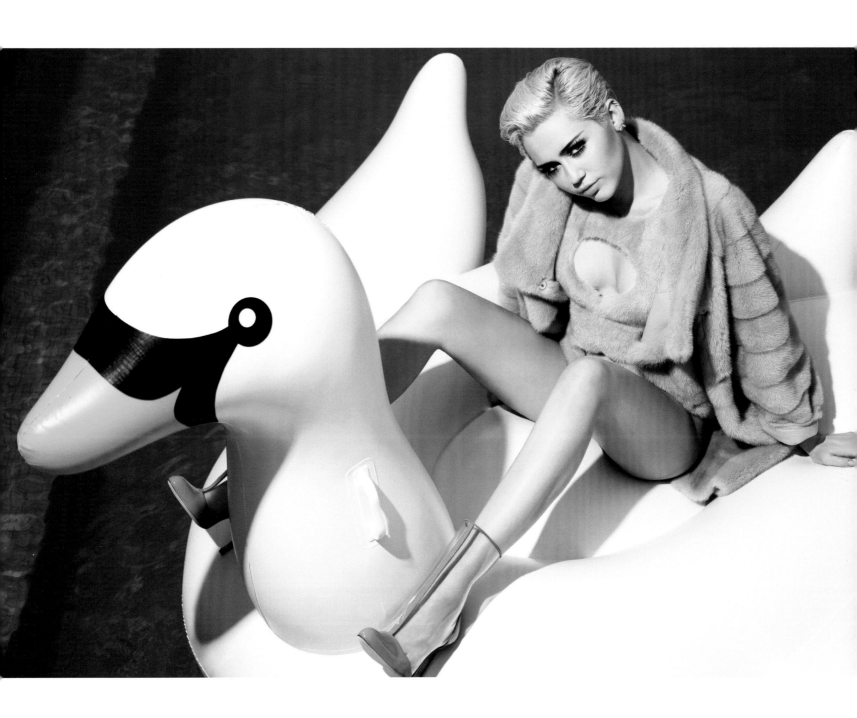

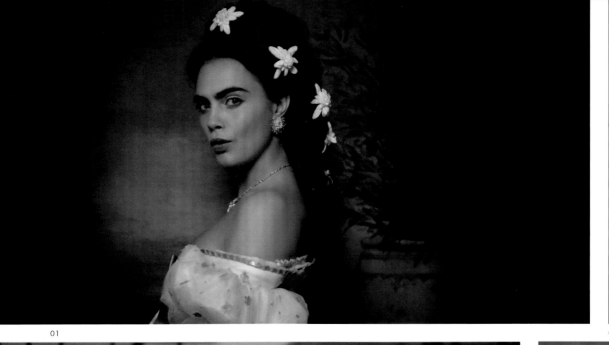

01

02

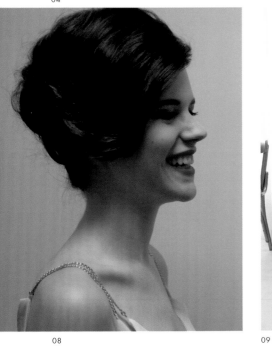

04

05

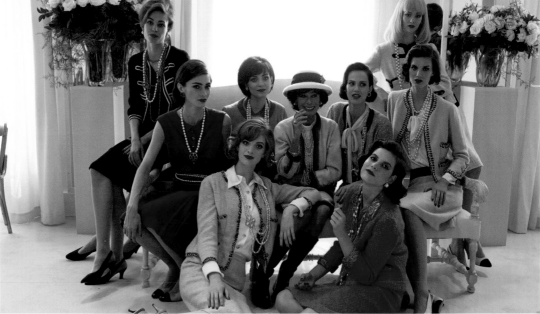

08

09

Chanel short films directed
by Karl Lagerfeld

01 Cara Delevingne
in *Reincarnation*,
Paris-Salzburg 2014/15.

02 Cara dancing with
Pharrell Williams
in *Reincarnation*,
Paris-Salzburg 2014/15.

03 Kristen McMenamy
in *The Tale of a Fairy*,
Chanel Cruise
Collection 2011.

04 Keira Knightley and
Clotilde Hesme in *Once
Upon a Time*, 2013.

05 Behind the scenes on
Once Upon a Time, 2013.

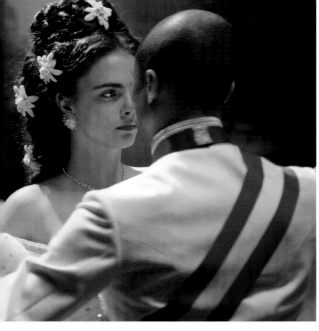

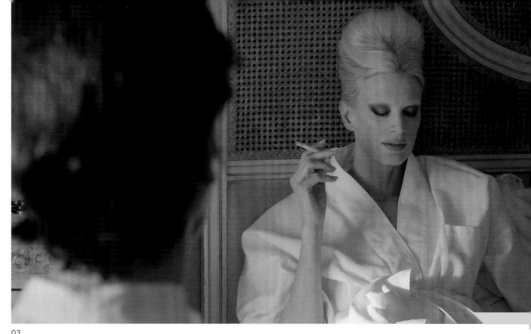

03

06

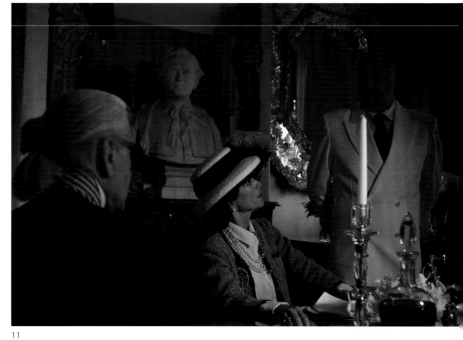

07

10

11

06 Antonia Wesseloh and Ashleigh Good in *The Return*, 2013.

07 Saskia de Brauw in *Once Upon a Time*, 2013.

08 Antonia Wesseloh in *The Return*, 2015.

09 Geraldine Chaplin as Coco Chanel and models in *The Return*, 2015.

10 Karl often casts his team, and I was asked to play Coco Chanel's butler alongside Geraldine Chaplin,

Amanda Harlech, and Kati Nescher in *Back to the Roots*, 2013.

11 Karl directing Geraldine Chaplin and me in *Back to the Roots*, 2013.

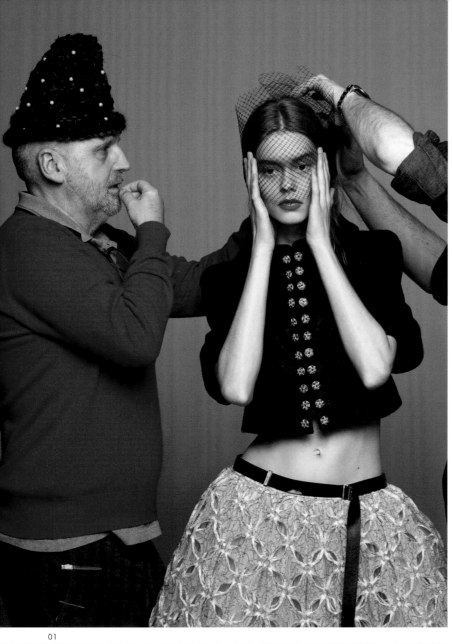

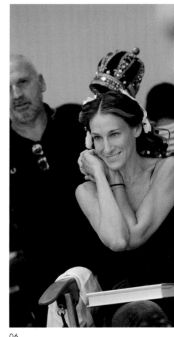

02

05

06

08

09

Behind the scenes
in Karl's studio.

01 With Ondria Hardin for
 Chanel S/S 2013 press kit.

02 Haze and Simi Khadra
 for *The Little Black Jacket*
 shoot 2012.

03 Behind the scenes
 with Linda Evangelista
 for Chanel Eyewear,
 Spring 2012.

04 Daria Strokous for the
 Chanel Pre-Fall 2012
 campaign.

05 Georgia May Jagger
 for *The Little Black Jacket*
 shoot 2012.

06 Sarah Jessica Parker
 for *The Little Black Jacket*
 shoot 2012.

07 Lindsey Wixson for
 the Chanel Fall 2015
 campaign.

03

04

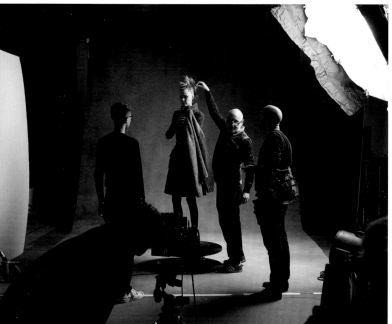

07

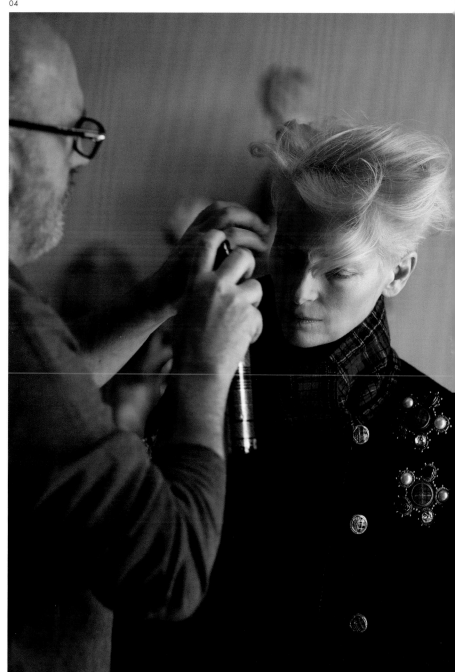

11

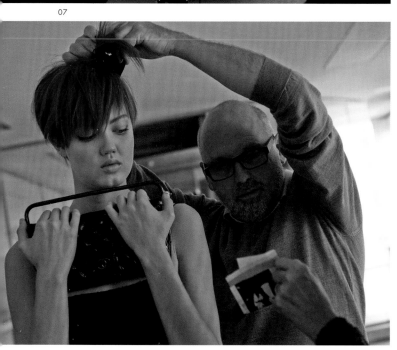

08 Claudia Schiffer,
Chanel eyewear, 2011.

09 Lindsey Wixson
for the Fendi Spring
2015 campaign.

10 Lindsey Wixson for the
Chanel Spring/Summer
2014 campaign.

11 Tilda Swinton
for the Chanel Pre-Fall
2013 campaign.

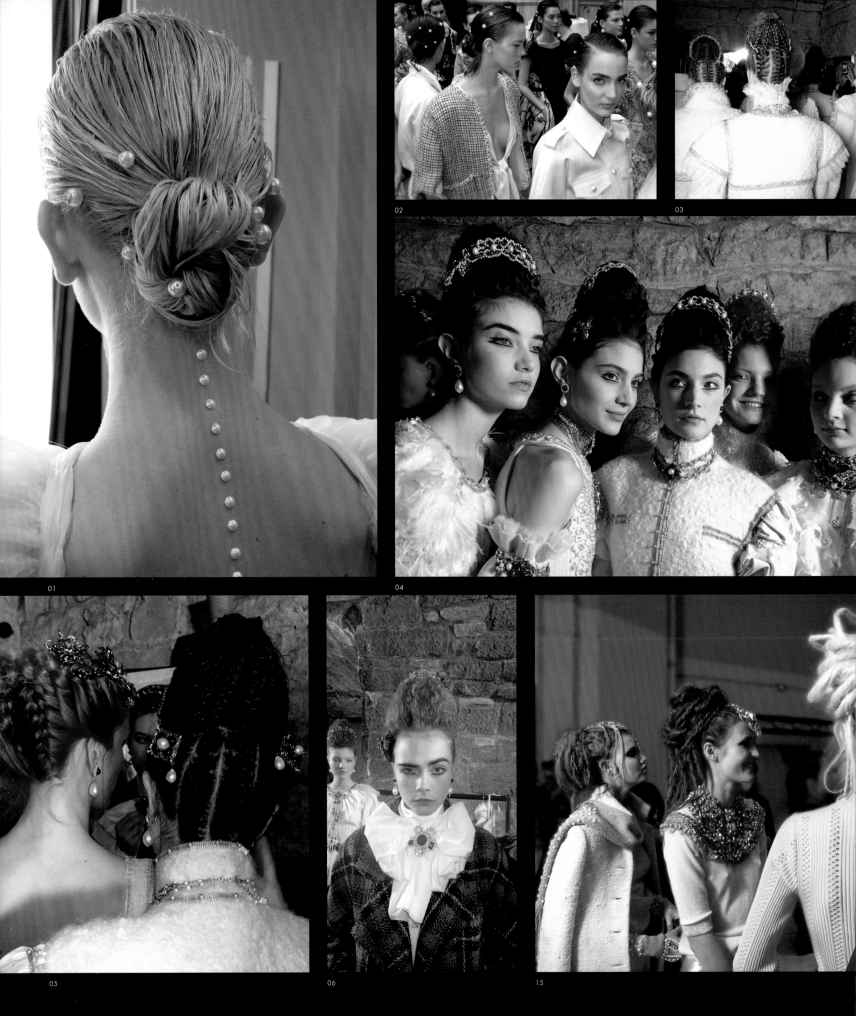

01

02

03

04

05

06

15

Trips to far-off locations feature in the Cruise and Métier des Arts collections. Sometimes inspiration is locally inspired, as in the traditional braids with a modern twist in Seoul, or the Sadhu priest's dreadlocks for the Paris-Bombay collection. A portrait of Mary Queen of Scots, along with a photo of an African princess's braids, resulted in the braided and frizzy updos in Edinburgh. The powder-pastel choppy bobs at Versailles reinterpreted the classic Chanel bob as a modern rebel in the spirit of Marie Antoinette.

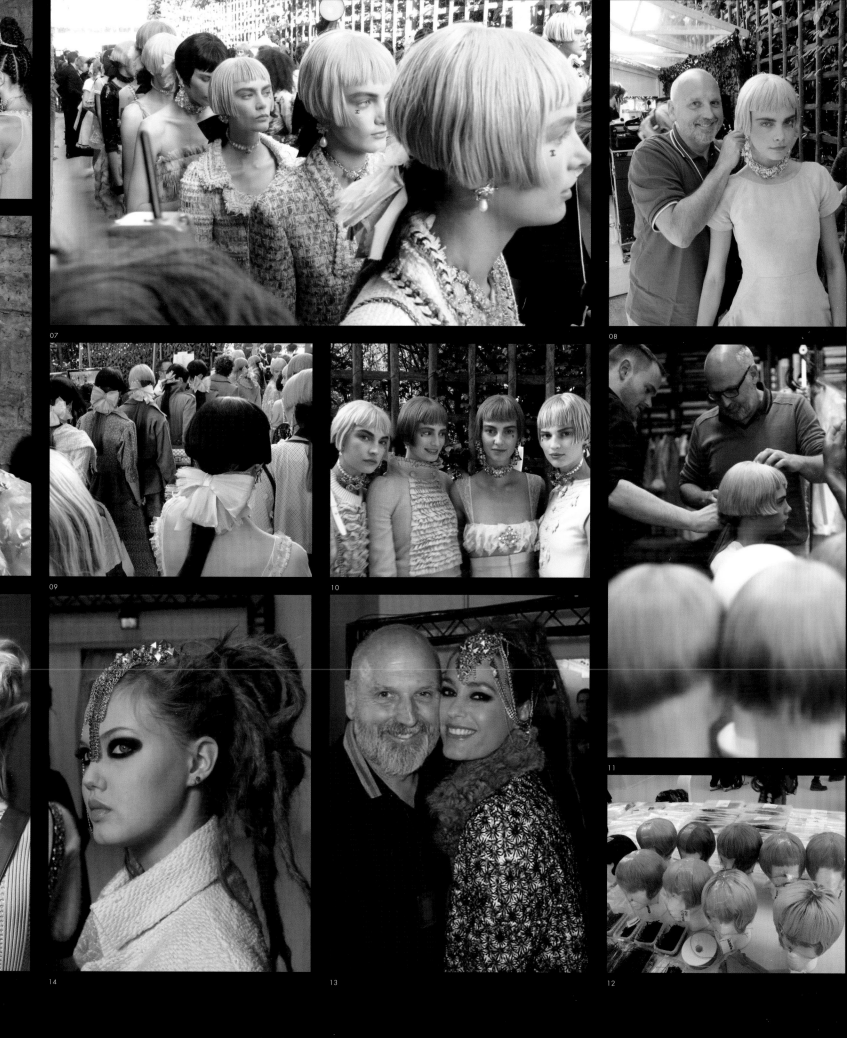

01 – 02
Chanel Ready-to-Wear
Spring 2012.

03 – 06
Chanel *Edinburgh*
Pre-Fall 2013.

07 – 12
Chanel *Versailles*
Resort 2013.

13 – 15
Chanel *Paris-Bombay*
Pre-Fall 2012.

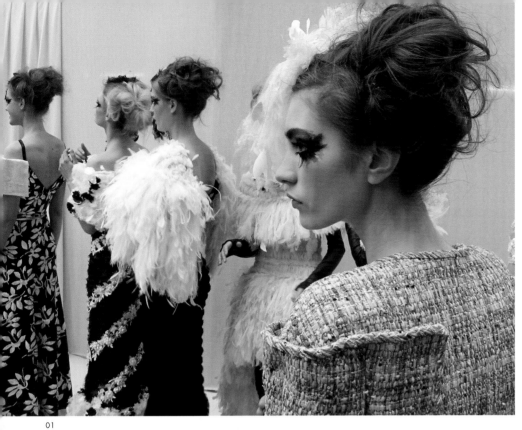

01

02

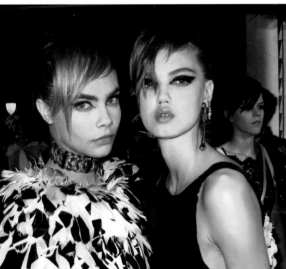

03

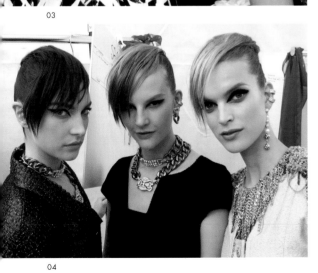

04

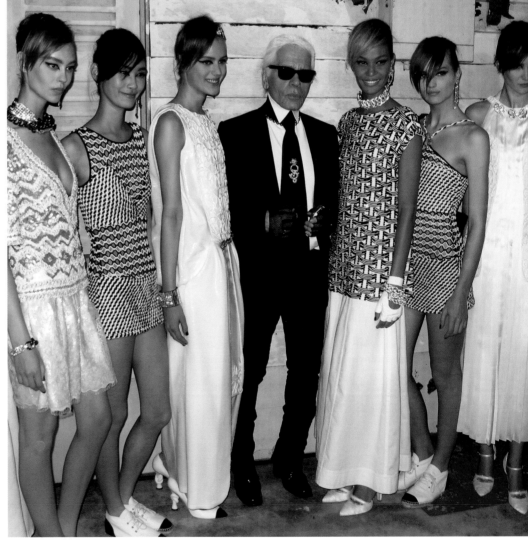

05

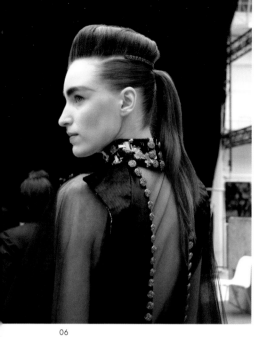

06

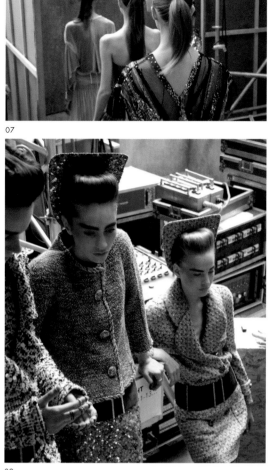

07

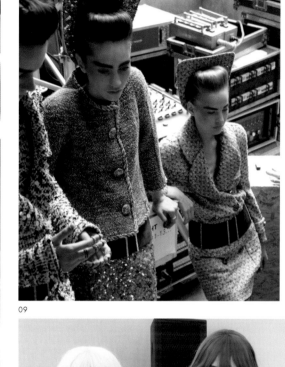

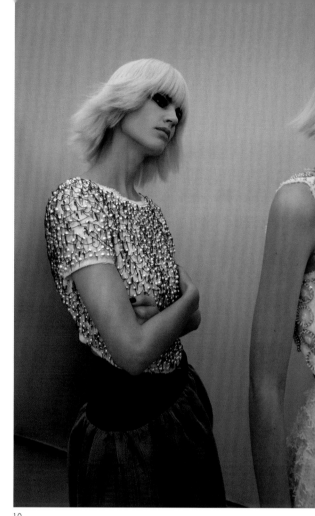

08

09

10

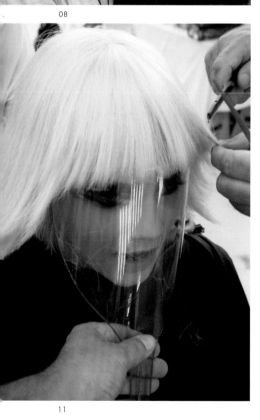

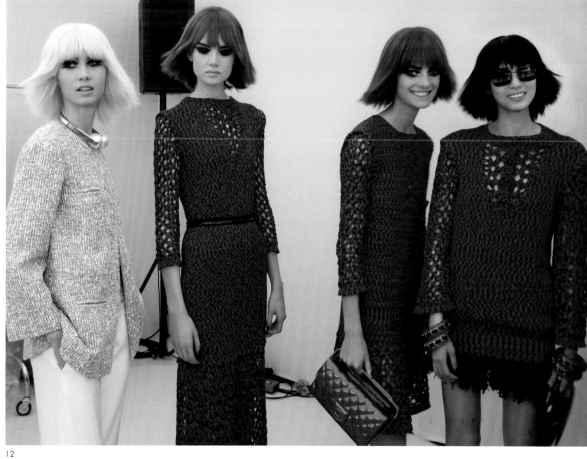

11

12

01 — 02

Chanel Haute Couture
Spring 2013.

03 — 05

Chanel *Singapore*
Resort 2014.

06 — 09

Chanel Haute Couture
Fall 2013.

10 — 12

Chanel Ready-to-Wear
Spring 2014.

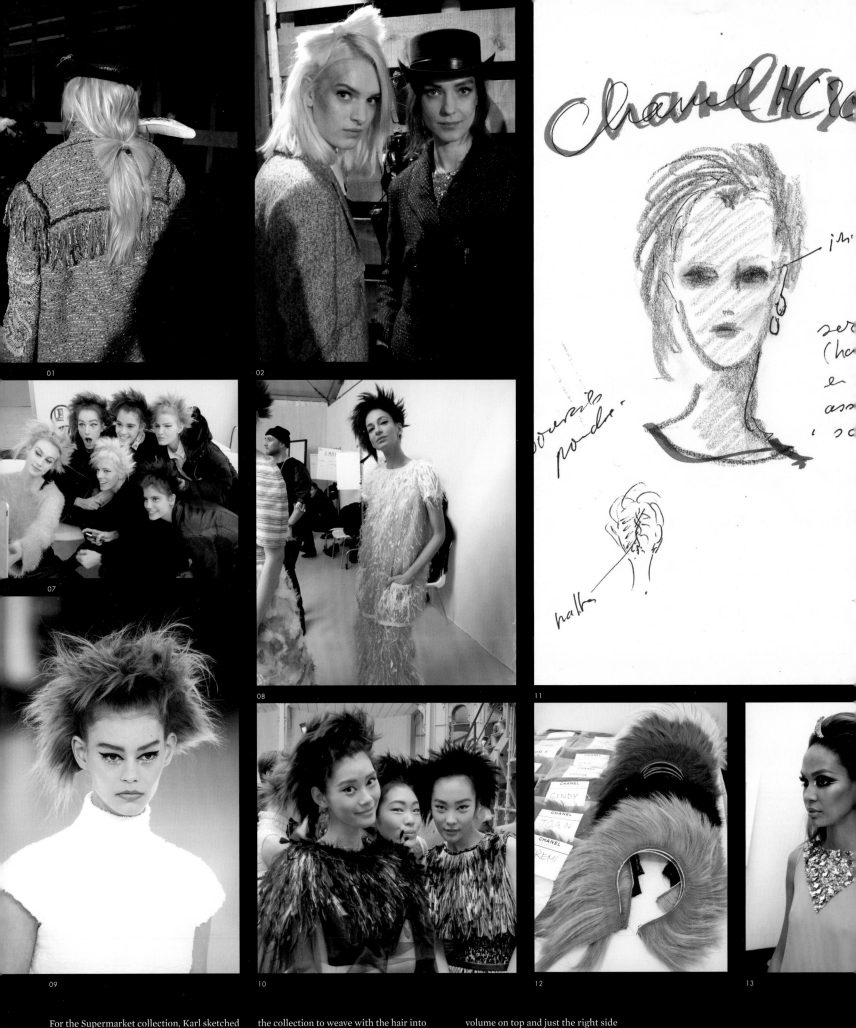

01

02

07

08

11

09

10

12

13

For the Supermarket collection, Karl sketched an oversized ponytail that became a surreal exaggeration in my hands. For the details within the ponytails, we used torn-off strips of the tweeds and printed silks from the collection to weave with the hair into mini braids and crimps. For the Paris-Rome collection, with Karl's idea of a Sixties French actress on a Roman film set, the hair developed into a modern Sixties hairdo, with volume on top and just the right side of undone. With all these looks, I never try to be too one-dimensional or serious with the end result. I always try to keep that sharp Lagerfeld wit.

214

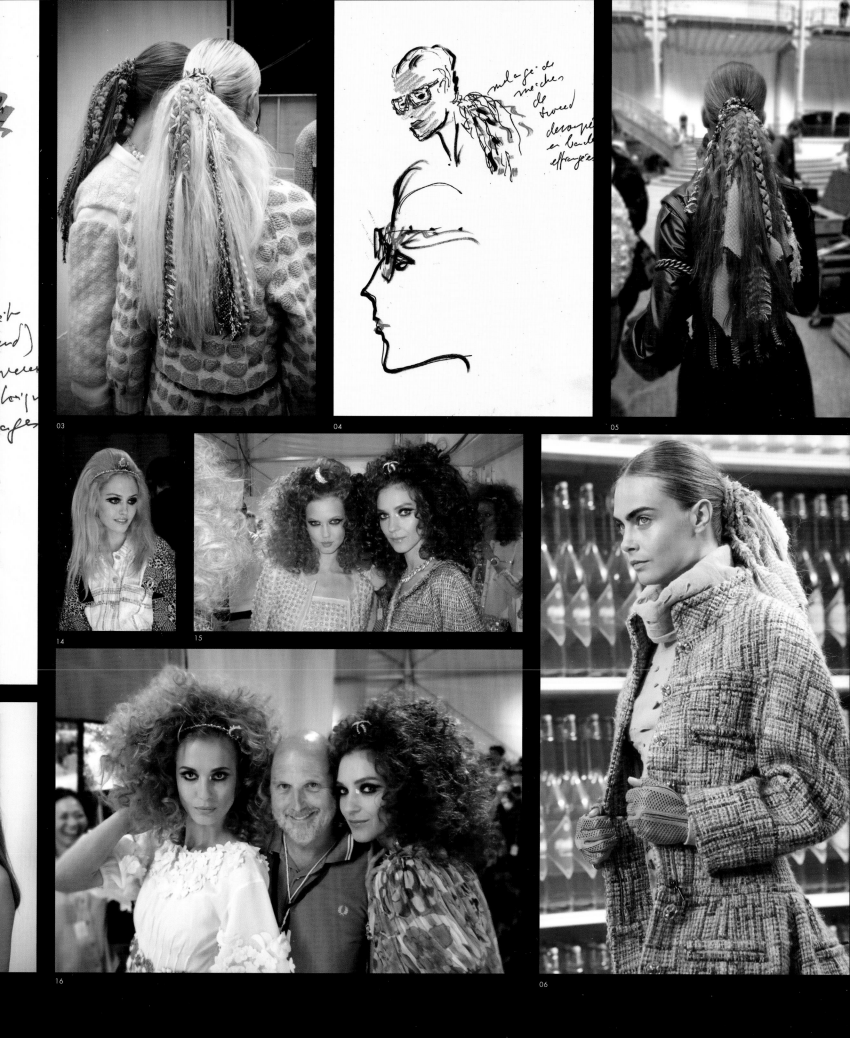

03

04

05

14

15

16

06

01 — 02
Chanel *Dallas* Pre-Fall 2014.

03 — 06
Karl's illustration and Chanel
Ready-to-Wear Fall 2014.

07 — 12
Karl's illustration and Chanel
Haute Couture Spring 2014.

13 — 16
Karl's illustration and Chanel
Dubai Resort 2015.

01

02

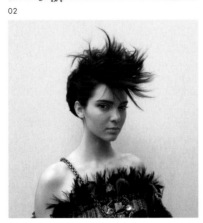

03

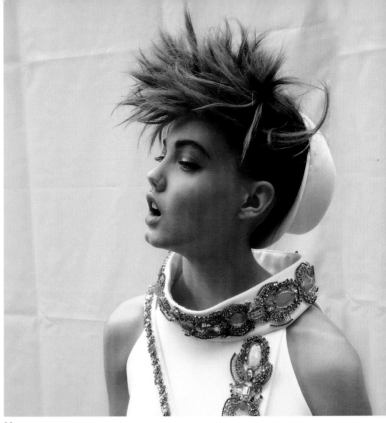

04

05

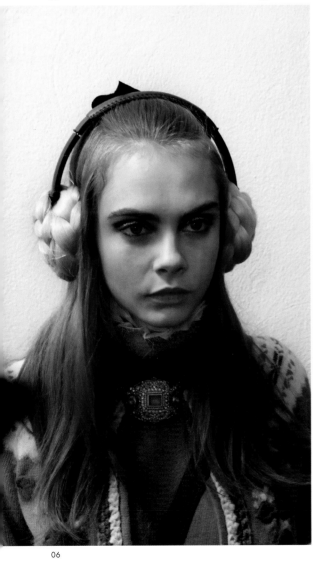

06

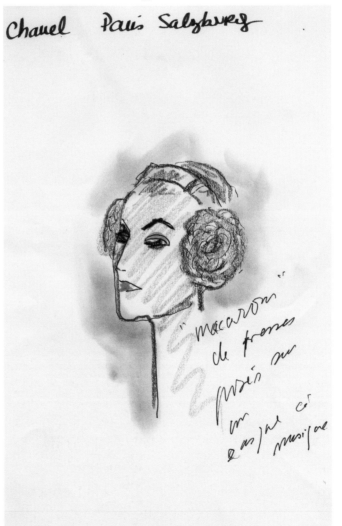

Chanel Paris Salzburg

07

08

09

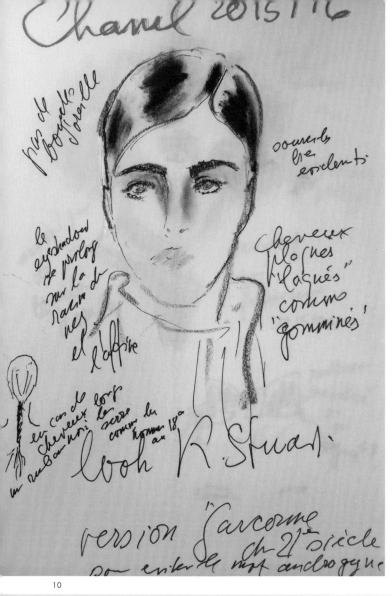

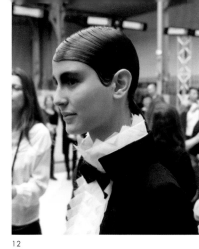

13

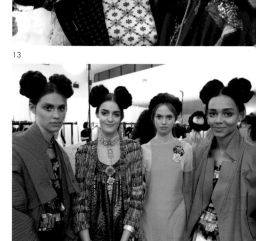

15

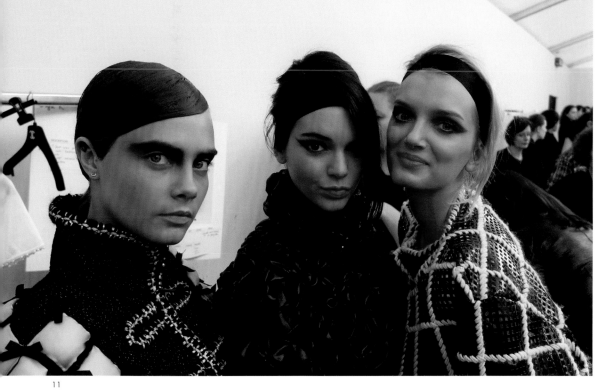

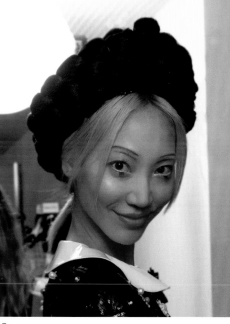

17

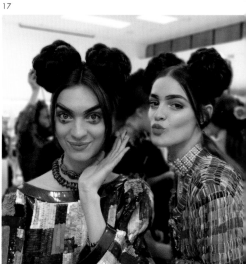

10

11

12

14

16

18

01 — 05

Karl's illustration and Chanel
Haute Couture Fall 2014

06 — 09

Karl's illustration and Chanel
Salzburg Pre-Fall 2015

10 — 14

Karl's illustration and Chanel
Ready-to-Wear Fall 2015

15 — 18

Chanel *Seoul* Resort 2016

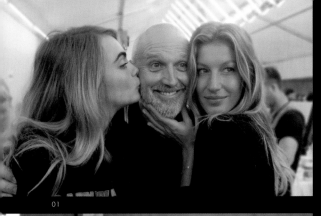

01

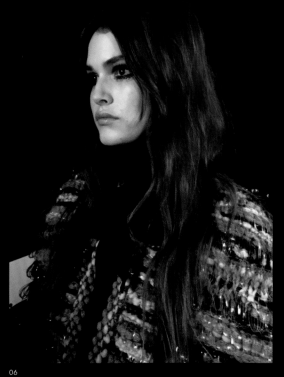

04

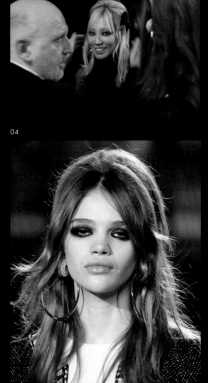

05

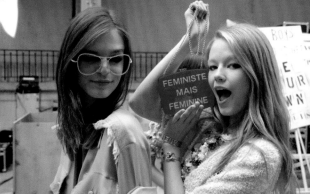

02

06

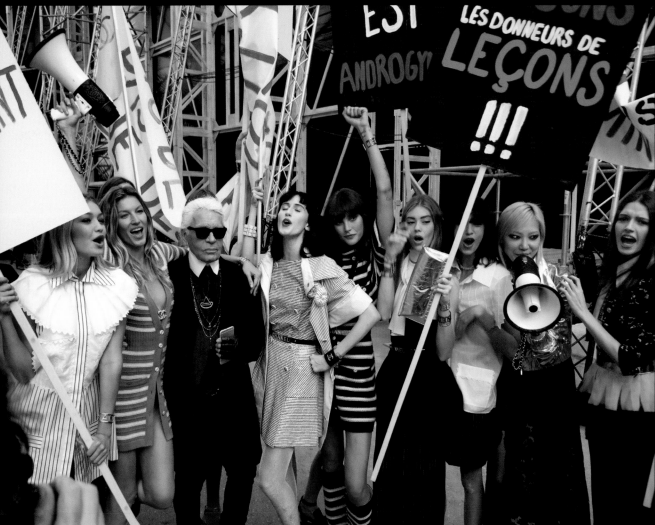

03

07

13

Karl has a different vision for every Chanel show and it's my challenge to create a different look each time. These are more than just fashion shows; they are art installations, theorical spectacles that originally elevated to

have an impact. Whatever look we do has to have a definite point of view, be consistent in its execution, and be strong enough to be understood by the spectators. The silhouette and detail of the hair and makeup in these

theatrical spectacles can help drive home the message of the collection. It helps if the beauty look is instantly Instagram-able, bringing an immediate global response.

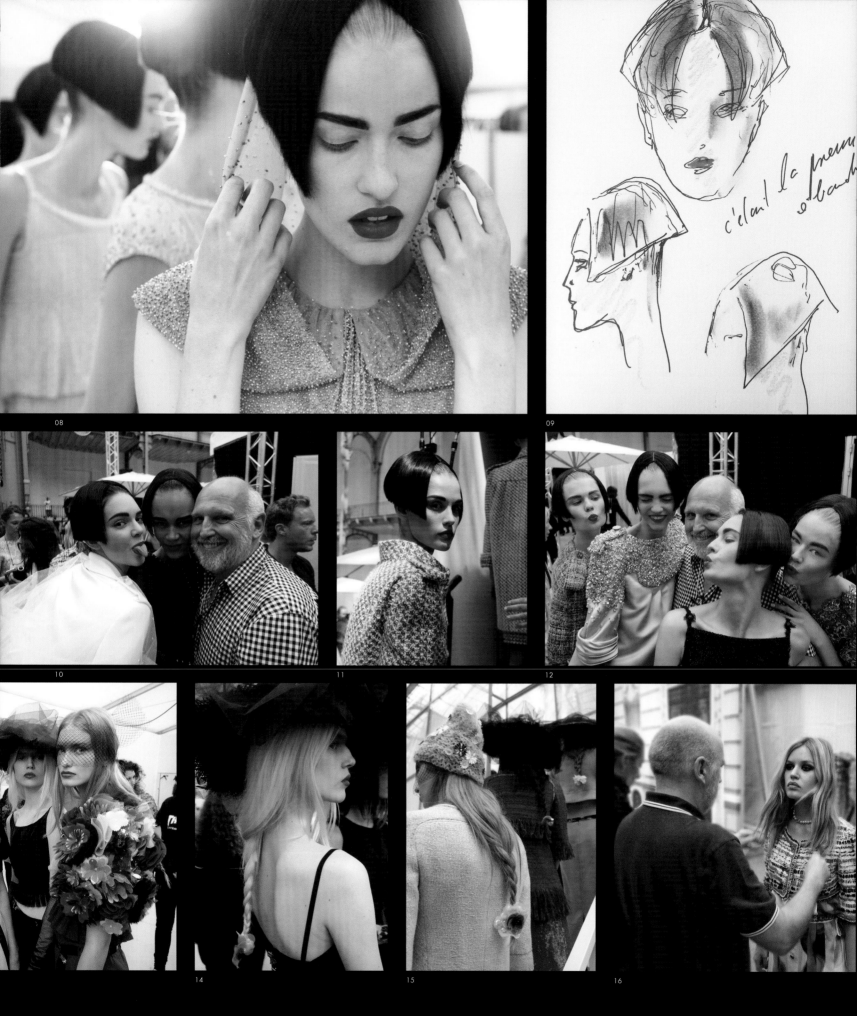

08
09
10
11
12
14
15
16

01 – 03
Chanel Ready-to-Wear
Spring 2015.

04 – 07
Chanel *Rome* Pre-Fall 2016.

08 – 12
Karl's illustration and Chanel
Haute Couture Spring/
Summer 2015.

13 – 16
Chanel Haute Couture
Spring/Summer 2015.

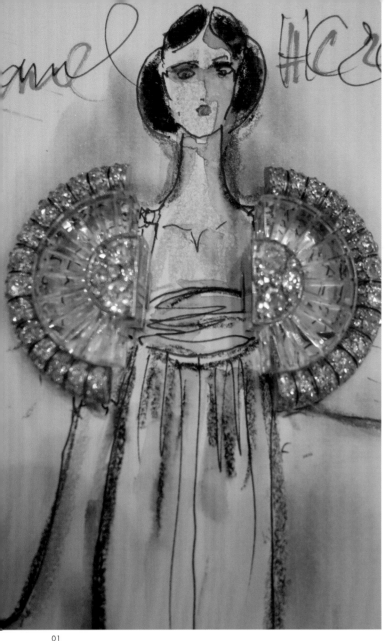

01

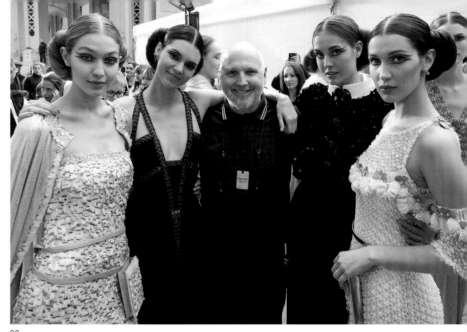

02

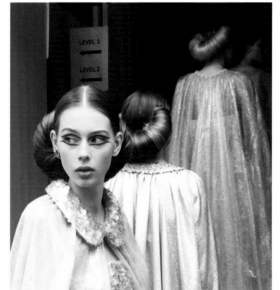

03

04

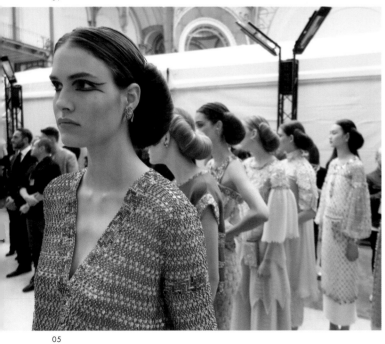

05

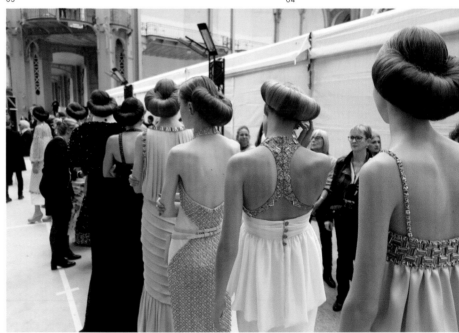

06

Karl's genius idea of the exaggerated croissant-shaped chignon at the haute couture Summer 2016 show was a perfect finish to the long, narrow sculptural silhouettes of the collection. All these ideas begin with a thought process, which develop into shape, texture, colour, scale, and detail in the course of a few weeks. The thousands of hairpieces and wigs—fifty to one hundred for each show—are made by my brilliant team of hairdressers in my London studio the week before the show.

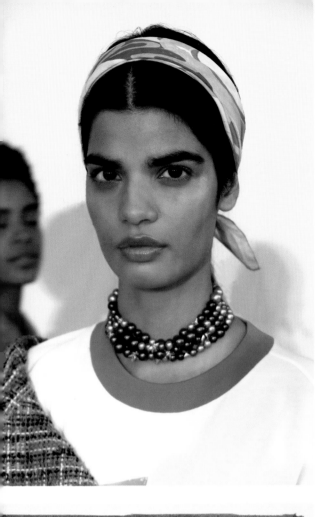

08

09

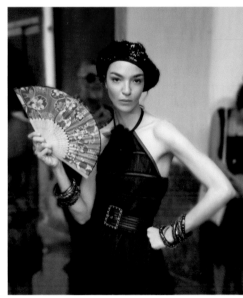

10

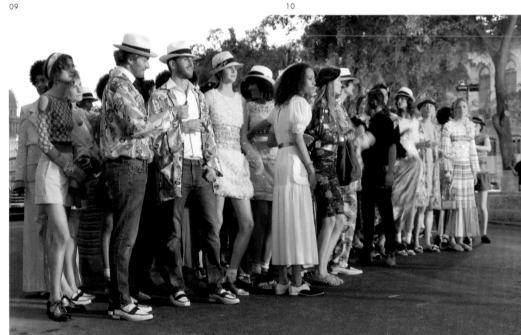

12

11

01

Karl's illustration.

02–06

Chanel Haute Couture
Spring/Summer 2016.

07–11

Chanel *Cuba* Resort 2017.

12

Karl's illustration.

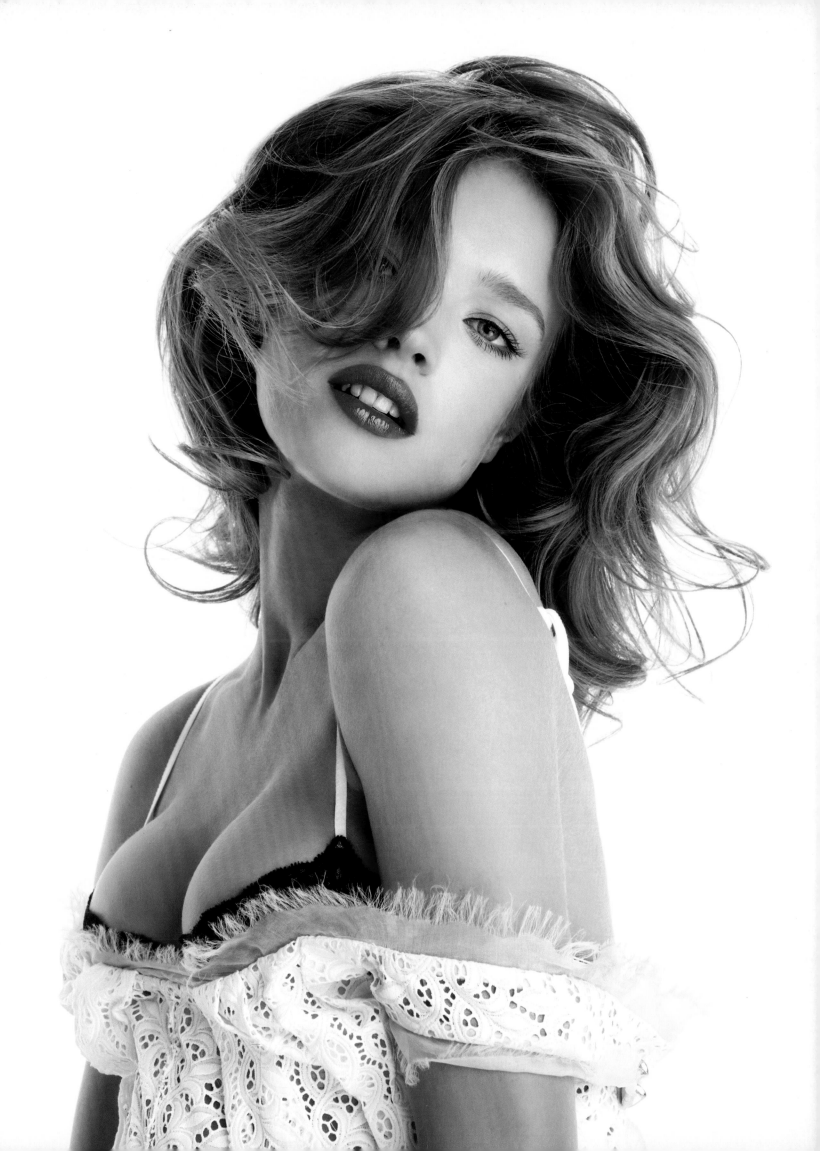

SEXY

There is a certain confidence about a woman who takes care of her hair. I believe that healthy hair gives that confidence. Abundant, well-treated hair you touch, run your fingers through, daring to let it fall wherever it pleases, and however you push it or pin it, pull it back or change the colour dramatically, it will always look good.

"Sam has magic fingers, he makes hair look effortless and can make any girl feel confident, feel their best, just with his touch. I see all the models and actresses smile when they are with him, because they relax and they fall in love with him. You can trust Sam and in return his touch on your hair is magic.

It's not because he comes to a shoot with lots of assistants and the most suitcases—often he just comes on his own. But what he does bring is very important: such big talent and experience and, most crucially, his genius hands. Sam makes hair effortless, or rather, he makes it look effortless, but really it's his fantastic touch that makes the hair fall into place. His talent is better than all the bags of props and wigs in the world.

Sam is working for the picture, not the hair. For him it's about the picture making, and this makes him a very important contributor and collaborator on sets and at shows, as he inspires everyone to give their best.

Sam has a great attitude, and he makes the girls feel confident, feel they can relax and let go. This is when you get the best pictures—and the most beautiful woman."
—Carine Roitfeld

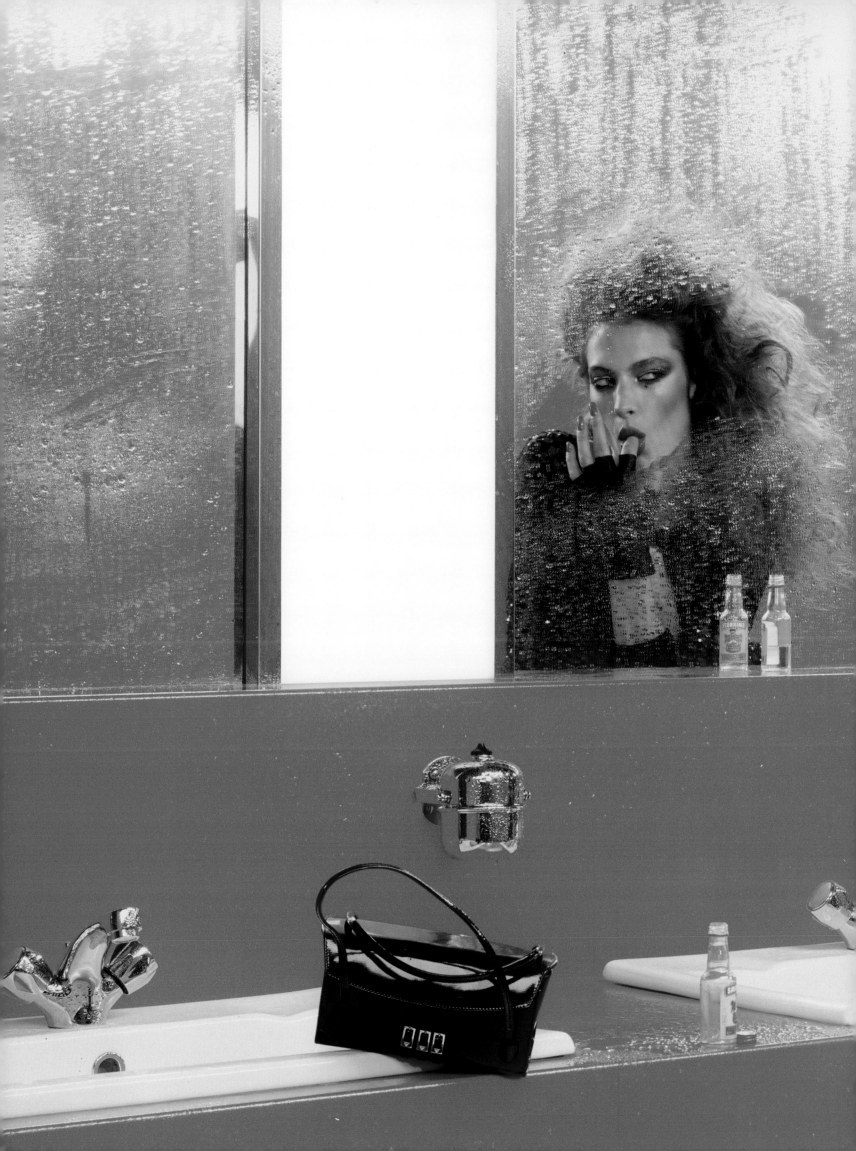

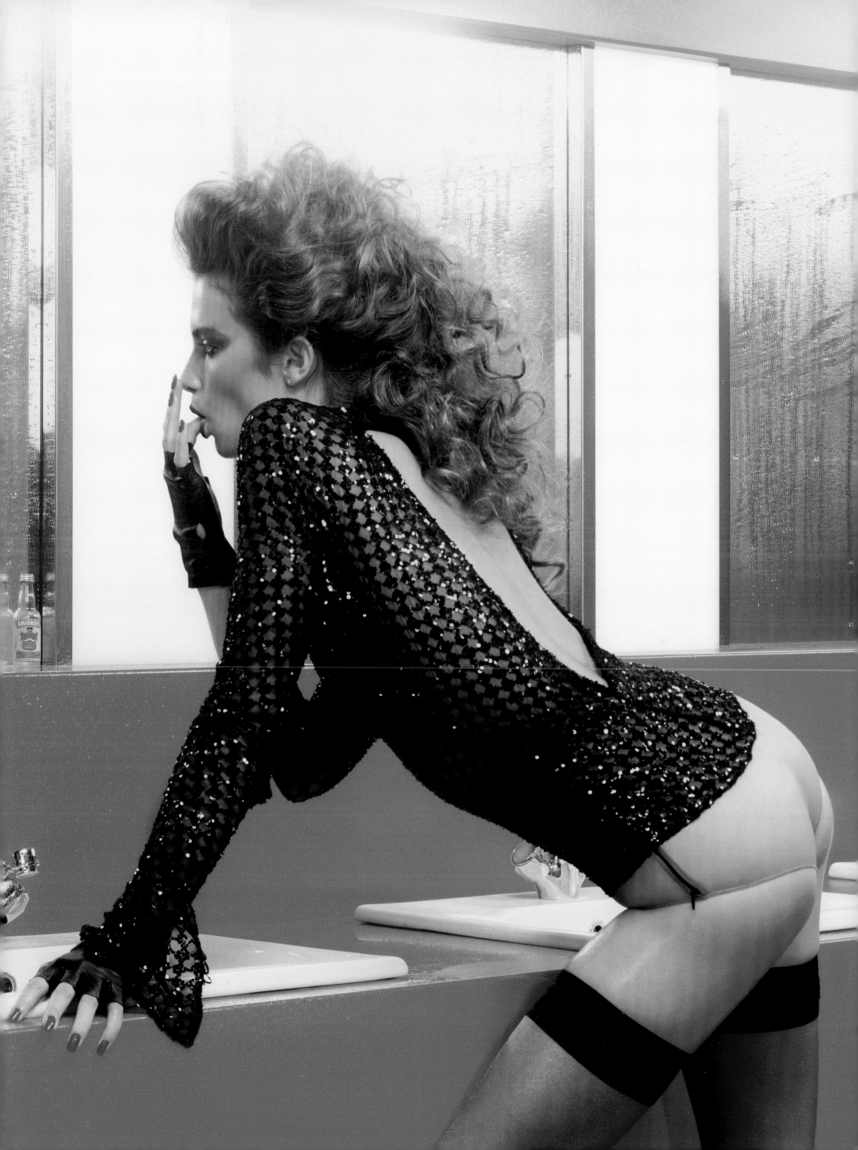

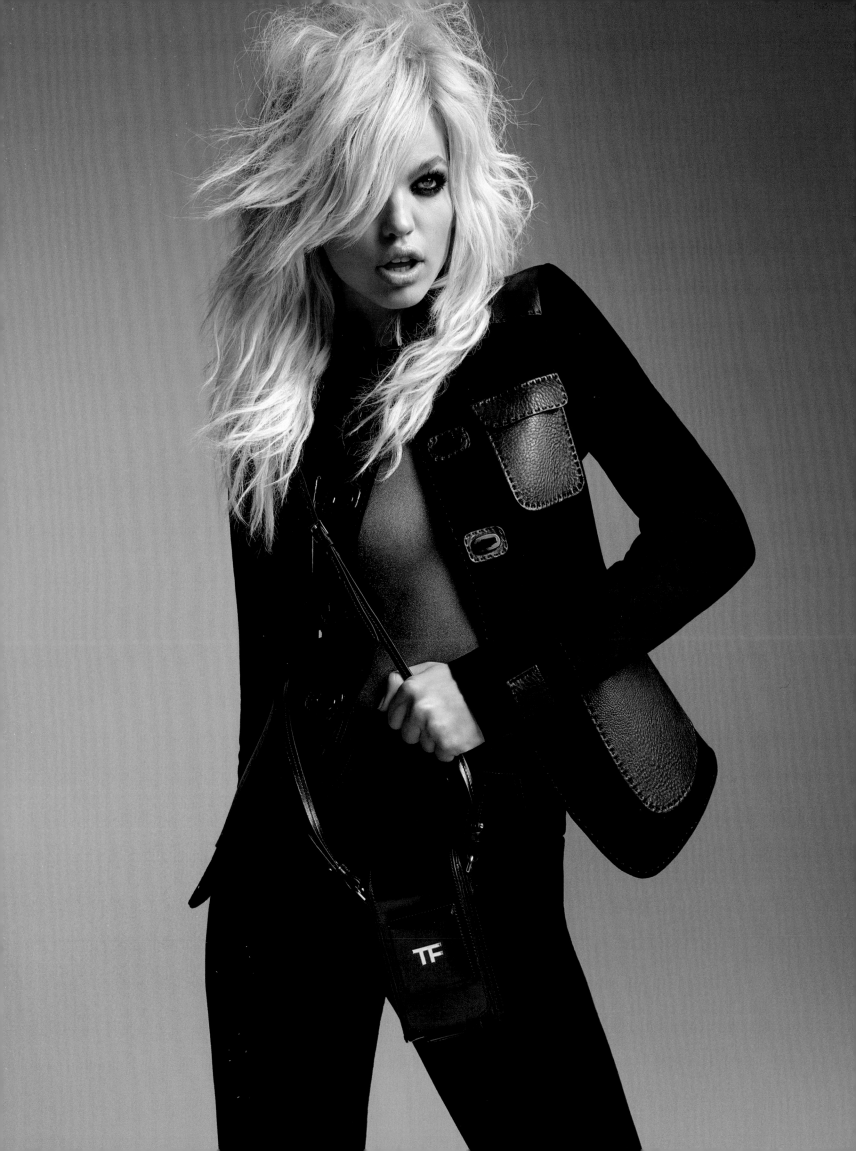

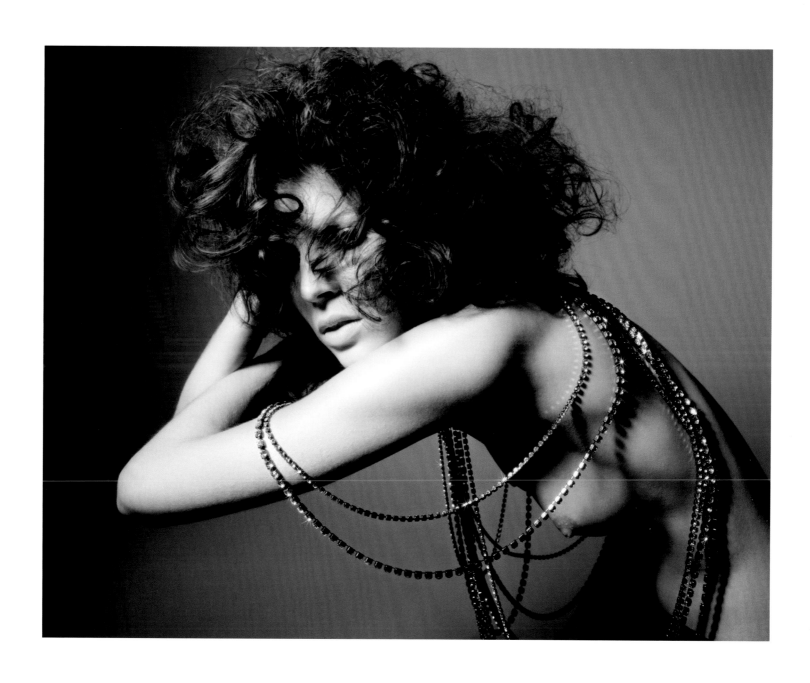

Page 222:

My signature done/undone modern glamour for Natalia Vodianova in British *Vogue*, May 2009. Photograph by Patrick Demarchelier.

Previous spread:

Jessica Miller's 1980s attitude for *Numéro*, December 2002. Photograph by Miles Aldridge.

Opposite:

Tom Ford campaigns are constantly redefining sexiness. Daphne Groeneveld in a razor cut wig for the Tom Ford Spring/Summer 2015 campaign. Photograph by Inez van Lamsweerde and Vinoodh Matadin.

Above:

Liberty Ross in *Dress Me Up, Dress Me Down* for SHOWstudio and the Independent, 2005. Directed by Nick Knight.

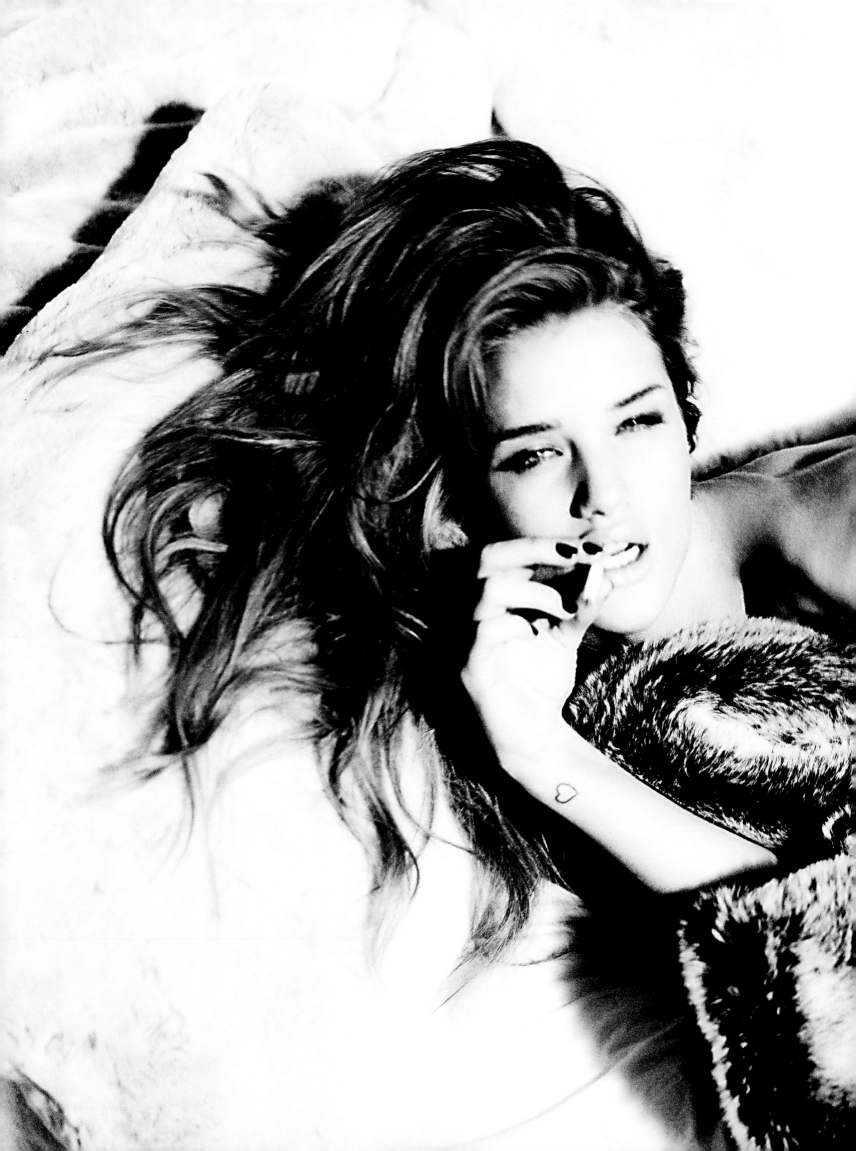

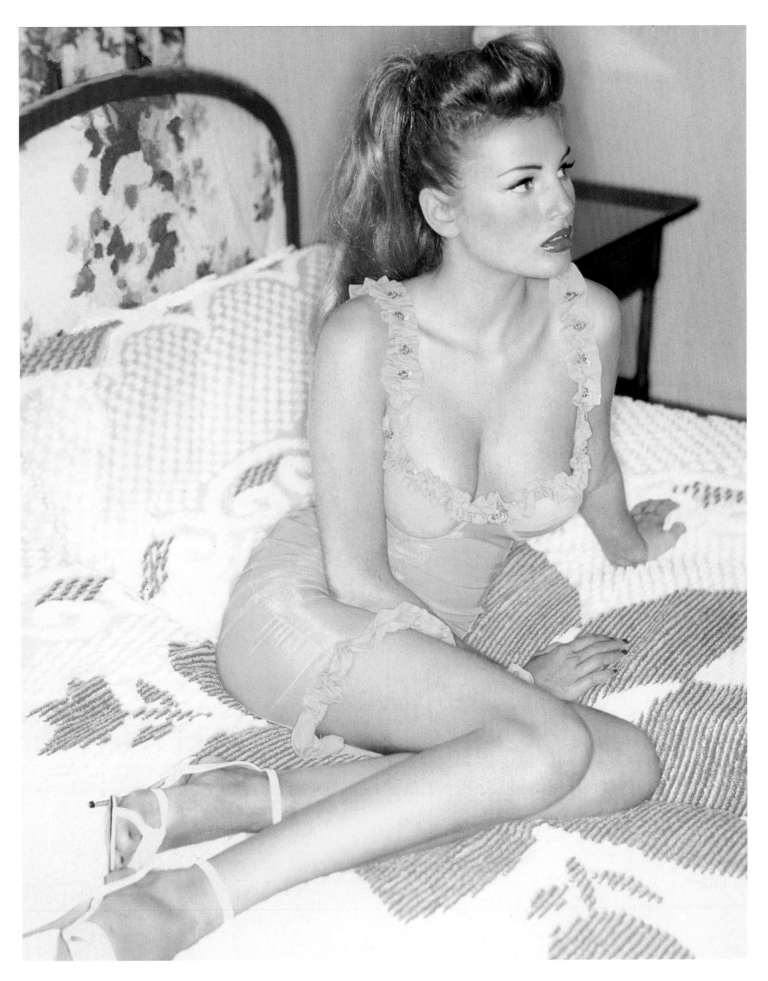

Previous pages:

Rosie Huntington-Whiteley as
centrefold for British *GQ*, May 2010.
Photograph by Ellen von Unwerth.

Above and opposite:

The smouldering beauty of Bridget
Hall in two different Ellen von Unwerth
shoots. British and Italian *Vogue*,
March 1995.

230

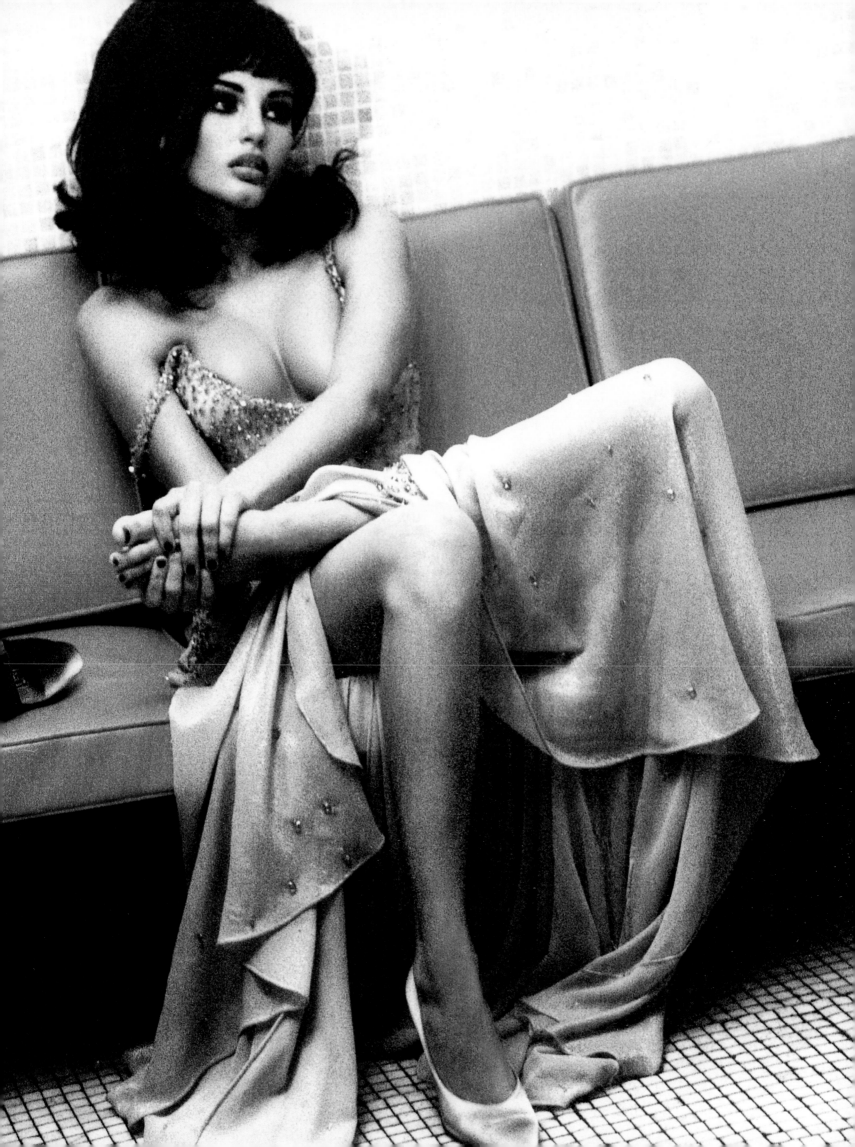

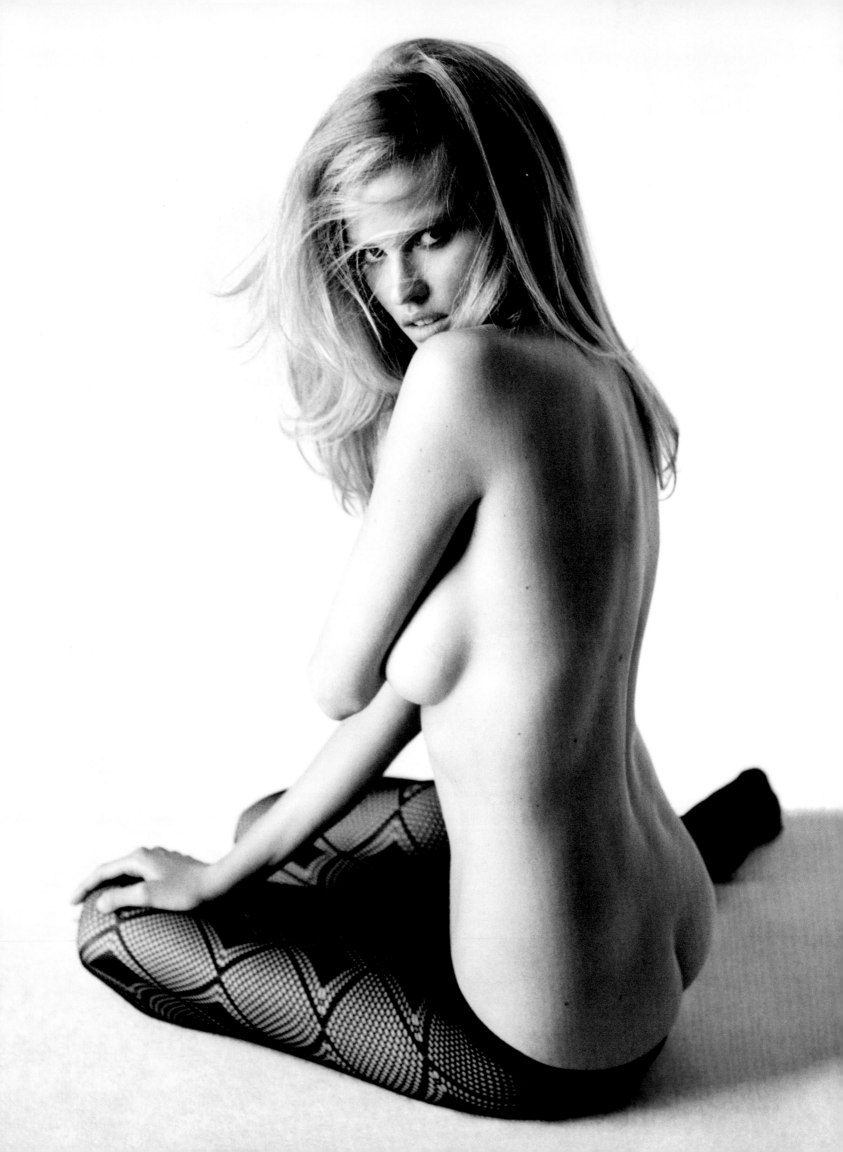

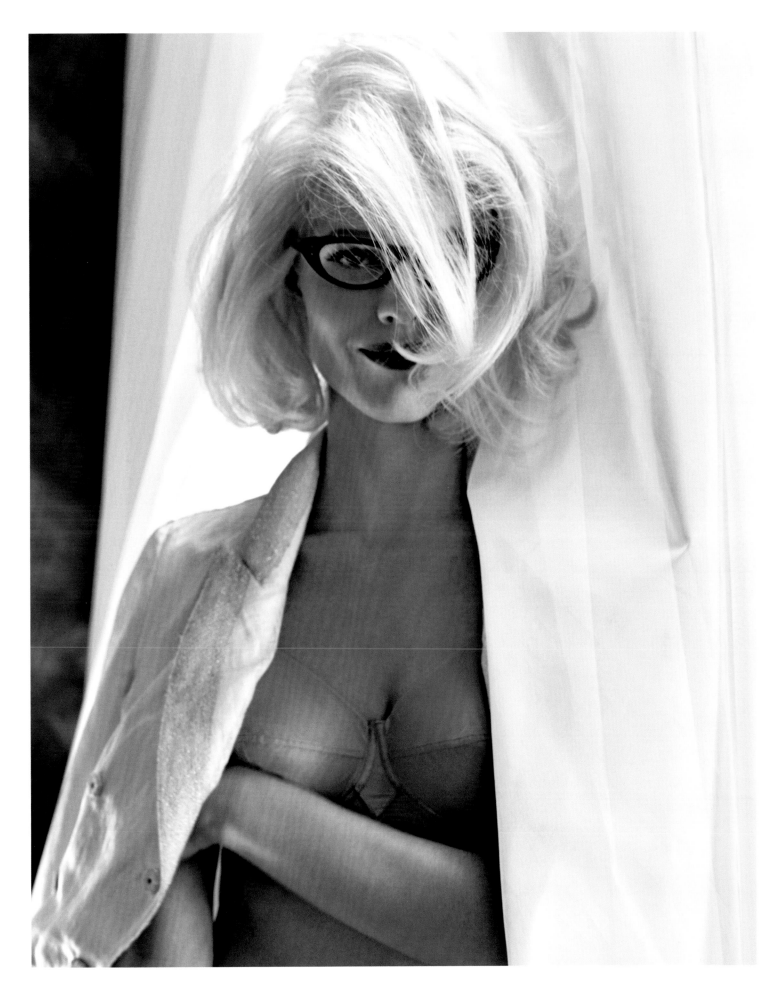

Opposite:

Lara Stone for British *GQ*, October 2011.
Photograph by Mario Testino.

Above:

A bewigged Eva Herzigova for
Italian *Vogue*, May 2005. Photograph
by Emma Summerton.

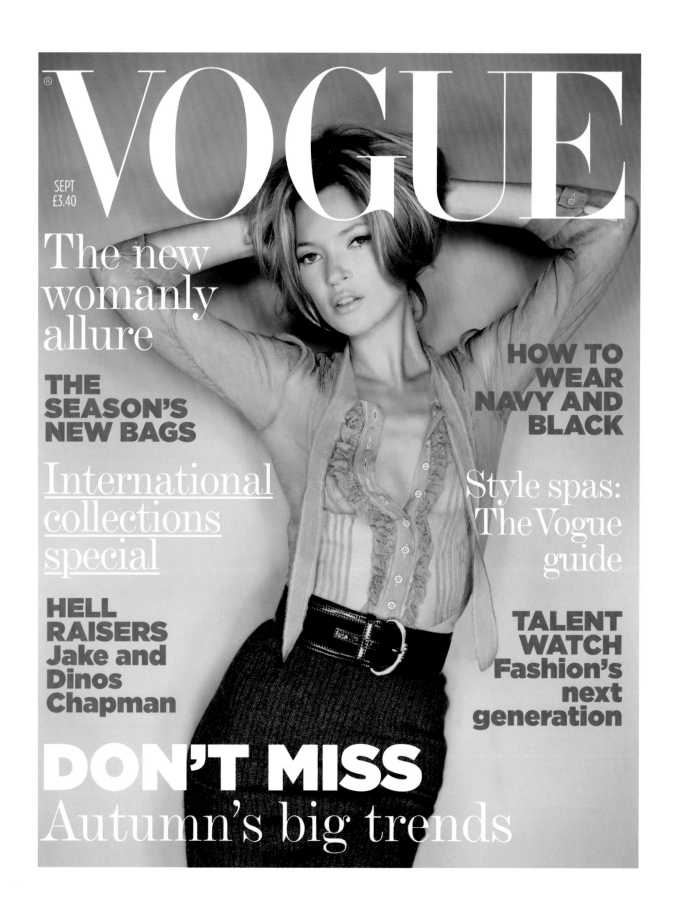

VOGUE

SEPT
£3.40

The new
womanly
allure

THE
SEASON'S
NEW BAGS

International
collections
special

HELL
RAISERS
Jake and
Dinos
Chapman

HOW TO
WEAR
NAVY AND
BLACK

Style spas:
The Vogue
guide

TALENT
WATCH
Fashion's
next
generation

DON'T MISS
Autumn's big trends

Above:

Provocateurs. One of my all-time
favourite *Vogue* covers. Kate Moss
for British *Vogue*, September 2005.
Photograph by Nick Knight.

Opposite:

Milla Jovovich for Anna Molinari
Spring/Summer 1996.
Photograph by Juergen Teller.

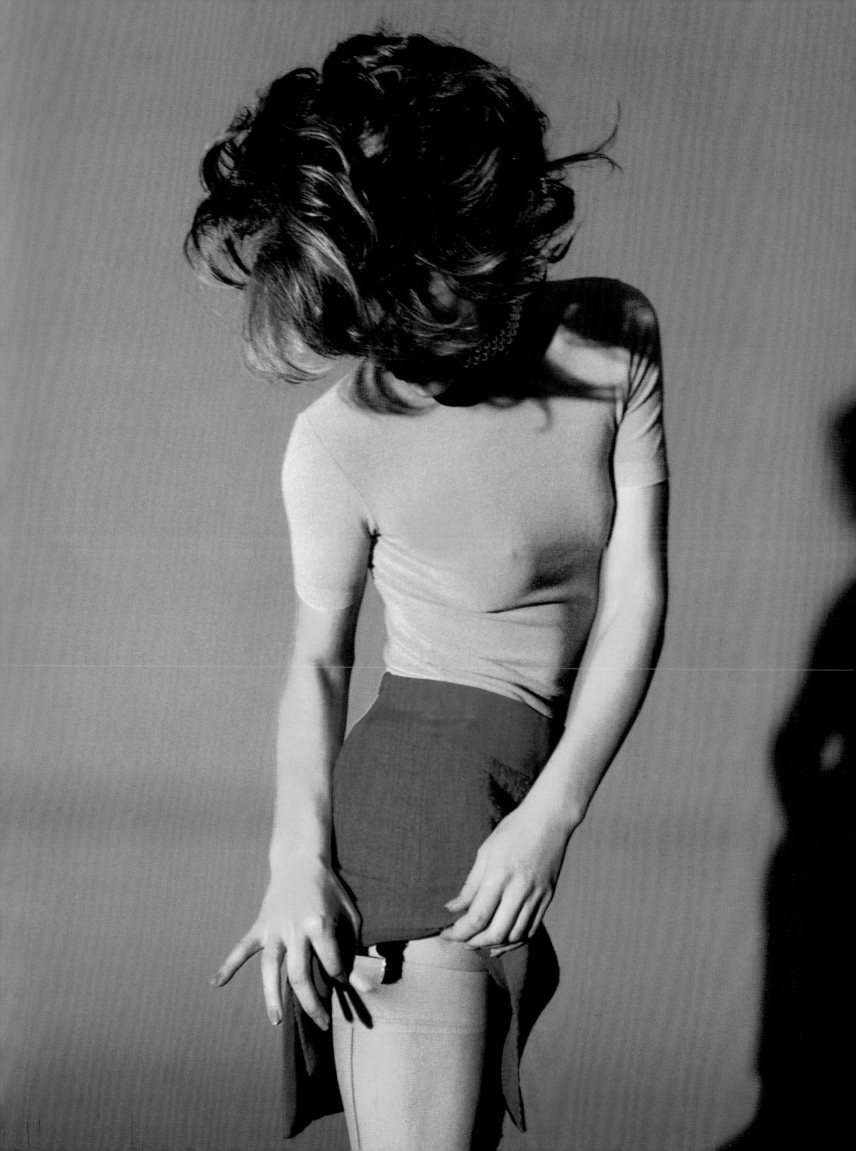

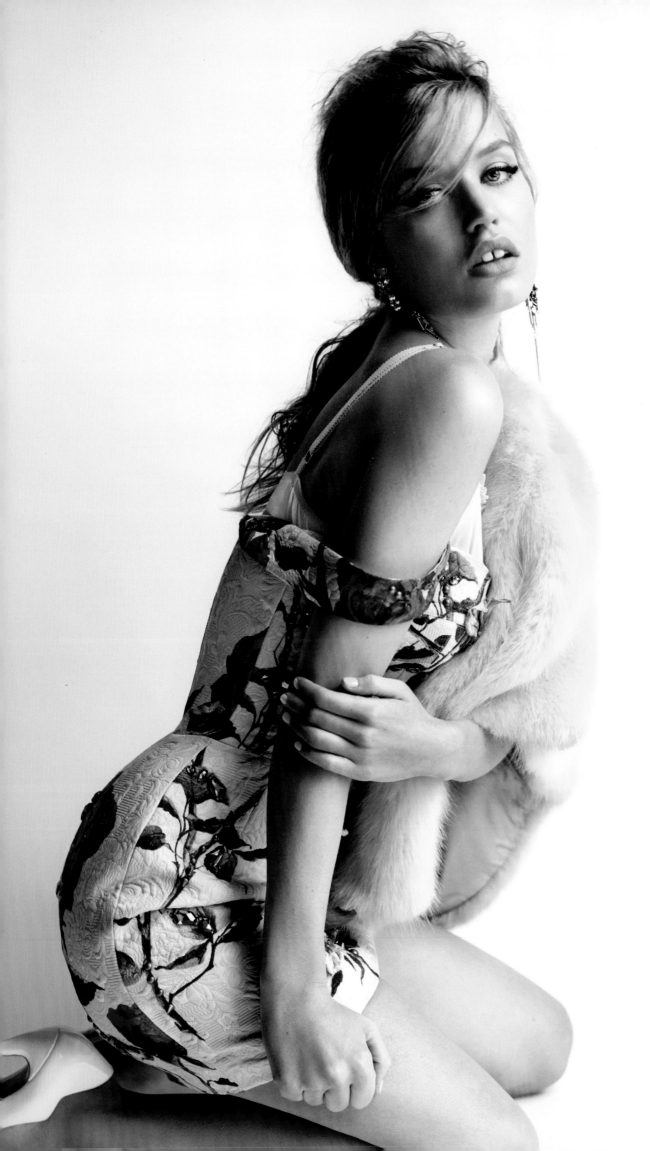

VOGUE

PARIS

Mars n°965

Mode :
LE STYLE
N'A
PLUS
DE
TABOU.

Isabelle
Huppert
Message
personnel.

Gigi Hadid

LE
CORPS
phénomène
aux
10 *millions*
de fans.

Opposite:

Vargas pin-up girl Georgia May
Jagger for British *Vogue*, April 2005.
Photograph by Mario Testino.

Above:

Gigi Hadid on the cover of French
Vogue, February 2016. Photograph
by Mert Alas and Marcus Piggott.

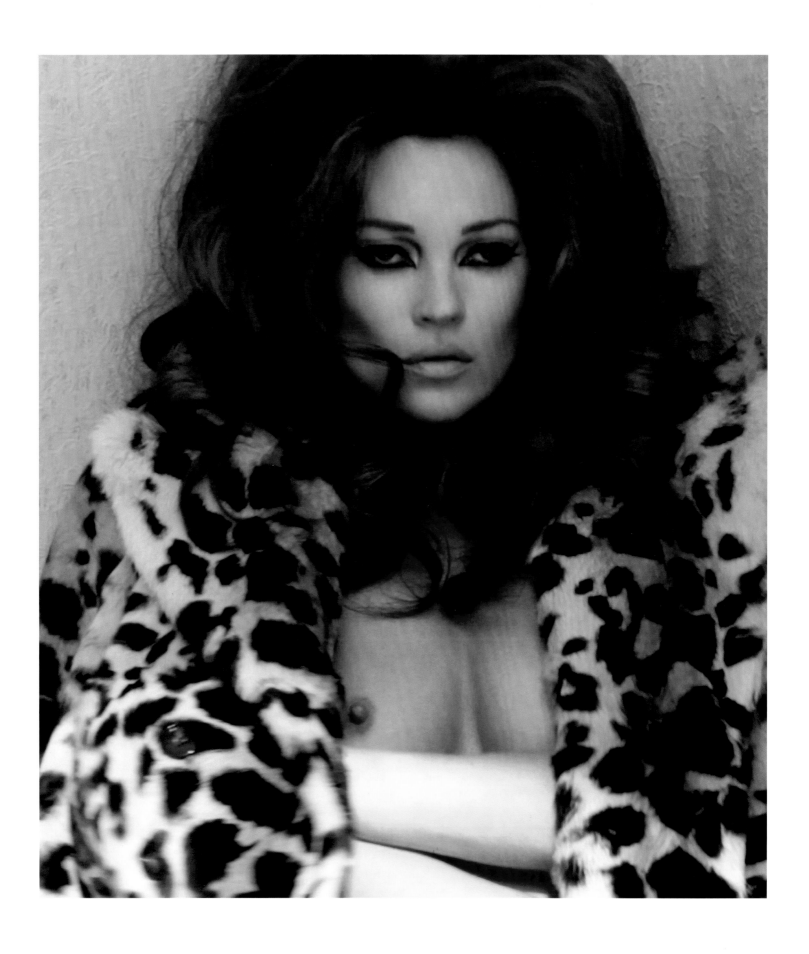

Above:

Kate Moss channelling Priscilla Presley for Italian *Vogue*, December 2010. Photograph by Nick Knight.

Opposite:

Lily Donaldson on location for British *Vogue*, August 2009. Photograph by Patrick Demarchelier.

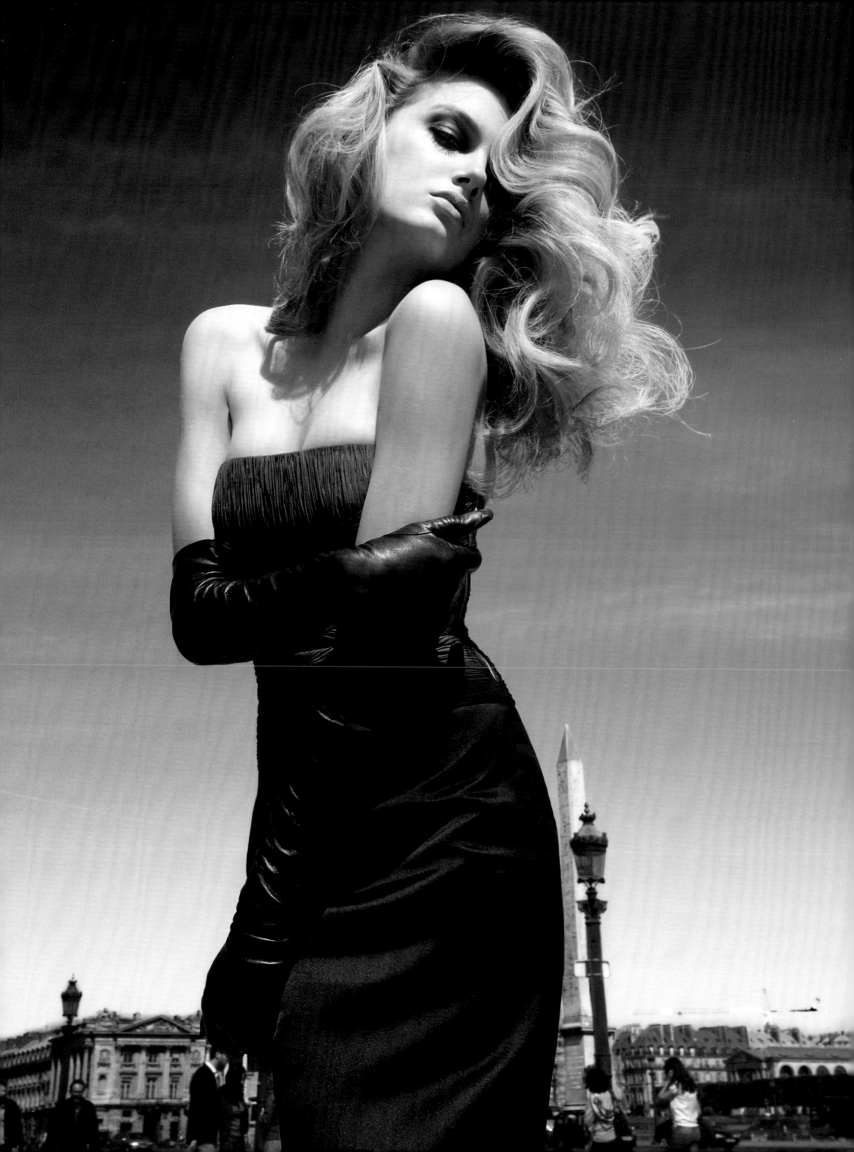

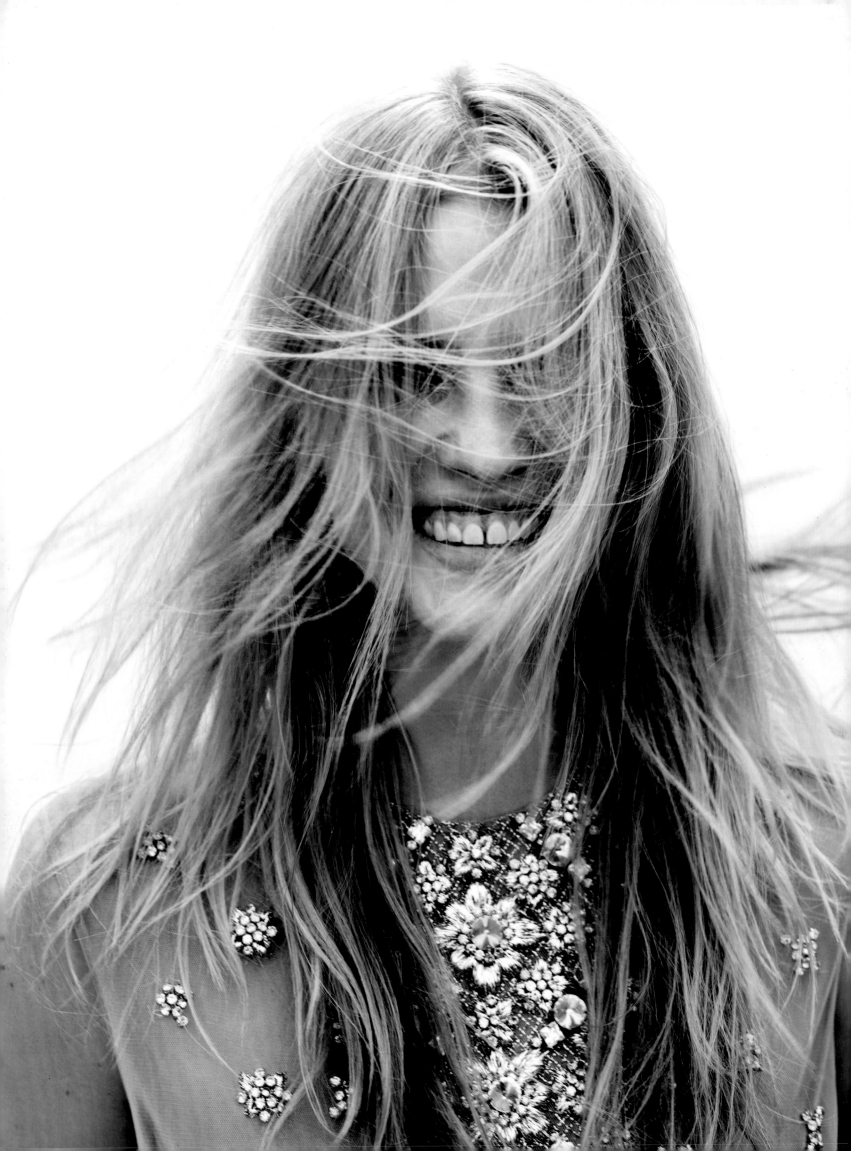

COOL GIRL

On countless occasions at both shoots and shows, I've witnessed this scene: A model walks in, and the editor, art director, or designer says, "I want the hair to look natural, like when she walked in." What they *really* mean is that they want a photo- or runway-ready version of that hair: a little amped up, ever so slightly perfected, prettily mussed. And for that hair, they want Sam.

Natural means easy, breezy, textured, wavy, *sexy*, layered, and, most of all, lived in and loved. Look at the body of Sam's work—nobody does it like him. It's his signature. Natural is always worn down, loose rather than up. Its "naked" hair that can fit many styles—beachy, windswept, urban, rural—and works both day and night. "Effortless" is the hair look designers want for their collections, to help the clothes move from the catwalks of Chanel, Isabel Marant, Balmain, and Burberry into your wardrobe. It's also the look associated with the most influential editors and the models with a cult following: Kate Moss, Gisele Bündchen, Freja Beha, Daria Werbowy, Gigi Hadid, Cara Delevingne. It's the antithesis of a rigid, lacquered salon style, and it also reflects a change in direction from the polish of editorials in previous decades. With her first cover for American *Vogue*, Anna Wintour set the tone—denim jeans and natural, healthy hair.

Sam invented natural hair in the 1970s while working at Molton Brown, the salon that fused the idea of organic products with an internationally starry clientele and was famed for banning hair dryers and for using rag rollers that left hair looking Pre-Raphaelite, tousled, tumbled. Sam was the first session stylist to take those ideas and apply them to editorial. Variations on the "new natural" look dominated fashion for much of the 1980s, morphing to fit the grungy 1990s, then evolving further for the new rave 2000s and instant access of the 2010s. Sam could be found at the heart of all of these looks.

Over the past decade, with the boom in blow dry bars and social media, there has been much more access to the world backstage and to beauty tricks and tips, so natural hair is now globally referenced as "done, undone." Sam coined that phrase to explain the recipe for achieving the natural look. When hair is "done, undone," you style it, then take it apart so that it relaxes and you can run your fingers through it. Touch and texture—created with everything from a rough blow dry to his "magic touch" and massaging volume into the roots—are key to this look. Sam said and did it first and creates the ultimate natural editorial hair. Cool girl hair. Enviable hair that is perfectly done—yet undone.

– Anna-Marie Solowij

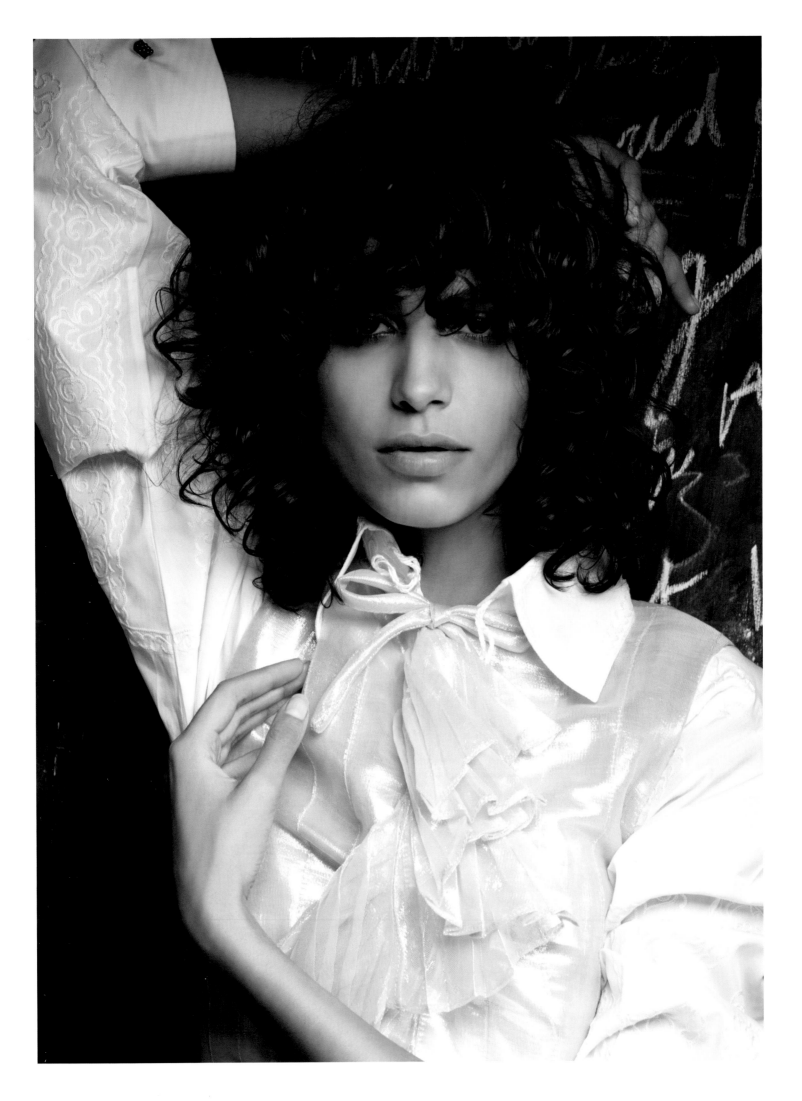

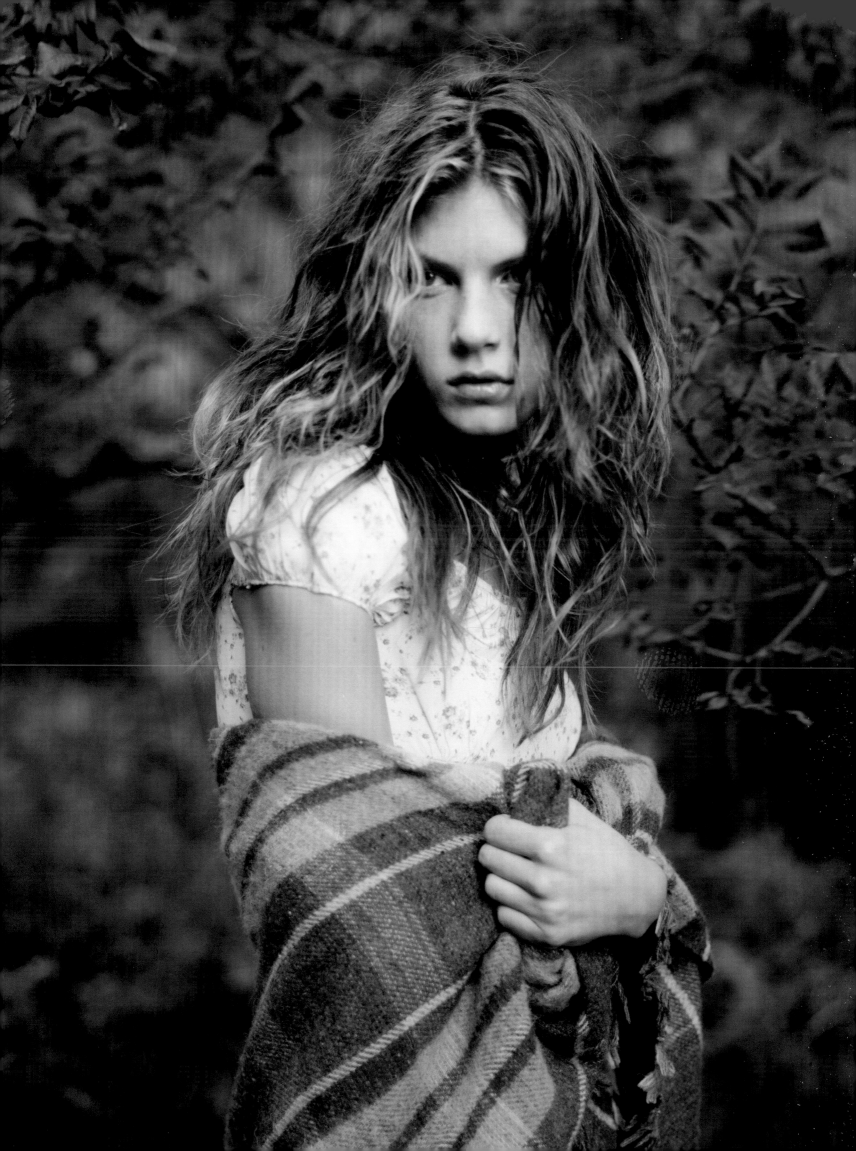

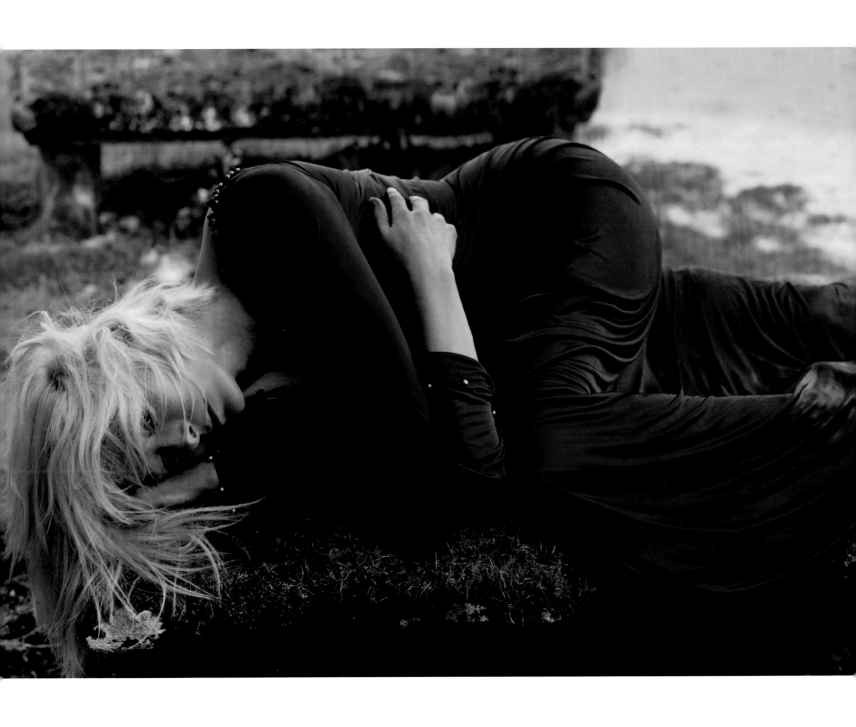

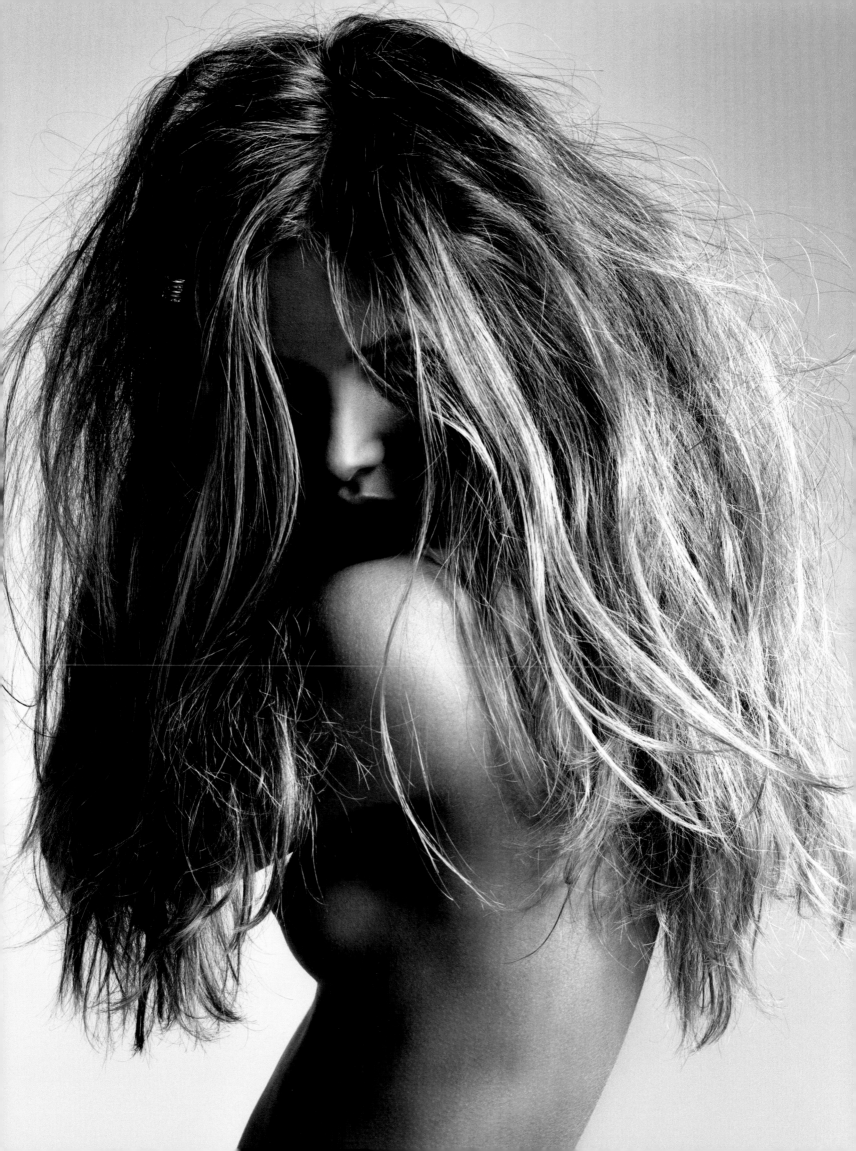

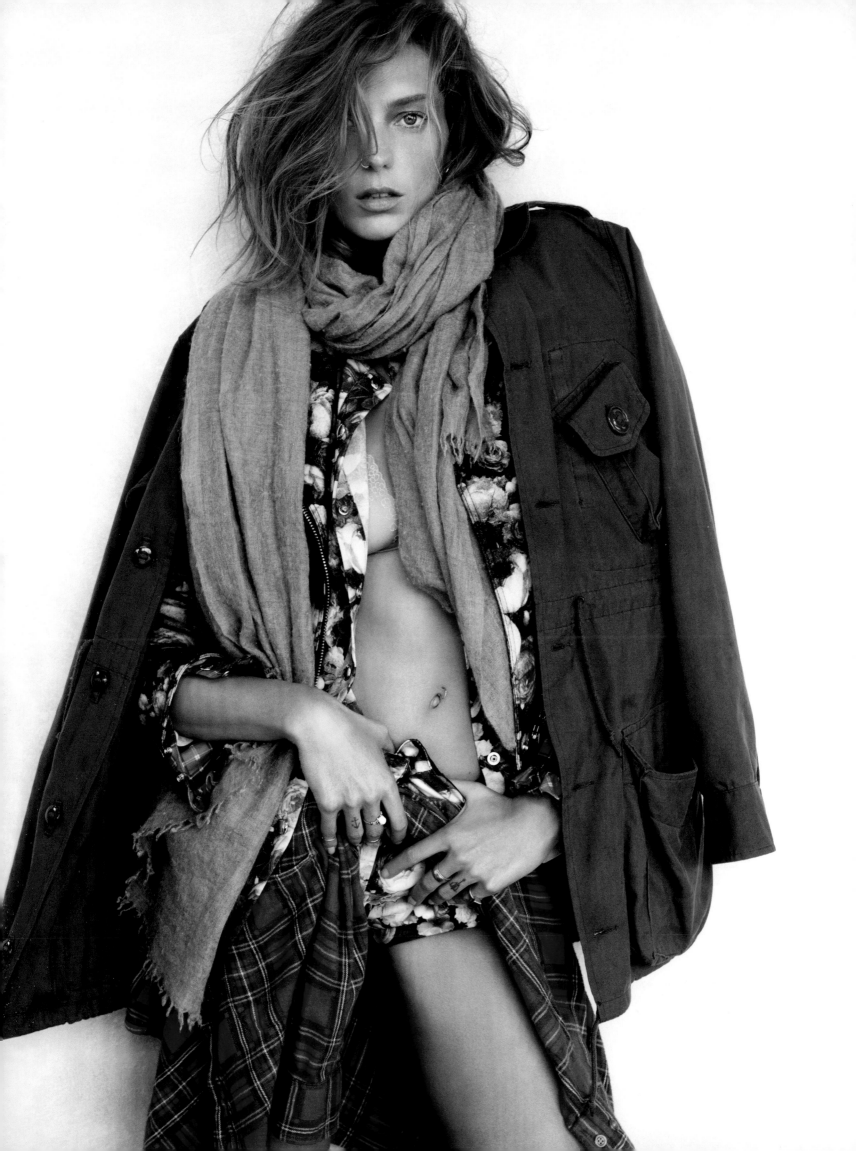

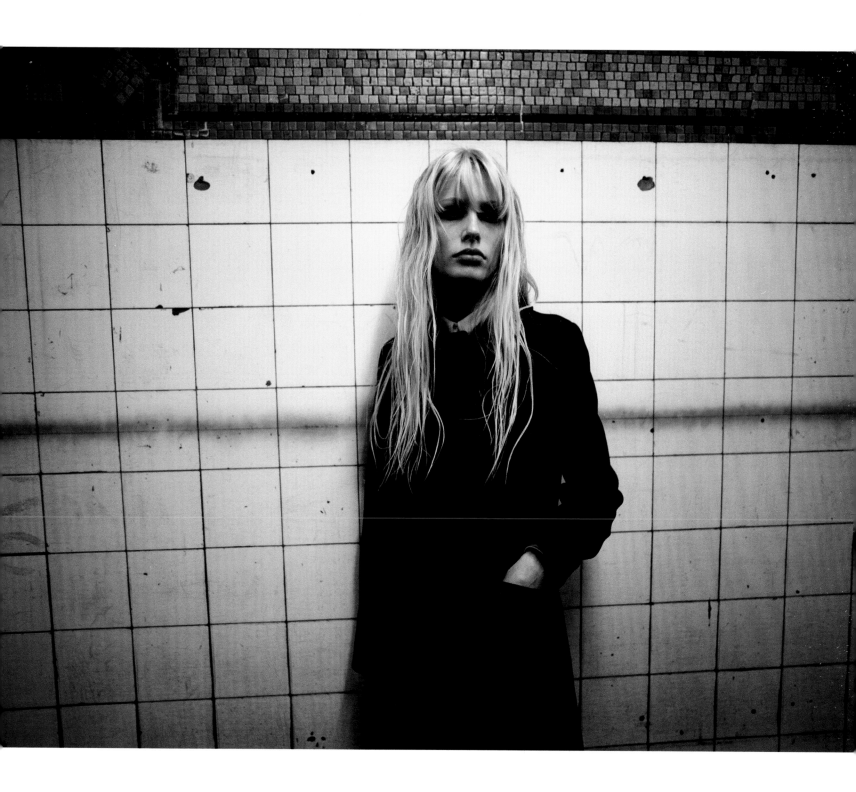

The trick is to know when to keep natural hair as real as possible, without feeling the need to do anything to it.

Opposite:

Daria Werbowy for British *Vogue*, September 2013. Photograph by Patrick Demarchelier.

Above:

A fake fringe echoing Nico for Kirsty Hume for *W* magazine, July 1996. Photograph by Satoshi Saikusa.

Following pages

Left: Charlotte Gainsbourg for French *Vogue*, December 2009. Photograph by Nick Knight.

Right: Vanessa Moody for British *Vogue*, June 2015. Photograph by Paul Wetherell.

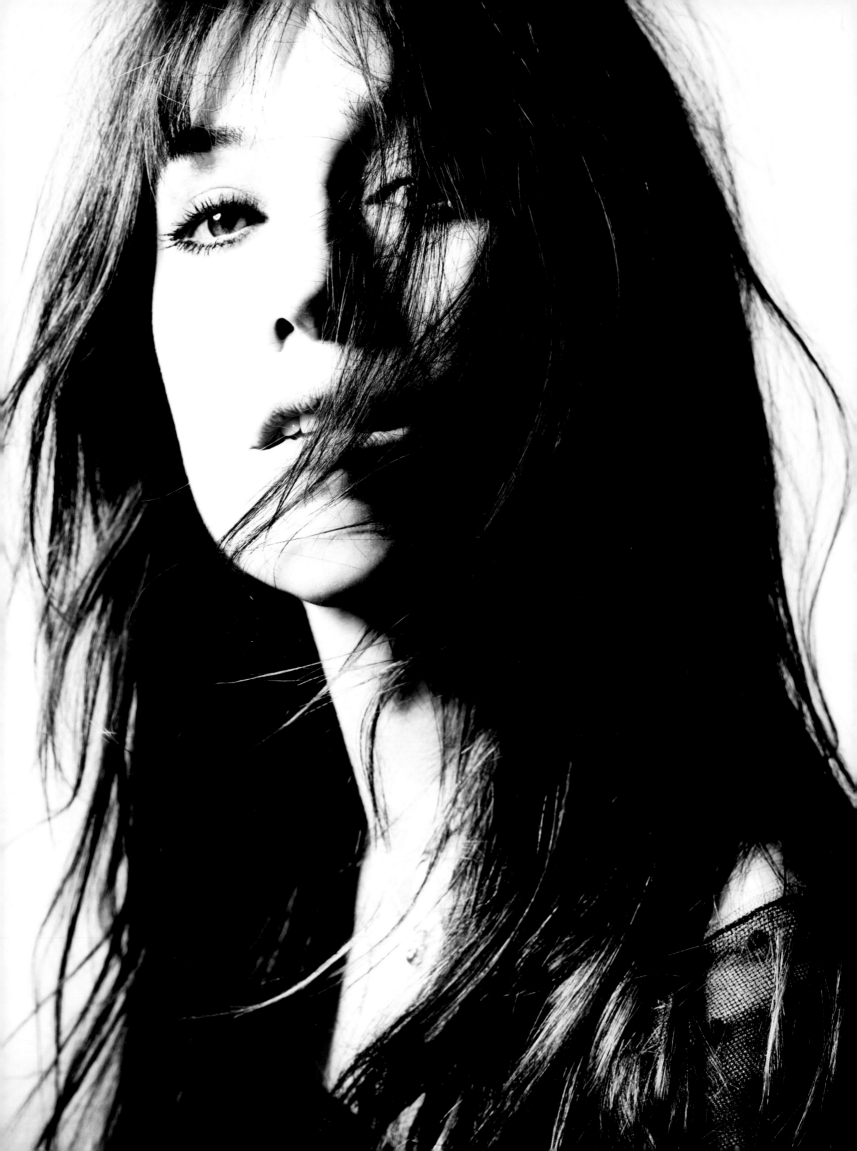

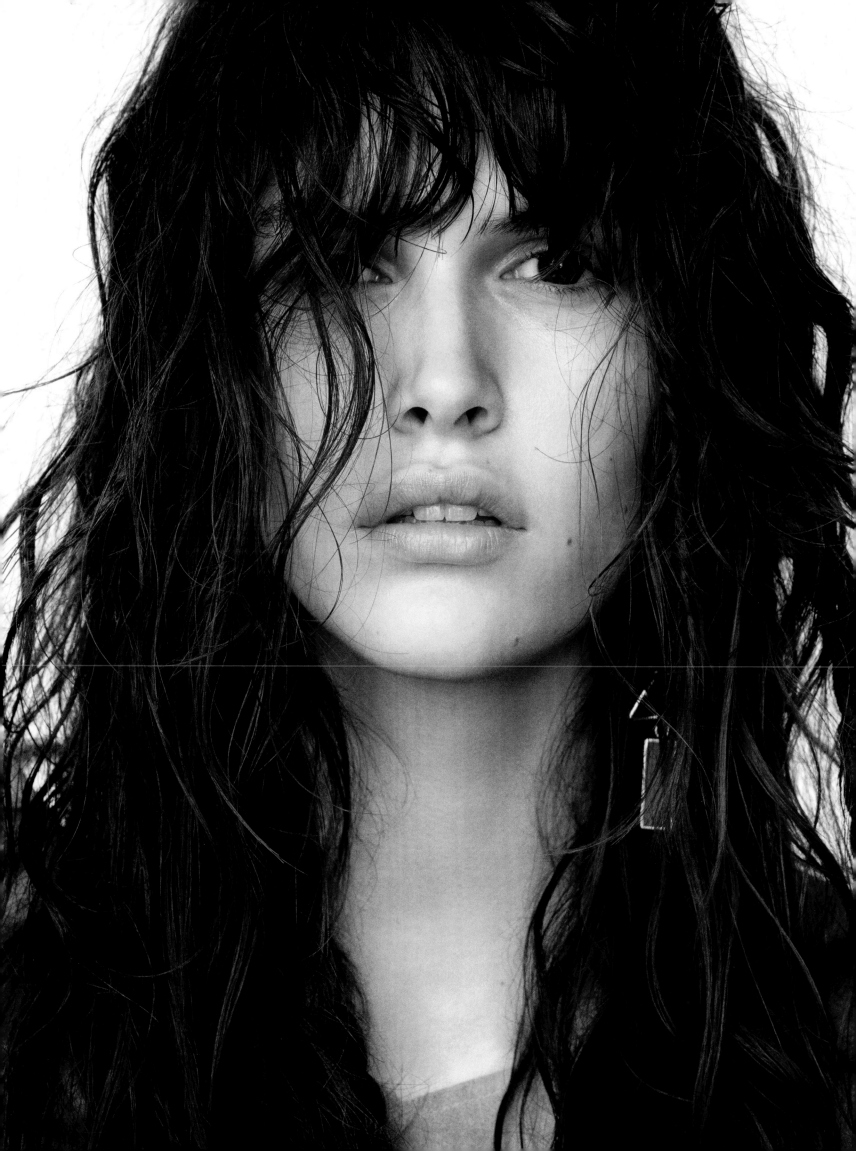

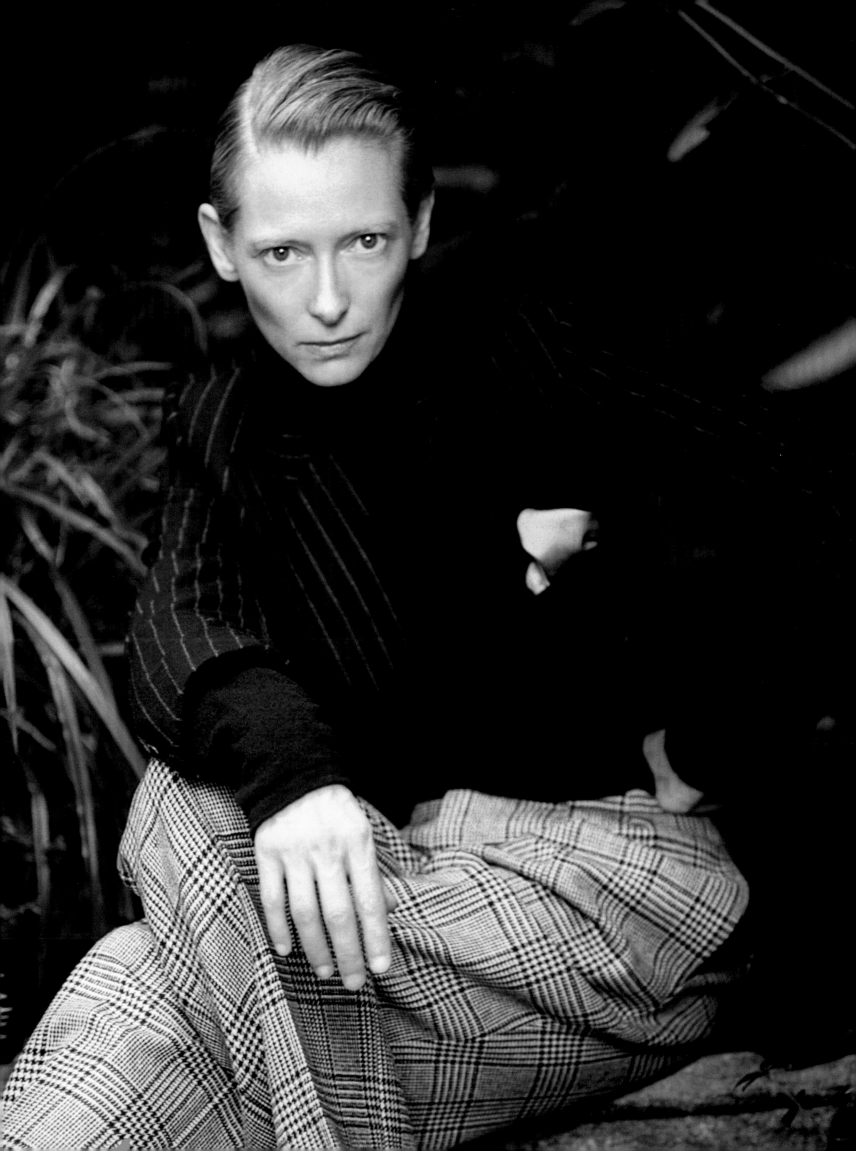

WHEN YOU'RE
A BOY

When glam rock and a new wave of gender confusion hit London in the 1970s, it was an antidote to the decade's economic depression and social tensions. It was a peacock parade, a glitter-lidded rebellion against a system of staid sexual mores whose smouldering embers had been stoked in the '60s but now burst into lightning bolts of crotch-licking flames. Marc Bolan and David Bowie became the Dandy in the Underworld and Ziggy Stardust and beneath their pagoda shoulders they proudly wore their androgyny on their star-sequined sleeves.

They had the nazz, boogaloo dudes, loud, luscious, lascivious. All tight T-shirts and loose tongues, Glam was a call to arms!

I was brought up in Bromley, a stone's throw from whence Bowie himself hailed. Like so many of my generation, including, naturally, Sam McKnight, he was part of our cultural DNA, a constant presence from the time that I, like Sam, saw him perform "Starman" on Top of the Pops in 1972. He introduced hair and makeup to a generation of working class youths: the "bricklayer in drag" was born!

I saw Bowie live for the first time at the Empire Pool Wembley in 1976 performing the Station to Station tour. A slow, rumbling white noise accompanied the title track of the album, its looping feedback and whining industrial drone sending the audience into a state of trance-like reverence, as his alter-ego, The Thin White Duke, glided onto the stage like a black mamba. The concert coincided with the birth of punk rock: leather- and fishnet-clad girls from Madame Louise's, locked in a Sapphic embrace,

danced with my friend in her slashed Sex T-shirt and latex mini, and her stunning mixed race boyfriend dressed in a duck's egg blue, Freddie Burretti-style suit like Bowie's on the cover of David Live. I bought my own vintage version from Granny Takes a Trip years later. Tilda Swinton then wore it when Craig McDean shot her for Italian *Vogue*. Sam dyed her hair Titian red, Lucia Peroni sculpted her face while Edward Enninful chose the drag. Tilda /Bowie was born out of a diet of glam, punk, and cursed poets.

In the early '80s, I gravitated towards a group born of the punk generation from which evolved the Billys and Blitz club scenes in London, whose musical and style reference was David Bowie. Virginia Woolf's Orlando and Jean Genet's Our Lady of the Flowers were my bedtime stories. The models of the time were Leslie Winer, a lethal cocktail of razor-cut, Katharine Hepburn angles and the spit and swagger of a downtown street hustler, and Jeny Howorth, a cropped blond Dickensian street urchin. Boys were beautiful like Barry Kamen.

In his work Sam has explored beauty in all its manifestations. The photographs in this chapter are evidence of our generation's subcultural heritage. Stella, Milla, Diane, and Isabella, skin-walkers, strange anthropomorphic creatures who commune with the spirits. Due in part to the vision of Sam and others like him, androgyny today is no longer a fashion signifier, it is a statement of identity. Wham Bam Thank You, Sam, for taking us on your journey!

– Jerry Stafford

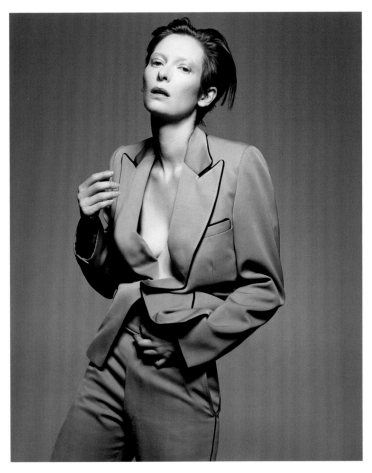

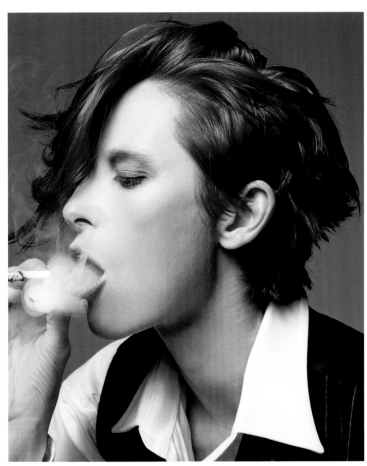

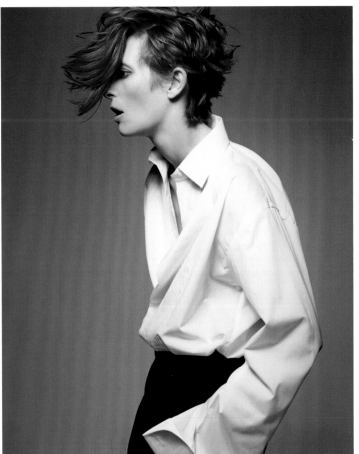

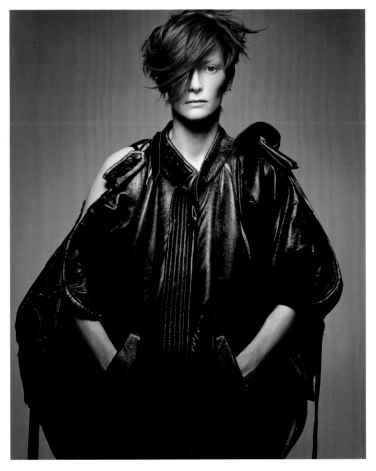

Page 250:
Tilda Swinton for *L'Uomo Vogue*,
September 2008. Photograph
by Paolo Roversi.

Above and opposite:
Quintessential Craig McDean—a cool
modern strength to this beautiful
Bowie-inspired shoot with Tilda
Swinton for Italian Vogue, February
2003. All photographs by Craig McDean.

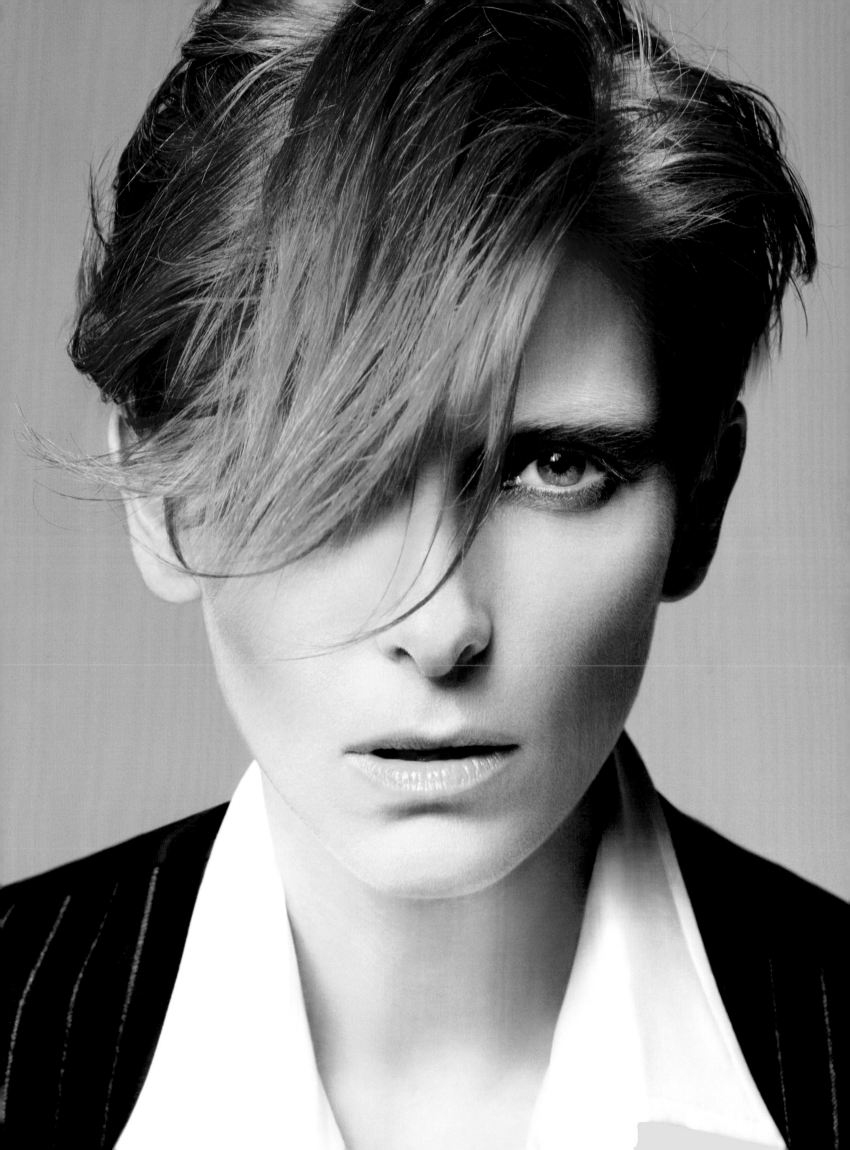

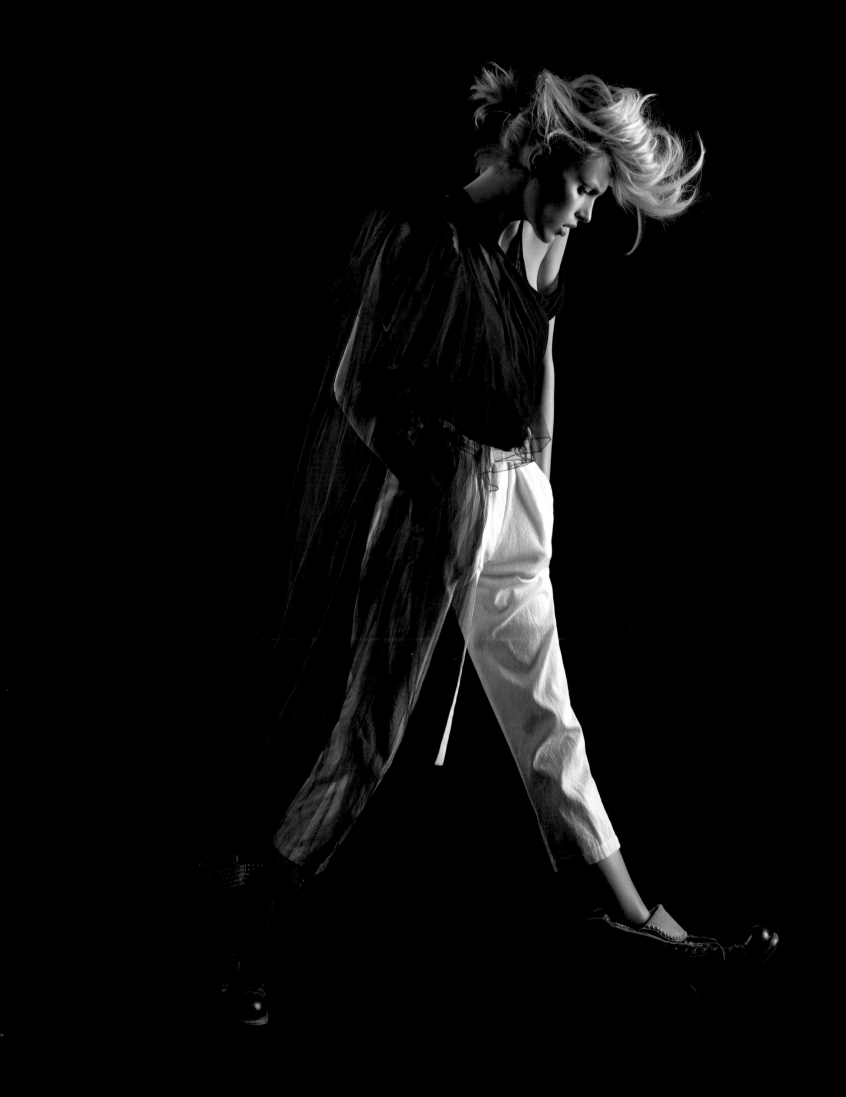

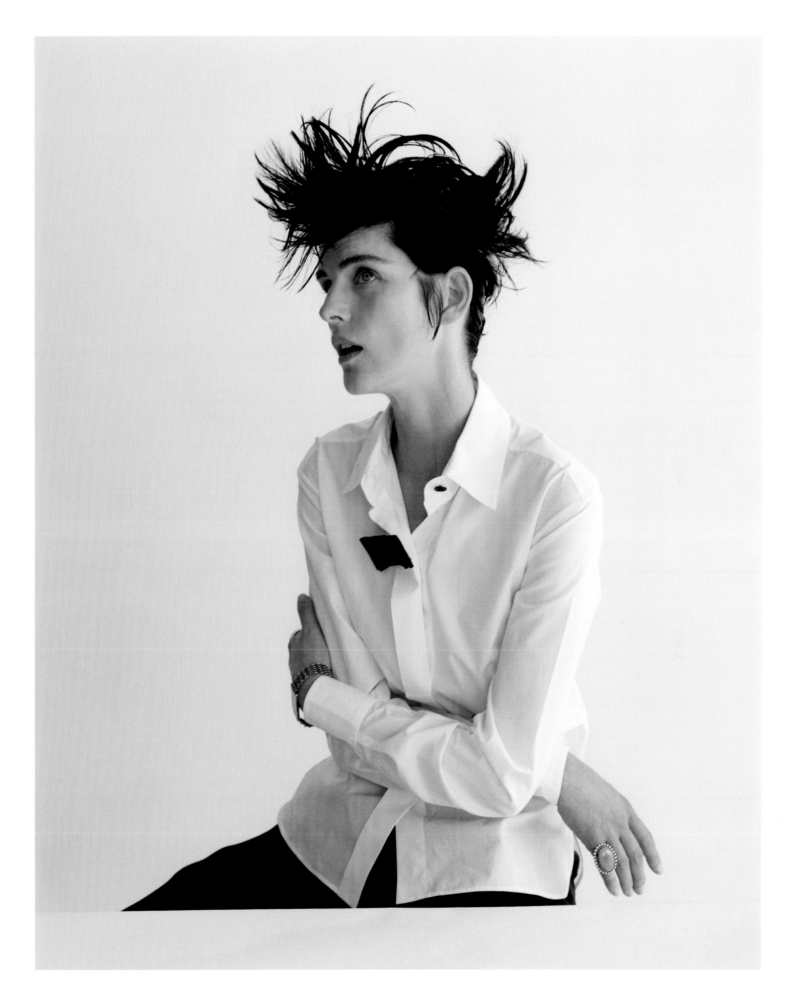

Opposite:

Anja Rubik for Japanese *Vogue*,
July 2009. Photograph by Karl Lagereld.

Above:

Stella Tennant for British *Vogue*,
December 2013. Photograph
by Tim Walker.

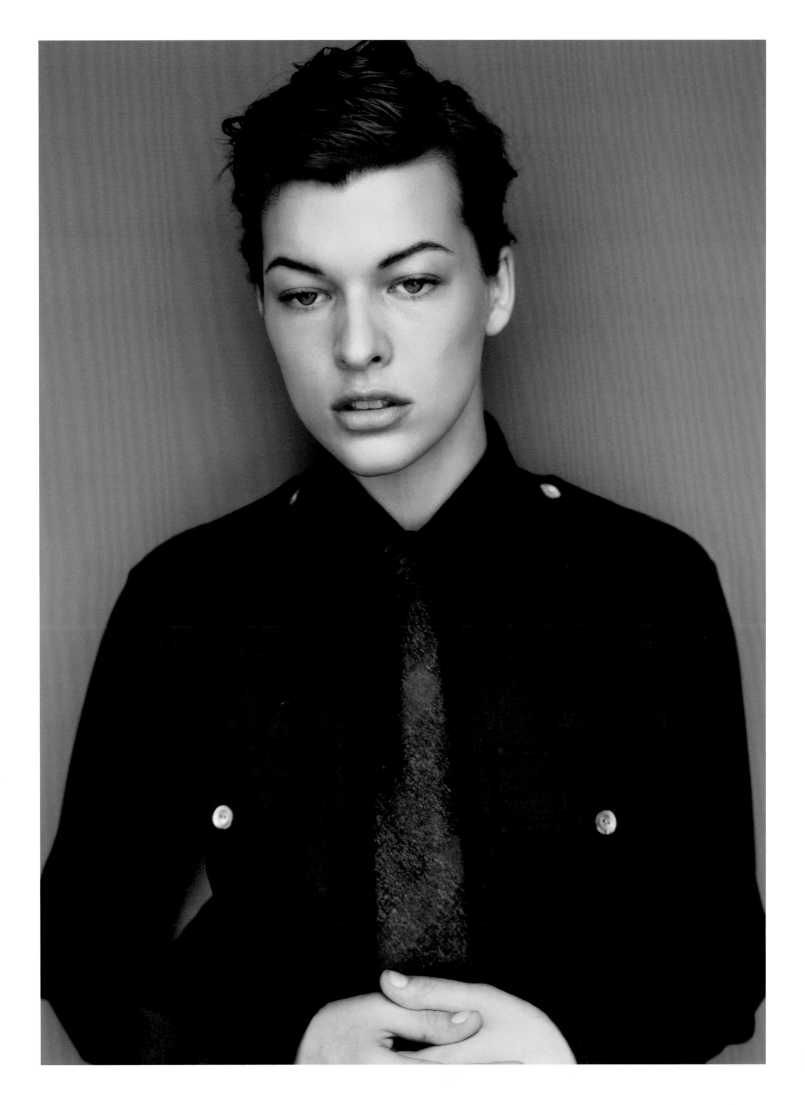

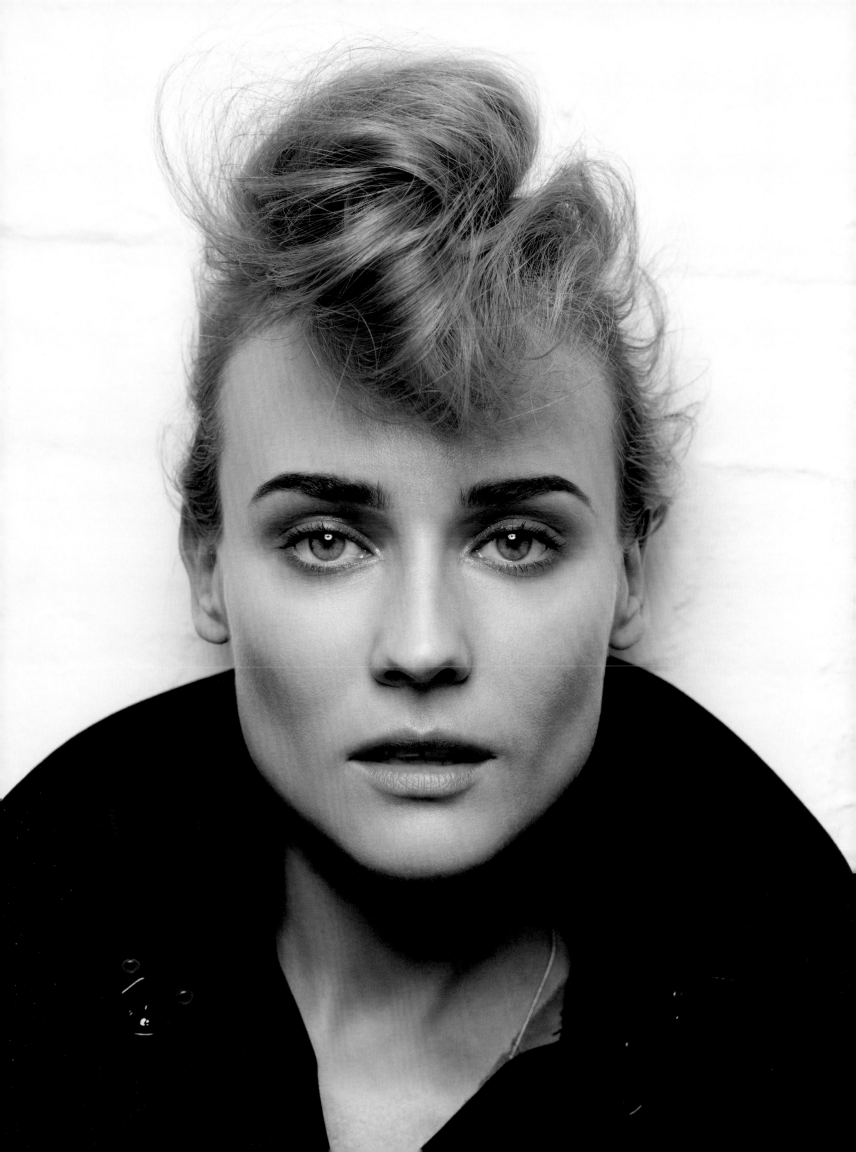

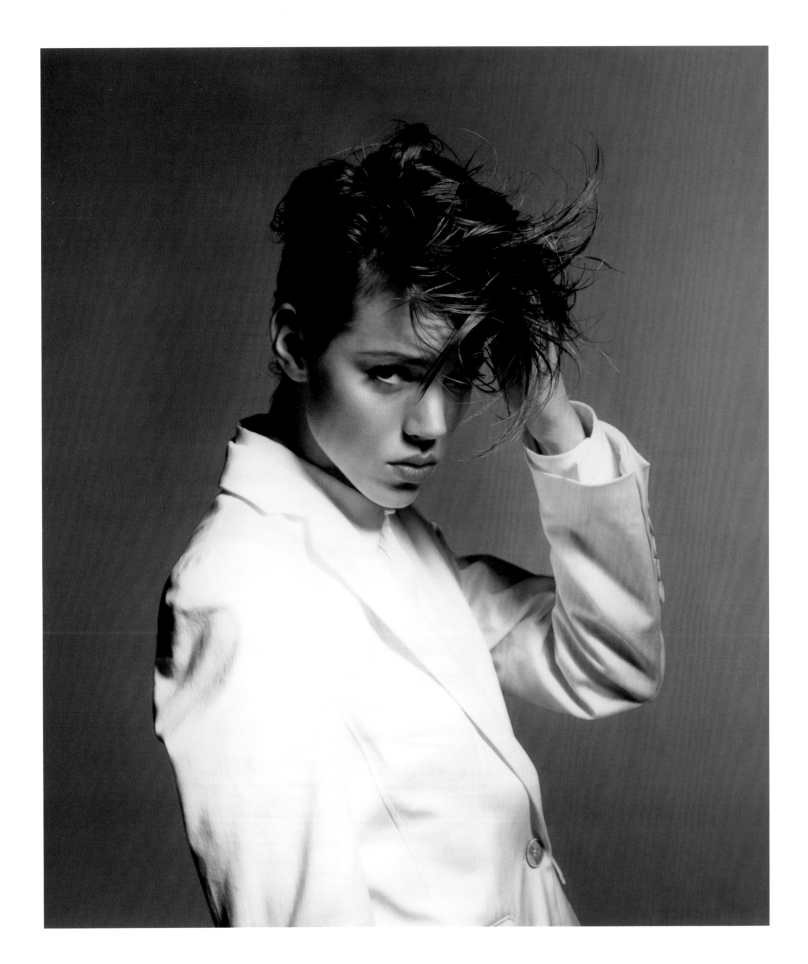

Previous pages

Left: Milla Jovovich for *W* magazine, September 1996. Photograph by Michael Thompson.

Right: Diane Kruger for German *Vogue*, April 2010. Photograph by Karl Lagerfeld

Above:

Freja Beha Erichsen for British *Vogue*, April 2008. Photograph by Nick Knight.

Opposite:

Sara Blomqvist for Chinese *Vogue*, April 2009. Photograph by Jem Mitchell.

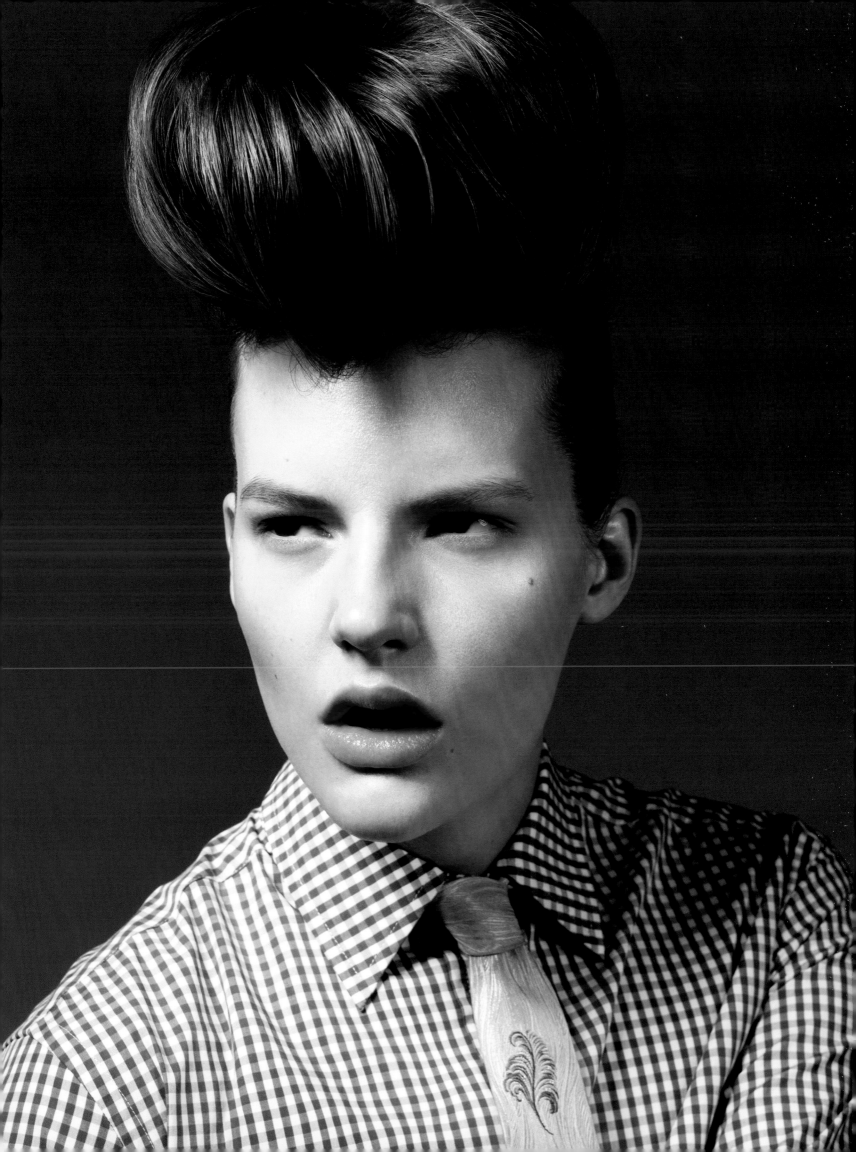

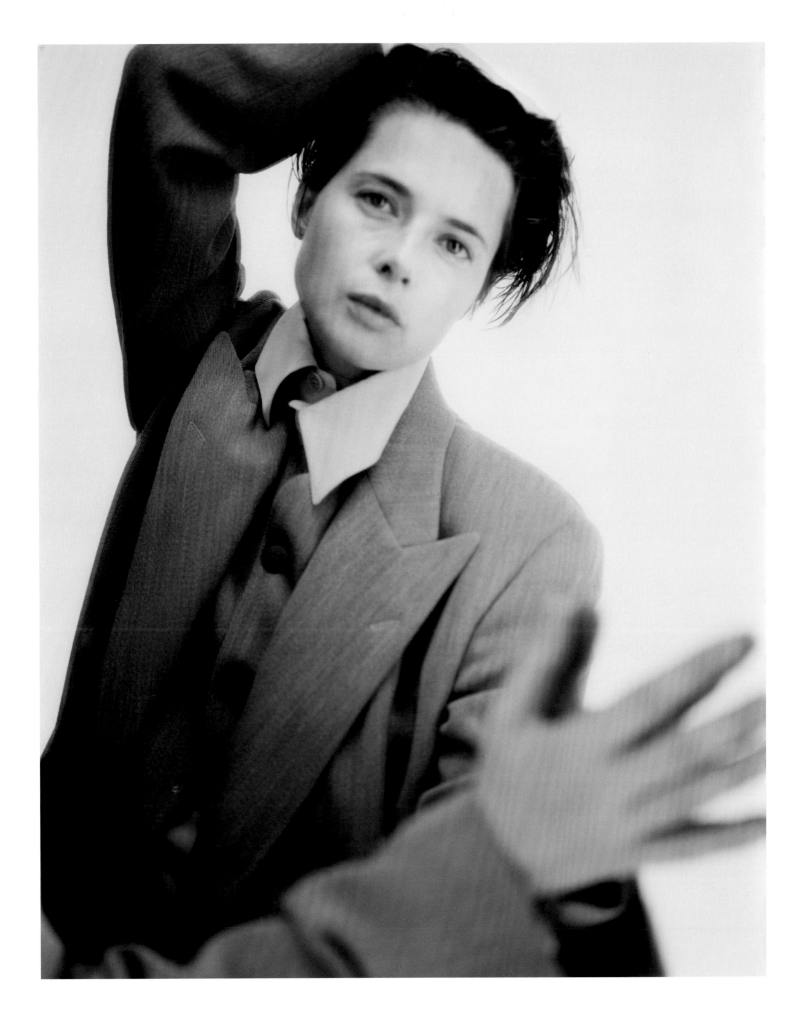

Above:

Isabella Rossellini for *Donna* magazine
Italy, September 1993. Photograph
by Paolo Roversi.

Opposite:

Lady Gaga's alter ego, Jo Calderone.
Japanese *Vogue Hommes*, Fall/Winter
2010. Photograph by Nick Knight.

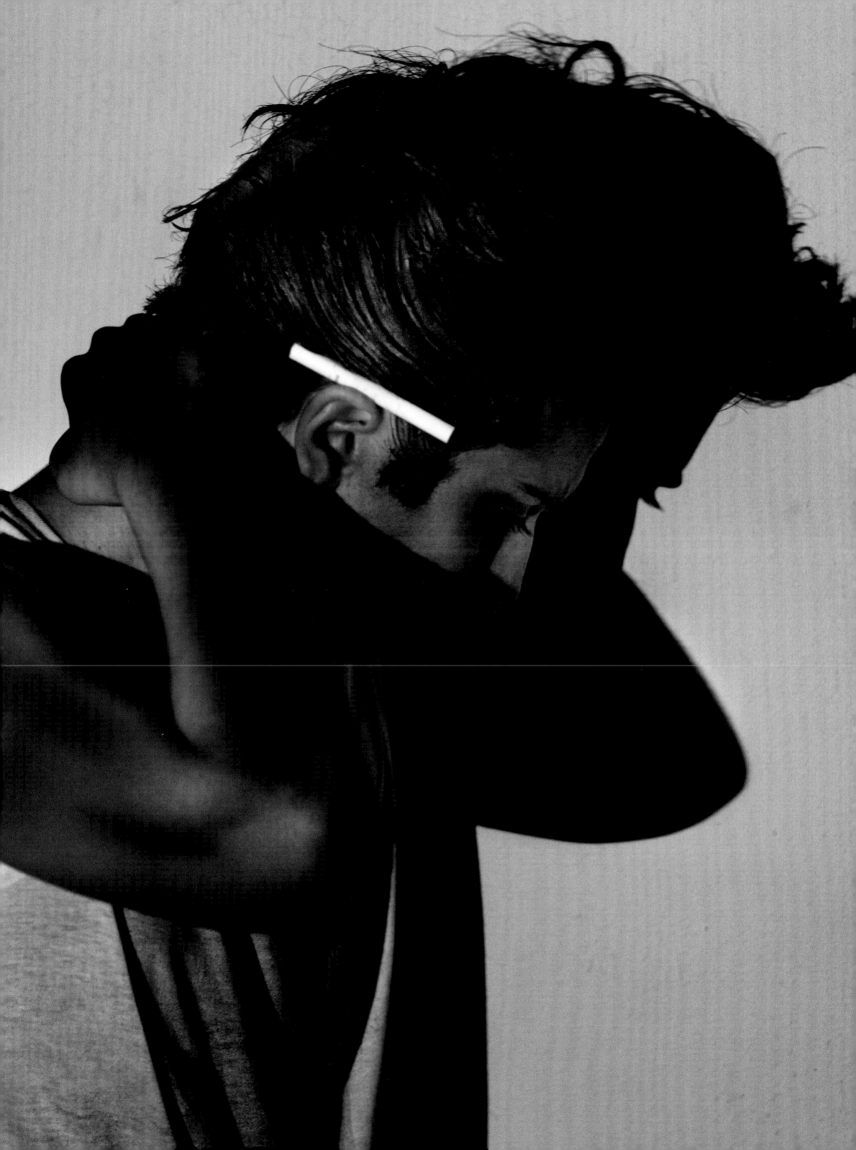

01

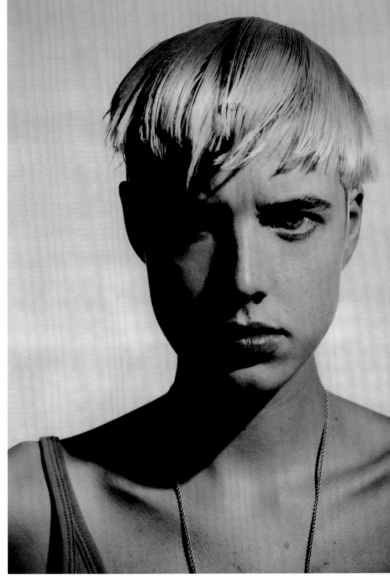

02

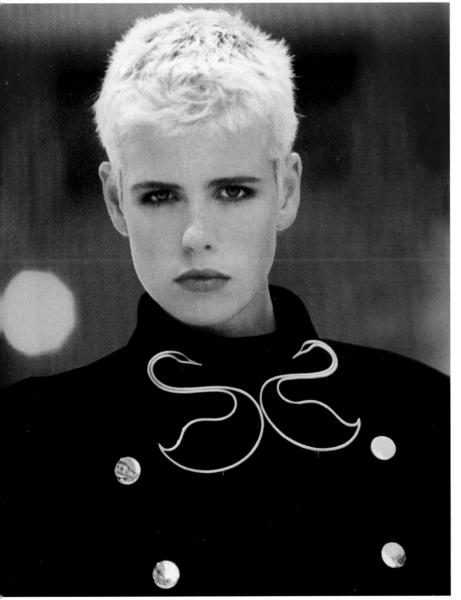

05

06

Girls who got the crop.

01 Scottish beauty Honor Fraser with a short page-boy cut. Photograph by Robert Fairer.

02 Mario Testino and I met Agyness with shoulder-length hair and thought she needed a sharper look. I cut it that day and bleached it the next and she never looked back. Agyness Deyn photograph by Ben Dunbar-Brunton in 2005.

03 A short choppy cut for Beri Smither for British *Elle*, April 1994. Photograph by Troy Word.

04 I was asked to cut Tilda Swinton's hair for a press junket and she suggested I cut it really short. Her publicist's face went pale, but this became her signature look. Photograph by Glen Luchford for *Dazed & Confused*, 2010.

262

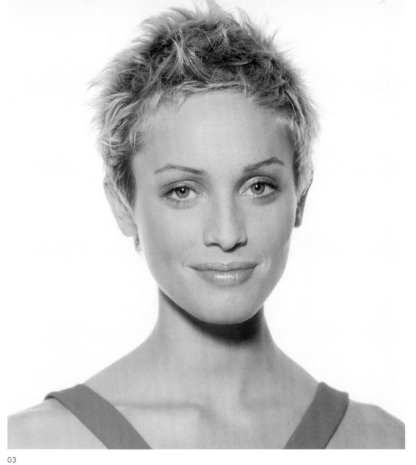

03

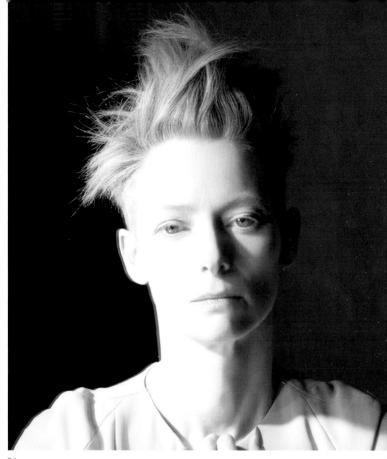

04

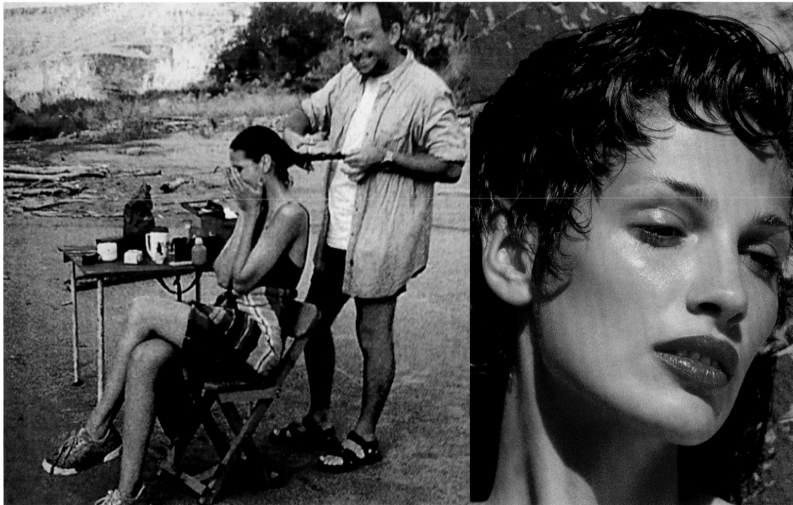

07

05 Jeny Howorth's iconic
1980s bleached crop,
British *Vogue*, October
1986. Photograph
by Neil Kirk.

06 Short boyish cut for
Kylie Minogue in 1996,
photographs by
Stéphane Sednaoui.

07 Location shoot
water-rafting in Utah
with Sheila Metzner.
We were shooting two
stories for British *Vogue*
with Fabienne

Terwinghe. We shot
one with her hair
in a chignon, then
for the second she was
McKnighted! Fabienne
didn't see what it looked

like until she got to
a mirror back on dry
land. British *Vogue*,
April 1993. Photographs
by Sheila Metzner.

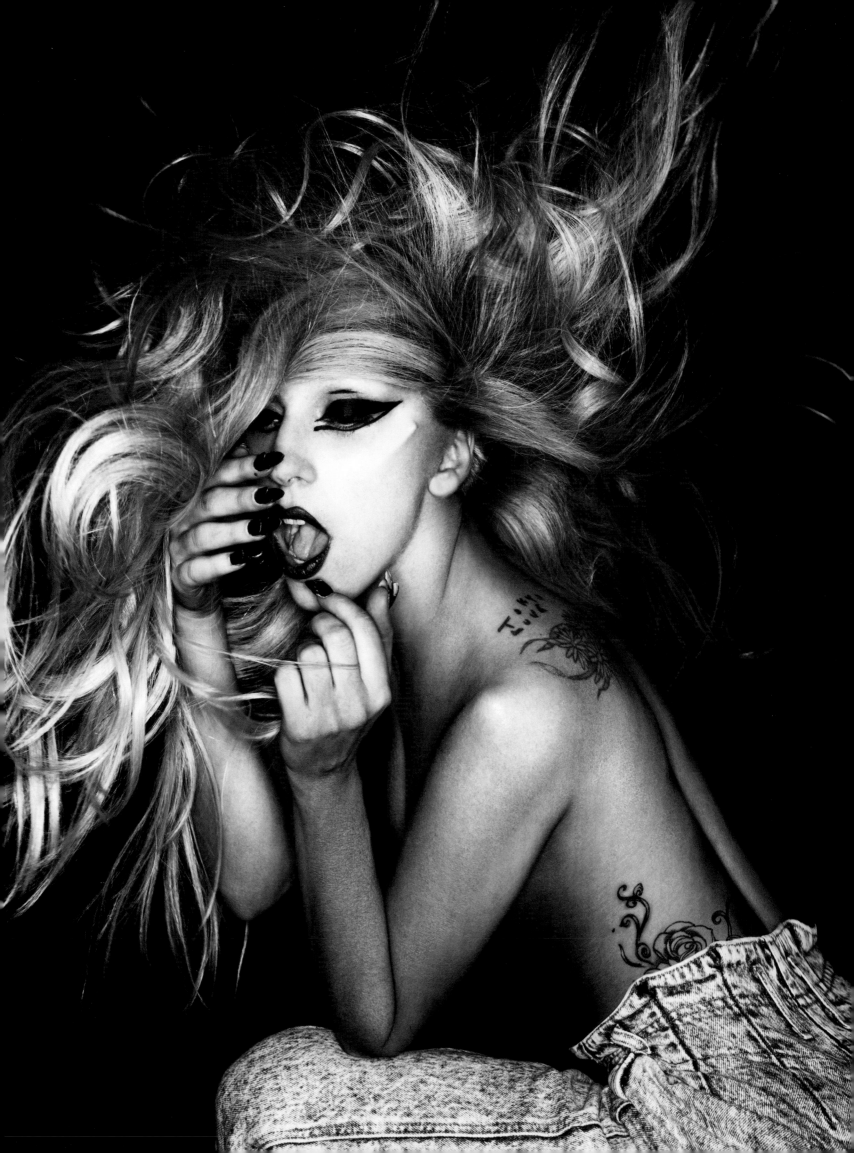

TRANSFORMATIONS

Wigs are the new hats. Wigs, extreme colour, and hairpieces can instantly transform an appearance as well as a character and are great for models or actresses who want to transform for a shoot and broaden their range. I have been delving into my wig box since the start of my career. Here are some of my favourites, from transforming Lara Stone into Liz Taylor with Carine Roitfeld to restyling Nicole Kidman with a long dark wig—it's all about using hair to create a new persona.

I love meeting people; I love understanding what inspires them and then it can be fun to offer them a complete change of look. Transformations take a lot of trust, so you need a space where the person can prepare themselves before they step onto the set. I want them to feel protected in the hair and makeup room when we're working so that they relax and begin to trust you— that's when you can find something "new." I enjoy the idea of using hair to transform a face into something totally different.

Lady Gaga is a great character chameleon and collaborator. I worked with her previously, and then introduced her to Nick Knight. We went on to work together on several different projects, including her male persona, Jo Calderone, her meat-dress appearance for the 2010 MTV Music Awards, and her *Born This Way* video and album artwork. The only way to prepare for something like that is to be prepared for anything, so I had about thirty wigs and everything but the kitchen sink, in just about every different colour you can imagine.

Sometimes transformation just happens; often the best things are not planned, but evolve. A brand new face can appear from under a sharp short fringe, or a new shade of hair colour can transform a personality as much or even more so than clothes. Hair can express as many contradictions as you can tease into it through the cut and the shape. After all, how many models and actresses do you see on magazine covers who have brand new faces? What can and will be new is their hair.

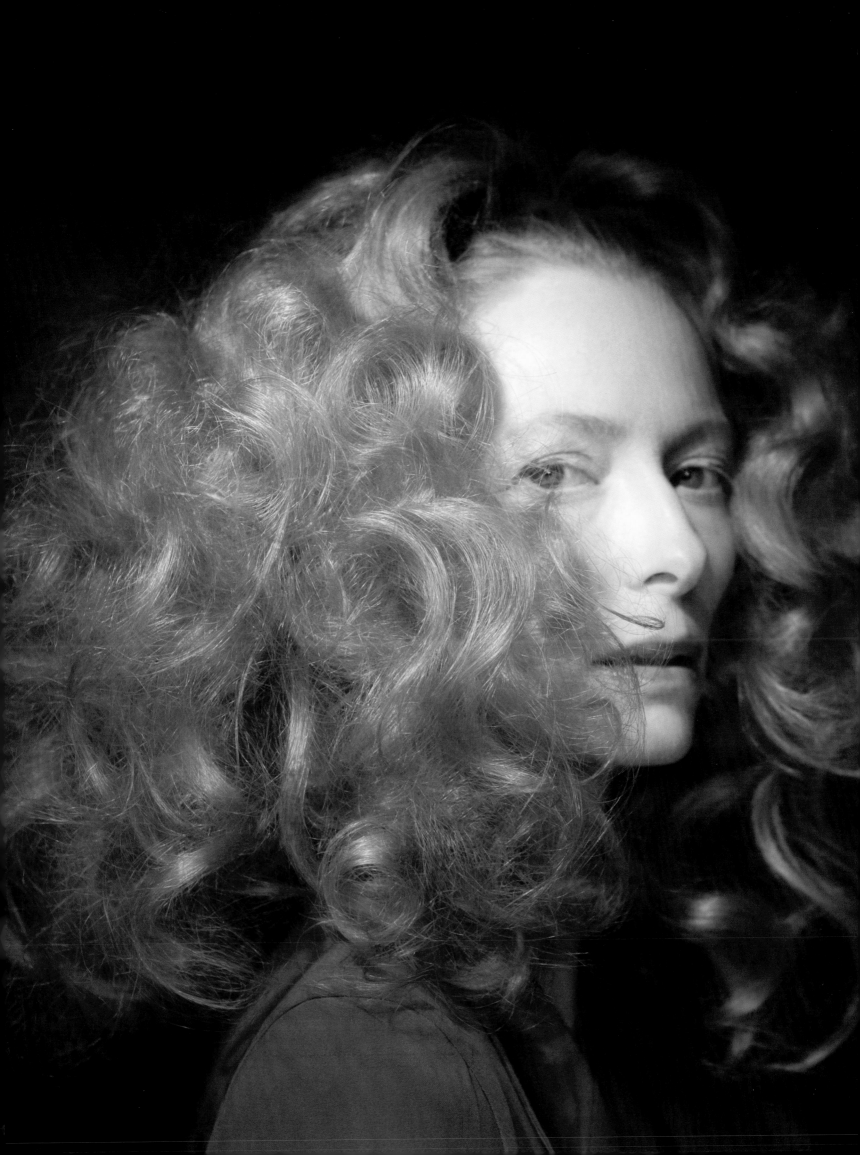

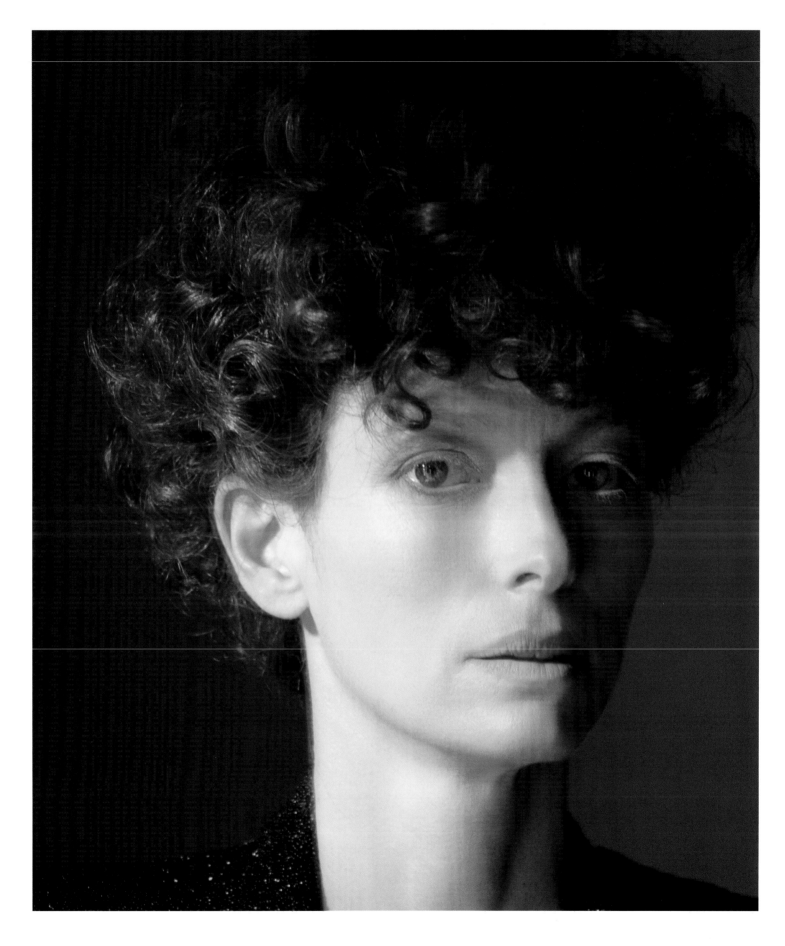

Page 264:

Lady Gaga Born This Way shoot, 2011.
Photograph by Nick Knight

Opposite and above:

Exploring different characters with
Tilda Swinton. I chose to use curled
wigs in contrast to the recent short
haircut I had given her. Shot and filmed
for the May 2010 issue of *Dazed &
Confused*. Both photographs
by Glen Luchford.

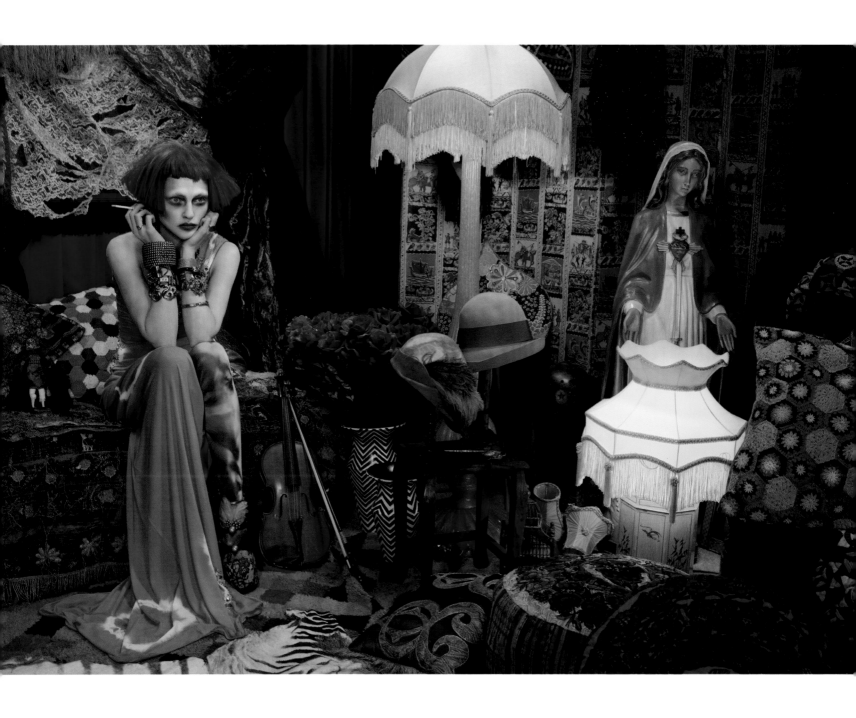

Above:

Sasha Pivovarova for Italian
Vogue, February 2010. Photograph
by Emma Summerton.

Opposite:

Bleach and colour on Liberty Ross's
own hair for British *Vogue*, July 2002.
Photograph by Nick Knight.

268

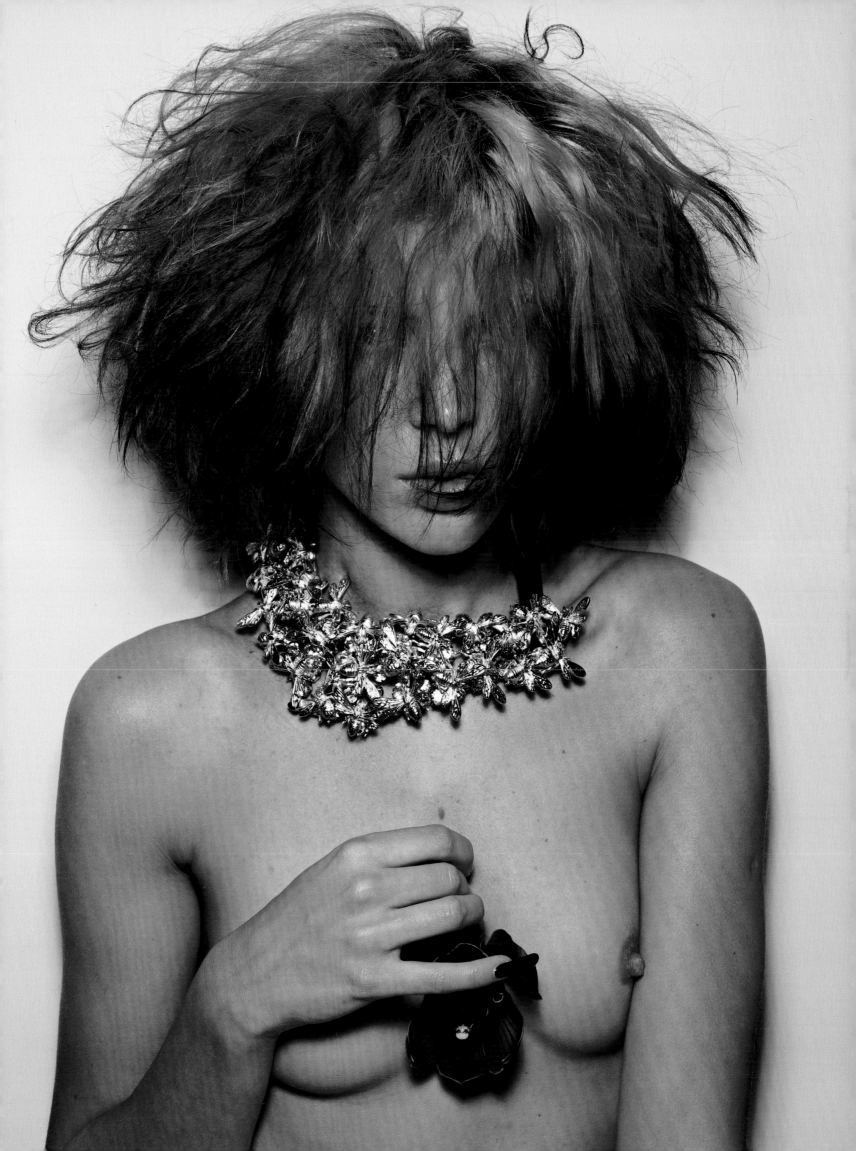

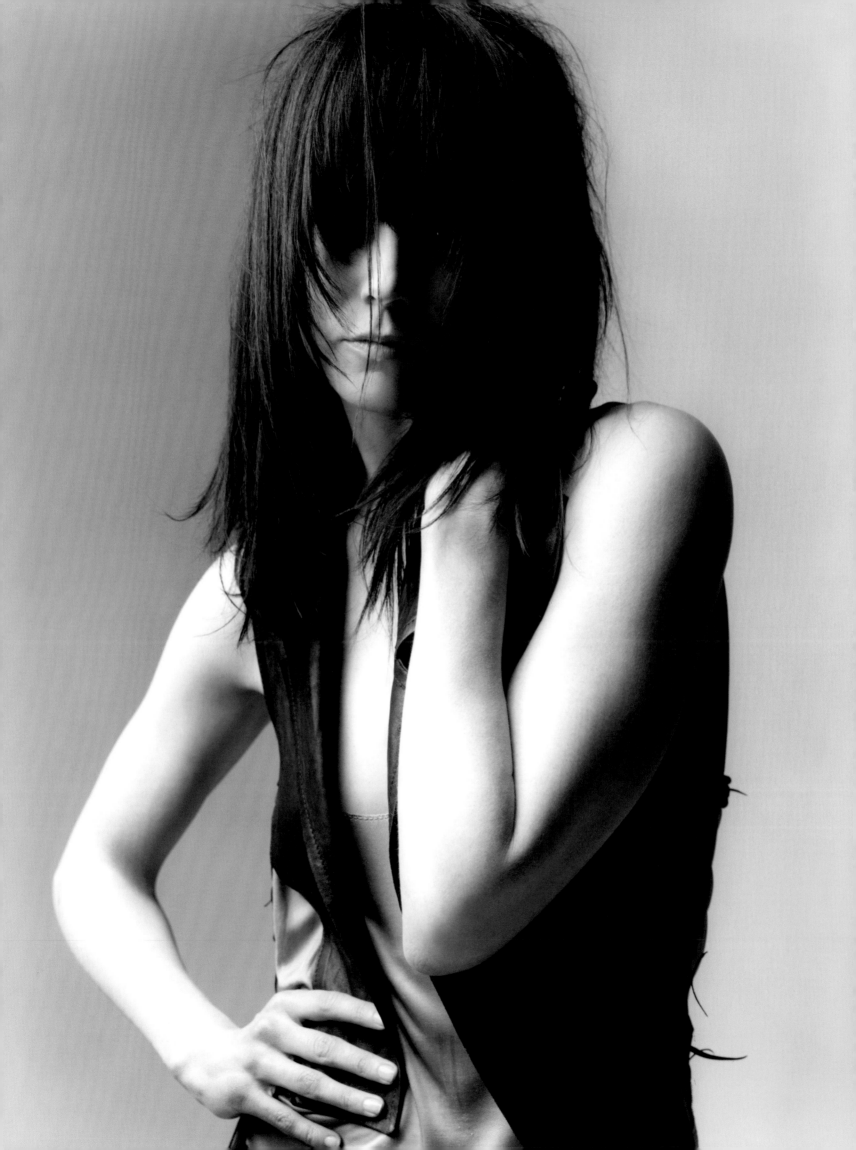

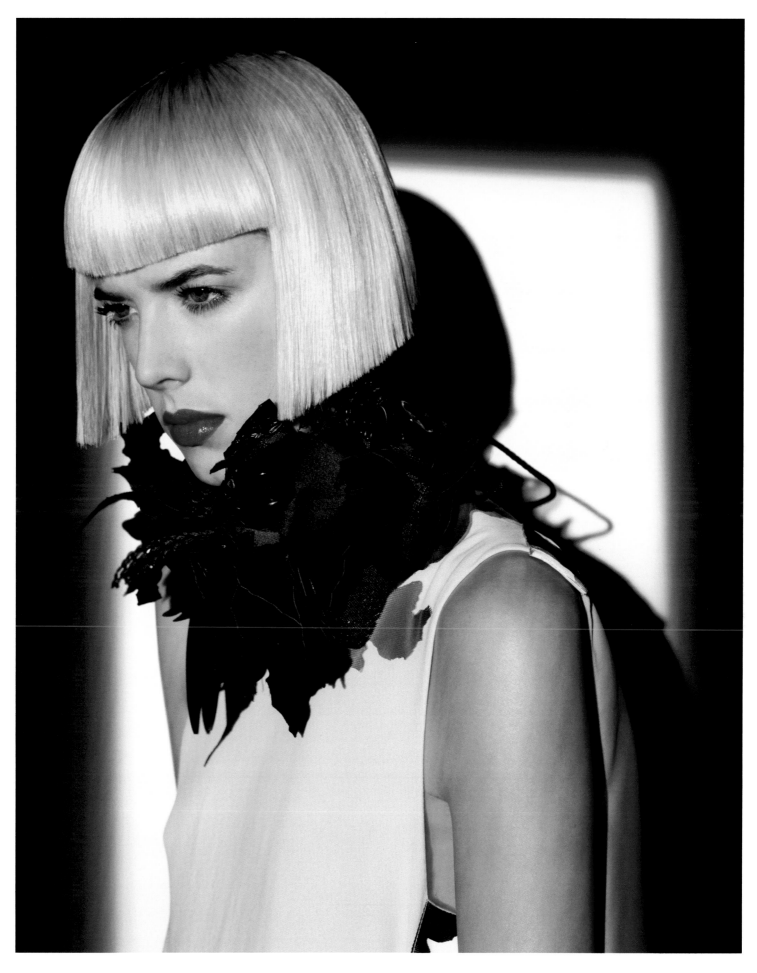

Opposite:

Nicole Kidman transformed in
a black wig for *AnOther Magazine*,
Spring/Summer 2003. Photograph
by Craig McDean.

Above:

A sharp edge for Agyness Deyn
in British *Vogue*, March 2009.
Photograph by Patrick Demarchelier.

Following pages:

Hand-colouredwigs, at right a version
in goat's hair. Kelly Mittendorf for
Italian *Vogue*, March 2012. Photographs
by Emma Summerton.

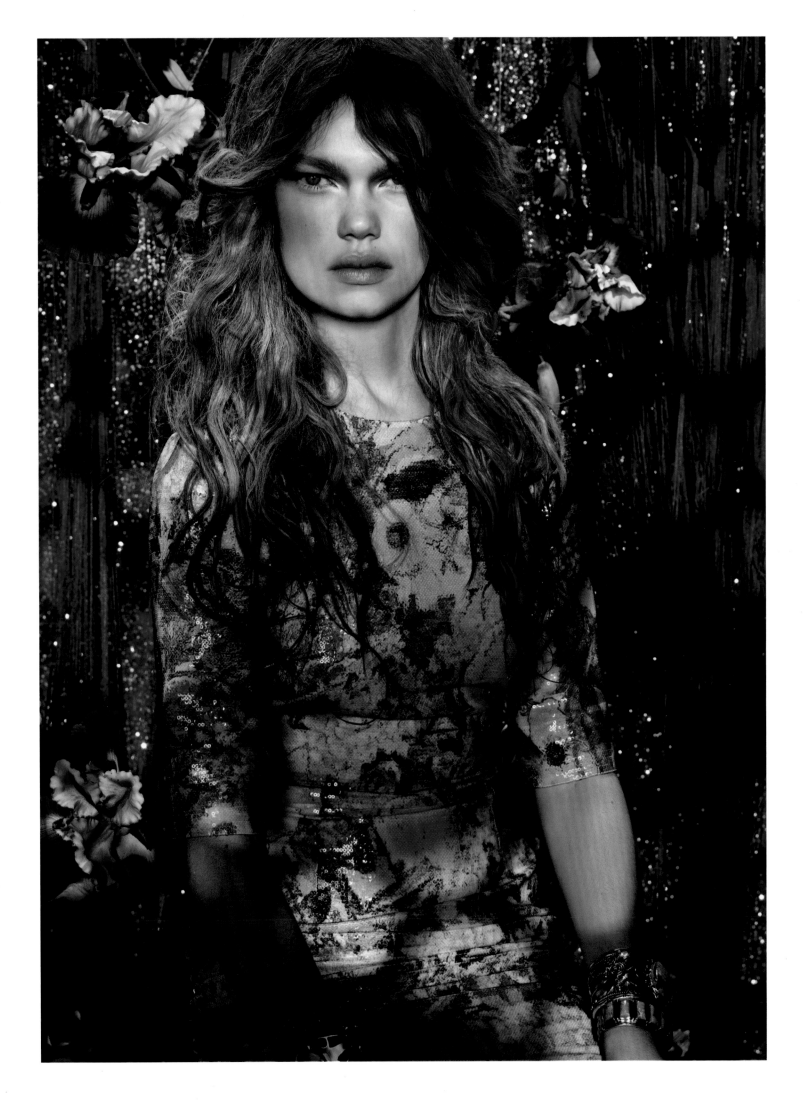

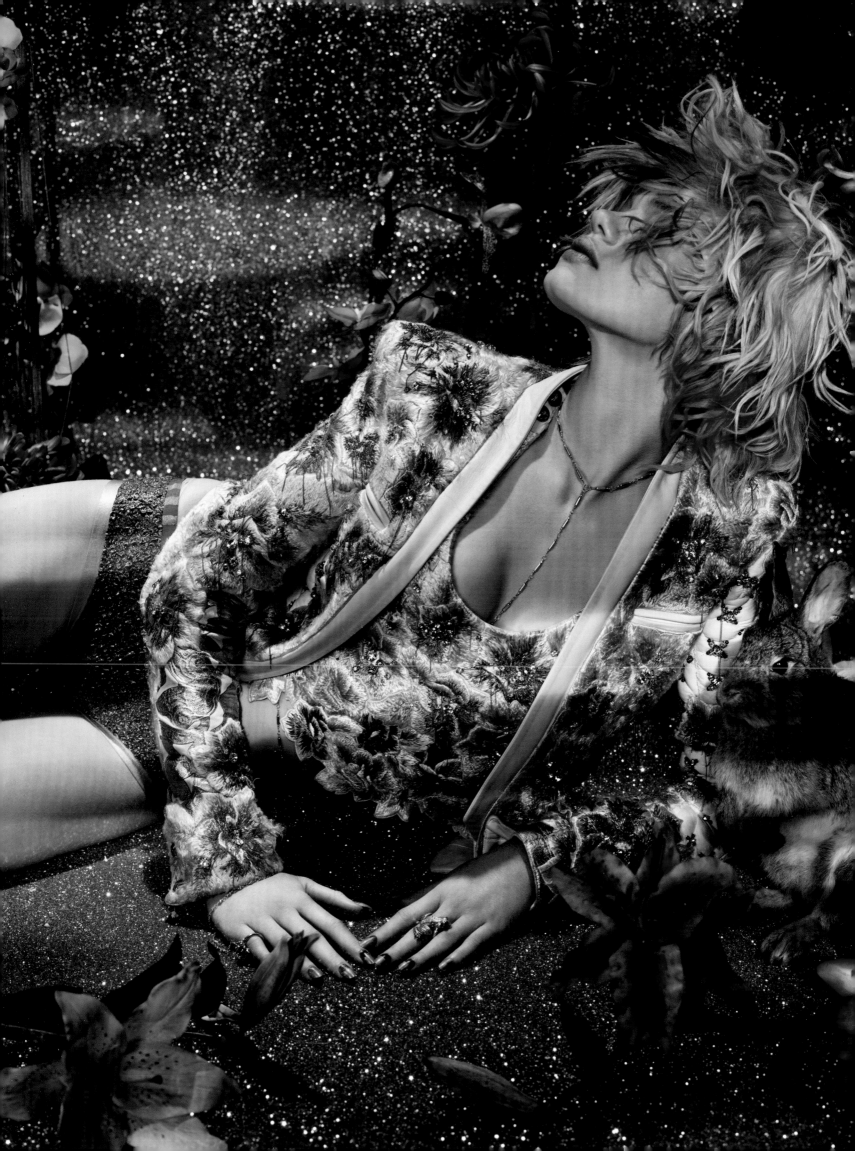

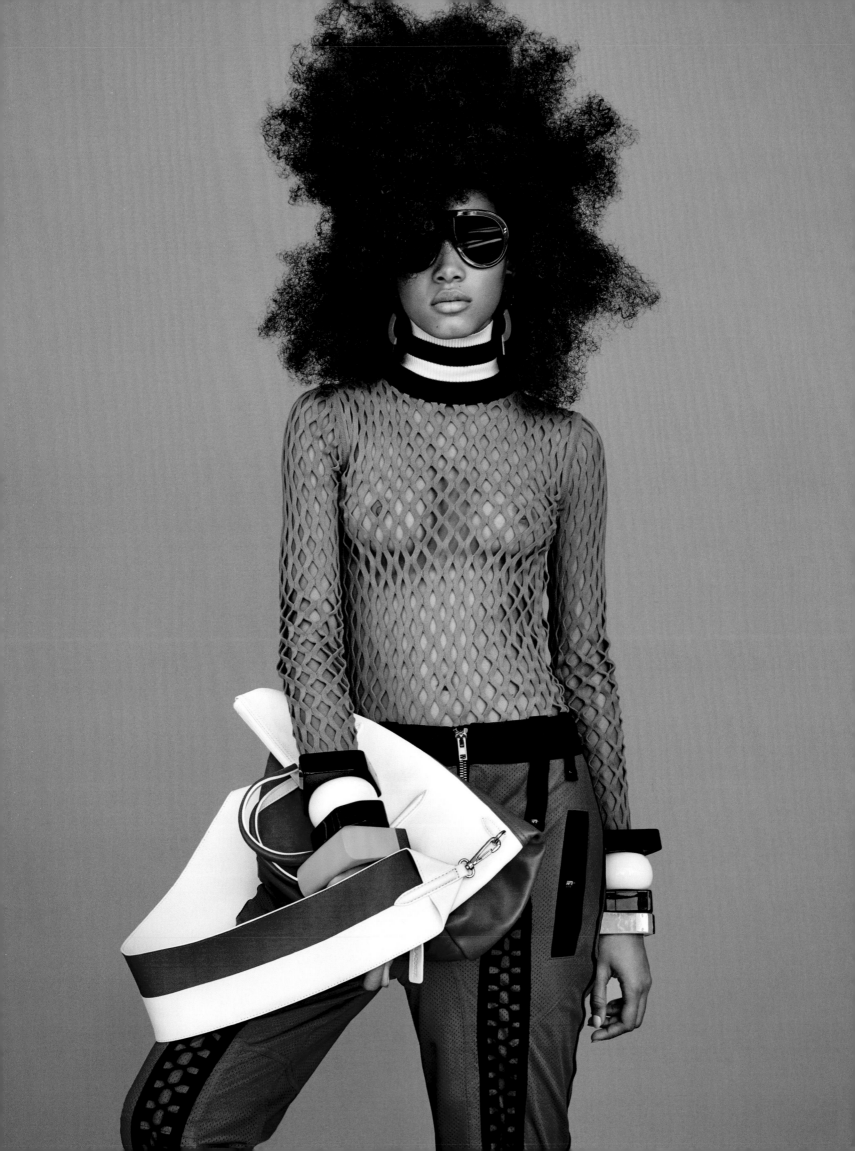

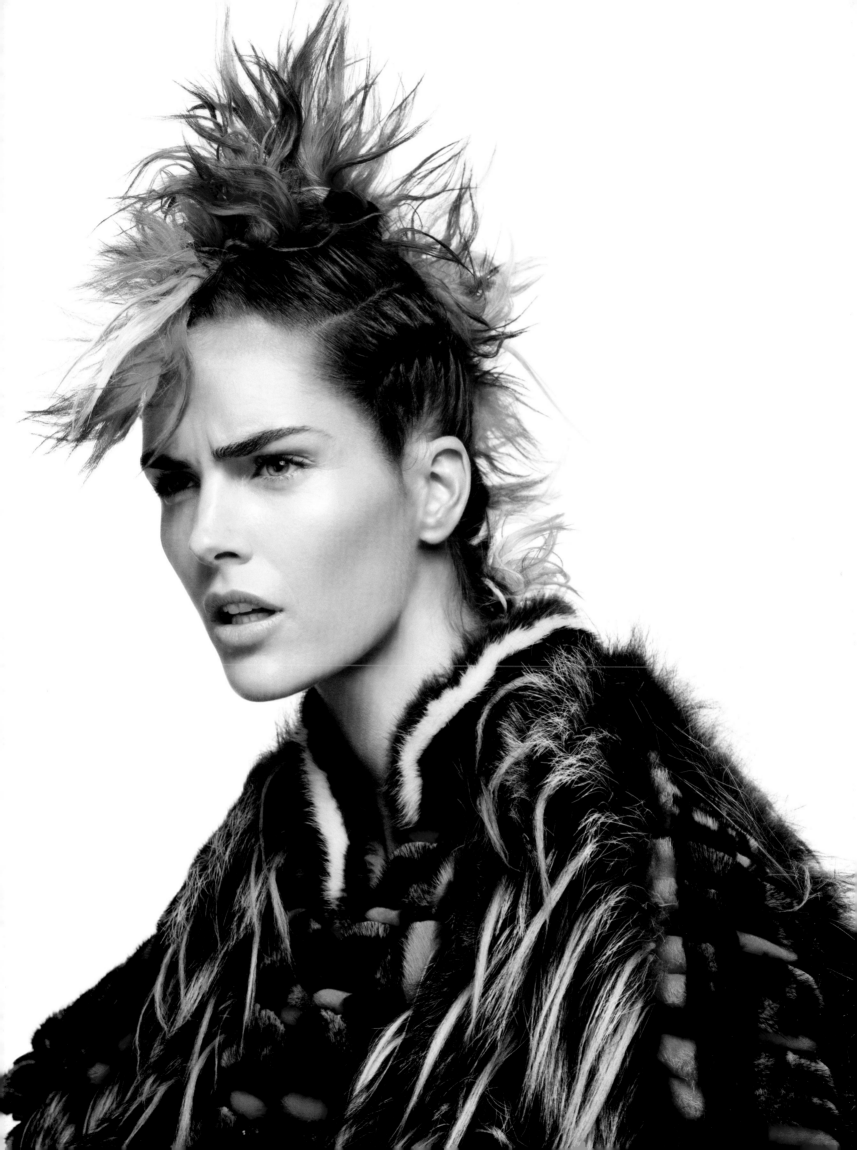

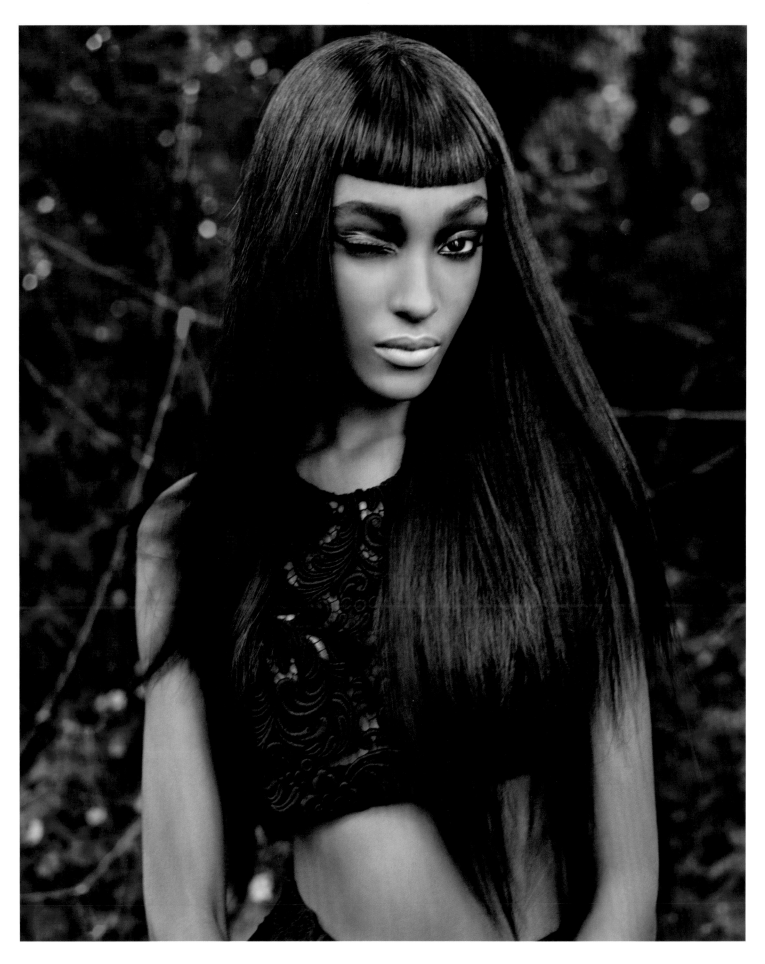

Previous pages:

Left: Lineisy Montero wearing a combination of three afro wigs stitched together for British *Vogue*, February 2016. Photograph by Patrick Demarchelier.

Right: Hilary Rhoda with a braided strip of hand-dyed goat's hair for *Allure*, September 2013. Photograph by Terry Tsiolis.

Above:

Jourdan Dunn's Cleopatra wig for *i-D magazine*, September 2008. Photograph by Emma Summerton.

Opposite:

Lindsey Wixson's chopped bob for British *Vogue*, April 2011. Photograph by Tim Walker.

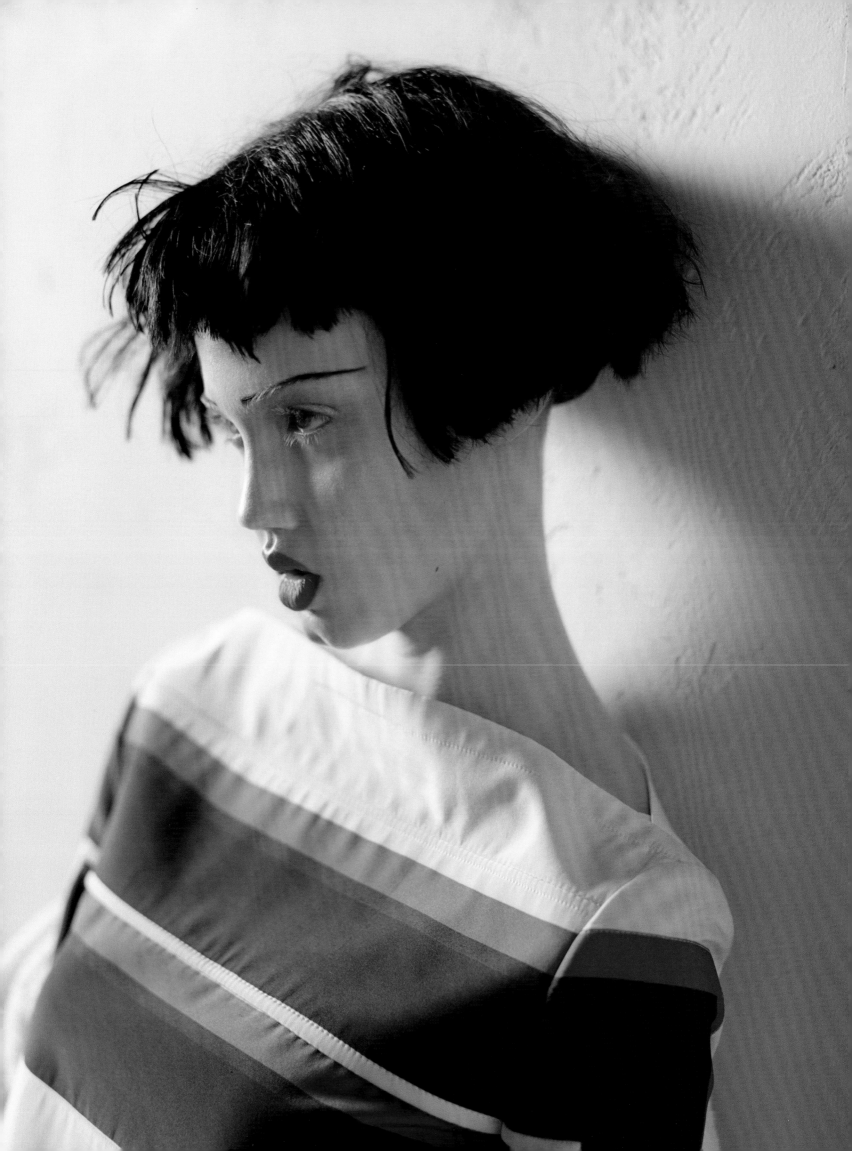

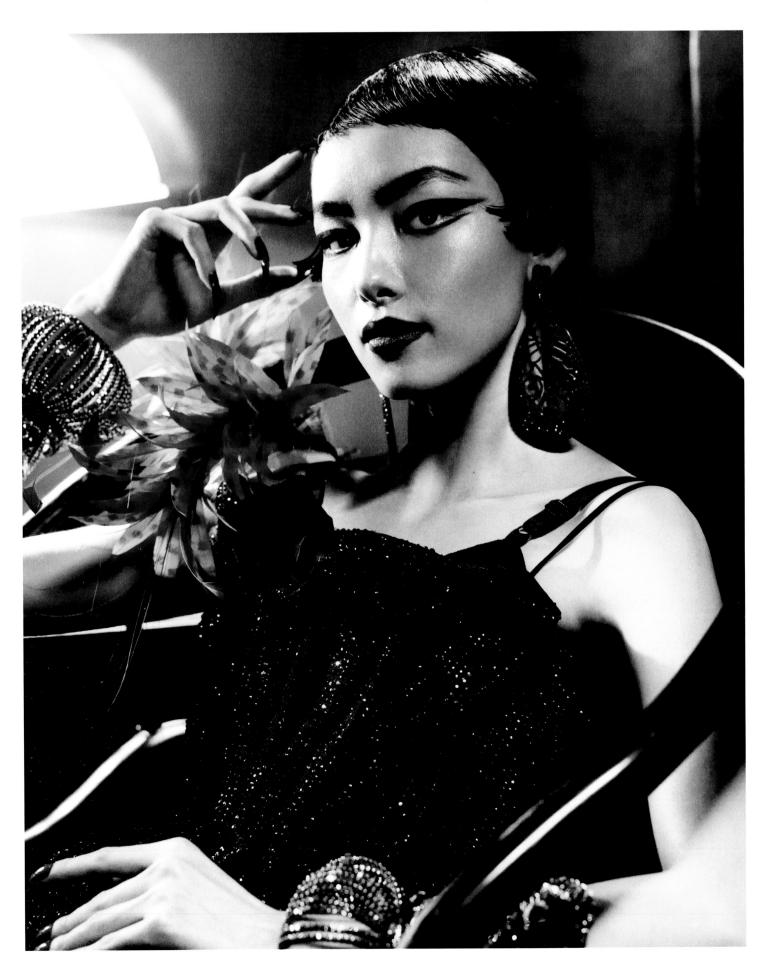

I love working with Mario he always has a strong point of view, and is involved in the whole process from concept to execution

Pages 278–283:

All photos by Mario Testino.

Above:

Fei Fei Sun for British *Vogue*, March 2013.

Opposite:

Lara Stone re-imagined by Carine Roitfeld as Elizabeth Taylor in short black curls for V magazine, Fall/Winter 2011.

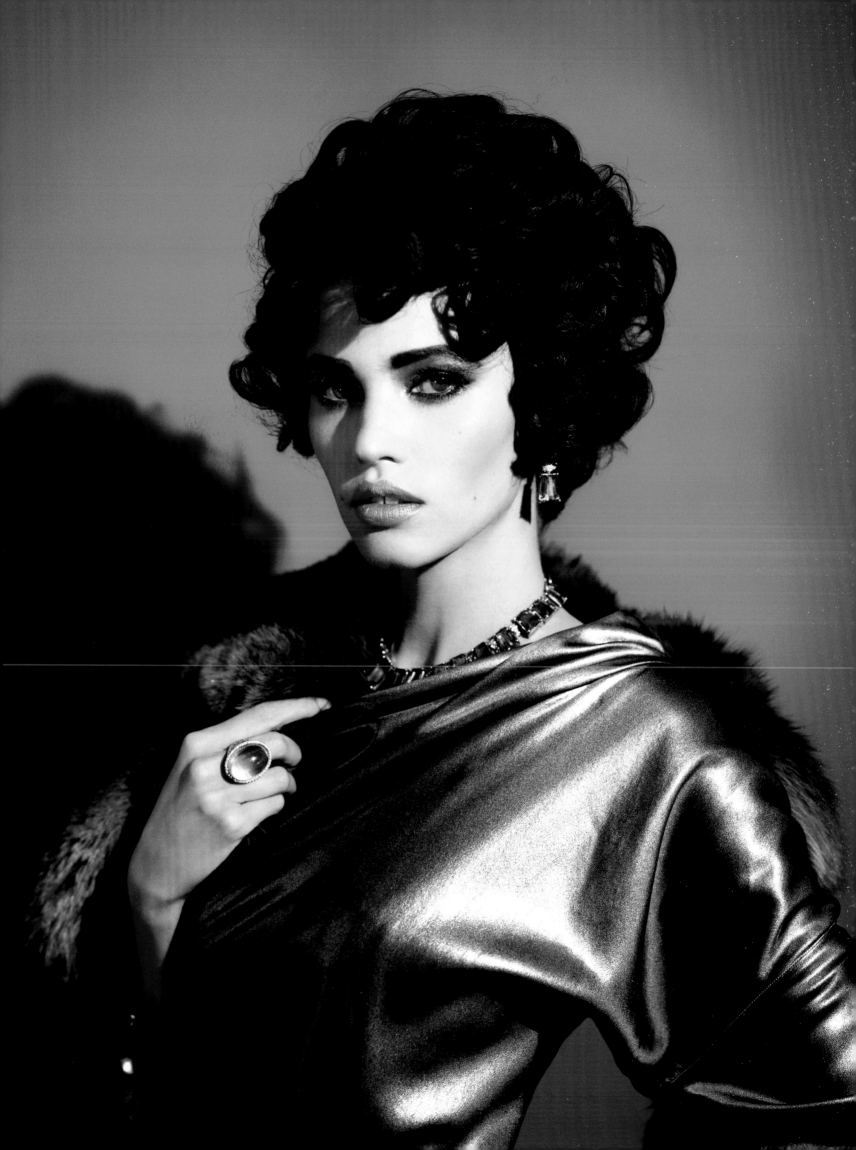

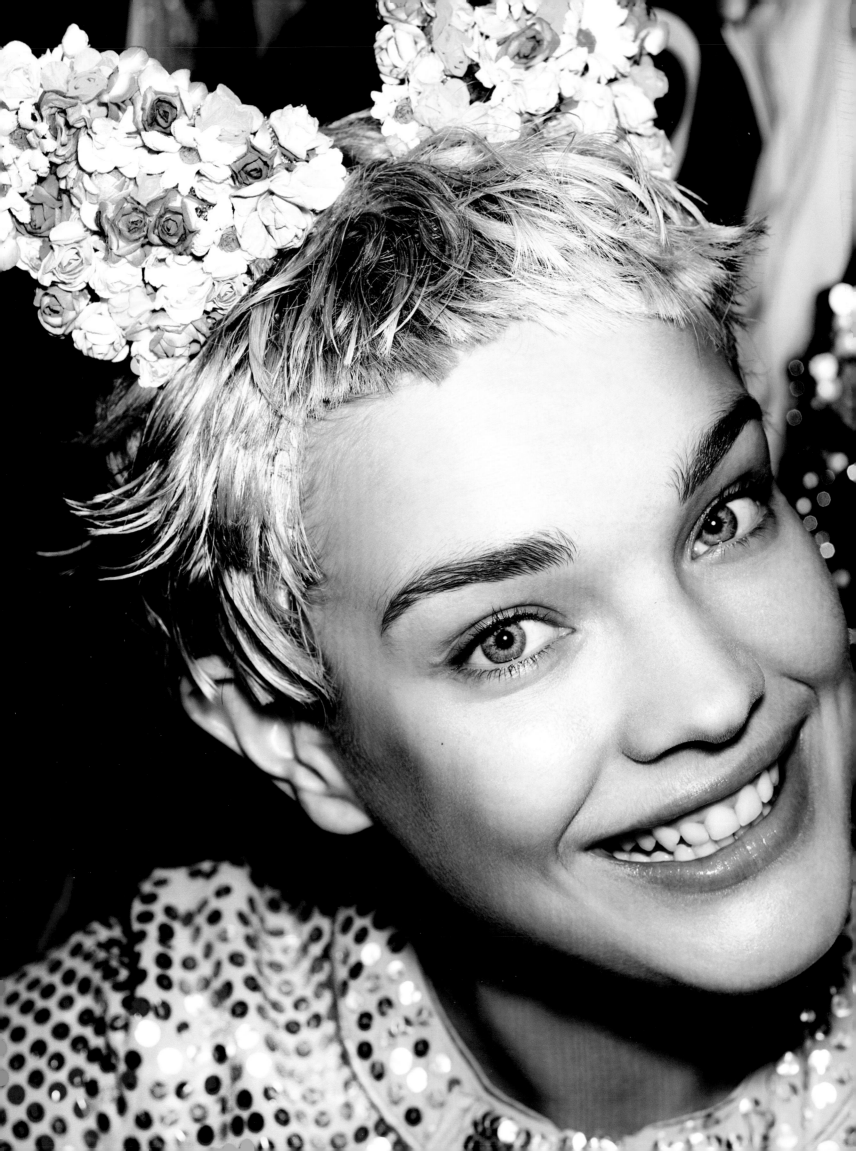

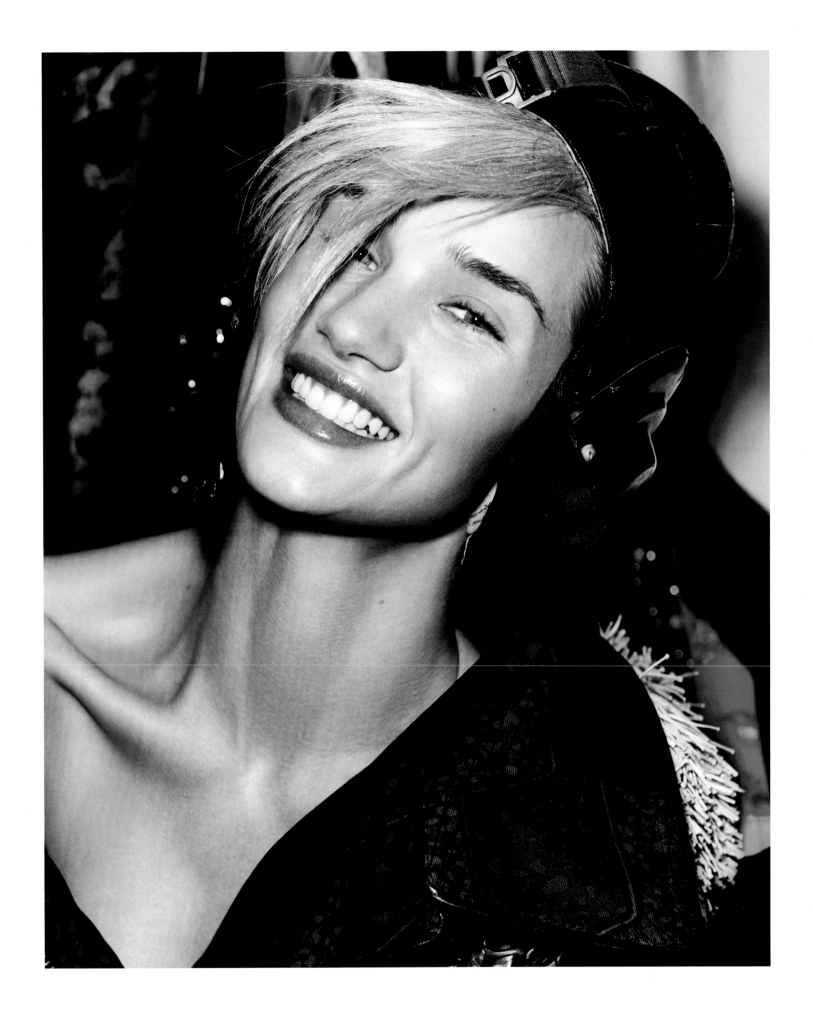

Opposite:
Natalia Vodianova for *LOVE* Magazine,
Spring/Summer 2010.

Above:
Rosie Huntington-Whiteley for *LOVE*
Magazine, Spring/Summer 2010.

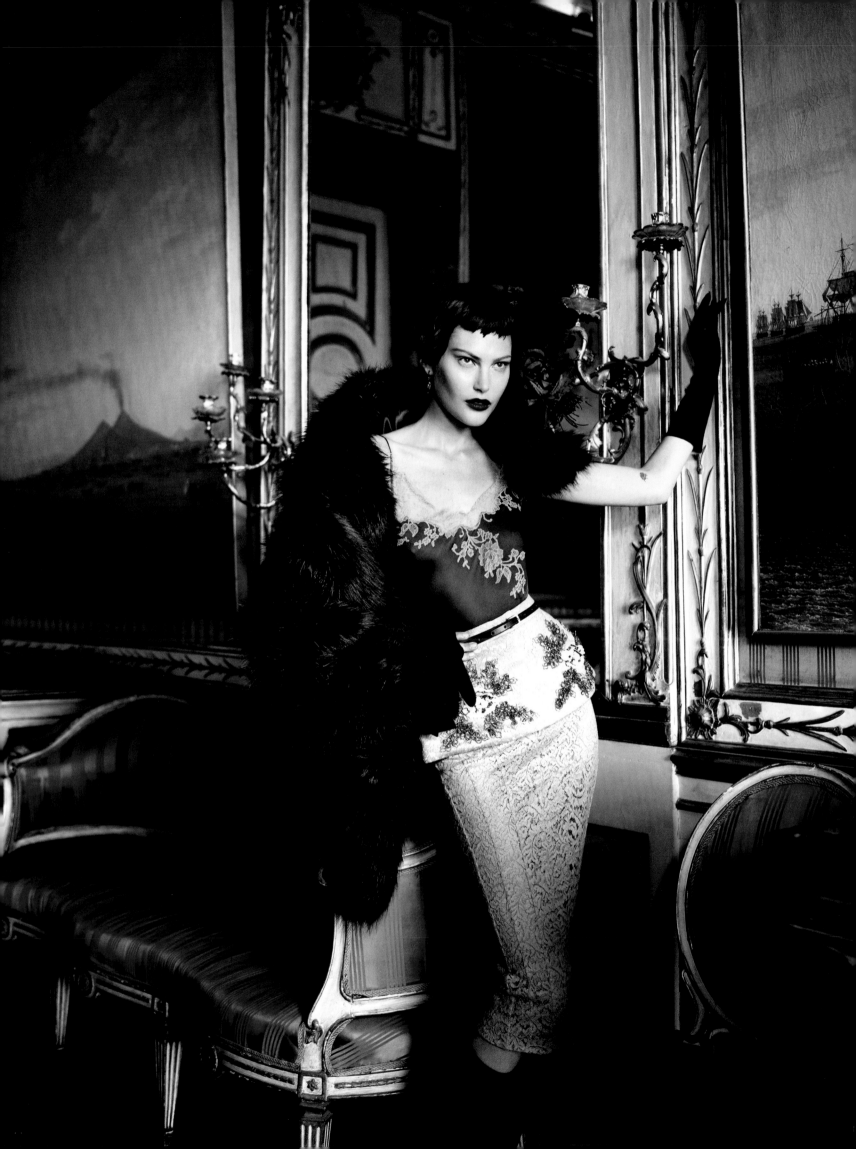

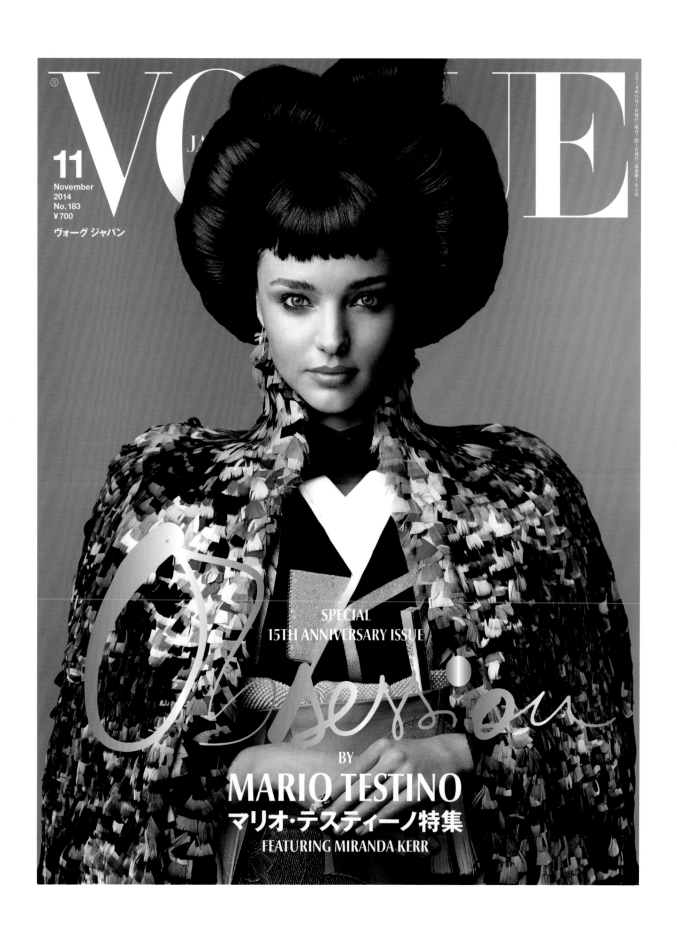

VOGUE

JAPAN

11
November
2014
No. 183
¥700
ヴォーグ ジャパン

SPECIAL
15TH ANNIVERSARY ISSUE

BY
MARIO TESTINO
マリオ・テスティーノ特集
FEATURING MIRANDA KERR

Opposite:

Catherine McNeil for British *Vogue*,
September 2013.

Above:

Mario's modern-day geisha Miranda
Kerr, styled by Anna Dello Russo, for the
fifteenth anniversary of Japanese *Vogue*,
November 2014.

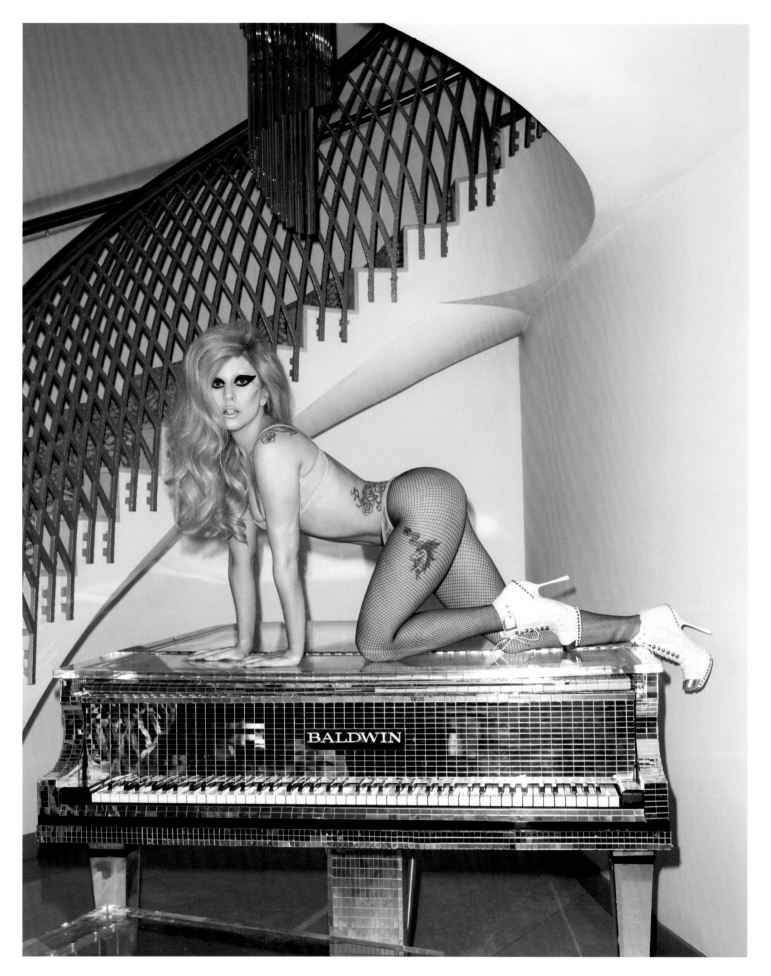

Above:

Lady Gaga, performer and original
transformer, gives good Barbarella
for *Harper's Bazaar*, May 2011.
Photograph by Terry Richardson.

Opposite:

Vanity Fair, September 2010 cover
by Nick Knight.

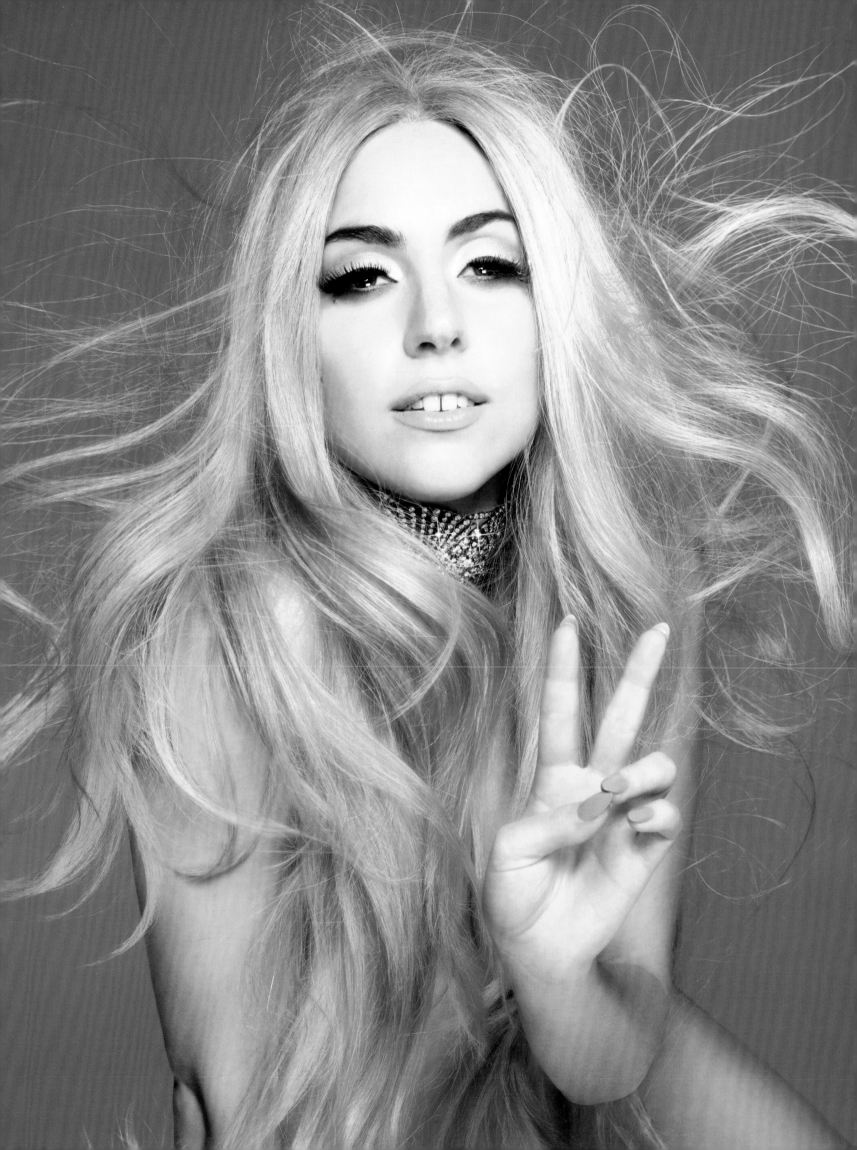

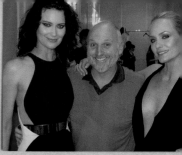
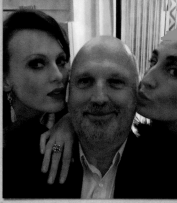

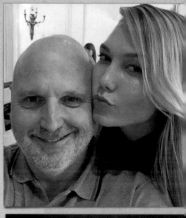

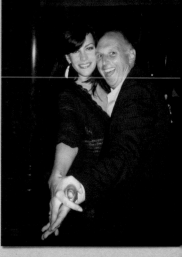

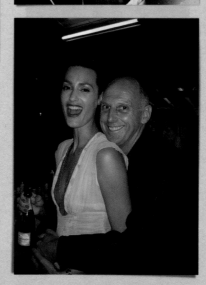
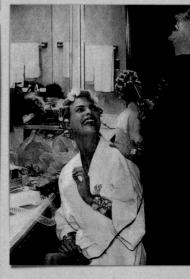

1 <u>Hair is in the Air</u>

Far fr... occupy...
a co...
sph... of...

2
of...

3 with hap...
often.
His wor...
special...
expres...
His...
oti...
per...

4
...
pro...
No...
with...
hair...
with...
alwa...
His...
necess...
renew...
in our...
Beauty...
outside...
of conne...
this is what makes
Sam unic!

5 Thank you Sam
for what you
are and what
you gives us all
Much love
Ra...

ACKNOWLEDGMENTS

Looking through over forty thousand images from my forty years in fashion was quite a daunting prospect, but the process has been a pure joy. The memories came flooding back with some fabulous forgotten shoots—and a few horrors!—reminding me of the once-teenage girls who are now mothers and grandmothers and of photographers and stylists, many of whom I still work with to this day and, in recent years, with whom I have been lucky enough to continue creating great images with newer talents. Looking through the book, I can see very clearly that all this beauty is created by a finely tuned collaboration with the many talents that make up a team: the photographer, model, makeup artist, stylist, manicurist, set designer, and producer. This is not just a book about hairstyles, it is a book to inspire. The end result of days and weeks of preparation, long hours of hard work, trials and errors…and did I forget to say…fun! So, thanks to all of the wonderful teams that made these images possible and here's to many more.

— *Sam McKnight*, 2016

Special Thanks

Eamonn Hughes - for loyalty, dedication, perseverance, and laughs. My Teams - for all your support, hard work, and cups of tea. Lindsay Cruickshank and all at Premier Hair & Makeup. Palma Driscoll and all at Bryan Bantry. Myles Grimsdale, Jenny Parkinson, Tory Turk, Tobi-Rose Milward, Hugh Devlin, Jo Jones, Susanna Flynn, Lilli Anderson.

Team (Past and present)

Valerie Benavides, Salvador Calvano, Nicola Clarke, Anna Cofone, Juan-Carlos Dayaruci, Colin Gold, Cyndia Harvey, Gary Haliday, Koji Ichikawa, Joseph Konyack, Marcia Lee, Sam Leonardis, Mia McSorley, Yesmin O'Brien, Declan Sheils, Chris Sweeney, Fabio Vivan, Sheridan Ward, Christian Wood, Lara Zee.

Photographers

Mark Abrahams, Mert Alas and Marcus Piggott, Miles Aldridge, Richard Avedon, François Berthoud (Illustration), Andrea Blanch, Eric Boman, Gavin Bond, Martin Brading, Brad Branson, Julian Broad, Regan Cameron, Walter Chin, Patrick Demarchelier, Sante D'Orazio, Matthew Donaldson, Terence Donovan, David Downton (Illustration), Ben Dunbar-Brunton, Richard Dunkley, Arthur Elgort, Simon Emmett, Robert Fairer, Fabrizio Ferri, Hans Feurer, Michel Haddi, Pamela Hanson, Ben Hassett, Alexei Hay, Marc Hispard, Horst P Horst, Eamonn Hughes, Nick Jarvis, Neil Kirk, Nick Knight, Kim Knott, Karl Lagerfeld, Paul Lang, Rocco Laspata & Charles DeCaro, Peter Lindbergh, Sandra Lousada, Roxanne Lowit, Glen Luchford, Andrew Macpherson, Mary McCartney, Craig McDean, Tony McGee, Niall McInerney, Alasdair McLellan, Raymond Meier, Sheila Metzner, Jem Mitchell, Tom Munro, Josh Olins, Irving Penn, Vincent Peters, Denis Piel, Stefan Rappo, Terry Richardson, Paolo Roversi, Satoshi Saikusa, Francesco Scavullo, Lothar Schmid, Collier Schorr, Kristian Schuller, Stéphane Sednaoui, Patric Shaw, Thomas Schenk, Lord Snowdon,

Mario Sorrenti, Emma Summerton, Wayne Takenaka, Gilles Tapie, Juergen Teller, Tesh, Mario Testino, Michael Thompson, Nick Towers, Scott Trindle, Terry Tsiolis, Max Vadukul, Javier Vallhonrat, Inez van Lamsweerde and Vinoodh Matadin, Willy Vanderperre, Ellen von Unwerth, Tim Walker, Albert Watson, Troy Ward, Bruce Weber, Paul Wetherell, Michael Williams.

Makeup & Manicurists

Kevyn Aucoin, Regine Bedot, Bobbi Brown, Lisa Butler, Linda Cantello, Lesley Chilkes, Sharon Dowsett, Lisa Eldridge, Anny Errandonea, Fulvia Farolfi, Issamaya French, Val Garland, Alice Ghendrih, Yvonne Gold, Tracey Gray, Mary Greenwell, Lorraine Griffin, Inge Grognard, Mark Hayles, Stevie Hughes, Miranda Joyce, Sonia Kashuk, Marie Jose La Fontaine, Sophie Levy, Vincent Longo, Stephane Marais, Laura Mercier, Kay Montano, Hannah Murray, Francois Nars, George Newell, Marian Newman, Maria Olsson, Dick Page, Tom Pecheux, Peter Philips, Lucia Pieroni, Sara Raeburn, Anatole Rainey, Brigitte Reis-Anderson, Sophy Robson, Wendy Rowe, Emmanuel Sammartino, Maria de Schneider, Adam Slee, Laurie Starrett, Charlotte Tilbury, Tyen, Ashley Ward, Gucci Westman.

Editors & Stylists

Miranda Almond, Christiane Arp, Emmanuelle Alt, Lisa Armstrong, Anastasia Barbieri, Camille Bidault-Waddington, Judy Blame, Michel Botbol, Sally Brampton, Laura Brown, Jane Bruton, Fran Burns, Paul Cavaco, Isabella Cawdor, Carlyne Cerf de Dudzeele, Lucinda Chambers, Madeleine Christie, Anne Christensen, Mandy Clapperton, Kirstie Clements, Grace Coddington, Nicholas Coleridge, George Cortina, Pat Crouch, Anna Dello Russo, Jessica Diehl, Aurelie Duclos, Alison Edmond, Katy England, Edward Enninful, Elaine Farmer, Charlotte-Anne Fidler, Nicola Formichetti, Sacha Forbes, Simon Foxton, Bay Garnett, Tonne Goodman, Katie Grand, Alisa Green, Amanda Harlech, Tallulah Harlech, Anna Harvey, Sophie Hicks, Sarajane Hoare,

Michael Howells, Jane How, Kim Hunt, Heathermary Jackson, Harriet Jagger, Cathy Kasterine, Jonathan Kaye, Freddie Leiba, Sascha Lilic, Deborah Lippman, Tiina Llaakkonen, Debbi Mason, Joe McKenna, Linda McLean, Polly Mellen, Grace Mirabella, Nicola Moulton, Bill Mullen, Sophia Neophitou-Apostolou, Charlotte Newson, Camilla Nickerson, Manuela Pavesi, Kate Phelan, Kathy Philips, Jayne Pickering, Roseann Repetti, Andrea Quinn-Robinson, Carine Roitfeld, Elissa Santisi, Venetia Scott, Alexandra Shulman, Tabitha Simmons, Elliott Smedley, Jerry Stafford, Alessandra Steinherr, Charlotte Stockdale, Karl Templar, Liz Tilberis, Alex White, Gillian Wilkins, Patti Wilson, Anna Wintour, Brana Wolf, Rosie Vogel- Eades, Panos Yiapanis, Victoria Young, Joe Zee, Anya Ziourova.

Designers

Victor Alfaro, Christopher Bailey at Burberry, Antonio Berardi, Graeme Black, Blumarine, All at Chanel (Eric Pfrunder, Virginie Viard, Oceane Sellier, Katherine Marre, Pascal Brault, Aurelie Duclos, Marilyn Smith), Chloe, Dean & Dan Caten at DSquared2, Yasmine Eslami, All at Fendi (Maria Elena Cima), Ferragamo, Tom Ford, John Galliano, Anya Hindmarch, Iceberg, Jaeger, Stephen Jones, Betsey Johnson, Donna Karan, Calvin Klein, Karl Lagerfeld, Miu Miu, Anna Molinari, Emma Hill and Mulberry, Isabel Marant, Max Mara, Stella McCartney, Thierry Mugler, Ralph Lauren, Charlotte Olympia, Phoebe Philo, Prada, Fausto Puglisi at Ungaro, Olivier Rousteing at Balmain, John Rocha, Sam Rollinson, Tanya Sarne at Ghost, L'Wren Scott, Sir Paul and Lady Pauline Smith, Sportmax, Riccardo Tisci, Ellen Tracey, Richard Tyler, Valentino, Dries Van Noten, Vivienne Westwood & Andreas Kronthaler, Matthew Williamson.

Models

Jackie Adams, Devon Aoki, Mica Arganaraz, Nadja Auermann, Andie Arthur, Michaela Bercu, Victoria Beckham, Nadja Bender, Freja Beha Erichsen, Julia Bergshoeff, Bjork, Josie

Borain, Maria Borges, Sara Bloomqvist, Oxana Bondarenko, Caroline Brasch, Zuzanna Bijoch, Gisele Bündchen, Christie Brinkley, Cate Blanchett, Avery Blanchard, Molly Blair, Sarah Brannon, Saskia de Brauw, Helena Bonham-Carter, Jamie Bochert, Naomi Campbell , Jeanne Cadeau, Edie Campbell, Susie Cave, Jo Calderone, Elise Crombez, Cindy Crawford, Emilia Clarke, Geraldine Chaplin, Alexa Chung, Helena Christensen, Cecilia Chancellor, Marion Cotillard, Lily Cole, Miley Cyrus, Mina Cvetkovic, Marine Deleeuw, Cara Delevingne, Princess Diana, Ana Drummond, Agyness Deyn, Lily Donaldson, Jourdan Dunn, Rhea Durham, Karen Elson, Michelle Eabry, Iris Egbers, Lida Egorova, Elizabeth Erm, Alexandra Elizabeth, Linda Evangelista and Marisa Evangelista, Anna Ewers, Victoria Ewen, Elaine Farmer, Dakota Fanning, Magdalena Frackowiak, Honor Fraser, Bette Franke, Sanna Friesland, Charlotte Free, Lady Gaga, Charlotte Gainsbourg, Daphné Groeneveld, Patrycja Gardygajlo, David Gandy, Toni Garrn, Alice Ghendrin, Eva Green, Simonetta Gianfelici, Jasmine Guinness, Shalom Harlow, Bridget Hall, Gigi Hadid, Ondria Hardin, Grace Hartzel, Sung Heekim, Sui He, Esther Heesch, Eva Herzigova, Kim Henderson, Clotilde Hesme, Lisa Hollenbeck, Jeny Howorth, India Hicks, Mickey Hicks, Taylor Hill, Georgia Hilmer, Pauline Hoarau, Elizabeth Hurley, Kirsty Hume, Rosie Huntington-Whiteley, Georgia May Jagger, Jade Jagger, Jacquelyn Jablonski, Kendall Jenner, Jessica the Chimp, Milla Jovovich, Mona Johannesson, Aya Jones, Valery Kaufman, Lynne Kaester, Jo Kelly, Miranda Kerr, Haze & Simi Khadra, Karlie Kloss, Suvi Koponen, Kim Kardashian, Liya Kebede, Doutzen Kroes, Nicole Kidman, Jodie Kidd, Keira Knightley, Diane Kruger, Ji Young Kwak, Harleth Kuusik, Karolina Kurkova, Ginta Lapina, Yasmin LeBon, Yumi Lambert, Joséphine Le Tutour, Virginie Ledoyen, Estelle Lefebure, Victoria Lockwood, Maria Loks, Brogan Loftus, Letitia Lucas, Angela Lindvall, Stella Lucia, Mirte Maas, Madonna, Grace Mahary, Maarte Mei, Kate Moss, Heidi Mount,

Andie MacDowell, Emma McLaren, Catherine McNeil, Helena McKelvie, Dauphine McKee, Kelly Mittendorf, Sienna Miller, Jessica Miller, Vanessa Moody, Vika Mostovnikova, Moira Mulholland, Kylie Minogue, Kristen McMenamy, Rosemary McGrotha, Lineisy Montero, Arizona Muse, Karen Mulder, Marina Nery, Kati Nescher, Ine Neefs, Katoucha Niane, Masha Novoselova, Kremi Otashliyska, Chiharu Okunugi, Carré Otis, Erin O'Connor, Sarah-Jessica Parker, Tatjana Patitz, Joanna Pacula, Louise Parker, Soo Joo Park, Antonina Petkovic, Paulina Porizkova, Shu Pei, Sasha Pivovarova, Isabella Rossellini, Coco Rocha, Hilary Rhoda, Josefien Rodermans, Liberty Ross, Sam Rollinson, Holly Rose, Jamie Rishar, Anja Rubik, Angel Rutledge, Winona Ryder, Hollie-May Saker, Amanda Sanchez, Monika Samika, Anette Stai, Cierra Skye, Othilia Simon, Brooke Shields, Stephanie Seymour, Jessica Stam, Daria Stroukus, Anna Selezneva, Léa Seydoux, Renée Simonsen, Berri Smither, Joan Smalls, Ava Smith, Claudia Schiffer, Lara Stone, Nostya Sten, Tatiana Sorokko, Vivien Solari, Tilda Swinton, Fei Fei Sun, Stella Tennant, Fabienne Terwinghe, Ai Tominaga, Alexandra Titarenko, Christy Turlington, Uma Thurman, Tetyana Tudor, Liv Tyler, Guinevere Van Seenus, Eline Van Houten, Michelle Van Bijnen, Grets Varlese, Alicia Vikander, Natalia Vodianova, Aymeline Valade, Natasa Vojnovic, Amber Valetta, Sophie Ward, Gemma Ward, Suki Waterhouse, Binx Walton, Maud Welzen, Alek Wek, Xiao Wen, Kate Winslet, Tami Williams, Lindsey Wixson, Amy Wesson, Antonia Wesseloh, Alexia Wight, Daria Werbowy, Kiki Willems, Devon Windsor, Kara Young Georgiopoulos, Ming Xi.

Thank You

Alamy, Art + Commerce, Art Partner, Artists Commissions, The Richard Avedon Foundation, Lucy Baxter, Bryan Bantry, Sophie Baudrand-Venables, Jonathan Bender at IMG Model Management, Tim Blanks, Bloomsbury Publishing, Nikki Carter, Penny Calder, Murray Chalmers, Michael & Caroline

Coliss at Molton Brown, Ronnie Cooke-Newhouse, Condé Nast Publications Ltd, Lizzie Cuthbertson at Picture House NYC, Richard Deal at Dexter Premedia, D Management, Carole Demoulin at Condé Nast, Robin Derrick, Samuel Dobrowolski at Elite Models Amsterdam, Giulia Di Filippo, Jessica Diner, Terence Donovan Foundation, Sarah Doukas, DNA Models, Tori Edwards, Elite, Didier Fernandez, Michele Filomeno, FIRSTview, Lynne Franks, Alexander Fury, Sam Gainsbury, Daniel Galvin, Getty Images, Jo Hansford, Hearst Publications, Adam Hindle, Tom Hingston & Hingston Studios, Homeagency, Hyman Archive, IMG Models, Daniel Kershaw at Storm Model Management, Charlotte Knight, Trey Laird, Jan Lane, Marcia Lee, The Lions NYC, Little Bear Inc, Management Artists, Models 1, Camilla Morton, Shonagh Marshall, Tim Clifton-Green at Next Model Management, The Irving Penn Foundation, Jen Ramey, Reuters, Rex Features, Charles Miers & Rizzoli, Jed Root, Select Model Management, SHOWstudio, The Society Management, Anna-Marie Solowij, Somerset House, Storm Model Management, Tess Management, Trump Models, Trunk Archive, Unsigned Group, Sissy Vian, Viva Model Management, Frances Knight-Jacobs & Saoirse Kennelly & Dolce Cioffo at Vivienne Westwood, Harriet Wilson at Condé Nast Publications Ltd, Wilhelmina Agency, Women Management.

My sincerest apologies to anyone whose credit has been unintentionally omitted from this book. Gathering together my archive over the past forty years has been a tremendous challenge and precise information has not always been available; and occasionally, time has blurred the memories.

— Sam McKnight

Condé Nast Publications Ltd. •*Page 122* © Nick Knight, December 2006, Courtesy of British Vogue •*Page 123* Mert Alas and Marcus Piggott/Vogue Paris.

Chapter 7: Poetic Fantasy

•*Page 124* © Nick Knight, February 2010, Courtesy of British Vogue •*Page 126 to 127* Tim Walker/British Vogue © The Condé Nast Publications Ltd. •*Page 128* Paolo Roversi/British Vogue © The Condé Nast Publications Ltd. •*Page 129* British Vogue © The Condé Nast Publications Ltd. •*Page 130* Patrick Demarchelier/British Vogue © The Condé Nast Publications Ltd •*Page 131* Photographer Jem Mitchell /Vogue Russia © The Condé Nast Publications Ltd •*Page 132 to 133* Paolo Roversi/ British Vogue © The Condé Nast Publications Ltd. •*Page 134* Tim Walker/ British Vogue © The Condé Nast Publications Ltd. •*Page 135* Tim Walker/ LOVE Magazine •*Page 136* Simon Emmett/Vogue China © The Condé Nast Publications Ltd •*Page 137* Scott Trindel/Teen Vogue •*Page 138 to 139* Paolo Roversi/Vogue Italia © The Condé Nast Publications Ltd.

Chapter 8: Shows

•*Page 140* Cara Delevingne at Dsquared2 Fall 2012, Photography Tulio M. Puglia/ Getty Images •*Page 142 and 143 From left to right, Line one: Images one to four* © Robert Fairer *Line two: Images five to seven* © Robert Fairer; © Roxanne Lowitt; *Images nine to eleven* © Robert Fairer *Line three: Images twelve to fourteen* © Robert Fairer; Sam McKnight ©; *Images sixteen to seventeen* © Robert Fairer; Aldo Castoldi/Blumarine © •*Page 144 to 145 From left to right, Line one: Images one to four* © Robert Fairer *Line two: Images five to ten* © Robert Fairer *Line three: Images eleven to fourteen* © Robert Fairer; Sam McKnight ©; Robert Fairer •*Page 146 to 147 From left to right, Line one: Images one, three and four* Eamonn Hughes ©; *Image two* Balmain Autumn/Winter 2012 ph: © Robert Fairer *Line two and three:* Eamonn Hughes © •*Page 148 to 149 From left to right, Line one:* Lady Gaga for Mugler Autumn/Winter 2011 ph: Becky Maynes; Lady Gaga for Mugler Autumn/Winter 2011 ph: Getty Images; all other images Eamonn Hughes © *Line two:* Eamonn Hughes © *Line three:* Eamonn Hughes © •*Page 150 to 151 From left to right, Line one: Images one to five* Eamonn Hughes ©; Karlie Kloss for Tom Ford ph: Getty Images; Eamonn Hughes © *Line two:* Eamonn Hughes © *Line three:* Eamonn Hughes ©; L'Wren Scott Fall/Winter 2013 ph: © Robert Fairer; Eamonn Hughes ©.

Chapter 9: Modern Retro

Page 152 © Craig McDean •*Page 154 and 155* Inez and Vinoodh/British Vogue © The Condé Nast Publications Ltd •*Page 156* Mario Testino/British Vogue © The Condé Nast Publications Ltd •*Page 157* Karl Lagerfeld/Vogue Germany © The Condé Nast Publications Ltd •*Page 158*

Javier Vallhonrat at mfilomeno.com/ Vogue © The Condé Nast Publications Ltd •*Page 159* © Nick Knight, September 2008, Courtesy of British Vogue •*Page 160* Mario Testino/Vogue © The Condé Nast Publications Ltd •*Page 161* Patrick Demarchelier/Vogue © The Condé Nast Publications Ltd •*Page 162* Mario Testino/British Vogue © The Condé Nast Publications Ltd •*Page 163* © Willy Vanderperre/W Magazine •*Page 164* Winona Ryder by Michel Haddi for Interview Magazine 1993 •*Page 165* Bruce Weber/Vogue Italia © The Condé Nast Publications Ltd •*Page 166* © David Downton •*Page 167* © Craig McDean/US Vogue © The Condé Nast Publications Ltd •*Page 168* Javier Vallhonrat at mfilomeno.com/British Vogue © The Condé Nast Publications Ltd •*Page 169* Patrick Demarchelier •*Page 170* Sheila Metzner/German Vogue © The Condé Nast Publications Ltd •*Page 171* © Craig McDean/British Vogue © The Condé Nast Publications Ltd •*Page 172* Patrick Demarchelier/British Vogue © The Condé Nast Publications Ltd •*Page 173* Patrick Demarchelier/Vogue India © The Condé Nast Publications Ltd •*Page 174* Photography Patric Shaw/British Glamour •*Page 175* © Nick Knight, April 2008, Courtesy of British Vogue.

Chapter 10: Energy

•*Page 176* Alexei Hay •*Page 178 to 179* Ben Hassett •*Page 180* Simon Emmett •*Page 181* Photographer Jem Mitchell •*Page 182* © Nick Knight, 2001 •*Page 183* © Matthew Donaldson •*Page 184* © Mario Testino/Vogue China © The Condé Nast Publications Ltd •*Page 185* © Nick Knight, March 2009, Courtesy of British Vogue •*Page 186* © Nick Knight, June 2006, Courtesy of Pop Magazine •*Page 187* Vincent Peters •*Page 188* © Nick Knight, October 2001, Courtesy of British Vogue •*Page 189* © Nick Knight Courtesy of W Magazine •*Page 190 to 191* Photography Patric Shaw.

Chapter 11: Karl Lagerfeld

•*Page 192 to 205* All Photographs by Karl Lagerfeld •*Page 206 to 207 From left to right, Line one: Images one to three* Chanel short films: Walter films for Chanel © *Line two: Images four and five* Chanel short films: Walter films for Chanel ©; *Images six and seven* Eamonn Hughes © *Line three: Image eight* Eamonn Hughes ©; *Images nine to eleven* Chanel short films: Walter films for Chanel © •*Page 208 to 209* Chanel behind the scenes: Olivier Saillant for Chanel © •*Page 210 to 211 Images one and two* Chanel Ready-to-Wear Spring 2012 ph: Eamonn Hughes ©; *Images three to six* Chanel 'Edinburgh' Pre-Fall 2013 ph: Eamonn Hughes ©; *Images seven to twelve* Chanel 'Versailles' Resort 2013' ph: Eamonn Hughes ©; *Images thirteen to fifteen* Chanel 'Paris-Bombay' Pre-Fall 2012 ph: Eamonn Hughes © •*Page 212 to 213 Images one and two* Chanel Haute Couture Spring 2013 ph: Eamonn Hughes ©; *Images three to five* Chanel 'Singapore' Resort 2014 ph:

Eamonn Hughes ©; *Images six to nine* Chanel Haute Couture Fall 2013 ph: Eamonn Hughes ©; *Images ten to twelve* Chanel Ready-to-Wear Spring 2014 ph: Eamonn Hughes © •*Page 214 to 215 Images one to two* Chanel 'Dallas' Pre-Fall 2014 ph: Eamonn Hughes ©; *Images three to six* Karl Lagerfeld © & Chanel Ready-to-Wear Fall 2014 ph: Eamonn Hughes ©; *Images seven to twelve* Karl Lagerfeld © & Chanel Haute Couture Spring 2014 ph: Eamonn Hughes ©; *Images thirteen to sixteen* Karl Lagerfeld © & Chanel 'Dubai' Resort 2015 ph: Eamonn Hughes © •*Page 216 to 217 Images one to five* Karl Lagerfeld © & Chanel Haute Couture Fall 2014 ph: Eamonn Hughes ©; *Images six to nine* Karl Lagerfeld © & Chanel 'Salzburg' Pre-Fall 2015 ph: Eamonn Hughes ©; *Images ten to fourteen* Karl Lagerfeld © & Chanel Ready-to-Wear Fall 2015 ph: Eamonn Hughes ©; *Images fifteen to eighteen* Chanel 'Seoul' Resort 2016 ph: Eamonn Hughes ©. •*Page 218 to 219 Images one to three* Chanel Ready-to-Wear Spring 2015 ph: Eamonn Hughes ©; *Images four to seven* Chanel 'Rome' Pre-Fall 2016 ph: Eamonn Hughes ©; *Images eight to twelve* Karl Lagerfeld © & Chanel Haute Couture Spring/ Summer 2015 ph: Eamonn Hughes ©; *Images thirteen to sixteen* Chanel Haute Couture Spring/Summer 2015 ph: Eamonn Hughes ©. •*Page 220 to 221 Image one* Karl Lagerfeld ©; *Images two to six* Chanel Haute Couture Spring/ Summer 2016 ph: Eamonn Hughes ©; *Images seven to eleven*, Chanel 'Cuba' Resort 2017 ph: Eamonn Hughes ©; *Image twelve*, Karl Lagerfeld ©.

Chapter 12: Sexy

•*Page 222* Patrick Demarchelier/British Vogue © The Condé Nast Publications Ltd •*Page 224 to 225* Miles Aldridge •*Page 226* Inez and Vinoodh •*Page 227* © Nick Knight, 2005, Courtesy of The Telegraph Magazine •*Page 228 to 229* Ellen Von Unwerth •*Page 230* Ellen Von Unwerth/British Vogue © The Condé Nast Publications Ltd •*Page 231* Ellen Von Unwerth/Vogue Italia © The Condé Nast Publications Ltd •*Page 232* © Mario Testino •*Page 233* Emma Summerton/Vogue Italia © The Condé Nast Publications Ltd •*Page 234* British Vogue © The Condé Nast Publications Ltd •*Page 235* Courtesy of Juergen Teller •*Page 236* Mario Testino/British Vogue © The Condé Nast Publications Ltd •*Page 237* Mert and Marcus/Vogue France © The Condé Nast Publications Ltd •*Page 238* © Nick Knight, December 2010, Courtesy of Vogue Italia •*Page 239* Patrick Demarchelier/British Vogue © The Condé Nast Publications Ltd.

Chapter 13: Cool Girl

•*Page 240* Josh Olins/British Vogue © The Condé Nast Publications Ltd •*Page 242* Karl Lagerfeld ©/Harper's Bazaar •*Page 243* Paolo Roversi/British Vogue © The Condé Nast Publications Ltd •*Page 244* © Craig McDean •*Page 245* Patrick Demarchelier/Vogue France ©

The Condé Nast Publications Ltd •*Page 246* Patrick Demarchelier/British Vogue © The Condé Nast Publications Ltd •*Page 247* Satoshi Saikusa/W Magazine •*Page 248* © Nick Knight, December 2009, Courtesy of Vogue France •*Page 249* Paul Wetherell/British Vogue © The Condé Nast Publications Ltd.

Chapter 14: When You're a Boy

•*Page 250* Paolo Roversi/L'Uomo Vogue © The Condé Nast Publications Ltd •*Page 252 to 253* © Craig McDean/ Vogue Italia © The Condé Nast Publications Ltd •*Page 254* Karl Lagerfeld © •*Page 255* Tim Walker/ British Vogue © The Condé Nast Publications Ltd •*Page 256* Michael Thompson/Trunk Archives •*Page 257* Karl Lagerfeld ©/Vogue Germany © The Condé Nast Publications Ltd •*Page 258* © Nick Knight, April 2008, Courtesy of British Vogue •*Page 259* Photographer Jem Mitchell /Vogue China © The Condé Nast Publications Ltd •*Page 260* Paolo Roversi/Donna Magazine •*Page 261* © Nick Knight, Autumn/ Winter 2010, Courtesy of Vogue Homme Japan •*Page 262 to 263 From left to right, Line one:* © Robert Fairer; Mario Testino; Photo by Troy Word/Elle; Glen Luchford/Art Partner *Line two:* Neil Kirk/British Vogue © The Condé Nast Publications Ltd; Photo by Stéphane Sednaoui; Sheila Metzner/British Vogue © The Condé Nast Publications Ltd.

Chapter 15: Transformations

•*Page 264* © Nick Knight, 2011 •*Page 266 and 267* Glen Luchford/Art Partner •*Page 268* Emma Summerton/Vogue Italia © The Condé Nast Publications Ltd •*Page 269* © Nick Knight, July 2002, Courtesy of British Vogue •*Page 270* © Craig McDean/AnOther Magazine •*Page 271* Patrick Demarchelier/ British Vogue © The Condé Nast Publications Ltd •*Page 272 to 273* Emma Summerton/Vogue Italia © The Condé Nast Publications Ltd •*Page 274* Patrick Demarchelier/British Vogue © The Condé Nast Publications Ltd •*Page 275* Terry Tsiolis/Allure •*Page 276* Emma Summerton/i-D Magazine •*Page 277* Tim Walker/British Vogue © The Condé Nast Publications Ltd •*Page 278* Mario Testino/British Vogue © The Condé Nast Publications Ltd •*Page 279* Mario Testino/V Magazine •*Page 280 to 281* Mario Testion/LOVE Magazine •*Page 282* Mario Testino/British Vogue © The Condé Nast Publications Ltd •*Page 283* Mario Testino/Vogue Japan © The Condé Nast Publications Ltd •*Page 284* Terry Richardson/Art Partner/Harper's Bazaar •*Page 285* © Nick Knight, September 2010, Courtesy of Vanity Fair •*Page 286 to 287* Personal photographs: Mary McCartney, Pamela Hanson, Thoai Niradeth, Eamonn Hughes ©, © Nick Knight, Rex Features, Getty Images, Sam McKnight ©. •*Page 288 to 289* Selfies: Sam McKnight © •*Page 290* Sam McKnight ©